EXTRAORDINARY VOYAGES

LOUIS VUITTON

FRANCISCA MATTÉOLI

EXTRAORDINARY VOYAGES

LOUIS VUITTON

ABRAMS, NEW YORK

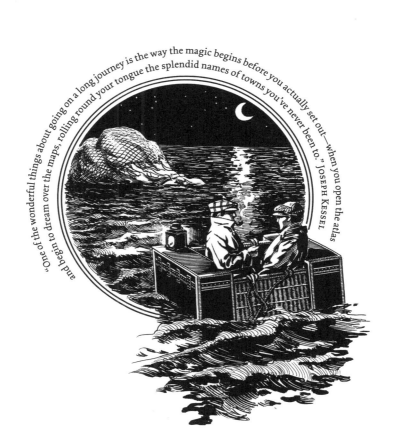

"One of the wonderful things about going on a long journey is the way the magic begins before you actually set out—when you open the atlas and begin to dream over the maps, rolling round your tongue the splendid names of towns you've never been to." JOSEPH KESSEL

PREFACE

FRANCISCA MATTÉOLI

The tales recounted to me as a child always involved extraordinary adventures. Growing up in Chile, it seemed obvious to me that visiting other parts of the country or any other nation in the world necessarily involved a proper expedition, given the geography. It went without saying that each and every voyage was extraordinary, as it was not simple to leave a land 2,670 miles long, and wedged between the Pacific Ocean and the Andes mountains. This was borne out when my family decided to move to France, leaving behind a country in turmoil and undertaking a journey worthy of the conquistadors.

My grandparents, my parents, my sister, and I began by driving from our house, way out on the plains, to the Chilean capital, Santiago. From there, we took a train, for the first time in my life, to the top of the Andean cordillera, where we changed trains and descended the Argentinian side of the mountain range as far as the port of Buenos Aires. There we boarded a liner operated by the Compagnie des messageries maritimes, which ran a service between South America and

France. The voyage was punctuated by ten or so stops in as many different countries, sailing up the Brazilian coast and across to Europe and some of its most important ports. We finally reached Le Havre—the end of the world, in my mind— setting off again almost immediately in two cars headed for Paris, our final destination. After nearly three weeks of travel across half the globe, using all the means of transportation available to us, we had gone from our living room to a vision that, until then, had only existed in our minds.

This is the theme of this book. Means of locomotion are, above all, a way for human adventures to occur. It is by no means an encyclopedic work, and requires no particular expertise. It does not offer a host of knowledge, nor is it in any way scientific, geographic, ethnological, meteorological, or what have you. It is merely the pretext for departing, for escaping to a world of dreams that were actually realized before becoming part of history and the collective imagination, transforming eras, lives, and sometimes even destinies. The Frenchman Nadar, for instance, did not just invent aerial photography and his famous hot-air balloon *Le Géant*: He also gave the world a machine that was to play a major role in the Franco-Prussian War, enabling Léon Gambetta, France's minister of the interior, to escape Paris and the bombardment in order to organize the resistance. In this way, he demonstrated the strategic use of these machines in times of war. The Wright brothers, from the depths of their modest bicycle workshop in Ohio, did no less than give us the first real aircraft, the Wright Flyer. John Muir, in crossing the wild expanses of America with the help of the simplest means of locomotion ever invented (namely his solid legs and a brisk pace) opened the way for a new philosophy, becoming the hero of naturalists and ecologists around the world and dreaming up

the formidable notion of national parks, the ultimate realization of his, and our, dreams. Those who came up with the idea of building the first train for the legendary Orient Express line created a geographical link between European nations, as well as inventing a fascinating means of travel. As for the creators of the transcontinental railroad across America, spanning from one ocean to the other, they completely transformed the country, unifying it in a way that had never before seemed possible and forever changing the outlook of its inhabitants.

The creation and use of every means of transport draw on tales as much as technique. They reflect the diversity of the human mind, crystallizing everything that motivates it, its desires, its need to leave its mark on history. It's difficult to imagine Lawrence of Arabia leading his Arab Revolt in any way other than with a camel charge, abandoning his way of life for that of the peoples by whom he wished to be adopted. In the same way, it's hard to imagine Henri Mouhot exploring

Francisca Mattéoli's parents, Philippa and Eduardo Yrarrázaval, in South America in the 1960s.

the lush jungle overrunning the ruins of Angkor Wat other than by elephant. The luxury liners of the legendary shipping companies evoke an era that will never exist again. They symbolize everything a sea voyage can offer in the way of opulence and magic, while cargo ships opened up a new era and another, no less exceptional, idea of travel.

The means of transport used for each voyage was far more than just a physical, practical machine. These voyages afforded an alternative take on the world, opening up to new worlds of the imagination. A junk consistently evokes tales of adventure in the China Sea. The well remembered and revolutionary Ford T recounts stories linked to the very earliest automobile excursions on American roads. The supersonic planes that broke the sound barrier, previously unimaginable, speeding through the sky like lightning, celebrate the stuff of heroes, the technical prowess of certain nations, supersonic magic. All these journeys are both poetic and captivating, whether made by train, car, truck, plane, boat, or the very earliest aircraft. In recounting them, we are already traveling, our spirits taking off, embarking, dashing along roads, deserts, seas, frozen continents, and everything becomes possible. In short, I see no better way of realizing our dreams.

Some of these voyages took place at a time in history when many in Asia, Africa, and the Americas were experiencing the aftermath of colonialism and imperialism. This complicated legacy is important to acknowledge, before we delve into the stories that follow. This book presents a specific and beautiful world. At its heart, it is a celebration of innovation, the joy of travel—the awe of experiencing new landscapes and cultures—and the undeniable lure of adventure and the unknown, a calling that we all share and that I believe can bring us together.

Francisca Mattéoli during her childhood in Chile.

EXTRAORDINARY VOYAGES

CONTENTS

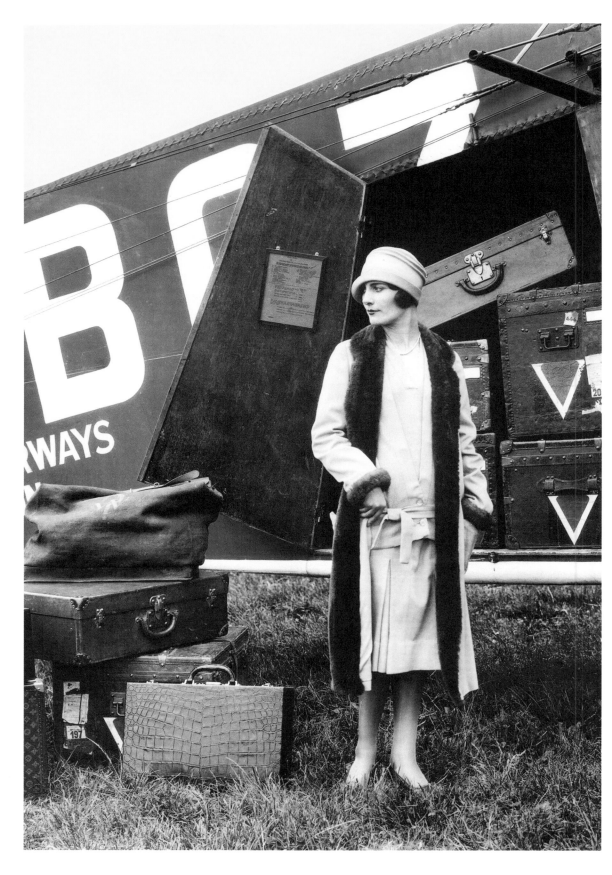

WITH GREAT STRIDES

———

JEAN-LUC TOULA-BREYSSE
TRAVEL HISTORIAN

Love is not the only thing that transports us to the ends of the earth. In the atlas of our dreams, choosing one's means of travel is choosing one's path. And according to a Tibetan saying: "There's no path to happiness; happiness is the path." Setting out on a wonderful trip, pacing yourself on foot, or in a canoe, by sled, in a caravel, or an airship—anything goes when it comes to embracing the farthest reaches of unknown lands. The globetrotting writer and poet Blaise Cendrars noted in his last collection of poems, *Feuilles de route*: "Leaving begins with a visit to Louis Vuitton," for the trunkmaker equipped long-distance travelers from the outset, be they explorers, hedonists, aristocrats, or artists.

 With the Industrial Revolution and then the technological progress of the twentieth century, dream makers did away with distances by inventing the railroad, the motor car, ever more efficient and comfortable boats, and the most incredible machines, including aircraft that rubbed shoulders with the clouds. These new transport means crossed borders, bringing

Thérèse Bonney, *Le Voyage en avion* [The journey], c. 1927. The luggage stamped with a V was personalized by Gaston-Louis Vuitton. Paris, Louis Vuitton archives.

with them changes in lifestyle and defying the test of time. The performance of vehicles drastically reduced journey times. Speed altered perspectives.

Seen from Francisca Mattéoli's perspective, the art of travel becomes the art of living. As a woman of the world, she roams the four corners of the globe, recounting incredible stories, page after page. She has chosen the title *Extraordinary Voyages* here, as did Jules Verne, a writer passionate about science and way ahead of his time, for his collection of eighty stories including *Five Weeks in a Balloon*, *From the Earth to the Moon*, *Twenty Thousand Leagues under the Sea*, *Journey to the Center of the Earth*, and *Around the World in Eighty Days*. The latter recounts the travels of a British gentleman Phileas Fogg, and his French valet, Jean Passepartout, who take all available means of transport to win the crazy wager that Fogg has made with his friends at the Reform Club in London. These two globe-trotters brave distant horizons, from the banks of the Bosporus to Valparaiso, from the Siberian tundra to the peaks of the Andes, from Africa to Asia. As did the wealthy adventurer W. C. Sandeman, who congratulated Georges Vuitton for the solidity of his luggage: "They traveled unhindered from the United States to South-East Asia, via Japan, Korea, Tonkin, Cochinchina, Siam, and Burma, on the backs of horses, mules, oxen and elephants."

Luggage tag of the Danish-Polish shipping company Gdynia-America Line, 1950s.
Paris, Gaston-Louis Vuitton collection.

BY RAIL

The advent of the train, invented by the British engineer George Stephenson, sounded the death knell for stagecoaches and postilion riders. In the early days of this railroad adventure, these fire-breathing steeds worried the population at large and were cause for much concern. It was said, after all, that the noise, smoke, and sparks from the engine might provoke fires, prevent chickens from laying eggs and trees from bearing fruit, make the milk turn in the stables, and ruin the corn and potato crops. By the second half of the nineteenth century, rail travel turned the world of transport, and its uses, on its head. So much so that in an article in *The World of Yesterday*, the writer Stefan Zweig wrote: "It always gives me pleasure to astonish the young by telling them that before 1914 I traveled from Europe to India and America without a passport and without ever having seen one. One embarked and alighted without questioning or being questioned." At that time, the laissez-passer of wealthy adventurers was a dinner jacket and the very finest jewelry for their companions. That had not always been the case. Ever since the reign of Louis XIV, the subjects of the kingdom of France and then the citizens of the French Revolution had had to hold a passport to cross their country's borders. But in the nineteenth century, the movement of people exploded to such an extent, as a result of trains, that the authorities decided to do away with this precious "door opener."

I passed my childhood in the hanging gardens of Babylon | Playing hooky from school, in the stations as the trains pulled away | Now I have made all the trains run behind me | Basel–Timbuktu | I have also played the horses at Auteuil and Longchamps | Paris–New York | Now I've made all the trains run the length of my life | Madrid–Stockholm | I've lost all my bets

Blaise Cendrars, *Prose of the Trans-Siberian and of Little Jehanne of France* (1913, translated by Donald Wellman)

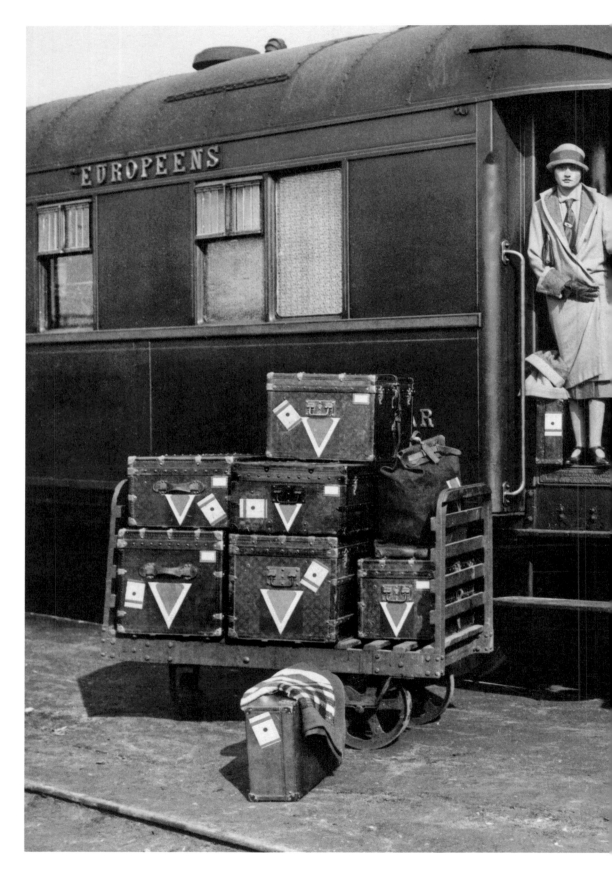

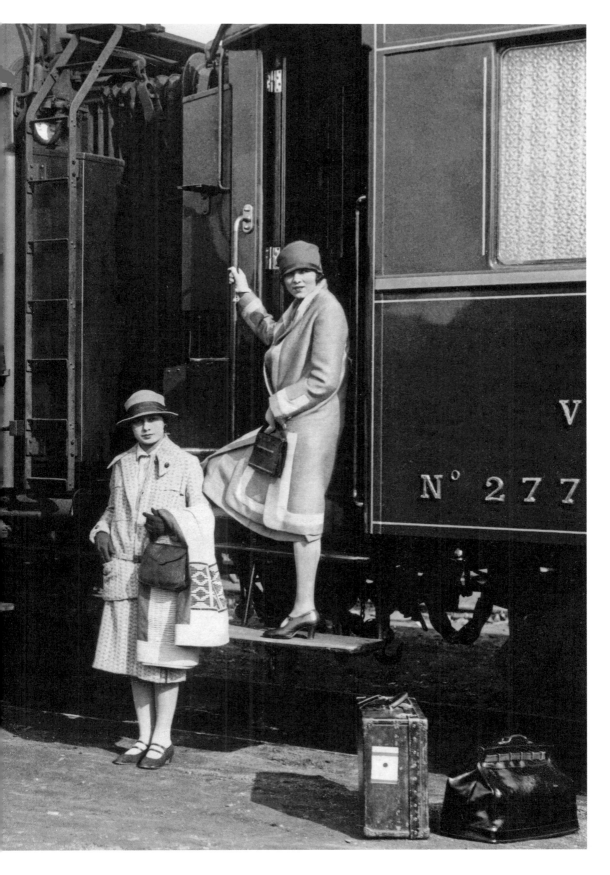

The invitation to travel, so dear to Charles Baudelaire, befit-
ted sybarites in search of mobility, of "luxury, calm and exquisite
pleasure." Train stations became the heart of transport. Trunks
made of poplar covered with impermeabilized fabric stood on
platforms, waiting to be carried to Pullman cars headed to new
destinations. In 1870, George Mortimer Pullman, an American
industrialist and engineer, transformed traveling into a way
of life. He built salon-cars and sleeping-cars before founding
the Pullman Palace Car Company. First the United States, then
England and France were won over by these outstanding train
carriages, filled with velvet, steel, rosewood, citrus tree wood,
and mahogany fixtures and fittings. Minds wandered to the scan-
sion of the railroad trucks. "Lend me your great sound, your great
and gentle motion, / Your nighttime glide across illuminated
Europe, / O deluxe train!," wrote Valéry Larbaud in *The Poems
of A. O. Barnabooth* (translated by Ron Padgett and Bill Zavatsky).

The first North American transcontinental railroad
opened to the public in 1872, linking the Atlantic and Pacific
coasts, shortly before the Trans-Andean railroad opened between
Argentina and Chile. In Eurasia, the Trans-Siberian railroad
pursued its conquest of the East by reaching Vladivostok in 1902.
Starting in Paris, the incomparable Orient Express crossed Swit-
zerland, Italy, and the Balkans en route for Athens and Istanbul.
These trains traced their rail lines on the map of world legends.

A passion for trains is also found in art. For example, the
Train Bleu overnight express from Calais to the Côte d'Azur,
with its luxury sleeping cars, inspired a ballet in 1924, with cho-
reography by Bronislava Nijinska (Vaslav Nijinsky's younger
sister), libretto by Jean Cocteau, music by Darius Milhaud,
a safety curtain based on a gouache by Pablo Picasso, and cos-
tumes by Coco Chanel! *Tender Is the Night* by F. Scott Fitzgerald

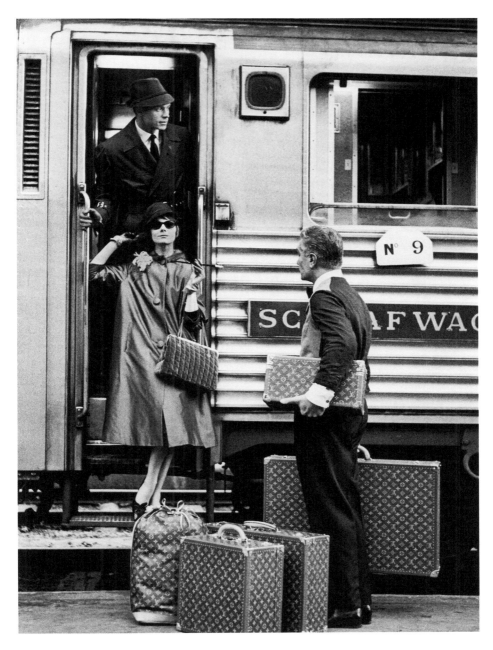

Elegant woman with her Alzer and Cotteville suitcases, a Marin bag, and a Monogram
canvas Vanity case, 1960s. Paris, Louis Vuitton archives.

also succumbed to the train's charm, and Arthur Honegger's symphonic movement, *Pacific 231*, celebrates a steam engine that has since become iconic. Echoing the daily life of Japanese commuters, movie director Yasujiro Ozu captured the quick movement of trains in his films. Then electricity arrived and the focus was on traveling ever faster. In the Japanese archipelago, the world's first high-speed train, the Shinkansen, was launched for the 1964 Olympic Games, linking Tokyo to Osaka at 125 mph. The prototype for a future Japanese maglev train reached 375 mph during a trial, beating all previous records. It is due to be put into circulation in 2027 between Tokyo and Nagoya.

BY SEA

Ever since *The Odyssey*, ships have sailed at the mercy of the seas. Sailors and poets have long been captivated by the vastness of the oceans. Paddleboats, cruise ships, icebreakers, cargo ships, trawlers, schooners, junks, and sailing ships dot the seas around the globe. While watersports, yachting, and the America's Cup and Louis Vuitton Cup regattas made sailing heroic and mythical, ocean liners embedded themselves in the collective unconscious of travelers, trailing a hint of the possible in their wake. By 1840, the first transatlantic steamships were able to link Le Havre and New York

French Lines shipping company luggage tag, 1920–30.
Paris, Gaston-Louis Vuitton collection.

in the space of ten days. America was brought closer to Europe, first for migrants, then for the wealthy few receptive to the call of the sea. In 1931, the president of the board of directors of the shipping service confided that "some people, when stepping aboard a liner, feel a need for luxuries that they would not have thought of expressing when on dry land." During crossings, life on the upper decks reflected all the luxury that the French knew so well how to provide. The ships weighed anchor with L.V. trunks on board that had been specially designed for the first-class cabins. The comfort of these ocean liners thrilled passengers. The interior decoration and layout made them into floating palaces, with drawing rooms, bars, and smoking rooms rivaling in splendor. Sporting activities, games, theatrical performances, cocktails, gastronomic dinners, and dances filled the days and nights of these transatlantic liners.

When you go sweeping by in your full, flowing skirts, You resemble a trim ship as it puts to sea Under full sail and goes rolling Lazily, to a slow and easy rhythm.

Charles Baudelaire, "The Beautiful Ship," *The Flowers of Evil* (1857, translated by William Aggeler)

The Compagnie Générale Transatlantique, Cunard, and White Star all competed for the highly sought after Blue Riband, an unofficial accolade for the fastest North Atlantic crossing of a passenger liner in regular service. Before the Second World War, the *Normandie* and the *Queen Mary* battled it out: in 1935, the French flag carried off the trophy, crossing the Atlantic in four days, three hours, and two minutes; the following year, the *Queen Mary* stole it off them. Then in 1937, the *Normandie* won it back, only to have its adversary from across the Channel take it back again. Their imposing size and frantic race symbolized the best of modern transport prior to the supremacy of aviation, which would prove fatal to these ocean giants, including the *France*, the world's largest ocean liner in the 1960s.

BY ROAD

The car—a major phenomenon of the twenti-eth century that was, at first, the preserve of a wealthy elite before coming within the grasp of the common man (largely thanks to Henry Ford)—facilitated both individual getaways and group explorations. When vehicles had gleaming chrome work, there were motorized rallies in 1924 and 1925 linking Algiers to Cape Town and Mad-agascar, as well as a rally in 1931 that set off in the footsteps of the Venetian, Marco Polo, for a new "Description of the World": nearly 7,500 miles along ancient silk routes via the Gobi Desert and dangerous Himalayan passes. The members of this mis-sion, organized by Georges-Marie Haardt and Louis Audouin-Dubreuil at the instigation of André Citroën, experienced an adventure that took them from "Beirut all the way to Peking over the summits of the world." These driving fanatics under-took this modern-day journey in cars, or more precisely, in half-tracks, with baggage from the Louis Vuitton workshops in Asnières. The firm also designed made-to-measure trunks for vehicles created by Bugatti, Kellner, and Rolls-Royce.

 The sleek American cars of the fifties—Cadillacs, Chev-rolets, Buicks, Plymouths, Chryslers, and Pontiacs—were the stuff of dreams for the nation's youth, thirsty for freedom and pleasure. Their powerful engines were a sensation. They embodied a lust for life. Cars became widespread as people took to the road, fulfilling their dreams. The winds of change and the rejection of consumer society led beatniks, hippies,

I think that cars today are almost the exact equivalent of the great Gothic cathedrals; I mean the supreme creation of an era, conceived with passion by unknown artists, and consumed in image if not in usage by a whole population which appropriates them as a purely magical object.

Roland Barthes, *Mythologies* (1957, translated by Annette Lavers)

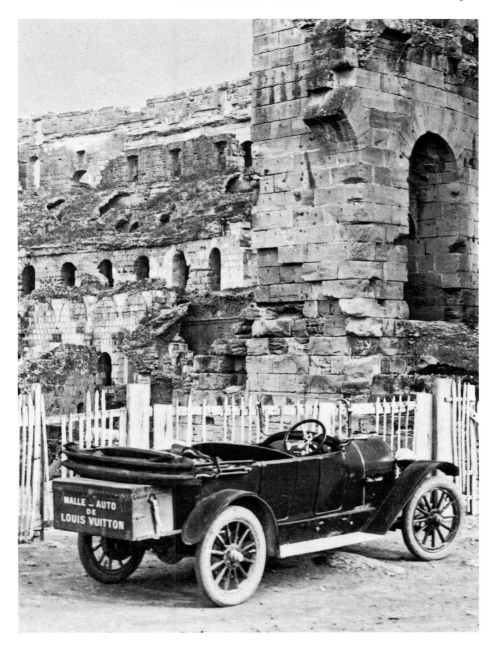

Jean du Taillis's car equipped with a Louis Vuitton trunk parked in front
of the Roman amphitheater of El Djem, or Thysdrus Coliseum, Tunisia, 1923.
Paris, Louis Vuitton archives.

and backpackers along Route 66 and all paths to Kathmandu. The car is synonymous with independence, and as such, a visa for traveling the world differently.

IN THE AIR

Mankind has always been fascinated by the sky. From the depths of the Earth to the heights of its atmosphere and beyond, the desire to explore has never known any limits. By doing away with the space between the two, hard-to-identify flying objects, airplanes, helicopters, seaplanes, propeller planes, jets, and supersonic jets have brought about major changes. With them, the planet has undoubtedly shrunk. Concorde, the Franco-British supersonic airliner, took this to new heights. The "white bird" broke the sound barrier on its three-and-a-half-hour flight from Paris to New York, and its four-and-three-quarter-hour flight from Paris to Rio de Janeiro. Gone were the travel companions, hotel stopovers, and long halts for men and machines to rest; from then on, it was merely a question of seats, connections, and time zones.

In 1951, Roger Vailland, an inveterate globetrotter and the author of several travel accounts and *The Law*, which won the Prix Goncourt, observed a radical change that no longer allowed time to take its course. He foresaw the twenty-first century as a true visionary. "We will no longer travel. We will move around

Luggage tag of the American company Delta Air Lines, 1952.
Paris, Gaston-Louis Vuitton collection.

'as fast as thoughts,' for our own business and that of others, and also for pleasure, but pleasure will be found in the place where we will go to seek it, rather than en route, which used to be a feature of travel," he wrote in *Boroboudour, voyage à Bali, Java et autres îles.* Clément Ader, Wilbur and Orville Wright, Alberto Santos-Dumont, and Louis Blériot, all pioneers of the great aviation saga, opened the way to a dazzling future that reached its apogee with the explosion of the large commercial airlines we know today. Emblematic airlines like Pan Am, TWA, and Swissair, nicknamed "the millionaire's airline," no longer fly, having vanished with the turbulence caused by cutthroat competition. Air France has resisted, but for how much longer? The cabin service of old no longer exists, except for the seats up front, if at all. However, flying has become more affordable and accessible to all in the process. Among avi-

Avion, *avion*, may it rise into air, | May it glide over mountains, cross oceans, | May it stare at the sun like Icarus | And higher still may an *avion* stray | And trace an eternal furrow in the ether. | But let us keep the sweet name *avion*, | For the five nimble letters of this unique word | Have opened up the mobile skies.

Guillaume Apollinaire,
"Airplane"
(published posthumously)

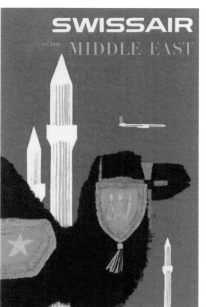

ation carriers, Qatar Airways, Singapore Airlines, All Nippon Airways, and Cathay Pacific are all at the height of service and quality, according to Skytrax.

The map of our dreams is covered with voyages reflecting our longing to escape everyday life. The distant becomes close at hand. Whether these journeys are lengthy or fleeting, static or mobile, there is no elsewhere or pleasure without different forms of transport. They afford the never-ending treasure hunts that have led to Francisca Mattéoli's *Extraordinary Voyages.*

Swissair luggage tag, 1958.
Paris, Gaston-Louis Vuitton collection.

A FLAT TRUNK
FOR A ROUND WORLD

The success of his business led Louis Vuitton to decide to build new workshops just outside Paris. In 1859, after searching for a site that would allow for future expansion, he settled on a 4,500-square-meter plot in Asnières, a small town to the north-west of Paris. The town sat on the banks of the Seine, the river used by the barges that linked the French capital to the Channel ports and transported the wood, particularly the poplar wood, with which Louis Vuitton's celebrated trunks were made. The Asnières workshops were built using the latest architec-tural ideas, with a metal structure and framework that allowed for airy, light-filled spaces. From twenty workers upon open-ing, the workshops quickly expanded and by 1880, the six workshops had one hundred employees. By the early twentieth century, the House's savoir-faire was internationally renowned. In 1914, Louis Vuitton had four shops in France, one in London, and fifteen agencies around the world.

Louis Vuitton always set himself apart thanks to his cre-ativity. In the 1850s, the House invented modern luggage and developed the concept of the flat-topped trunk, while in the 1870s, it created luxury luggage. In the heart of the new Madeleine neighborhood in Paris, near Charles Garnier's new Opéra, the leading department stores, and the Saint-Lazare station (the gateway to the United States and the United Kingdom) the Louis Vuitton shop on Rue Scribe attracted a cosmopolitan clientele, including travelers in search of hardwearing, practi-cal, and elegant luggage.

PREVIOUS DOUBLE PAGE:
Traveling with a Pégase suitcase and a Monogram canvas
Keepall bag, pre-fall 2011 collection.

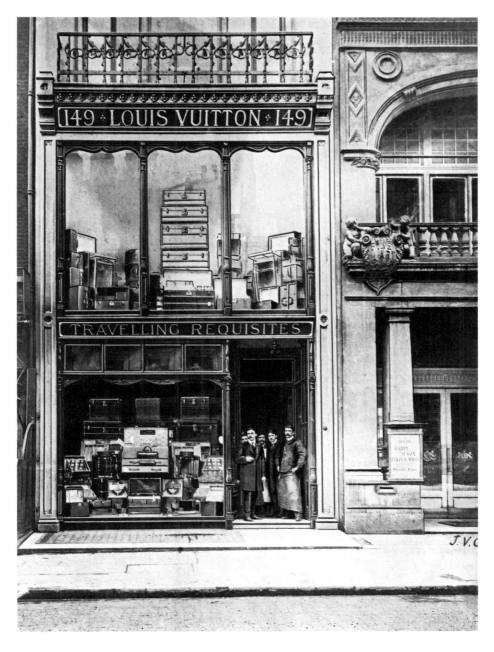

Louis Vuitton store in London, at 149 New Bond Street, c. 1902. It was the third English store,
opened after those on Oxford Street (in 1885) and Strand Street (in 1889).
Paris, Louis Vuitton archives.

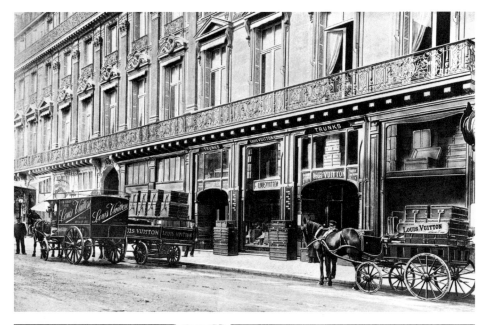

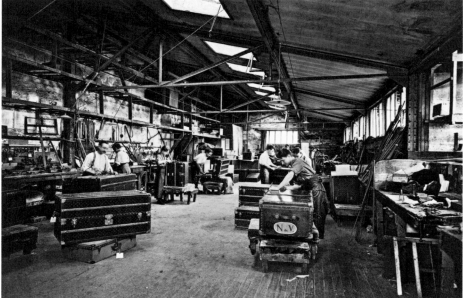

Louis Vuitton store, 1, rue Scribe, Paris, c. 1872. Opened the previous year, it offered trunks,
travel goods, and a packing service, with Louis Vuitton as much a trunkmaker
as a "layetier-packer." Paris, Louis Vuitton archives.

Craftsmen in the ironwork shop in Asnières-sur-Seine, c. 1903.
Paris, Louis Vuitton archives.

Yvette Labrousse, Miss France 1930, traveling with her Vuitton trunks for her dresses, 1930.
Paris, Louis Vuitton archives.

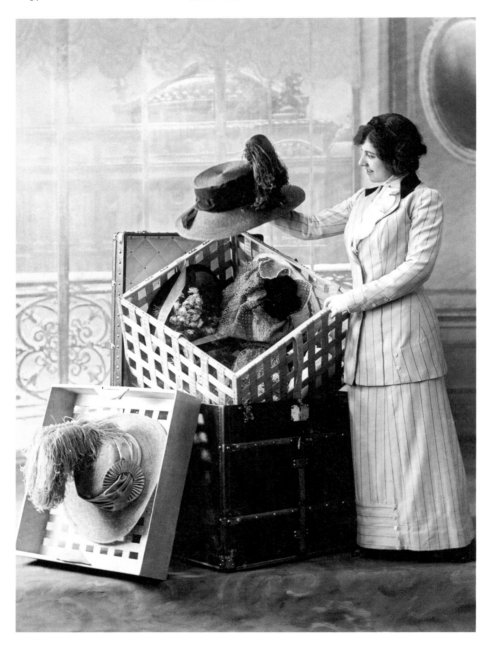

The actress Mademoiselle Andrée Mielly unpacks her Chapeaux pour dame
[women's hat] trunk, at the Théâtre des Bouffes Parisiens, c. 1910.
Paris, Louis Vuitton archives.

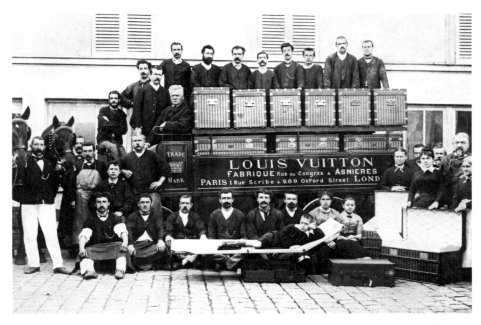

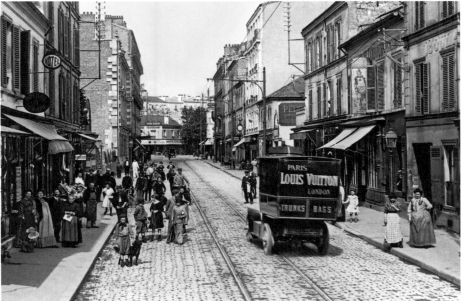

TOP

Louis, Georges, and Gaston-Louis Vuitton with the craftsmen of the Asnières-sur-Seine workshops, c. 1888. Around a delivery car, Louis is sitting in the driver's seat, Georges is on his right, and Gaston-Louis is lying on a trunk bed. Paris, Louis Vuitton archives.

BOTTOM

Louis Vuitton delivery car in Grande-Rue, Asnières-sur-Seine, c. 1888. The street was lined with workshops and the family's home. Paris, Louis Vuitton archives.

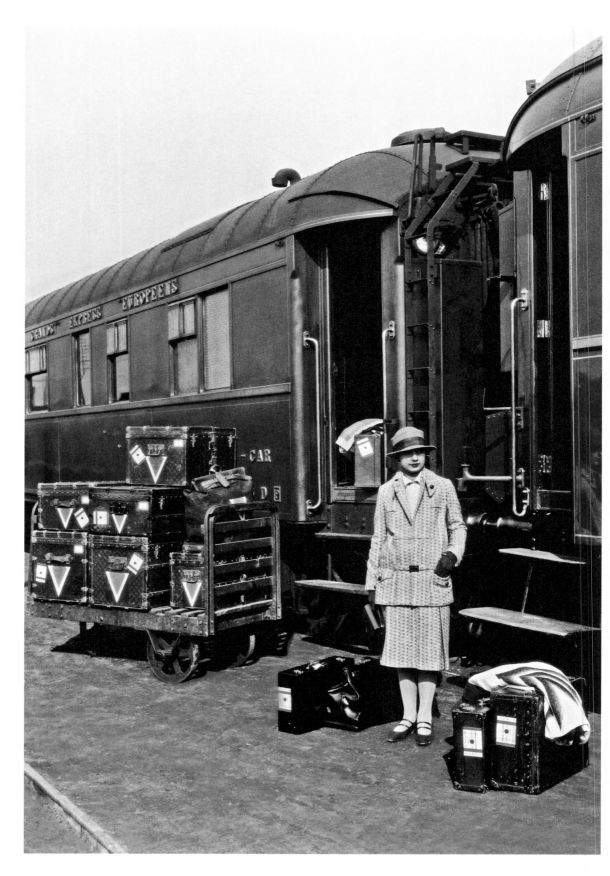

PLANET LOUIS VUITTON

The transport revolution of the first half of the twentieth century made traveling more comfortable and rapid, thanks to trains, planes, ocean liners, and airships. New travelers required luggage adapted to their distant destinations: trunks, bags, vanity cases, and sturdy, practical, and unique suitcases. The House of Louis Vuitton met their needs with extraordinary objects that combined functionality and elegance. In 1875, for example, Louis created his first vertical wardrobe trunk, which came with a hanging rail and drawers. Renowned for its sturdiness and originality, it soon became a classic. The House adapted to changes in transport, rethinking the weight and dimensions of its luggage—suitcases and trunks now had to fit under a train bench seat, in a transatlantic ship cabin, or in the hold of a plane. The idea was to transport as much as possible in as little space as possible—with absolute distinction.

FACING PAGE:
An elegant woman photographed by Thérèse Bonney with her luggage, stamped with the letter V by Gaston-Louis Vuitton and adorned with a dot and a stripe (*pois* and *raie*) by the couturier Paul Poiret. Paris, Louis Vuitton archives.

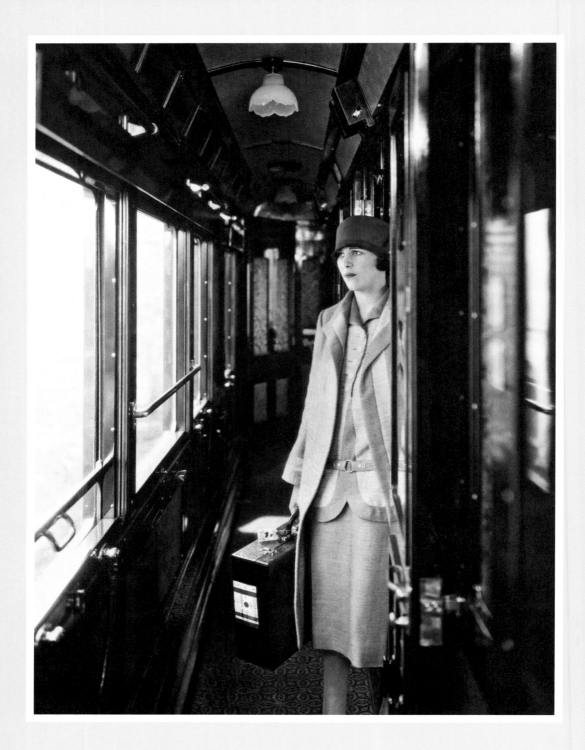

FIG. I

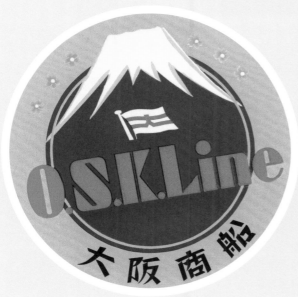

FIGS. II, III, IV

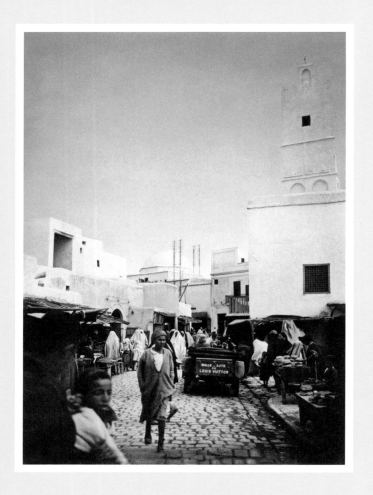

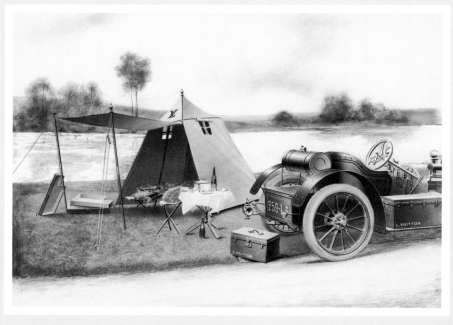

FIGS. V, VI

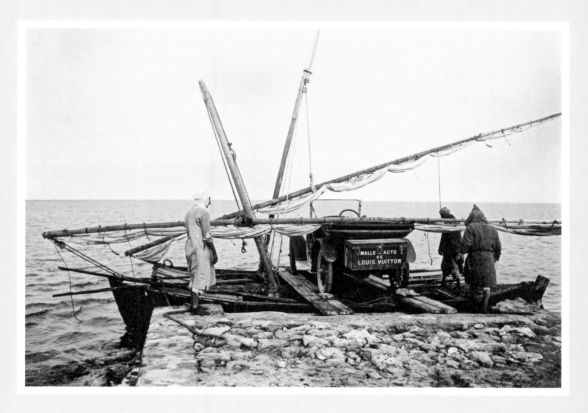

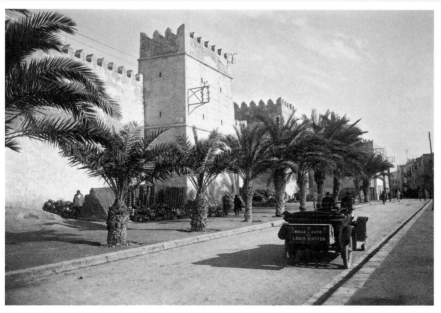

FIGS. VII, VIII

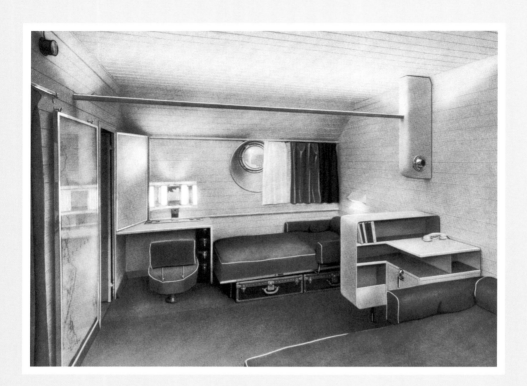

Bl🔷nd Line

Straits of Gibraltar

CLYDE-MALLORY LINES

NEW YORK
FLORIDA
TEXAS

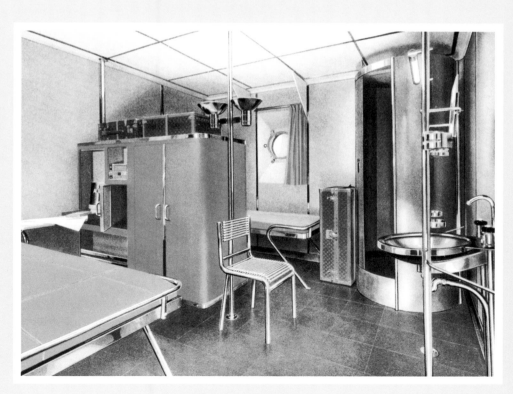

FIGS. XII, XIII, XIV

FIGS. XV, XVI, XVII

FIG. XVIII

CAPTIONS

FIG. I

A photograph by Thérèse Bonney showing a woman carrying a suitcase featuring the dot and the stripe design by couturier Paul Poiret.

FIG. II

Advertising drawing for hardsided Monogram canvas trunks and writing desks, 1929.

FIG. III

Luggage tag of the Japanese shipping company O.S.K. Line, 1930s.

FIG. IV

Civil Aviation Administration of China tag, 1960s.

FIG. V

Jean du Taillis's car, equipped with a Vuitton trunk's, crossing the souk district, rue Saussier, in Kairouan, Tunisia, 1923. A journalist for *Le Matin* and *Le Figaro*, Jean du Taillis published a Dunlop guide entitled *Le Tourisme automobile en Algérie-Tunisie* in 1913.

FIG. VI

In 1909, the brothers Pierre and Jean Vuitton had a special body built on a Stabilia chassis and equipped it with a two-seater tent.

FIG. VII

Jean du Taillis's car is loaded onto an improvised ferry bound for Djerba in southern Tunisia, 1923.

FIG. VIII

Road in front of the ramparts of the medina in Sfax, Tunisia, 1923.

FIG. IX

Boat cabin equipped with Vuitton trunks. Brochure by the Office technique pour l'utilisation de l'acier, 1935.

FIGS. X, XI

Luggage tags from the British shipping company, Bland Line (1950s), and the American company, Clyde-Mallory Lines (1940s).

FIGS. XII, XIII

Luggage tags from the American shipping company Delta Line (1960s) and the German company Hamburg-Amerika Linie (1930s).

FIG. XIV

Cruise ship cabin designed by René Herbst, presented at the Paris Salon d'Automne in 1934 by the Office technique pour l'utilisation de l'acier. The timeless motifs of the Monogram trunks fit perfectly with the modernist style of the decorative artists from the French Union of Modern Artists (UAM).

FIG. XV

L'Aviateur, advertising drawing by Pierre-Émile Legrain, c. 1910.

FIGS. XVI, XVII

Luggage tags from the New Zealand airline, the Tasman Empire Airways Limited (1950s) and the Indonesian airline, Garuda Indonesian Airways (1950s).

FIG. XVIII

Model Amory Carhart Jr. with her Monogram canvas suitcases photographed by John Rawlings for American *Vogue*, 1954.

FACING PAGE: FIG. 1

Félix Nadar, *Autoportrait en nacelle réalisé en studio* [Self-portrait in gondola made in studio], c. 1863. Private collection.

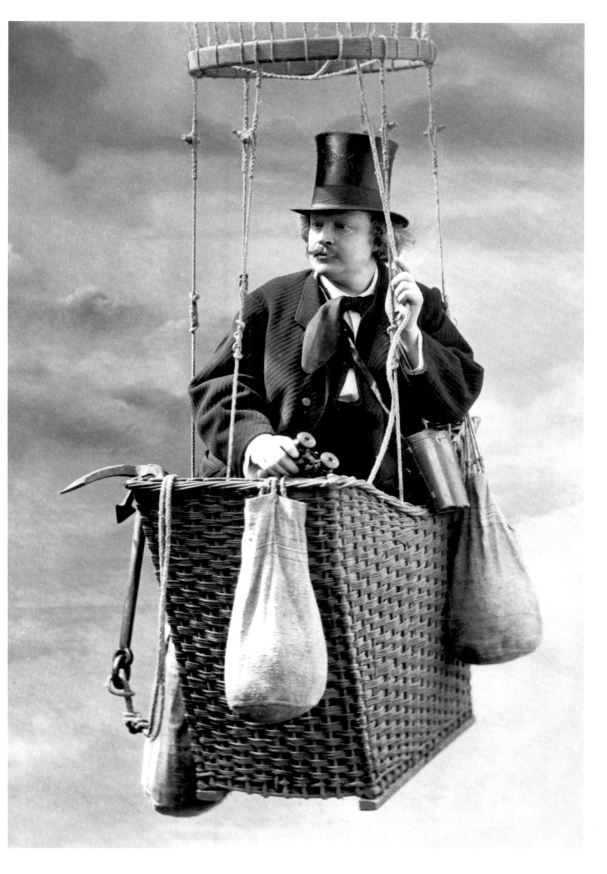

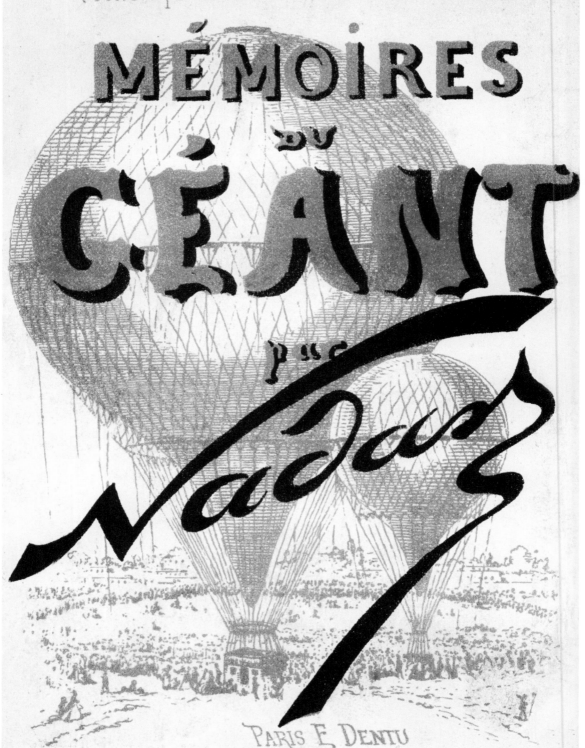

A TERRE ET EN L'AIR.....

(Préface par M. BABINET de l'Institut)

MÉMOIRES
DU
CÉANT
par

Nadar

PARIS E. DENTU

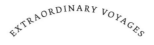

1

A SILK GIANT

RENOWNED FOR HIS PORTRAITS OF LEADING
FIGURES, THE PHOTOGRAPHER FÉLIX NADAR
CREATED A BALLOON TO REACH
NEW HEIGHTS OF ACCLAIM IN 1863.

It was an incredibly ambitious project, the product of an ebullient mind, one fascinated with the impossible—a new kind of machine, no longer destined to float but to travel through the atmosphere: 148 feet tall and containing 210,000 cubic feet of gas. This flying object, heavier than air, had been conceived by a revolutionary dreamer, for what could be more magical than seeing a balloon slowly rise up to the clouds? It was not solely a question of enthusiasm, poetry, and observation. It was also a question of calculation, of anticipation, of the triumph of the human mind.

Since 1783, the year when the Montgolfier brothers invaded the European sky with their silk envelope, "balloon mania" had abounded in fashion, in art, in celebrations organized by towns competing to set up flights that were at once worldly, technical, and popular. Ballooning took advantage of the revolution taking place in chemistry at that time and was even found in the arts—engravings, books, wallpaper, pictures—all celebrating the idyllic lightness of wicker baskets.

FIG. 2

Félix Nadar, *Mémoires du Géant,* published in Paris in 1864.

In 1863, the inventor of an outstanding vessel named *Le Géant* (The Giant) was convinced that the future lay with air transport and he intended to prove it. He was a caricaturist, photographer, writer, balloonist, and above all, visionary, who thought every capital city should invest in ballooning. His name was Nadar, a pseudonym for Gaspard-Félix Tournachon, born in Paris, who, until then, was best known for his photographs of important figures and who patched together an existence by accepting all sorts of other small jobs. He is even said to have been a spy. He was passionate about new techniques and in 1858, he threw himself into the world of balloons. He began by photographing them, and then decided to commission his own vessel, the famous Giant, organizing public "flights" which helped pay for the society he had just founded, encouraging air navigation.

The Giant's maiden voyage took place on October 4, 1863, amid much publicity, before a crowd of twenty thousand gathered on the Champ de Mars in Paris. Thirteen "passengers" climbed aboard, including Nadar, who had promised them the experience of a lifetime. Unfortunately, the balloon lost speed rapidly and landed in Meaux, a mere twenty-five miles away. This didn't prevent Nadar from having another go a fortnight later, with nine passengers including his wife. This time, the balloon crashed to the ground after a seventeen-hour flight and was pulled along for several hours in the most impressive "dragging" in the history of ballooning, at 37 mph, the speed of a fast train—a catastrophe that was covered by the press across Europe. Nadar and his wife were badly wounded but, undaunted, the inventor soon repeated the experience in Amsterdam. This flight lasted a mere hour. The fourth ascent took place in Brussels and, once again, instead of heading

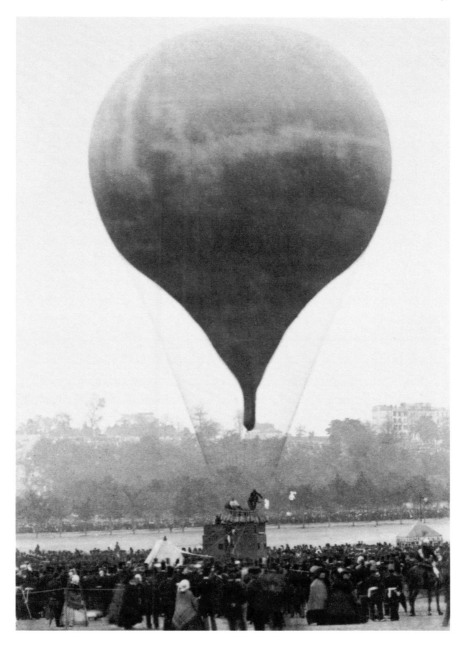

FIG. 3

Félix Nadar, *Ballon Le Géant sur le Champ-de-Mars pendant les préparatifs de la seconde ascension*
[*Le Géant* hot-air balloon on the Champ-de-Mars during preparations for the second ascent], 1863.
Paris, Bibliothèque nationale de France.

toward its intended destination, it stopped a few hours later, on the coast, near Ypres, in the middle of the night. Nadar was finally forced to abandon his project, left riddled with debts.

During the Siege of Paris by the Prussians in 1870–71, however, Nadar had the opportunity to use his talents in quite a different manner. Having created a company that made military balloons, he made the latter available to the French government to break through enemy lines. This first instance of mass production marked the official start of the aeronautical industry, and, after so many failures, brought unexpected glory to its constructor. While Paris was being besieged and bombarded every day, the government asked the minister of the interior to organize the resistance, which meant leaving the capital. To do so safely, the minister had no choice but to take to the air. It was in a balloon, and advised by Nadar, that he escaped, while the Prussians fired at the vessel from all sides. Two days later, after numerous incidents, the minister joined the other members of the government in Tours, thus becoming the first statesman to travel by balloon, at the same time proving, as Nadar had always dreamed, that these amazing flying vessels could be far more than mere eccentricity.

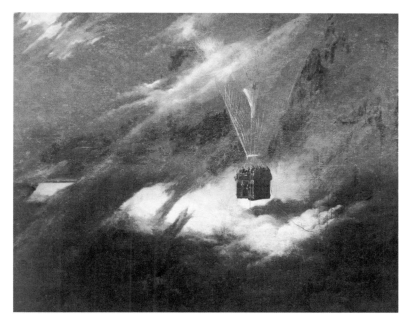

TOP: FIG. 4

Félix Nadar and Adrien Tournachon, Le Géant *au clair de lune, nuit du 4 octobre 1863*
[*Le Géant* by moonlight, night of October 4, 1863]. Paris, Bibliothèque nationale de France.

BOTTOM: FIG. 5

Félix Nadar and Adrien Tournachon, *Trainage du ballon* Le Géant*, le 19 octobre 1863*
[Dragging of the *Géant* hot-air balloon, October 19, 1863].
Paris, Bibliothèque nationale de France.

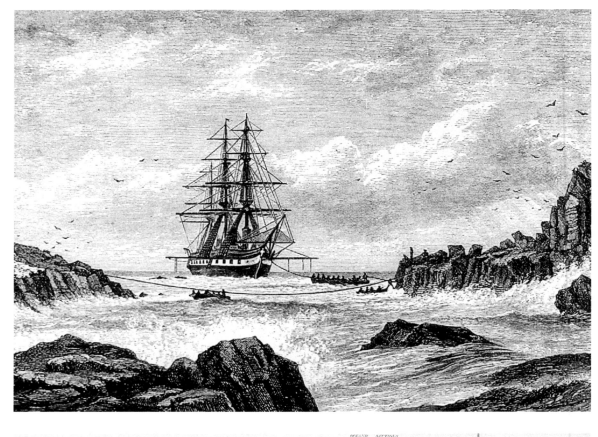

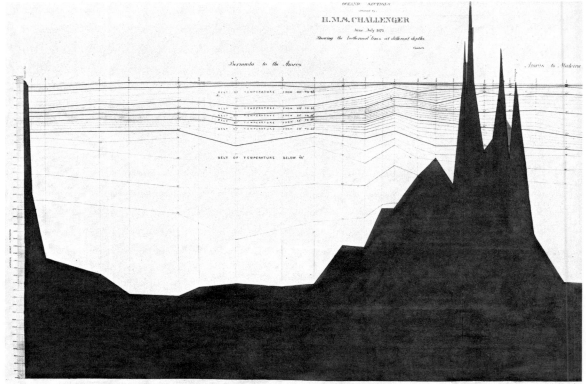

OCEANIC SECTIONS
obtained by
H.M.S. CHALLENGER
June–July 1873
Showing the Isothermal lines at different depths.

Bermuda to the Azores

Azores to Madeira

BELT OF TEMPERATURE FROM 60° TO 65°

BELT OF TEMPERATURE FROM 65° TO 60°

BELT OF TEMPERATURE FROM 55° TO 50°

BELT OF TEMPERATURE FROM 45° TO 50°

BELT OF TEMPERATURE FROM 40° TO 45°

BELT OF TEMPERATURE BELOW 40°

2

INTO THE ABYSS

———

BY EXPLORING THE DEPTHS OF THE OCEANS,
THE *HMS CHALLENGER* USHERED
IN A NEW SCIENTIFIC ERA IN 1872.

It was the first major oceanographic campaign in the world undertaken by a scientific team. Their ship, a British corvette named *HMS Challenger* belonging to the Royal Navy and lent to the Royal Society of London for the occasion, had been prepared down to the last detail. Everything, it seemed, had been arranged, organized, planned, and yet . . . Nobody had foreseen that this expedition would open up a new era for science, nor that it would enable the invention of a new type of boat— vessels created for large-scale scientific expeditions, and intended for oceanic explorations that were epics rather than straightforward voyages.

Between 1870 and 1872, the *HMS Challenger* was admirably fitted out to enable the scientists on board to work in the best possible conditions during the long months of navigation. It was equipped with a laboratory filled with instruments for the work of naturalists, botanists, chemists, and other researchers; additional cabins exclusively reserved for the scientific team; and a platform for dragging and trawling.

TOP: FIG. 6

The *HMS Challenger* at anchor on the reefs of St. Pierre and St. Paul,
located in the South Atlantic, c. 1873.

BOTTOM: FIG. 7

Isothermal curve recorded by the *HMS Challenger* scientific team
indicating the temperature variations recorded at different sea depths
between Bermuda and the Azores, c. 1873.

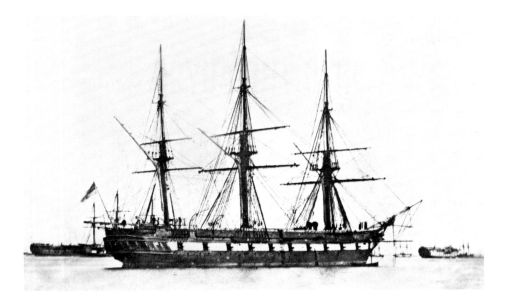

The corvette's cannons and certain internal partitions had been removed to create proper working spaces for the research- ers. One cabin had been transformed into a library filled with scientific books, while another was cleared for microscopes arranged on a large table, ready to receive all manner of prepa- rations. Surprisingly for the period, the ship was equipped to welcome more than two hundred men, all highly experienced, and thereby proving that it was possible to explore the ocean depths with a boat.

People were fascinated by science at that time: they won- dered if there was any animal life at the depths of the ocean. Fossils were studied, reference books were published, and numerous expeditions were undertaken that whet the curios- ity of scholars. The concerns of these men of science were all concentrated here, in this vessel, which completely surpassed the functions of a traditional ship. Indeed, this ship had to

FIG. 8
The *HMS Challenger* during a stopover in the West Indies, c. 1875.
The scientific expedition was the first with an official photographer on board.

TOP AND BOTTOM: FIGS. 9, 10

Naturalist's study room and laboratory set up on the *HMS Challenger*, c. 1875.

allow highly specialized work to be carried out. Its teams had to be able to access unknown sites, take soundings, fish, and even develop photographs. They also had to be able to observe, study, analyze, and document their findings. A darkroom had been set up for this practice—a proper photographic laboratory made available for an official photographer who was part of the crew for the first time.

When *HMS Challenger* took to the seas in December 1872, it was all set to sound the depths. As was appropriate for an adventure of this sort, the departure took place with great ceremony. A party was organized in the presence of many journalists, well-known figures, and scientists. While some of them maintained that the depths of the oceans were a desert, everyone was keen to know the truth of the matter. The ship began by sailing round the British coast from Sheerness to Portsmouth, where it loaded all the necessary provisions before making its "true" departure. On board were the naturalist Charles Wyville Thomson, in charge of the scientific team, and his assistant, the Canadian biologist, John Murray.

During the voyage, the crews would sound depths of up to 26,900 feet in the western part of the Pacific, travel 70,000 nautical miles, undertake investigations at previously unknown depths, and explore the bottom of the oceans as never before, from the Atlantic to the Canaries and the Antilles. The headed north to Halifax in Nova Scotia before following the American coast south to cross the Atlantic again toward the African coast. John Murray noted that the ship stopped more than one hundred times while out at sea to take measurements and samples. This enabled the discovery of the Mariana Trench, the deepest in the world, as well as of the Mid-Atlantic Ridge, and of oceanographic mechanisms like salinity.

The crew then headed west again toward Brazil, before traversing the South Atlantic and continuing south toward the Cape of Good Hope and on to the southern seas that so fascinated scientists. At a time when the world had barely entered the industrial era, *HMS Challenger* and other revolutionary corvettes were busily expanding our fields of knowledge. These legendary vessels gave rise to a new vision and understanding of the world.

FIG. 11

Members of the Royal Society of London on the bridge
of the *HMS Challenger,* January 1, 1875.

FOLLOWING DOUBLE PAGE: FIG. 12

The *HMS Challenger* at anchor in the South Seas, c. 1873–76.

N° 12. — 24 Mars 1912. SOLEIL DU Avec Mode : 25 CENTIMES

DIMANCHE ILLUSTRÉ

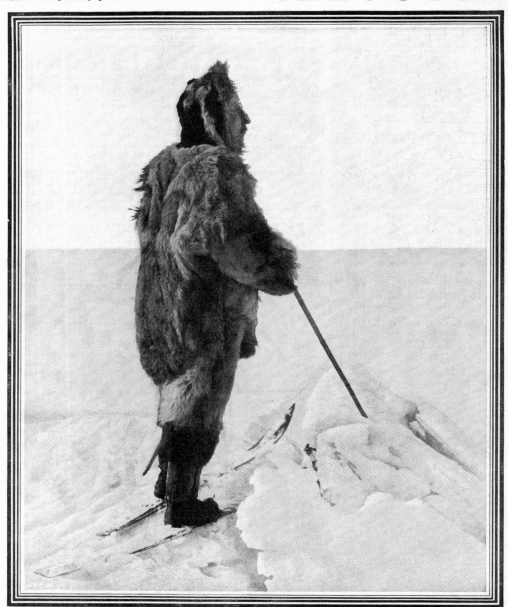

L'HOMME QUI A VU LE POLE

Le Capitaine norvégien Amundsen qui a atteint avec quatre de ses compagnons le Pôle Sud. L'explorateur dans son costume emprunté aux Esquimaux. Ce hardi voyageur aurait l'intention de repartir pour le Pôle Nord.

3
BREAKING THE ICE

———

SEA ICE IS NO LONGER IMPASSABLE.
ALTERING THE SHIP'S HULL MADE IT POSSIBLE
TO SET OUT AND CONQUER THE POLES.

In those lands where voyages are the stuff of dreams as well as of nightmares and where geography appears to know no boundaries, all progress requires extraordinary means. It's impossible to clear a way through ice fields with nothing but a small boat. It's equally unimaginable to slide over frozen surfaces aboard a vessel used for normal boat trips. In such unpredictable, constantly moving territory, an exceptional vessel is required—a boat with an adapted hull and a stem of a particular shape to allow for breaking and clearing the ice floes in such a way that they do not amass at the bow. It also requires immense technical skill to advance not through force but by settling on top of the frozen surface to create a passage. It's an art that not all boats are capable of. A route has to be drawn where there is nothing but a vast frozen expanse, slowly opening up a path, thanks to a reinforced bow, maneuvering amid the terrible harshness of winter.

From the outset, polar expeditions used special boats, at first made of wood and of traditional shapes, but nonetheless

FIG. 13

"L'homme qui a vu le Pôle" [The man who saw the Pole], cover of *Dimanche illustré*,
March 24, 1912. Paris, Bibliothèque nationale de France.

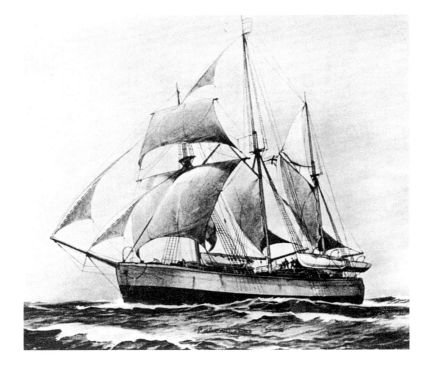

adjusted for the endeavor and therefore fitted with iron straps encircling the hull and metal plates level with the keel and the stem. Thanks to these protective elements, the boats were less likely to be damaged if caught in the ice, and less likely to be crushed if the force of the ice floe was too powerful for them to advance. *Pilot*, the earliest boat of this kind, built in Russia in 1864 to master the Arctic ice field, was already fitted with a modified bow. In Canada, special vessels were soon invented to be able to bring supplies to isolated communities. But it was the legendary expeditions launched to conquer the poles that were to popularize these extraordinary creations.

When the Norwegian explorer Roald Amundsen set off to conquer the South Pole in 1910, he chose to do so aboard the

FIG. 14

The *Fram*, during a first expedition led by the Norwegian Fridtjof Nansen
to Svalbard in the Arctic Ocean, 1895.

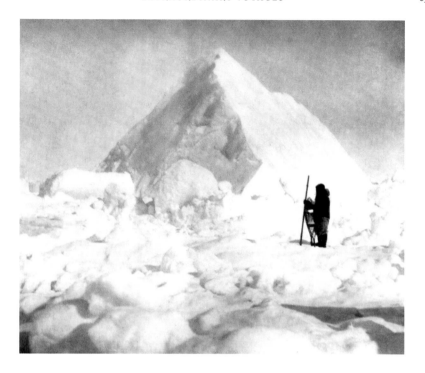

Fram, a remarkable vessel with a slender hull front and back, a rounded keel, and a low-set rudder to avoid it being broken which, like its propeller, could be retracted upward when the ship was raised up by the ice. At that time, it was the most solid wooden boat in the world, designed to resist all conditions. Amundsen wanted to reach the North Pole but he believed someone else had got there before him, stopping him in his tracks. He therefore set out to conquer the South Pole with the *Fram*, keeping his plan secret until he was out of reach in the southern seas. The boat was not new but remained virtually unscathed from its previous expeditions, with cabins insulated with reindeer fur and thick felt. Its name, *Fram*, meaning "forward" in Norwegian, was well chosen as Amundsen kept going straight

FIG. 15

Roald Amundsen on King Haakon VII's plateau, South Pole, located
at an average altitude of 3,000 meters, 1911.

ahead, choosing reliable men to accompany him, whom he only informed of his new plan when they reached Madeira. They crossed the equator, rounded the Cape of Good Hope and the Kerguelen Islands before reaching the Ross Sea that borders the Antarctic continent, where the first icebergs loomed into view. Some time later, the crew berthed in the Bay of Whales, which served as their base camp. They eventually reached the South Pole as planned, but by dog sled, for Amundsen had had the brilliant idea of embarking with one hundred or so Greenland Dogs on board, convinced that would be the best way to reach his destination.

Fram was one of the first ice breakers to initiate the era of legendary polar explorations, but also of vessels capable of taking on the most extreme geography and overcoming disaster. These early icebreakers were unique vessels, constructed to attain their objectives: traversing icefields, always pushing forward between icebergs of white, blue, and green hues, on water that appeared to be lit from within, cleaving the vast white expanses in their way magnificently, parting the ice fields and floes as easily as cutting through butter.

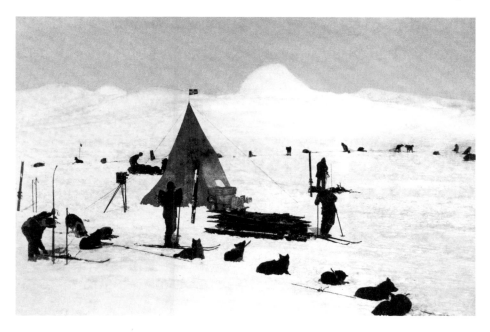

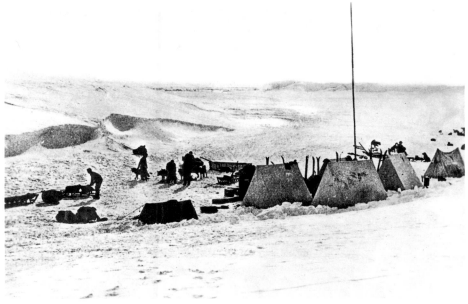

TOP AND BOTTOM: FIGS. 16, 17

Roald Amundsen and his companions at the Polheim
("house of the pole" in Norwegian) camp, 1911.

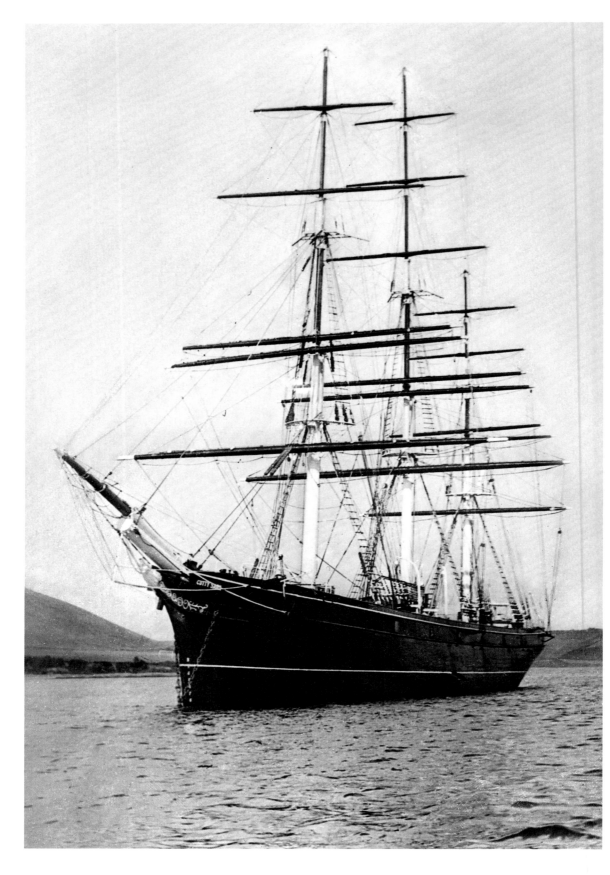

4

HOISTING UP

———

WITH THE APPEARANCE OF THE CLIPPER
AT THE END OF THE NINETEENTH CENTURY,
MARITIME ROUTES TOOK ON
A NEW COMMERCIAL DIMENSION.

As the Gold Rush spread across the American continent in the mid-nineteenth century, all routes to California were open to consideration—even the most fearsome, wild, and interminable, through the most terrifying regions that no one had yet written about, like those across the misleadingly named Tierra del Fuego (Land of Fire), which is as cold and humid as Iceland. To successfully round a cape like that, at the far end of the continent, required ships and crews capable of achieving great feats: of finding a passage through the fjords, of breaking the ice, of bearing up to the Antarctic winds, of sustaining the most frightening storms and untold damage. Such was the price of transporting goods and men in this era of discoverers and bright-eyed merchants. The fastest, toughest, and most maneuverable of vessels were required for the nineteenth-century trade routes, in order to sell British tea and cotton or to reach San Francisco and partake of the gold rush—vessels that attained the peak of perfection or were, in a word, exceptional.

FIG. 18

The clipper *Cutty Sark* at anchor in Falmouth Harbor,
Antigua and Barbuda, late nineteenth century.

These exceptional boats were clippers, made in American dockyards where competition between shipowners was fierce. Each one sought the most perfect and efficient forms in order to achieve the most spectacular performances, and the public and press alike were crazy for this race between constructors. They were capable of anything. Their boats chartered gigantic loads to build towns in Australia, South America, and the Far West, undertook all manner of trafficking, sailed up and down the Atlantic and Pacific coasts, going as far as the Arctic and Antarctic Circles, crossing the Indian Ocean, winding in and out of the remotest islands like snakes, through archipelagos that would have swallowed up any other vessel. These ships went to collect opium, cotton, wheat—all traded around the world—replacing overland means of transport and taking routes nobody would have dreamed of. Taming the elements, subduing them, arriving first, being the fastest, that was their role and their aim. It was also that of naval architects who were never satisfied and set themselves ever more stunning challenges, seeking the most perfect hull for cutting through water, the most aerodynamic forms, the tallest masts, in order to dash across the waves.

Clippers had three masts, sometimes more depending on their size, and were the fastest form of sea transport at the turn of the twentieth century thanks to their slender hull and large expanse of sails. They were used for transporting rare and perishable goods as well as people. The most remarkable examples had names like *Surprise*, *Flying Cloud*, *Marco Polo*, and *Great Republic*, the largest clipper ever built. The *Flying Cloud*, a gigantic cathedral of unmatched complexity and elegance, was as likely to be loaded with those seeking a better life as with cargo. On June 2, 1851, in the throes of the gold rush,

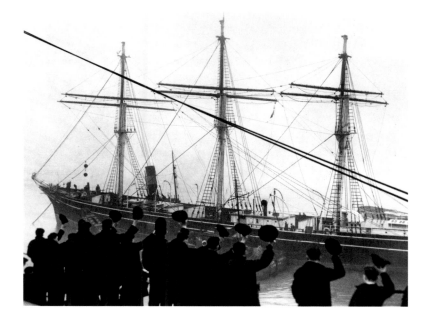

the clipper left New York for San Francisco with a strange crew
composed of all manner of men, some of whom were not even
sailors. The holds were loaded with perishable goods and, most
unusually, there was actually one of the first female navigators
onboard, the wife of Captain Josiah Perkins Creesy, Eleanor,
who would become famous for beating the record for the fast-
est sail between New York and San Francisco with this vessel.
During the voyage, the ship suffered all kinds of damage, and
even the insubordination of its crew, but it succeeded in reach-
ing California in eighty-nine days—an unbelievable record for
the period.

A few years later, other clippers sought to distinguish
themselves, like the *Thermopylae* and the *Cutty Sark* in their
famous race in 1872, a celebrated competition which rewarded
the first to get its cargo of tea to London—a bitter challenge

FIG. 19

The *Cutty Sark* leaving the port of Greenhithe, on the Thames,
for its last voyage on February 2, 1954.

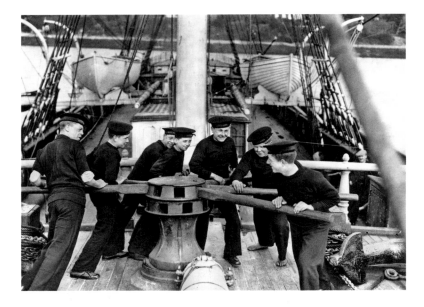

without recourse to weather forecasts or any of today's facilities. Their battle remains legendary. After racing neck and neck through the South China seas, the *Cutty Sark* managed to forge ahead, making victory look likely. However, seven weeks into the race, it lost its rudder in the middle of a storm and was forced to pull up for repairs. The captain did not give up, and the ship made it safely back to London nine days after its rival. Despite coming second, it is the *Cutty Sark* that everyone remembers for its incredible adventure. It was one of the last famous clippers to be built before the advent of steamships, a more restful means of transport that lacked the elegance and style of clippers but could navigate the Suez Canal without fearing unforeseen events, incredible adventures, or meteorological hazards.

FIG. 20

Maneuvers on the *Cutty Sark* off the coast of Cornwall, 1926.
The ship was then a training ship for young British sailors.

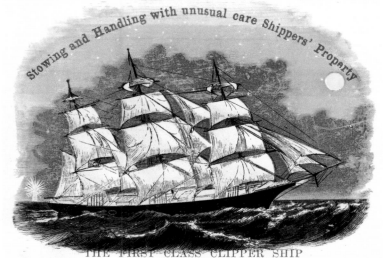

MERCHANTS' EXPRESS LINE
FOR
SAN FRANCISCO.

CURRENT RATES AND NO DECEPTION.

CLIPPER OF SATURDAY, NOVEMBER 6th.

Stowing and Handling with unusual care Shippers' Property

THE FIRST CLASS CLIPPER SHIP

MOONLIGHT

BRECK, Commander,

IS NOW RECEIVING THE BALANCE OF HER CARGO AT

PIER 9 EAST RIVER.

This clipper ranks among the fleet of California ships second to none—her ventilation is unsurpassed.

Insures at the Lowest Rates!

The former fast passages, and the well-known experience and knowledge of her commander to ventilate his cargo by extra attention required, warrants us in assuring that the merchandise shipped by "MOONLIGHT" will be delivered in the same good order as received, and reach an early market.

She positively will not be detained beyond the above date. Favorable rates secured by early application to

BABCOCK, COOLEY & CO.,
118 WATER ST., (Tontine Building.)

Messrs. DEWITT, KITTLE & CO., Agents in San Francisco.

FIG. 21

Advertising poster for the *Moonlight* clipper that operated the line
to San Francisco, 1850.

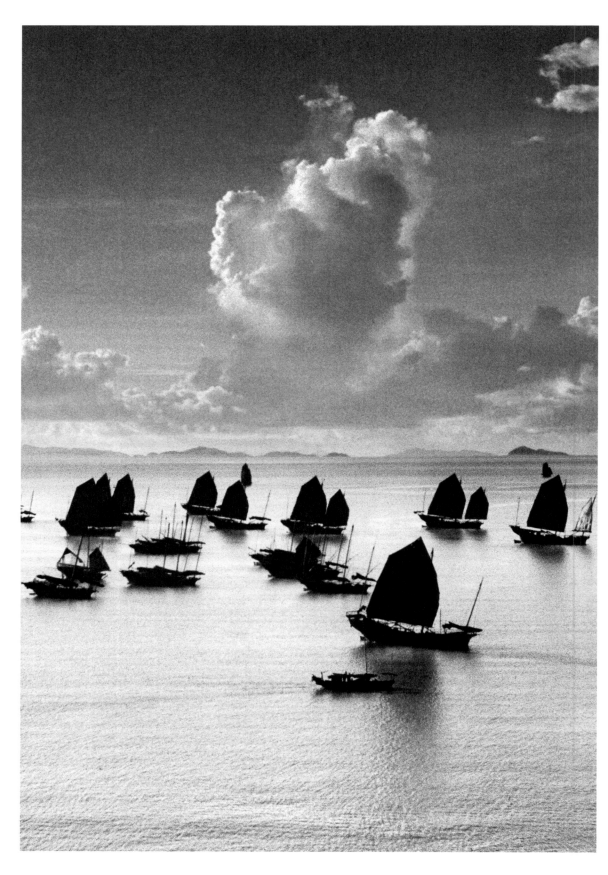

5

BUTTERFLY WINGS

———

SKIMMING THE SEA AND MEANDERING
ALONG RIVERS, JUNKS HAVE BEEN
A SYMBOL OF CHINA AND VIETNAM
FOR CENTURIES.

According to several legends, Fu Xi, the founder of human-ity and the great ancestor of the Chinese emperors, was the inventor of junks and the first to describe how they were made. Junks are pictured on ancient scrolls where groups of them are seen sailing up the Yellow River for a spring festi-val. Elsewhere, they are seen peacefully anchored in ports in northern Vietnam.

In the thirteenth century, the Italian explorer Marco Polo recounts that Emperor Kublai Khan owned nearly fif-teen thousand junks, kept at the mouth of the Yellow River. Zheng He, one of the most famous maritime explorers during China's early Ming Dynasty, was known to have used the most fabulous junks for his expeditions, fitted out in ways unknown to the West.

Centuries later, the French novelist and naval officer Pierre Loti provided a detailed description of these amazing boats in which he and his team sailed up the Pei Ho River, spurred on by his fantasies as an explorer.

FIG. 22
Werner Bischof, *Port of Kowloon, Hong Kong*, 1952.

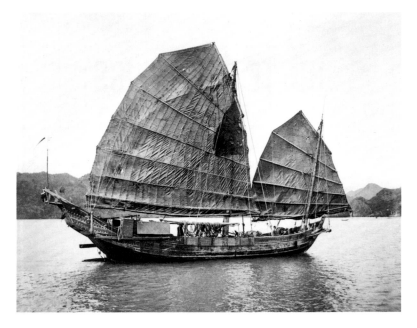

Upon arrival in China in 1901, Loti encountered a wide range of climates, the most spellbinding light, and the most absolute of silences, not to mention the tail end of the Boxer Rebellion, and was surprised at the relative ease of this existence as an explorer, as a water nomad. At that time, it was not unheard of for the paths of explorers to cross when navigating the world's rivers and seas. Imagine the amazement of these travelers when they, too, boarded these junks, gently swept along by breezes, gliding from one port to another, from one gulf to the next, coming across fellow travelers in stunningly beautiful places like Hạ Long Bay. From afar, junks resemble butterflies suddenly coming to life, rustling gently before heading off, leaving behind them nothing but a silvery trail. Navigating adeptly, they can glide across the water without the slightest noise.

FIG. 23

Fisherman's junk in Hạ Long Bay, Quảng Ninh Province, Vietnam, 1920s.
Paris, Musée du Quai Branly-Jacques Chirac.

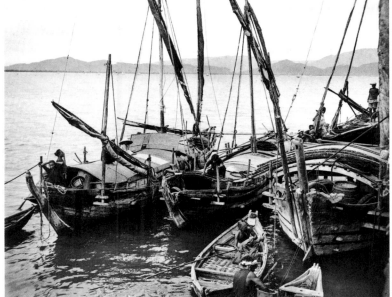

TOP: FIG. 24

Junk in Tam Quan Bay, Bình Định Province, Vietnam, 1920s.
Paris, Musée du Quai Branly-Jacques Chirac.

BOTTOM: FIG. 25

Junk moored in Da Nang, Quảng Nam Province, Vietnam, 1920s.
Paris, Musée du Quai Branly-Jacques Chirac.

For his journey across Sichuan and Yunnan, the French explorer Gabriel Bonvalot chose to descend the Red River as far as Hanoi aboard a Chinese junk, which proved to be "one of the most beautiful exploratory trips of his century," as it was referred to in a newspaper upon his return to Marseille. During his voyage to China, undertaken in 1890, he studied the country's flora, fauna, and geography, alternately donning the cap of scholar, engineer, botanist, geographer, scientist, and sailor, and becoming the most famous French explorer of the period in the process.

His journey aboard the junk was exceptional. Bonvalot was particularly interested in regions that had rarely been visited by Europeans, and opted for a daring route that inevitably aroused people's curiosity, traveling from Paris to the French Protectorate of Tonkin in the space of a year or so, observing and collecting as much as possible.

His traveling companion, Prince Henri of Orléans, collected the most precious samples for their magnificent herbarium. He also took numerous photographs, operating the cumbersome camera in all weather and situations, together with the extremely fragile glass plates and large quantities of chemicals which he had brought with him.

The achievements of these daring explorers should also include all the nameless men and women of the period who, upon glancing at a map of the world, also wished to explore the depths of faraway lands, descending rivers on these magical junks, inspired by the adventures recounted in the newspapers of the time.

The sails of junks evoke the pliancy of Venetian blinds or bat's wings. When moored, junks look as though they are balancing on the water, almost levitating, hull and sails forming

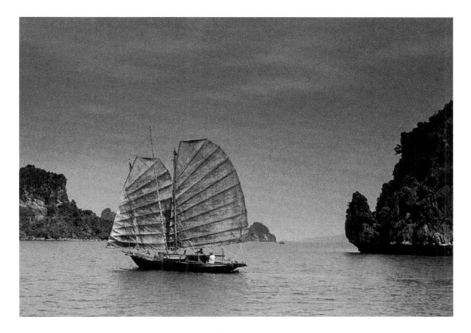

a graceful silhouette. They skim the waves with extraordinary agility, wending their way discreetly along rivers. At nightfall the large, oiled rice paper lanterns cast shimmering reflections on the water. The shapes and sizes of these vessels vary according to their use; it is said they can transport up to a thousand men. They seem to appear and disappear effortlessly, their silhouettes melding slowly with the horizon.

FIG. 26

Junk in Hạ Long Bay, Vietnam, 1990s.

FOLLOWING DOUBLE PAGE: FIG. 27

Sampans were another vessel commonly seen at this time,
here in front of Hon Gai, Quảng Ninh Province, Vietnam, 1920s.
Paris, Musée du Quai Branly-Jacques Chirac.

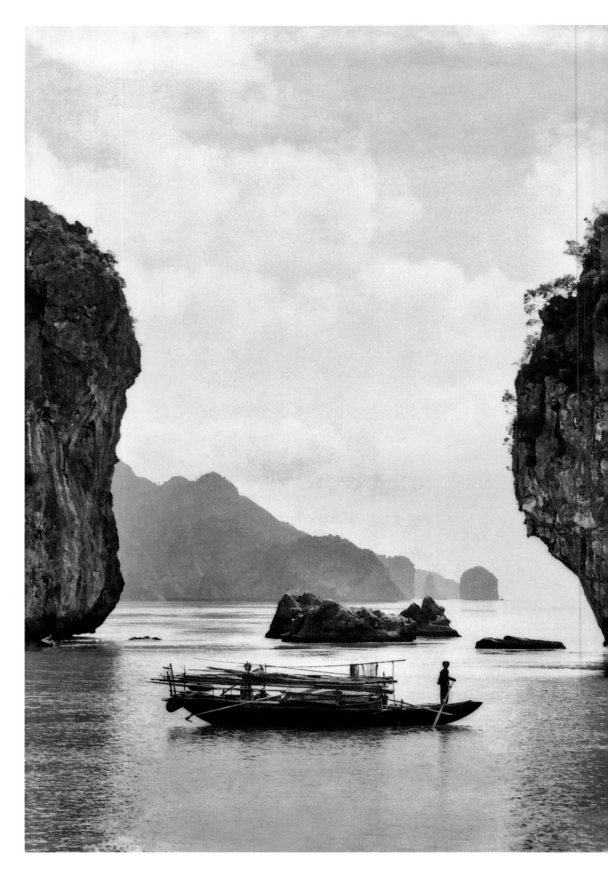

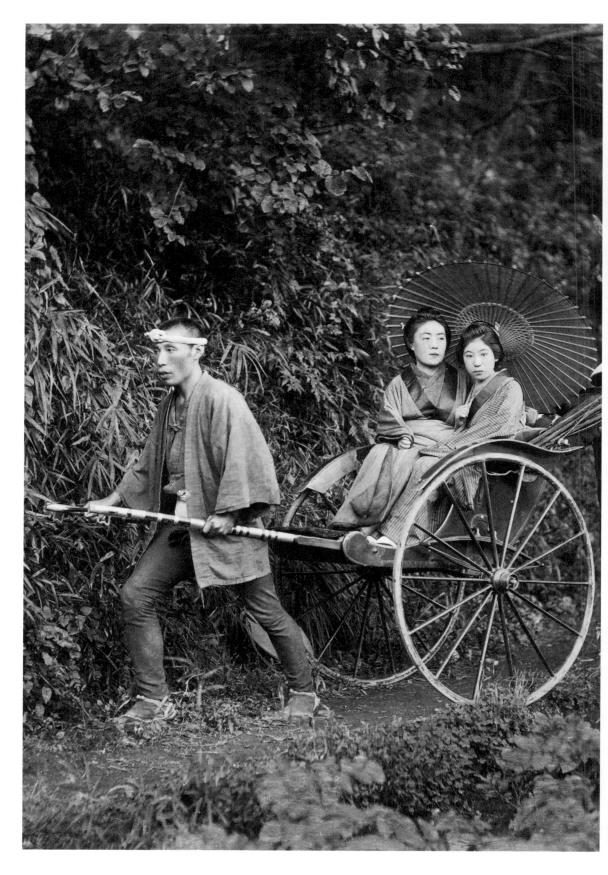

6

WINDING THROUGH THE STREETS

———

BEFORE THE CAR, MANY IN JAPAN EMBRACED
THE RICKSHAW. LUXURIOUS OR MODEST,
THEY WERE A COMMON SIGHT IN
JAPANESE STREETS.

Yokohama, 1869: The sea breeze from the port provided a little freshness for the first tourists making their way through the narrow alleys. They had spotted the European district, the Bund, from their boat, and all the activity around its solidly constructed houses, which were built to resist earthquakes. Many of these passengers had read the accounts of travelers returning from this amazing country, Japan, and followed the construction of its new hotels such as the Royal British Hotel, the Anglo-Saxon, and the Tycoon. Now they were keen to see this world for themselves as described in the very first Western tourist guides published on the country that talked of remarkable sites. While some of the tourists might have seen the Japanese pavilion at the Exposition Universelle in Paris two years earlier, few would have been prepared for this world so different from anything they could have imagined, and which fascinated Western artists and writers alike, many of whom were lovers of Japonisme, the craze for Japanese art and design in the West at that time.

FIG. 28

Elegant young Japanese girls on a rickshaw ride, c. 1880–90. Washington, D.C.,
Smithsonian Institution, Freer Gallery of Art and Arthur M. Sackler Gallery.

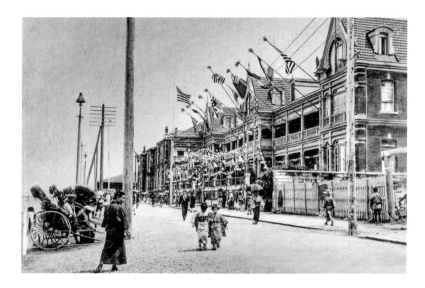

The town they visited was in the process of being restructured, its new existence largely dictated by the comings and goings of merchant ships. Shops were packed with buyers, goods cluttering the roadway, alongside magnificent temples. All the travelers were amazed by this former fishing village. People moved around on foot, on horseback, or in sedan chairs—by far the most comfortable means of transport but far too large and cumbersome for getting about quickly in a town with such lively commerce.

The American missionary Jonathan Scobie (sometimes referred to as Goble) is said to have come up with the idea of the rickshaw in 1869, in order to help his disabled wife who was otherwise unable to get about town. Another version has it that it was Izumi Yosuke, a Japanese restaurateur in Tokyo, who invented it, describing it as a small, Western-style seat mounted on wheels so that it could be pulled. It didn't shake its passengers about as much as a normal handcart, and was easy

FIG. 29

Shopping streets near the port of Kobe, c. 1900.

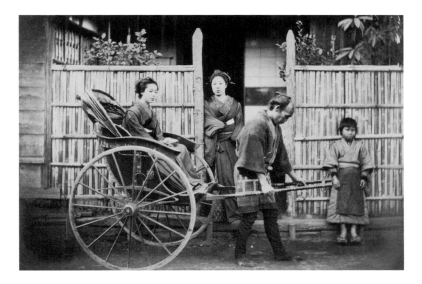

to turn. It didn't get in the way of traffic and only needed one person to pull it, which also made it very cheap. Basically, it was an immensely practical, easily maneuvered "car" that rapidly appealed to the population and was immediately adopted by Japanese geishas and the aristocracy. Some people even had their own private rickshaw and appointed puller.

In Japan at this time, the beginning of the Meiji Era, it was often former samurai who, stripped of their titles and reduced to poverty, served as "chauffeurs." They created a new profession, forming trade unions and enrolling in professional organizations in order to protect their new activity. New rickshaw models soon made their appearance, including ones with two seats, where men and women could travel side by side in an almost intimate fashion—an invention that many found scandalous and which, being heavier to maneuver, was soon abandoned in favor of the traditional model. By the early twentieth century, all manner of rickshaws were seen in the street. Elegant,

<div style="text-align:center">

FIG. 30

Lady in a rickshaw, c. 1890.

</div>

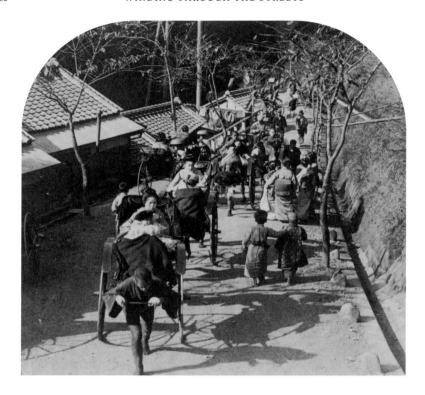

wealthy women traveled around in small, black lacquered won-
ders richly decorated with inlay depicting sophisticated floral
decorations, garlands, and foliage. Everyone else took small,
simple rickshaws, like those used by itinerant traders. Rickshaws
varied in size, decoration, and comfort, with stuffed seats and
colorfully lined convertible tops.

They quickly became part of the Japanese landscape,
accessing places that not even the lightest of sedan-chairs was
able to, insinuating their way into crowded districts by day and
night, into the smallest hideaways down on the quays and the
port, and as far as the upper districts of town where some West-
erners lived. They became invaluable accessories for travelers and

FIG. 31

On the road to the Daijingu Shinto temple, Yokohama, 1904.
Washington, D.C., Smithsonian Institution, Freer Gallery of Art and Arthur M. Sackler Gallery.

natives alike, adding character to the most congested, somber, and austere towns.

The Western writer-travelers who discovered Japan in the late nineteenth century were quick to note this practical and lightweight means of transport that so easily and agilely navigated the winding streets of Japanese cities. In his 1888 novel *Madame Chrysanthème*, French writer Pierre Loti describes his wanders through the streets of Nagasaki, comfortably seated in a rickshaw next to his young Japanese wife, Kiku. Rickshaws were used by all and were still frequently seen in front of the station in Tokyo, the temple in Nara, and throughout the residential neighborhoods of Kyoto until the 1920s.

FIG. 32
Mississippi Bay, Yokohama, 1904.
Washington, D.C., Smithsonian Institution, Freer Gallery of Art and Arthur M. Sackler Gallery.

FOLLOWING DOUBLE PAGE: FIG. 33
Cherry blossoms in the Sankeien Garden in Yokohama, c. 1900.

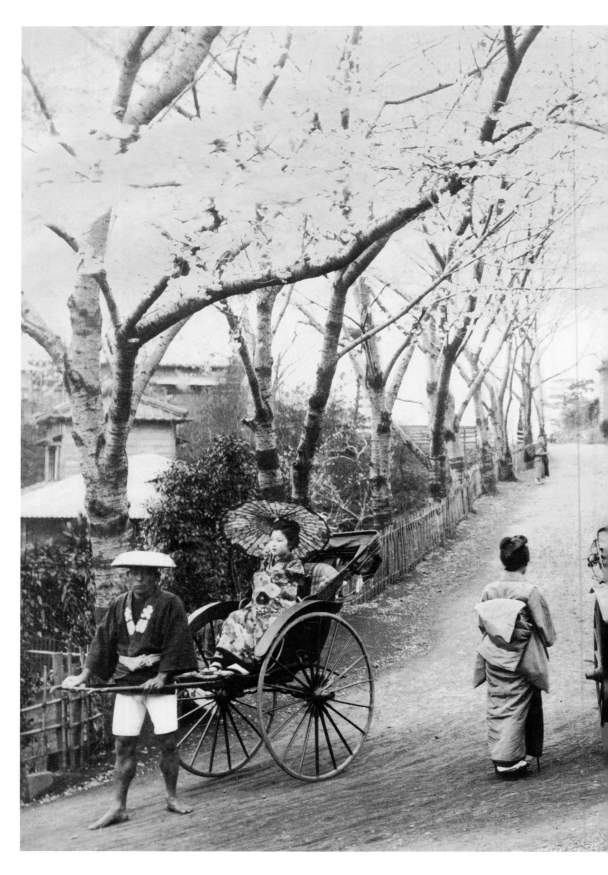

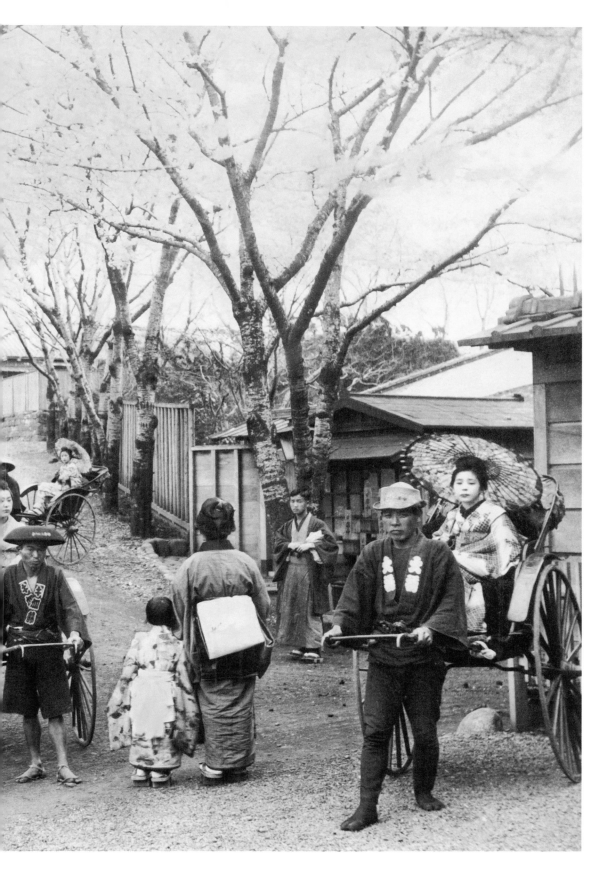

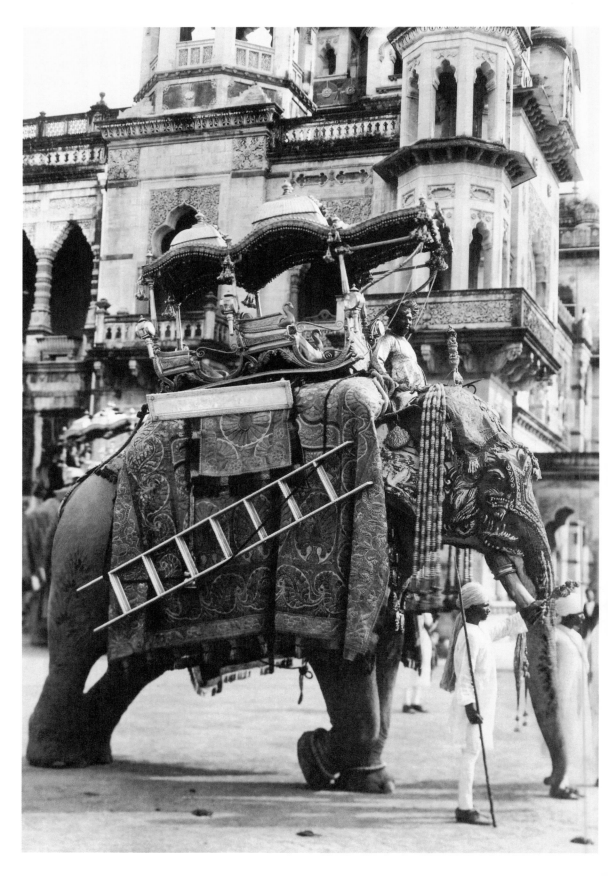

7

HEAVY LIFTER

———

TO MAKE YOUR WAY THROUGH THE JUNGLE
OR TO WARD OFF FELINE ATTACKS,
NOTHING BEATS A RIDE ON
AN ELEPHANT'S BACK.

The discolored photographs from the days of the British Raj in India recall an era when maharajas of Calcutta and Bombay climbed into their howdahs strapped to the backs of elephants, and went on excursions or on tiger hunts. It was alleged, at the time, that there was nothing more comfortable than these palanquins, covered in gold leaf and draped with fabrics, for pursuing of these jungle trophies. From on high, the hunter was protected from the attack of a tiger or any other wild animal, as were his bodyguards and right-hand men installed in a small compartment behind him. A wooden seat with two compartments was solidly fixed to the elephant's back with girth straps and the underside of the howdah was fitted with protections to avoid wounding the animal whose shape it ingeniously covered. It was thus as comfortable as possible, enabling its passengers to wander the jungle at their leisure while the *mahout*, or keeper, directed the extraordinary "vehicle" with his voice, seated astride the animal's neck.

FIG. 34

"Elephant adorned for a sacred ceremony," *Souvenirs of Baroda* album, 1920–30.

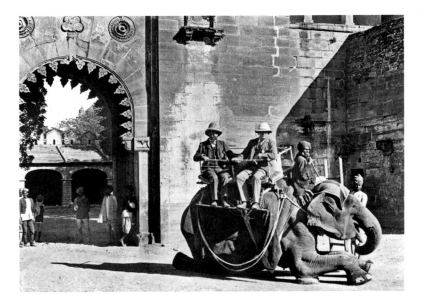

The swaying often made the journey unpleasant after a while, but that was the price of safety. Neither the period nor the place called for hurrying. People celebrated untamed nature, slow travel, and trips lasting several days in untouched regions. These slow voyages were perfectly suited to the oppressive tropical heat.

What were these "domesticated vehicles" or "animal machines"? Pets, transporters, ornamentation for ceremonies and processions, or a symbol of wealth for those with power? They were all of these at once, both in reality and in fiction. In *Around the World in Eighty Days*, Phileas Fogg, Jules Verne's hero, takes all available means of transport, including an elephant. He purchases one for a phenomenal sum, equips it posthaste and settles on its back with his traveling companion, Sir Cromarty, a brigadier in the British army whom he had met at a gambling table. At that time, these legendary pachyderms

FIG. 35

Two British tourists on an elephant ride in Gwalior, Madhya Pradesh, India, 1890s. Boswell collection.

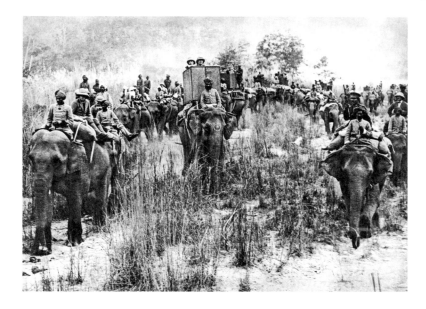

were used as an easy way to clear paths on routes mainly used by those on foot. Only with the help of these powerful animals could some of the most densely forested routes be cleared. The pachyderm and its *mahout* were virtually inseparable. The animal was a sacred emblem, a hero of its kind, and was accorded the same emotional intelligence as humans.

These magnificent creatures also accompanied explorers, scientists, and naturalists like Henri Mouhot, mistakenly considered in the West as "the discoverer of the Angkor ruins," who, in 1858, traveled through Siam, Cambodia, and Laos on his own, possessed with the desire for adventure. He traversed the most remote regions on an elephant. The journey was long and risky, but he pursued the mission he had set himself defiantly. After stumbling across the mythical site of Angkor by chance, he undertook to cross the Korat region, advancing on tracks that were impassable for harnessed carts. Setting

FIG. 36

The Prince of Wales on his way to a tiger hunt in Nepal,
January 29, 1922.

out from Bangkok, it took him six grueling weeks to reach his destination, from where he continued, still by elephant, to the small isolated villages situated on the banks of the Mekong River, advancing on steep mountainous slopes, under the blazing sun, at the mercy of the unknown and of tropical solitude. He did not make it back from this adventure, but his passion lives on in every page of his magnificent travelogue, full of valuable descriptions and comments, personal anecdotes, and impressive drawings, recounting an expedition that went down in history.

This passion for the region and for major expeditions was shared by Auguste Pavie, France's vice-consul in Laos, who visited the same places a few years later, and who chose to travel in the same manner with his "Mission Pavie." He crisscrossed the country setting up a diplomatic delegation and carried out the first reconnaissance of the outlying territory of "the land of the million elephants and the white parasol," as Laos used to be known, a name that Pavie used in the title of one of the affectionate accounts he wrote at the end of his life, after returning to France. *Mahouts* would be photographed a century later, proudly posing with their motionless animals in front of the same ruins, at a time when the sites were opening up to the first tourists. The times have changed, as had the voyages and the voyagers, but the revered animal has maintained a sense of adventure with its every step.

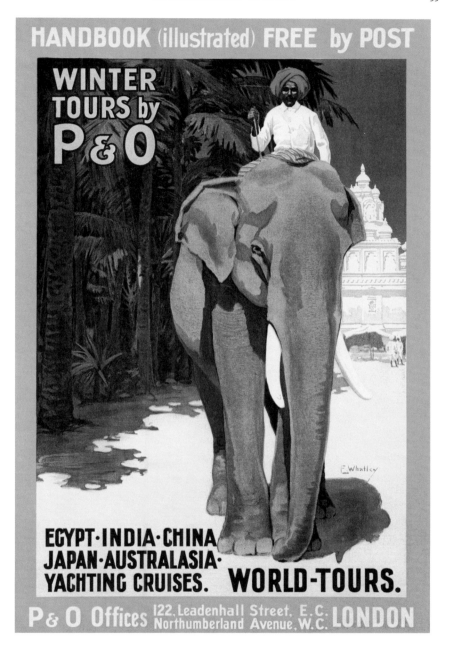

FIG. 37
Advertising poster for the P & O travel agency, based in London,
early twentieth century.

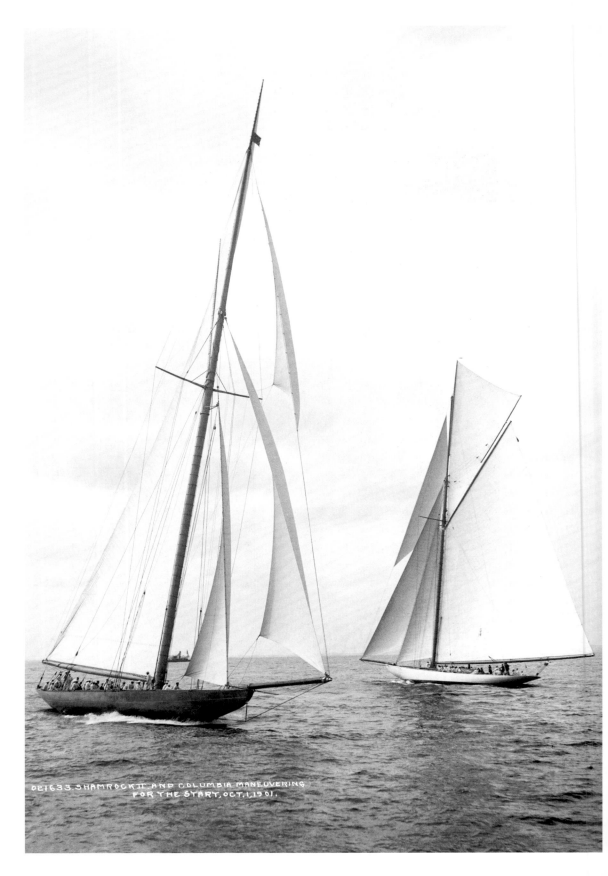

OE1633. SHAMROCK II. AND COLUMBIA MANEUVERING FOR THE START, OCT. 1, 1901.

8

AMERICA, AMERICA!

IN 1851, A NEW YORK SCHOONER DEFEATED
THE ENGLISH AROUND THE ISLE OF WIGHT
IN A CUP RACE THAT BECAME
THE STANDARD.

How could one not begin with a description of the splendid vessel that took to the seas on August 22, 1851, when it had such allure, style, and outstanding brilliance, and owed its existence to an eminent member of the supremely elegant New York Yacht Club? The vessel in question was a magnificent schooner, just over 100 feet in length, weighing 153 tons, with 5,263 square feet of sail, handled by eight professional sailors and an outstanding captain, Richard Brown. It was commissioned by John Cox Stevens, a rich American industrialist and Commodore of the highly exclusive New York Yacht Club, who had heard talk at the Great Exhibition in London of the interest of English maritime merchants for a race between American yachts and the best English yachts. The idea of challenging the English on their home turf did not worry him in the slightest. In order to do so, he undertook the construction of this superb vessel equipped with cotton sails that made better use of the winds than the linen ones used by his competitors and a more slender stem—another advantage compared to the other participants.

FIG. 38

Shamrock II and *Columbia* leave New York Harbor,
at the start of the America's Cup, 1901.

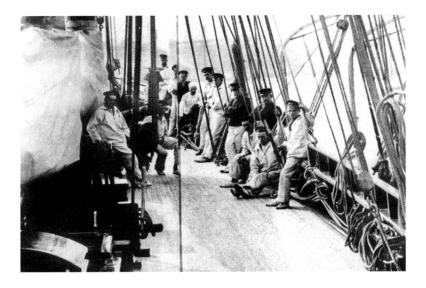

John Cox Stevens employed George Steers, an ambitious young
naval architect, to design his schooner. Even if the construction
fell behind schedule and the boat was not ready for the trials,
the Commodore felt that he had shaken up existing concepts
and created a unique model. What he did not foresee, however,
was the destiny awaiting his yacht, and just how legendary it
would become.

On August 22, 1851, the race began. Victorian England
wished to establish its sporting and economic supremacy with
this challenge, at a time of tough maritime competition, espe-
cially with regard to the United States, its most direct com-
petitor. Naval architecture was synonymous with modernity,
and the British, who had long distinguished themselves in
this field, were certain of their supremacy. That was without
taking into account the American yachting industry, a sort
of nautical laboratory that had enabled fantastic advances
to be made. For sure, the British followed the construction of

FIG. 39
Skipper and crew of the British yacht *Livonia* during the 1871 America's Cup.

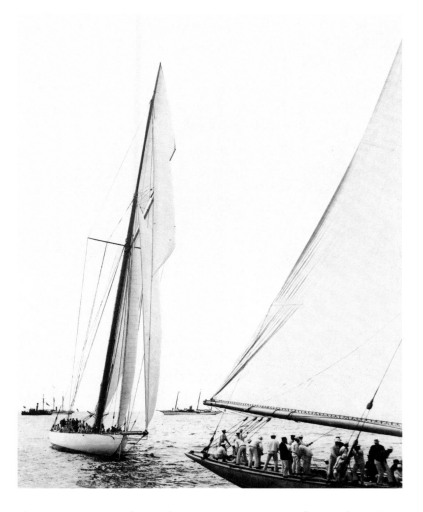

the American yacht with a certain amount of apprehension, but it had not really made a dent in their confidence. For the Americans, therefore, their boat was considerably more than a straightforward means of participating in a race. In the space of several months, it had been transformed into a means of conquering and, above all, an extraordinary national symbol.

FIG. 40

The *Columbia* and *Shamrock II* sailboats during the 1901 America's Cup.
Both challengers were already present at the previous edition in 1899, and the *Columbia*
went on to win again.

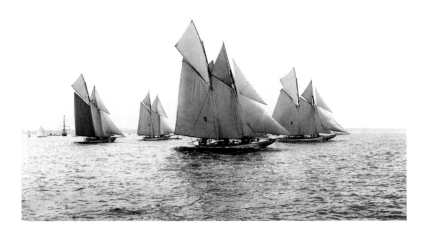

The rules of the challenge were simple: to sail clockwise around the Isle of Wight as fast as possible, a distance of fifty-three miles. The departure and arrival points were in Cowes Harbour.

The New World was taking on the Old World, old Europe faced young America, all in the presence of Queen Victoria who had come specially to watch the race from her yacht. The schooner *America* started late and was in last place when it finally got going. Gradually, however, and against all expectation, it managed to catch up with its rivals and within half an hour found itself in fifth place, continuing its comeback, to the alarm of the British, who were stunned by such swift progress. No information had been given on the exact route, but traditionally all the boats sailed around the east side of the lightship. To do otherwise required an unusually competent man. The *America* had such a man in the person of its captain, Richard "Old Dick" Brown, accompanied by John Cox Stevens himself, who decided to sail between the lightship and the

FIG. 41

Sailboats in the eleventh edition of the America's Cup, in 1901.

mainland, taking advantage of the imprecise rules. This bold
and fruitful initiative enabled him to cross the finish line well
ahead of the next vessel, beating the British triumphantly in
their own territory.

That day, the "100 Guineas Cup," as the trophy was called
at that time, became the America's Cup, and the Commodore's
yacht entered the annals of history. Legend has it that at the
end of the race Queen Victoria asked who had come second
and was told: "There is no second, Your Majesty." First yacht to
the finish, sole winner. No second, indeed.

FIG. 42

The Canadian schooner *Bluenose*, the winner of the International Fishermen's Trophy,
off the coast of Boston, on its way back to Canada, 1938.

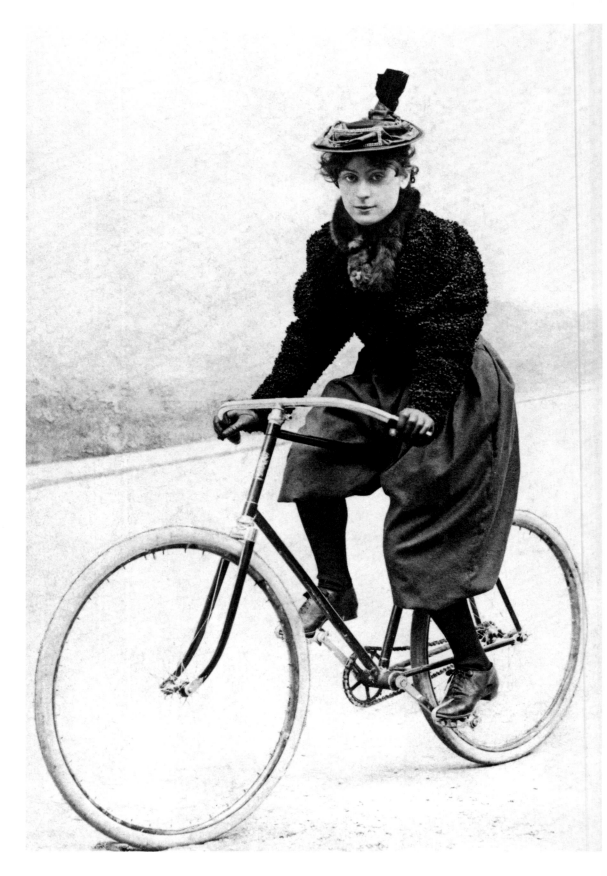

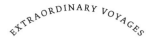
9

ON THE ROAD TO EMANCIPATION

WITH A SINGLE PEDAL PUSH, THE BICYCLE
ALLOWED WOMEN TO LEAVE THEIR HOMES
AND BREATHE THE AIR OF FREEDOM.

The bicycle in the late nineteenth century was a marvelous, tremendously practical vehicle that was not yet entirely common but was on the point of becoming so. It was easy, accessible, light, and above all, oh so liberating. It was less of a means of transport than a way of life, combining, in a single push of the pedal, the pleasure of traveling completely independently, the joy of being able to move at one's own pace, of taking the roads one wants, of changing one's mind on a whim, of being far from everything and everyone, without any pressure—basically, as free as the wind.

The bicycle was also a symbol and not just any old one. That of power, of revolt even! With it, women were at last able to put away their suffocating corsets and cumbersome skirts, as it was impossible to sit on a bicycle without suitable clothing like the new baggy short pants, Turkish-style pants, and bloomers, which were far more comfortable. If they scandalized people, so much the better! If scientists wanted to claim that bicycles were dangerous for women's reproductive organs,

FACING PAGE: FIG. 43

Woman in cycling costume, 1894.

let them! Those who criticized these women were forced to face up to the evidence: more and more women wished to get out of their homes and go for an outing like men, so that they too could come back enthusiastic about what they had seen. The bicycle was the means of emancipation par excellence. The suffragettes' deadly weapon. Women-only cycling schools opened in New York and Boston, and bicycles were designed especially for them.

Women's cycling clubs also came about with the same notion in mind, for why should men be the only ones to have clubs? Thanks to this means of transport, women managed, at long last, to get out of their kitchens and living rooms, and some of them even took advantage of this to venture considerably further than the local park. Like the American geographer and explorer Fanny Bullock Workman, who, together with her husband, decided to travel the world on a bicycle. They went everywhere an adventure was to be had—Europe, Africa, Asia,

FIG. 44

Jules Beau, "Woman on a bicycle," *Sports photography* album, volume 1, 1894–95.
Paris, Bibliothèque nationale de France.

India, Java, Ceylon—everywhere where foreigners were still a rarity at that time, at the dawn of mass tourism. Their means of transport was certainly well chosen for getting around the narrow lanes of bazaars, in between ox-drawn carts, animals, and dense crowds, for traversing towns and villages at the end of the world in unbearable heat. The bicycle really was the vehicle of freedom, incredibly easy to handle, made to make its way through everything, avoiding the turbulence of traffic jams. At its helm, cyclists melded with the landscapes they passed through.

The Workmans' trip lasted for over two years and was to make them famous. Other than their clothes, they took the bare minimum so as not to weigh down their bicycles. This included a supply of tea and biscuits, some cheese and tinned meat, a blanket each, writing materials, and medical and repair kits. They often lacked food and water, were continually attacked by mosquitoes, slept in unlikely places, and experienced all

FIG. 45
Cyclists passing in front of the Château de Madrid in the Bois de Boulogne, Paris.
Le Figaro illustré, September 1893.

manner of adventures, but Fanny Workman's innovative Rover bicycle—a model specially created for women—held up splendidly in the countryside, going from one isolated village to another, proving its reliability and resistance. This Rover safety bicycle was the very latest thing, and a far cry from the hugely heavy, clumpy bicycles of old.

If the means of travel changes our perception of the journey itself, then this incredible voyage undoubtedly provided these two explorers with a unique experience. We can but envy their passion, determination, and sense of freedom as they embarked on this trip, at a time when the mere thought of a woman's legs on a machine of this kind killed, for most men, any sense of femininity. And we can but imagine their joy at each step of their journey at a time when barely a handful of Westerners had set eyes on these distant lands.

FIG. 46
Stop during a bike ride in the countryside, c. 1905–10.

FIG. 47

Advertising poster for Peugeot ladies' cycles, produced in Valentigney,
Doubs, c. 1900.

THE AUTOMOBILE, AN ORDINARY ITEM

Coined in 1875, the term "automobile" gradually appeared through the art nouveau ornamentation of a booming advertising industry. Manufacturers and dealers praised the elegance of the first cars, a luxury still reserved for the wealthy. The promises of speed, autonomy, and freedom appealed to both men and women, who saw this vehicle as an object of emancipation. French brands spread unrivalled French chic on international roads. During the Roaring Twenties, the automobile became more democratic, transforming landscapes, customs, and mindsets. From then on, the car, the symbol of modernity, meant the possibility of a journey, however ordinary, for everyone.

FIG. 48

Advertising poster by Georges Gaudy for Delin bicycles,
produced in Leuven, Belgium, 1898.

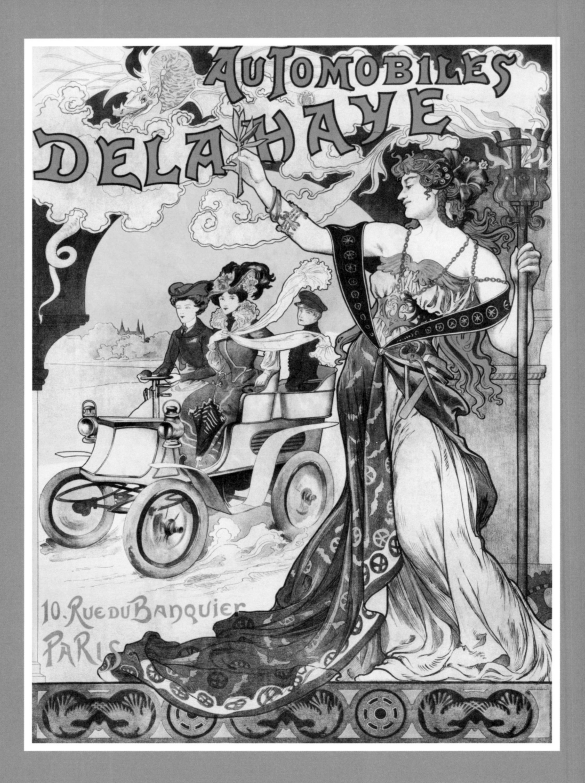

FIG. I

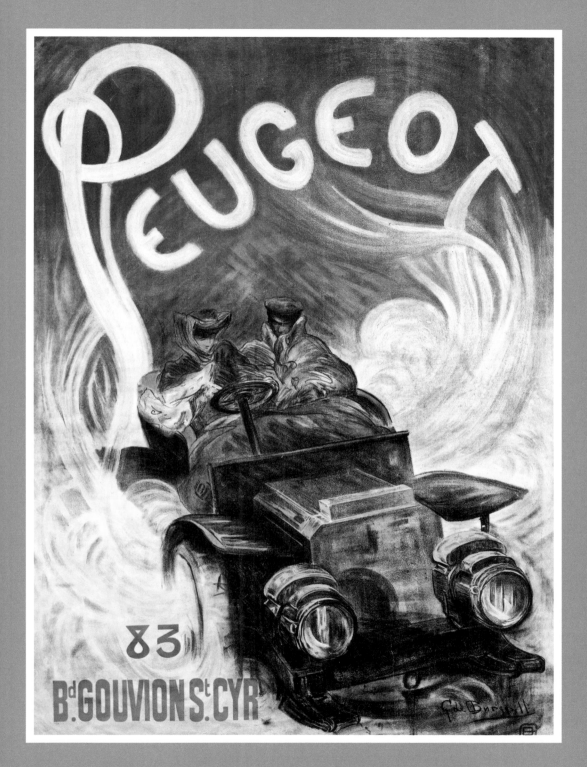

FIG. II

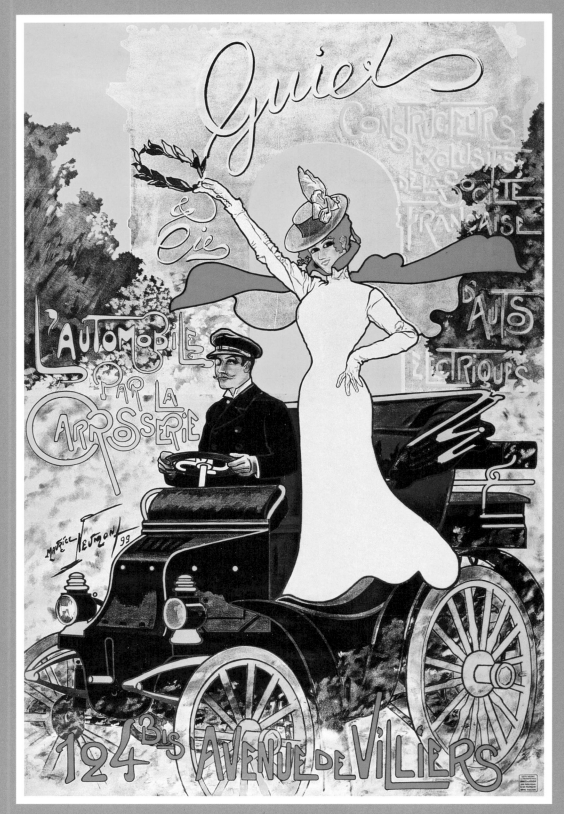

FIG. III

FIG. IV

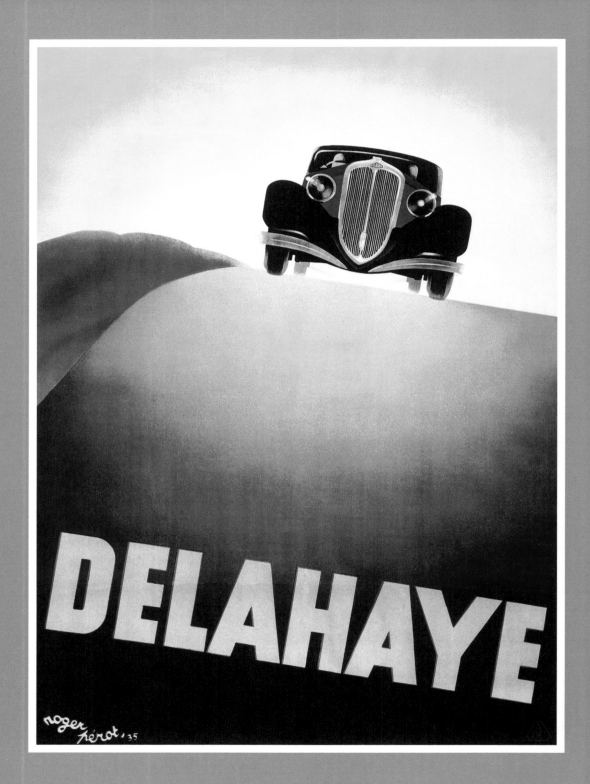

FIG. V

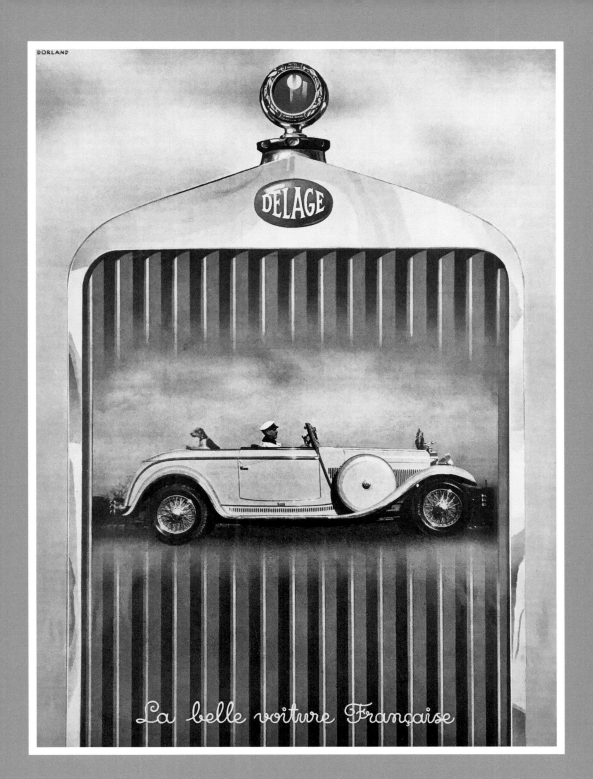

La belle voiture Française

FIG. VI

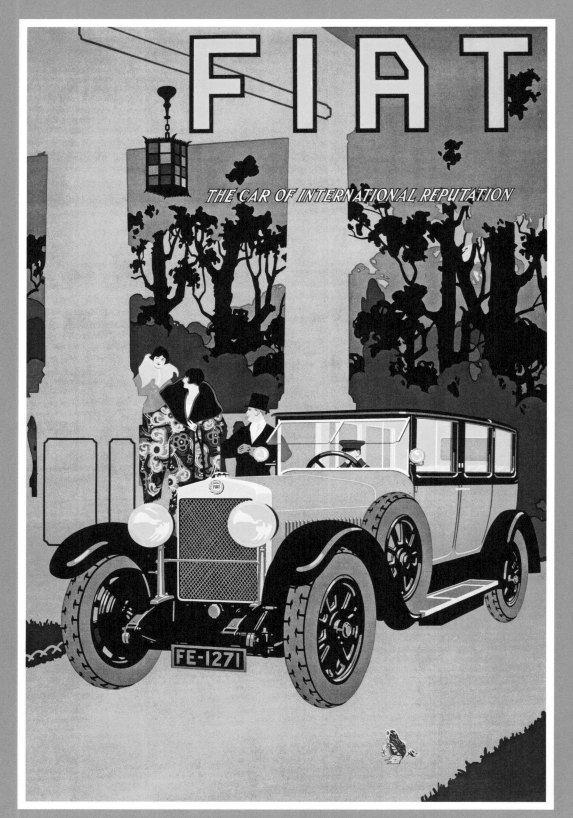

FIG. VII

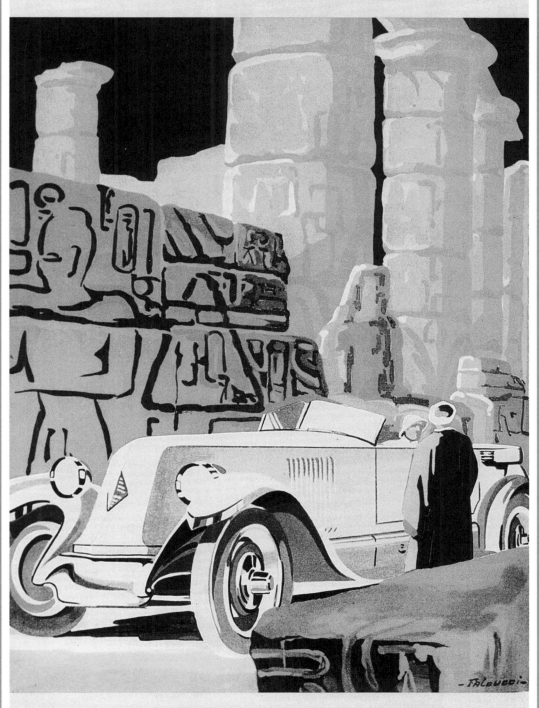

RENAULT

FIG. VIII

FIG. IX

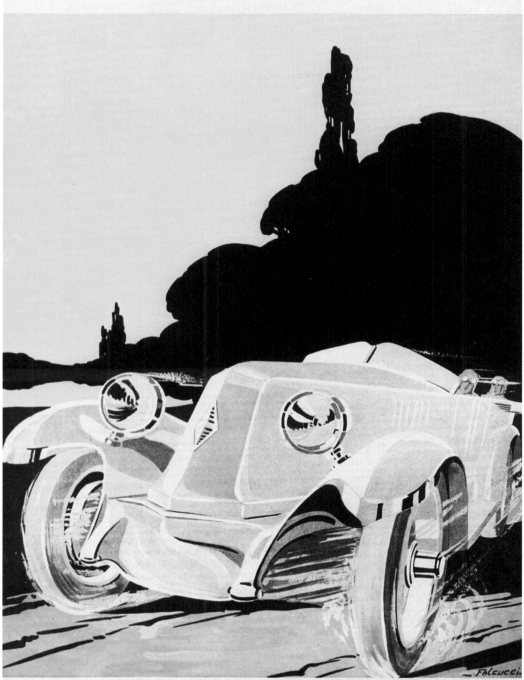

B. C. Seine Nº 189.286

Renault

FIG. X

CAPTIONS

FIG. I

Henri Thiriet, *Automobiles Delahaye, 10 rue du Banquier Paris*, c. 1895–98. Private collection.

FIG. II

Gaston Frédéric de Burggraff, *Peugeot, 83 Bd Gouvion, St.-Cyr*, c. 1905. Private collection.

FIG. III

Maurice Neumont, *Guiet, constructeurs exclusifs de la Société française d'autos électriques* [Guiet, the exclusive manufacturer of the *Société française d'autos électriques*], 1899. Private collection.

FIG. IV

German school, *Mercedes Daimler, Motoren-Gesellschaft Stuttgart-Unterfürkheim*, c. 1914. Private collection.

FIG. V

Roger Pérot, *Delahaye motor car*, 1935. Private collection.

FIG. VI

Dorland, *Delage, la belle voiture française* [Delage, the beautiful French car], 1931. Paris, Bibliothèque Forney.

FIG. VII

Ray Mount, *Fiat, the car of international reputation*, 1929. Turin, Centro Storico Fiat.

FIG. VIII

Robert Falcucci, *Torpedo Sport*, 1924. Boulogne-Billancourt, Renault archives.

FIG. IX

Anonymous, *Renault, la voiture française la plus répandue et la plus élégante* [Renault, the most popular and elegant French car], 1920. Boulogne-Billancourt, Renault archives.

FIG. X

Robert Falcucci, *Torpedo Sport*, 1924. Boulogne-Billancourt, Renault archives.

FACING PAGE: FIG. 49

The American actress and aviatrix, Miss Elinor Blevins, in front of her race car, Washington, D.C., c. 1915. Washington, D.C., Harris & Ewing collection.

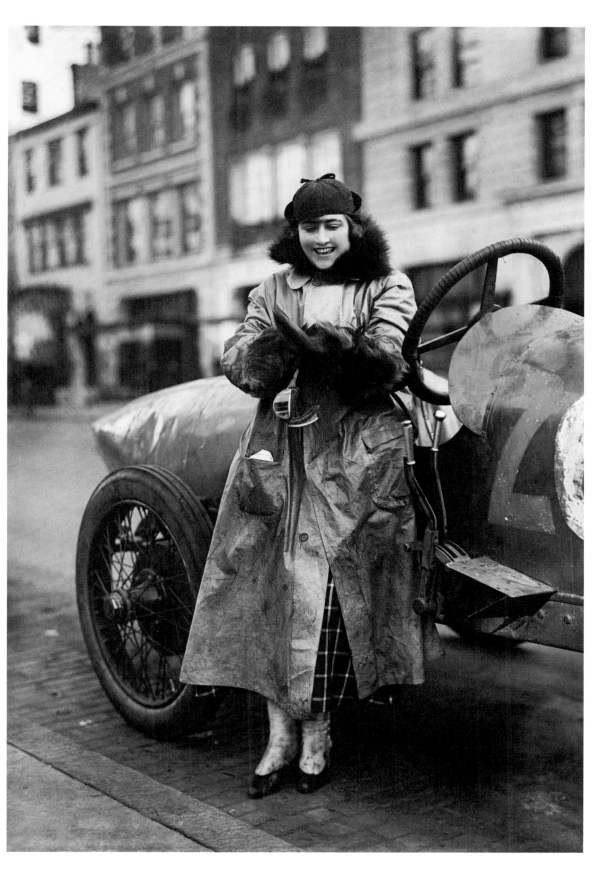

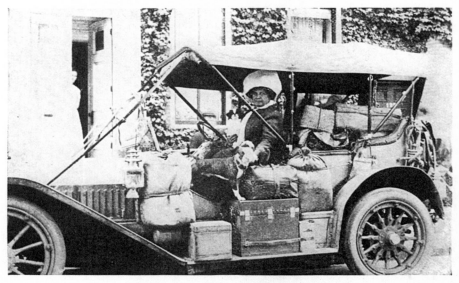

READY FOR THE START, TRENTON

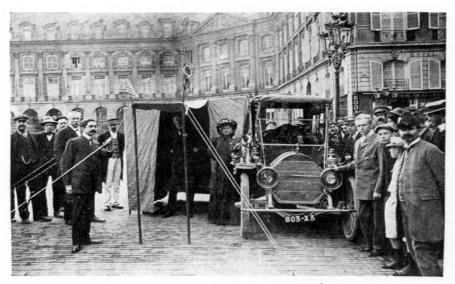

THE TRIAL OF THE TENT IN PLACE VENDÔME, PARIS

TOP: FIG. 50

Harriet White Fisher at the wheel of her Locomobile in Trenton, New Jersey,
on the day of her departure for a world tour, July 1909.

BOTTOM: FIG. 51

Reception tent set up for Fisher's arrival at Place Vendôme, Paris, 1909.

10

A WOMAN OF THE WORLD

———

In 1909–10, the American Harriet White Fisher
was the first person to circumnavigate
the globe at the wheel
of a Locomobile.

Japan, 1910. It's difficult to imagine Western vehicles and tourist routes in a country that had remained closed to foreigners for centuries, ruled by an army of shoguns. And yet . . . The Meiji Era had suddenly opened Japan to the world and, for the previous few years, Emperor Meiji had been carrying out extraordinary changes on a regular basis. After 250 years of withdrawal, the country had come out of its isolation for the first time, experiencing unbelievable transformations in record time, watching new infrastructure emerge inspired by Western innovations. Newly developed luxury hotels, railroads, and roads were now accessible to foreign travelers, who, at long last, were allowed to pass Japan's borders. It is said that the first car to be driven in Japan was a Panhard & Levassor, imported by a Frenchman from Tokyo. That was in 1898. A few years later, the first motorized competition was organized in Tokyo's Ueno Park, which was won by a Gladiator quadricycle, also brought over from France. The Japanese quickly adapted to the new trends. But these innovations were considerably less surprising

than the spectacle that awaited them that year—one that no
one would ever have believed possible, nor even imagined,
and more revolutionary than any other: a female driver who
had driven around the world.

When Harriet White Fisher triumphantly entered Tokyo
at the wheel of her amazing Locomobile, she had indeed just
completed this tremendous feat. She was just over forty years
of age, a savvy American businesswoman from Trenton,
New Jersey, as at ease in her factory as at fashionable gath-
erings, at a time when it was rare not only for a woman to be
a business owner, but also to succeed at it, especially when
it entailed selling anvils. But Fisher had inherited the com-
pany from her deceased husband, and having been interested
in mechanics since childhood, soon made it profitable. She
embarked on her world tour, starting in the United States,
together with her nephew who acted as her chauffeur, her
cook who acted as her personal secretary and jack of all trades,
an Italian maid, a pet monkey, and a bull terrier. She refused
to let the prejudices of the time stop her doing things, not
least wearing a sari, when necessary, for greater comfort. After
traveling across Europe, Africa, and India, she reached Japan,
where she found the roads most practicable, some having
even been constructed specially to enable her to pursue her
journey. Her greatest difficulties were encountered when
crossing certain rivers and ravines, but her steam-powered
Locomobile miraculously avoided any serious technical prob-
lems during the ten-thousand-mile journey, and her chauffeur
successfully handled all the necessary repairs.

A real miracle, one might say, looking at the photographs
of the period, for Harriet White Fisher also took photographs,
or had herself photographed during her adventure. One shot

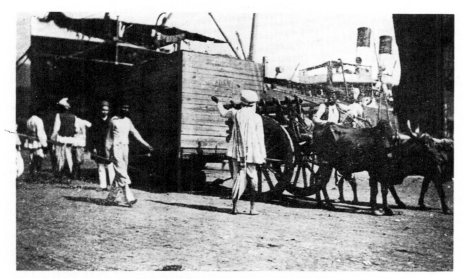

THE CAR ARRIVING AT BOMBAY

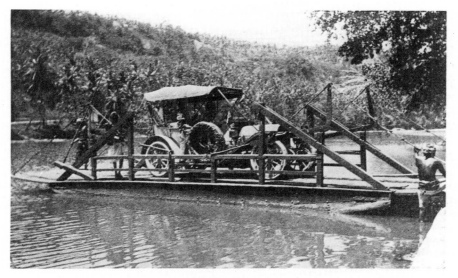

A CROSSING IN CEYLON

TOP: FIG. 52

Arrival of the Locomobile in Bombay, 1909–10.

BOTTOM: FIG. 53

Ferry crossing during the passage to Ceylon, 1909–10.

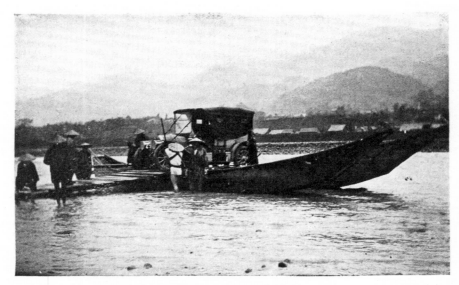

THE LANDING, FUGI RIVER

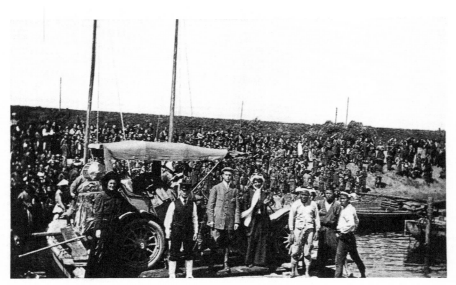

A JAPANESE CROWD

TOP: FIG. 54

Landing of the Locomobile on the Fuji River, Japan, 1909–10.

BOTTOM: FIG. 55

Fisher is greeted by a jubilant crowd upon her arrival in Japan, 1910.

shows a car laden with sacks, boxes, and travel trunks, with barely enough space for the passengers, and one wonders how such a heavily laden machine could even move. One also wonders at the sense of elation this adventuress must have felt during such a voyage. Thirteen months on the road, across four continents, in places as magnificent as they were dangerous, on lost country roads, or ones barely finished, through regions almost impossible to traverse. And yet, throughout her journey, people greeted her, astounded by a team like hers, as she drove through towns and villages that had never seen cars. The Locomobile was transported by boats and canoes, "navigating" the shimmering lakes at the foot of Mount Fuji.

It was in Japan that Fisher encountered her greatest problem, when faced with a precipice that appeared to be impossible to cross. The team spent the entire night seeking a solution. She ended up hiring some locals to build a makeshift bridge. It was their most worrying moment, and on the very last leg of their journey, prior to their victorious entry into Tokyo, having achieved the first round-the-world tour in a car, without encountering any major mechanical problems, at a time when people were still unsure about giving women the vote.

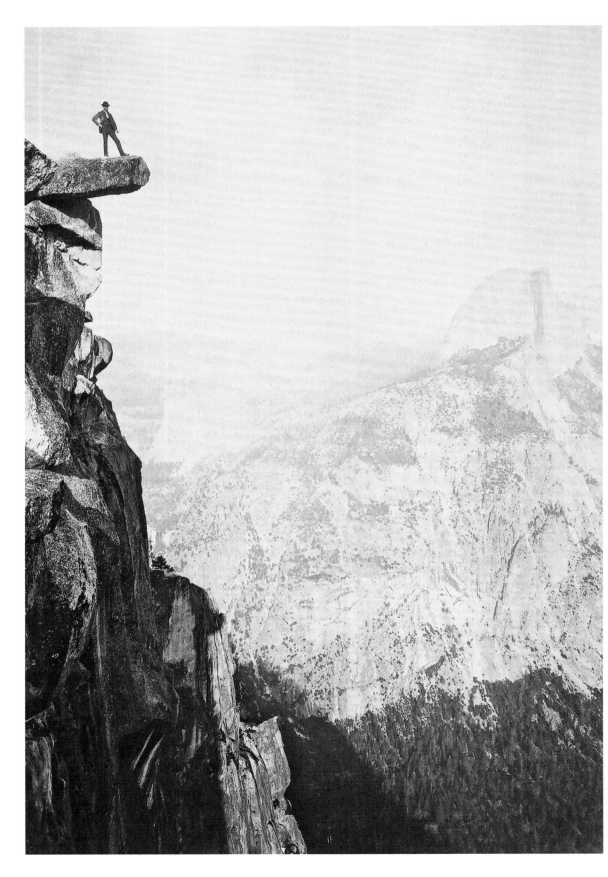

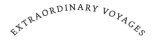
11

STEPPING FORWARD

———

IN THE SECOND HALF OF THE NINETEENTH
CENTURY, TRAVELING WRITERS,
WHO WERE KEEN WALKERS, VENTURED
OFF THE BEATEN PATH.

Setting out along a road, getting away from everyday life, placing one foot in front of the other at your own pace. Your heart, breath, blood, and mind all focused on the path, on what's new, relying only on yourself for moving forward. There's something wonderfully liberating about that. As soon as we set off, using the simplest means available to us, that of walking, another universe opens up, and the mere fact of organizing the moment as we see fit, without any obligations or particular ambition other than that of continuing on, makes us aware of another life. It's not just our muscles that are involved, nor just the heart, legs, thighs, arms, and arch of the foot; it's also the imagination that is awakened, the eyes that discover, scrutinize, examine, and the mind that is filled with enthusiasm, which marvels and expands. However, it took the tenacity of Henry David Thoreau, an obsessive walker, and the passion of John Muir, a naturalist and early ecologist, to defend this notion at a time when it applied solely to those who had no other choice but to walk.

FIG. 56

Hiker at Glacier Point Rock, perched 3,200 meters above sea level,
Yosemite National Park, Sierra Nevada, California, 1885.

In the second half of the nineteenth century, nobody
was concerned by the notion of wandering for leisure, as
yet. Terrestrial splendors were preferably admired in books,
at a safe distance from a country path. But in 1862, Thoreau
published *Walking*, a work extolling the virtues of walking.
Around the same time, Muir, a Scot who had emigrated to the
United States, embarked upon his first trip along the Wiscon-
sin River, as far as the Mississippi River. When he arrived home,
he felt nostalgic for the road and decided to set off again. Some
time later, in 1867, Muir began his famous thousand-mile walk
from Indiana through Kentucky, Tennessee, North Carolina,
and Georgia down to Florida, carefully avoiding towns, letting
his compass guide him. The traveling conditions were tough,
and the stars were frequently his blanket at night. He withstood
everything, happily giving himself over to an existence that
he had always dreamed of, discovering the immensity of the
world through nature. The Appalachians were the first real
mountains he had ever seen.

The following year, he undertook a trip to the Yosemite
Valley, about which he had heard so much. The outstanding
beauty of the place would shake up his life. The emotion he
felt in the face of nature there was so strong that he decided
to settle in the region, becoming a guide for the early scien-
tists visiting it, and studying the formation of valleys. Over
time, he became an eminent protector of the environment,
participating in scientific expeditions and crossing the coun-
try on foot repeatedly, thirsty for geographic discoveries.
He wanted to stand on the most beautiful natural sites across
all five continents. His quest for wild splendor was his sole aim.
With every step, he celebrated the magic of the world. Thanks
to his determination and his naturalist approach, he made

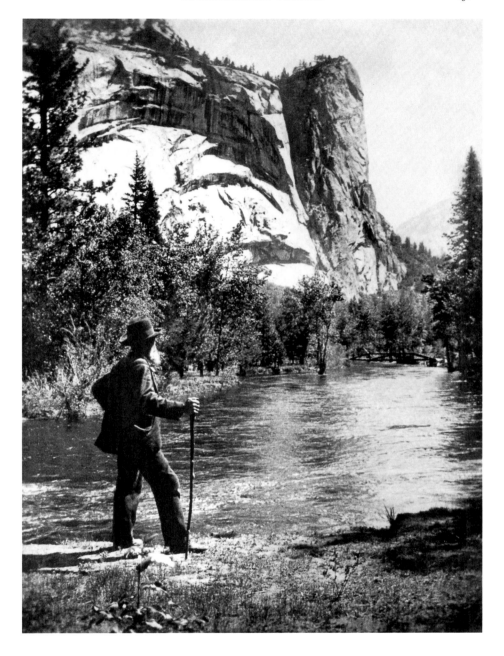

FIG. 57

Naturalist John Muir on one of his expeditions to the American West, c. 1903.

the public aware of the need to preserve outstanding natural sites, inspiring Congress to protect the Yosemite Valley by deeming it a national park. Muir's continued advocacy is credited with influencing Theodore Roosevelt to create national parks, bird sanctuaries, wildlife refuges, and national forests around the country. Travelers exploring the valley after Muir were to realize the same wishes and feel the same amazement before the powerful beauty of these landscapes.

Many authors have written about the virtues of walking, of strolling, and of movement, while wandering through towns, private gardens, or vast lands. In the 1930s, the British travel writer Patrick "Paddy" Leigh Fermor quit his London home to walk across Europe. He was eighteen and full of dreams of Holland, of the Bosporus, of sleeping under the stars, of making a journey like those made by monks and pilgrims. Abandoning England under a gray December sky, this son of a well-to-do family took eighteen months to reach Mount Athos in Northern Greece, which he found bathed in sun. It was a decisive adventure, a life-changing one that celebrated the freedom and carefree state of the walker, who is carried along by his voyage. Walking was the first means of transport, the most obvious and economic, a unique experience, a victory belonging solely to those who give themselves over to it. It involves moving, of course, but it's much more than that. You look at things in a new fashion, experiencing a voyage through space and time, endlessly reproduced. Walking, a means of travel that is affordable and accessible to many, nurtures our curiosity and capacity for amazement.

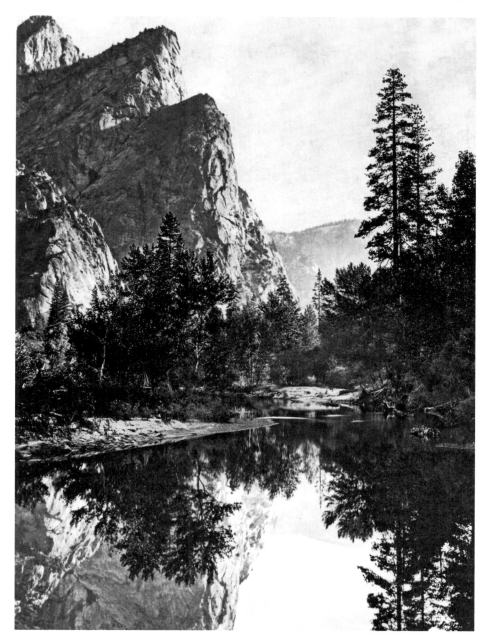

FIG. 58

Rock formation known as the Three Brothers and the Merced River, Yosemite National Park,
Sierra Nevada, California, c. 1890. John Muir considered the view from Eagle Peak
(the highest peak in the center) to be the most beautiful in the valley.

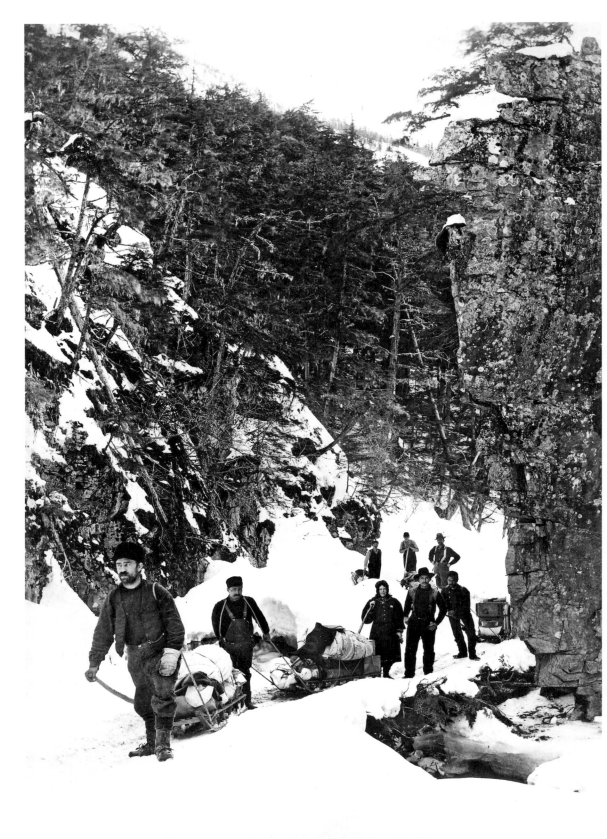

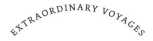
12

THE RUSH FOR WHITE GOLD

———

At the end of the nineteenth century, Alaska was still a vast underexplored territory.

It really doesn't matter whether the sun shines all day or not on these ice-covered windswept lands, for seasons barely exist. Whatever color the sky, getting about requires endurance. Adaptability and strength are the greatest assets. Speed as well, to cover these distances in a reasonable amount of time. At the very end of the nineteenth century, during the Klondike Gold Rush, sleds and their dogs were the only way to access the frozen wastelands of the Far North. At that time, wild Alaska was a kingdom totally forgotten by the rest of the world. Within the space of a few months, however, prospectors, who shortly before had been lounging around in their offices, dashed to this territory about which they knew nothing, having read an article in their morning newspaper. When they reached the Yukon, they soon realized that without specially adapted vehicles, it was impossible to get about, for winter there lasted almost all year.

On the endless frozen expanses and snow-covered, uneven terrain, nothing was more valuable than a sled and its Inuit-bred dogs. Paths had to be forged to move forward,

FIG. 59
Gold diggers crossing Dyea Canyon, Yukon, Alaska, c. 1897.

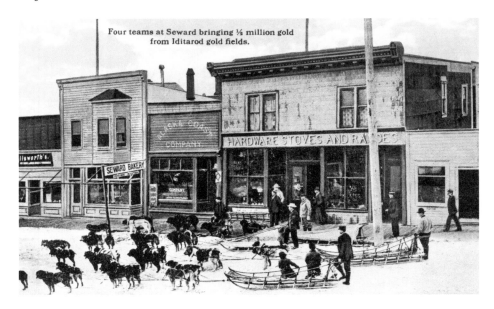

Four teams at Seward bringing ½ million gold
from Iditarod gold fields.

to pierce the white silence, to survive. The shrewdest among
them, therefore, purchased sturdy, powerful dogs and sleds
to accompany them, convinced, quite rightly, of the need for
this equipment in order to move about, to find the precious
metal and avoid dying. Never had a means of transport been
more vital and yet so far removed from any notion of pleasure.
These kind of teams had been a part of the daily life of Native
Americans and the inhabitants of the North for a long while.
Trappers, adventurers, and explorers had all adopted this tool,
indispensable not only for getting about, but also for trans-
porting goods and provisions, and for working the merest
strip of land. No roads were accessible at that time, and follow-
ing tracks was grueling. Heavy loads had to be dragged over
incredibly difficult terrain, for several hundred miles of wild
expanses, crossing gigantic glaciers, forges, forests, and rivers
that annihilated every kind of boat and killed men like flies.

FIG. 60

Arrival of sled dogs at Seward transporting half a million tons of gold from
the precious metal deposits of Iditarod, Alaska, c. 1910.

In certain instances, it took months to cross just over three hundred miles. How many expeditions on foot ended tragically as a result of failing to open up a route? What would the inhabitants of Nome, on the westernmost peninsula of Alaska, have done in 1925 when their town was struck by diphtheria had they not had huskies, malamutes, and Greenland dogs, and the competence and solidity of reliable sled teams, prepared like race cars? The town, situated on the Bering Sea, had attracted gold seekers, but it was still cut off from everything and extremely difficult to access.

The sea here was so frozen and the gusts of wind so violent that it was impossible to reach the small town by boat or airplane and at night, the temperature could drop to -58°F. The team that went to fetch the serum was made up of twenty mushers (dog sled drivers), like those described by Jack London, and of over one hundred intelligent, sturdy huskies

FIG. 61
Musher and his dogs supplying the villages of the region,
in the mountains of Alaska, 1938.

capable of traveling up to sixty-two miles per day and pulling a load of 110 pounds.

Men and dogs relied on one another, covering hundreds of miles or so, in blizzards in the depths of winter, frequently in total darkness. To do this required the mushers and their dogs to be but one, from start to finish, their synergy creating an incredible machine that was fast, practical, and efficient, making it possible to move around on the treacherous frozen expanses and narrowest of tracks, reacting rapidly and well on the trickiest sections of the Yukon River, crossing ravines and frozen lakes, a stone's throw from the Arctic Circle.

A unique partnership between man and animal, with the dogs receiving their masters' full attention. Once the task was achieved, and the sled had been halted, by lodging its brake in the powdery snow, as one would do with a fine automobile, the drivers were able to savor the trip, the distances covered, and the dangers avoided.

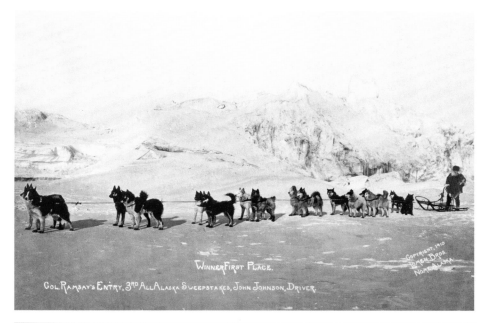

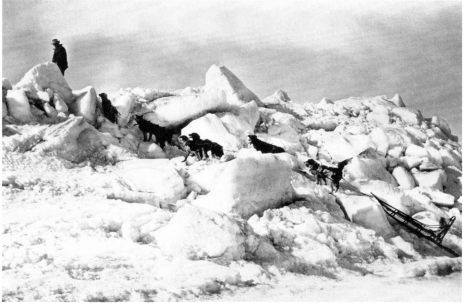

Ranked third in the All Alaska Sweepstakes, Colonel Ramsay's dog team, led by musher
John Johnson, crosses the snowy tundra of the Alaskan plains between
Nome and Candle, 1910.

Sled dogs making their way through blocks of ice near Nome, Alaska, c. 1910.

13
DRIFTWOOD

THE LIGHTNESS AND AGILITY OF THE CANOE
ENABLED EXPLORERS TO PENETRATE
THE WORLD'S REMOTEST
LOCATIONS.

Its banks were lined with forests of oak trees, poplars, and dense thickets of cotton plants growing freely on the rich alluvial soil. Uprooted trees, swept along by the current, ended up stuck in its muddy bed, causing terrible shipwrecks. Tree trunks amassed one on top of the other, forming inextricable floating mounds that transformed any journey into a nightmare. Navigation maps were useless on the Missouri River as the route was constantly changing and, after a while, canoes were the only means of finding a way through these ever-fluctuating zones. That was what Lewis and Clark soon discovered on their expedition—the first overland trip across the United States as far as the Pacific coast, undertaken between 1804 and 1806. The Wild West was being colonized at that time and the rivers were the main routes, with potential for trade as well. In 1803, President Jefferson, keen to develop trade with the Pacific, got Congress to agree to underwrite the two explorers, hoping they would discover rivers that could be navigated.

FIG. 64

Canoeing on Emerald Lake, Yoho National Park, British Columbia, Canada, 1951.

The expedition got underway, led by Captain Meriwether Lewis, Jefferson's private secretary, a young and introverted twenty-nine-year-old intellectual, who had the intelligence to choose his exact opposite as a traveling companion, his good friend William Clark, a big, strong, pragmatic lad and an excellent negotiator, adept at navigating and geography. The two men pictured themselves venturing deep into lands that were virtually untouched by Europeans. They discovered rivers flowing at prodigious speeds, their banks eroded, mounds of trees ripped from the muddy banks being swept along with them, groups of eagles and vultures flying overhead. The large boat they started out in soon proved useless in such a context and they decided to trace the river in Native American canoes. This choice was to prove decisive for the success of the expedition, and daring, given the maps of the period that showed a winding river with complicated bends to be negotiated.

In their travel log, the two friends describe navigating along rivers full of all-but-submerged rocks and knee-high grasses. They had to contend with terrible temperatures, landscapes entirely unfamiliar to them, hunger, cold, being attacked by bears, hostility from Native Americans, descending rapids . . . Without their canoes, they would probably not have been able to access the remotest areas, negotiate waterfalls considered to be impassable, or make their way over waterways that ended up as small streams.

What would have become of all the adventurers, explorers, expedition members, bush roamers, and discoverers who came after them had they too not had these simple hollowed-out tree trunks capable of wending their way through anything? One hundred and fifty years later, Jean Rouch, the filmmaker fascinated by African legends, would never have been able to

pursue his crazy project of descending the Niger River without the help of this type of craft. In 1946, Rouch embarked on a nine-month voyage in a canoe, together with two friends. All he had were some maps that were both imprecise and incomplete, but he had his camera with which he filmed the landscapes, the people they encountered, the savannah, and life along the Niger. Throughout their 2,500-mile journey, the three men witnessed the beauty the bush and the "gaiety of African society," as Rouch wrote. The ethnologist brought back a film of their meanderings on this complex river, *Au pays des mages noirs* (*In the Land of the Black Sorcerers*), a combination of fact and fiction, documentary and poetry, illustrating the wanderings of a new age of explorers who had opted for an ancient means of transport. The country and its population reveal themselves at the canoe's tranquil pace. The full beauty of adventure is right there—a simple craft gently navigating the brown waters laden with sand and silt.

FIG. 65

Dugout canoe on the Niger River, near Mopti, Mali, 1984.

14

FULL STEAM AHEAD

———

BEFORE THE ADVENT OF THE TRAIN,
PADDLE STEAMERS MADE IT POSSIBLE TO TRAVEL
AND TRADE ON THE MISSISSIPPI.

It was customary for boats to leave the port of New Orleans between four and five in the afternoon, transforming the dock into a hive of activity. Endless processions of crates and barrels moved speedily up the gangways, the crews blurting out orders and curses, adding to the general overexcitement. Last-minute passengers frantically made their way through the sea of people to climb on board, bumping into women with hatboxes and men laden with all manner of baggage. All eyes were on the boat and its vast, blazing white mass, and when the time to depart approached, everyone awaited the whistle blast that never failed to fill the entire space.

In the United States in the 1850s, the iron horse had not yet transported the nation to its conquest of the West. At that time, there were only roads for wagons and horses, and only small boats and barges for getting about on water. Mud rendered road transport extremely arduous, making journeys interminable and frequently dangerous. Rivers were unpredictable and constantly changing, and when not coming

FIG. 66

The *White Horse* steamer on the Yukon River, some sections of which, like the Mississippi River, can only be sailed up by low-draft boats, 1920.

upon rapids that drowned those that risked them, there were
all sorts of other, no less terrifying obstacles that had to be
faced. Within this context, this new kind of floating vessel
offered a dependable solution in a country with an uncer-
tain future. Their flat hulls glided over the water like ducks,
passing over sandbanks, adapting to the constantly changing
rivers, and their wooden structures were easy to repair. The
paddle wheels, toward the stern, only needed a few inches of
water to turn, and the captain could easily spot any obstacles
from his high vantage point, steering clear of them in good
time. There was no better way of transporting merchandise
and passengers in large numbers; it really was the perfect form
of locomotion, and yet it had great difficulty being accepted
as a proper means of transport!

 In the eighteenth century, the Frenchman Claude de
Jouffroy d'Abbans launched his first steam machine project on
the river Saône but failed to commercialize it. Robert Fulton, an

FIG. 67

Steamer captain on the bridge, c. 1870.

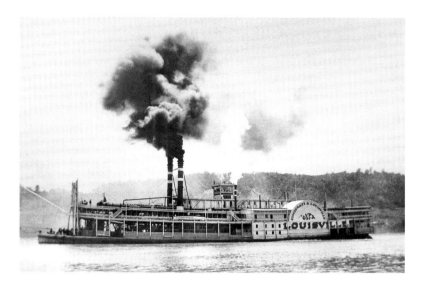

American living in France, pursued the adventure with a proto-
type on the Seine, but was equally unsuccessful with the French
authorities and decided to return to the United States to try his
hand there. And so it was on the Hudson River in New York that
he launched the first boat of this kind, before an astonished
crowd who nonetheless refused to believe in the project's suc-
cess. How could a so-called boat operate without oars or sails?
What a joke! Fulton withstood the mockery while watching
his invention set forth effortlessly, thereby launching the first
commercial line between Albany and New York. Not a single
passenger ventured aboard for this maiden voyage, despite
all the advertisements Fulton had placed in local newspapers.
The ignorant hordes even booed him when he cast off.

It was quite different, however, a few years later, on
the Mississippi and elsewhere, given the reliability, comfort,
and luxury offered by these wonders. As soon as navigation
on the Mississippi opened up, these boats appeared in their

FIG. 68

The steamer *Louisville* arrives in New Orleans, c. 1870.

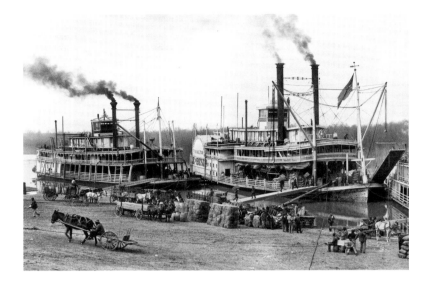

dozens, soon becoming part of river life—indeed, they really
gave it its soul, as it were—transforming simple pilots into
lords of the waters. They were easy to recognize from afar with
clouds of smoke escaping from their smokestacks and cascades
of splashing water, not to mention the whistle blasts and cries
of the captains who were never shy of adding to the racket.
They could be seen advancing at a peaceful pace, as if they too
were touched by the languor of the tropics. For the first time,
passengers were free to move about during the voyage and the
journey was neither exhausting nor tedious.

Once inside, passengers found beautifully decorated
salons, bedrooms like those in private houses, a chapel, restau-
rants, living areas exclusively reserved for women, games
rooms, and many other rooms where they could come and go
as they pleased. An endless supply of books, newspapers, and
cocktails was also on offer. On the grandest boats, there was
even electric lighting. All of a sudden, the river's endless twists

FIG. 69

Unloading of cargo on the Mississippi River, 1906.
Washington, D.C., Library of Congress.

and turns, its frightening bends, its dark bayous, its swamps, and even its crocodiles no longer posed a threat to those on board these fortresses, filled with merchants and explorers of all kinds.

Until then, the Mississippi had been an untamed river that devoured everything. These slow giants made it eminently human, blending into the landscape with unusual nonchalance. It was not until the arrival of the train that they were supplanted. Another era beckoned, one to which the captains reacted as quickly as possible, offering tourist outings, doing away with cabins to install dance floors, and inviting artists like Louis Armstrong and Fate Marable's band to entertain passengers. They inaugurated this new style of boat with their music harking directly from the cotton plantations. Tunes that unmistakably plunge us into the waters of the Mississippi.

FIG. 70

Restaurant with its tables set up for dinner aboard
the *City of Monroe* steamer, c. 1890.

FOLLOWING DOUBLE PAGE: FIG. 71

Night race between two steamers on the Mississippi, 1875.

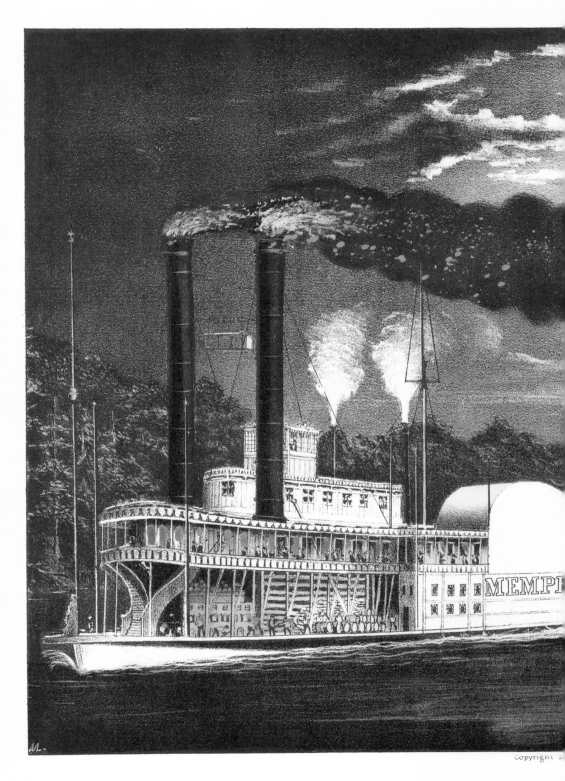

MIDNIGHT RACE O

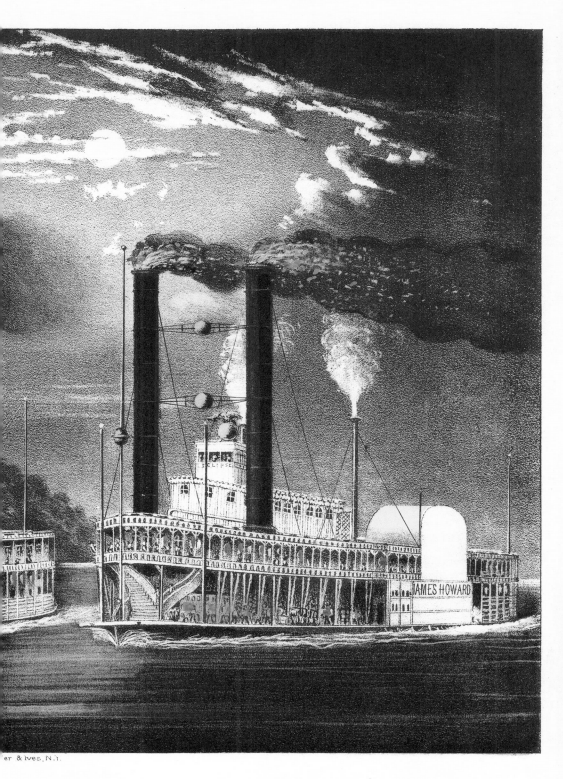

er & Ives, N.Y.

THE MISSISSIPPI.

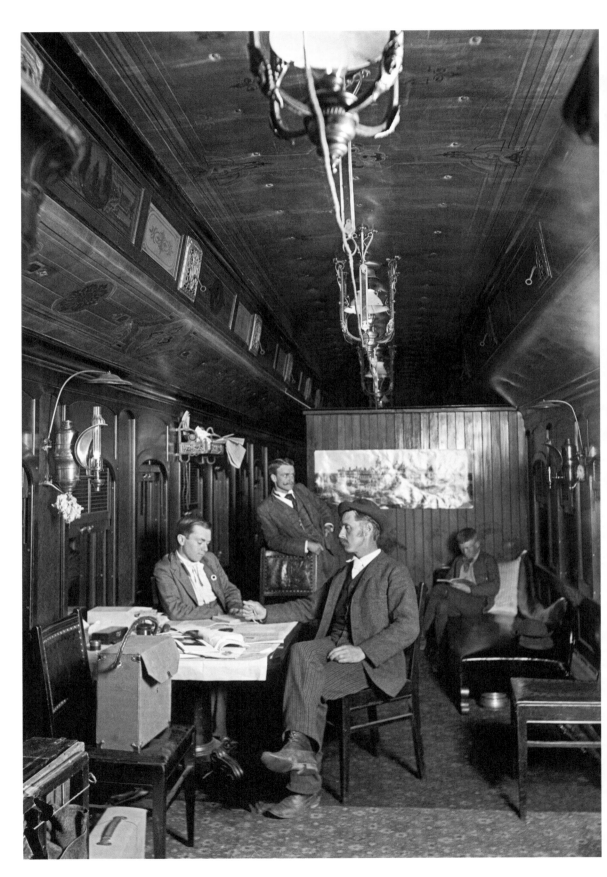

15

THE RAILWAY BATTLE

———

WITH THE CREATION OF A TRANSCONTINENTAL
RAILWAY LINE, THE UNITED STATES
ENTERED THE MODERN AGE.

In the mid-nineteenth century, the United States urgently needed to find a reliable means of transport for traveling across the country from one coast to the other to prevent its citizens from risking their lives in wagons or aboard clippers that had to brave rounding Cape Horn. For the country's economy too, to avoid waiting six months to receive materials or be able to settle business matters, and above all, to enable everybody to be in contact with the other end of the continent. Crossing the country was dangerous, long, and a hellish experience. The months spent on the road was a disaster in a country impatient for innovation. As a visionary president who had lived through the pioneering era, Abraham Lincoln understood this well. It was time to facilitate trade, to fall in line with the direction the world was moving in, by building a transcontinental railroad that would enable travel from one end of the nation to the other as quickly as possible, as speed was of the essence, as was reducing distances.

This railroad would be the most modern and daring one ever created, a revolution both in terms of the route itself and

FIG. 72

Travelers in a New York Central Railroad car set up for reading, c. 1895–1915.
Washington, D.C., Library of Congress.

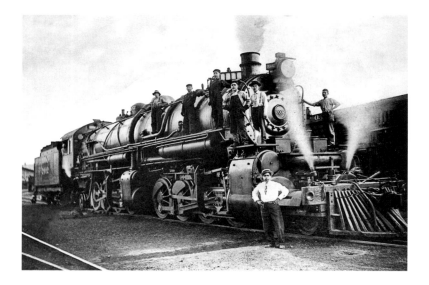

of the train that ran along it. In this respect, the first steam train, built in 1804 by the British inventor Richard Trevithick, traveling at the admirable speed of nearly 5 mph, must have seemed very basic, as did the highly innovative rocket-shaped one designed by railroad engineer George Stephenson, which traveled at 18.5 mph. This time, the speed topped 60 mph, and both rails and machine belonged to a new era, that of the Conquest of the West, in which progress and comfort were all-important. Americans wished to travel with as little disturbance as possible to their daily habits, so trains were therefore made to resemble houses without side doors, for ease of passenger circulation, with doors at either end instead for getting on and off. Inside, the carriages were very high, to allow passengers to travel with their hats on should they wish. There were coal stoves to heat the carriages in winter, as well as on cool summer evenings, especially in areas where the train climbed up to over 13,000 feet. Good lighting was also provided, as were bathrooms,

FIG. 73

Japanese workers from the Union Pacific Railroad & Southern Pacific Railroad posing
in front of a locomotive with their foreman in Ogden, Utah, 1910.
Utah State Historical Society.

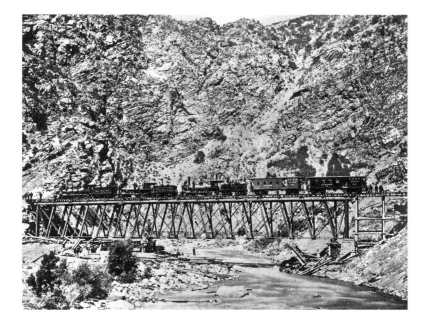

carriages for sitting and talking, viewing carriages, dining cars, seats that transformed into sleeping berths, places for smoking, playing whist and chess, or just dreaming under the stars.

The challenges were immense. Firstly, there was the sheer distance, for which two companies, one in the east, the other in the west, were to join forces to make a single railroad track to meet this insane challenge. Then there was getting over the Sierra Nevada, which would require a superhuman effort, digging tunnels through the mountain. And that was not all. The train would enable citizens to discover their own country, until then unknown to most of them, crossing lands larger than anything they had ever imagined, looking through the windows at farmers going about their daily tasks and waving to them from their ranches, traveling deep into all but wild regions, far from anything they might have read about in books or newspapers.

FIG. 74

Locomotives on Devil's Gate Bridge during the construction of the first transcontinental railroad line in the United States by the Union Pacific Railroad, 1868.

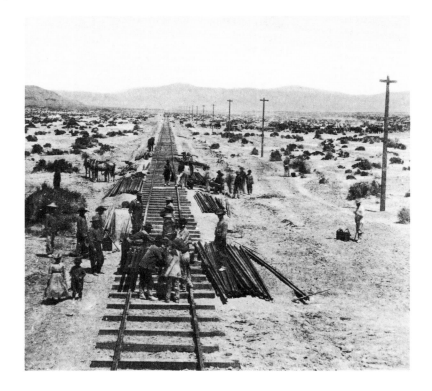

They would see what the regions described by Buffalo Bill really looked like—their nation's wildest and most mysterious sites, lands that until then had been inhabited by Native Americans and a few homesteaders, dotted with fields and small villages. The train and its iron ribbon honored a modern, technological world where speed was a requirement. This transcontinental train was also the first "train taken for pleasure." The trip from east to west now only took six days as opposed to the exhausting and frequently fatal journey in covered wagons that had previously lasted months. Gone were the carts tossed around on secluded tracks, the exhausting journeys on horseback, by foot or by boat, across a divided

FIG. 75

Laying tracks on the transcontinental line in Humboldt County, California, late nineteenth century. Sacramento, California State Library.

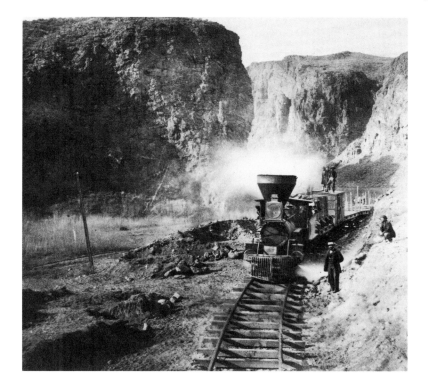

nation, with seemingly endless distances, and all the pro-
visions required for such a long route. The railroad and its
machine tearing along at full steam changed the vision of this
country and the lives of its inhabitants. With this train, travel
became a pleasure; it also created a new unity in this relatively
young nation composed of many different peoples.

FIG. 76

Passage of the first transcontinental train at Ten Mile Canyon, Colorado,
late nineteenth century. Sacramento, California State Library.

16

AT FULL TILT

As a faithful fellow traveler, the horse
allowed man to lead expeditions
that changed the course of history.

Poseidon is said to have brought forth the first horse from a rock with his trident, but for the Bedouins, it was Allah who created it, by blowing on a handful of wind from the south. They roamed the land on their speedy mounts, among barren peaks and sculpted rocks, in the hope of seeing a verdant oasis loom into view on the horizon, in much the same way as a sailor hopes to discover firm land.

When the British explorer Gertrude Bell set off for Jordan in 1913, she immediately purchased a horse, leather saddles, saddlebags, and gifts for the tribes she would encounter, and hired a caravan to accompany her. In photos, she is seen riding sidesaddle, with an elegant hat, boots, and an ample skirt, in which she hid pistols and ammunition. For years, she traversed the Middle East, venturing ever further into the desert, organizing explorations, and even lending her hand to spying where necessary.

Another legendary journey was the famous expedition of the highly distinguished Irish geographer John Palliser,

FIG. 77

Horseback riding at Emperor Falls in Mount Robson Park, British Columbia,
Canada, early twentieth century.

supported by the Royal Geographical Society, who set out to
explore Western Canada on behalf of the British government.
At that time in Europe there was little precise information on
these territories, about which a lot of contradictory things were
said. The team put together by Palliser began its adventure in
England in 1857. Once in Canada, they traveled by steamship
and canoe between Lake Superior and the Red River, continu-
ing overland with the help of twenty-nine horses, wagons, and
four-wheel American carts.

Among the team members was a twenty-three-year-
old geologist, doctor, and naturalist, James Hector, who was
also in charge of mapping the region. He and his horse would
leave their mark on history. In August 1858, the members of the
expedition reached a high point between Alberta and British
Columbia and discovered a spectacular pass through the rock.
While the landscape was magnificent, the terrain proved to
be terribly hazardous, forcing them to traverse the wildest of
white-water rapids.

James Hector decided to explore the area independently
with his horse. He found his way through the rock with diffi-
culty, and had barely begun edging forward among the formi-
dable waterfalls when all of a sudden he collapsed in the river,
for no apparent reason. He remained unconscious for so long
that his fellow travelers took him for dead and began digging
his grave. He eventually came to his senses and opened his eyes
before the stunned team.

Once on his feet again, he explained that he had been
struck in the stomach by his bucking horse while attempting
to help it across the rapids. The incident was to give its name
to the river, known ever since as Kicking Horse River, now an
established part of Canada's heritage. As for the impressive

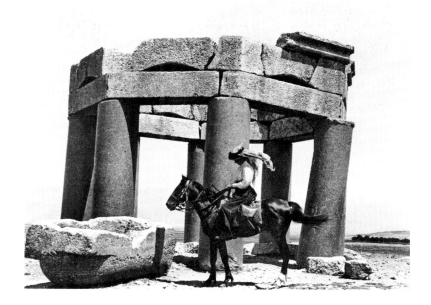

pass over the Rocky Mountains, it was named Kicking Horse Pass, becoming one of the great historical venues for those exploring British Columbia. These two names found on all maps of the region—proof that geography nearly always has a story behind it—recall the adventure of a resuscitated rider and an extraordinary expedition that made Palliser and his cartographer famous.

FIG. 78

British archaeologist Gertrude Bell at the *qubba* in Duris, Bekaa Valley, Lebanon, 1900.
Newcastle, Gertrude Bell archives.

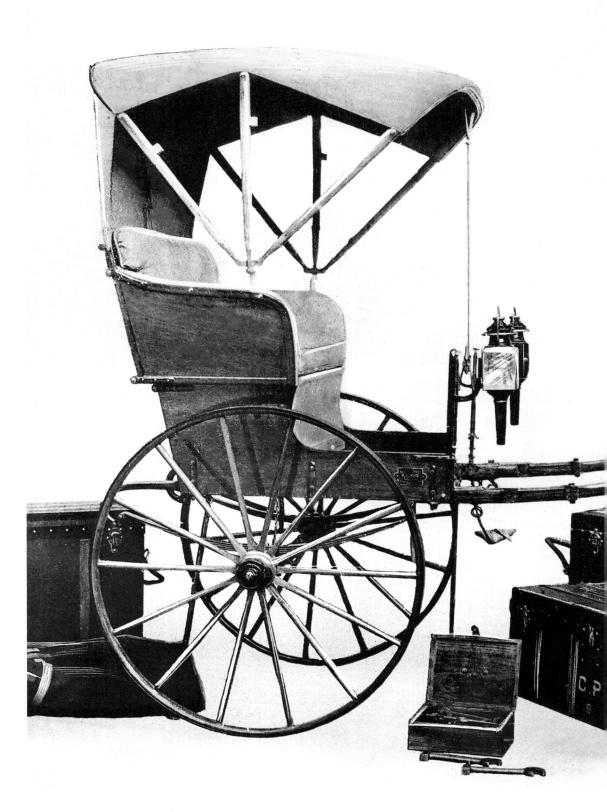

17

FOLDING CARRIAGE

———

AS IT COULD BE COMPLETELY DISMANTLED
AND STORED IN A VUITTON TRUNK,
THE TILBURY MADE IT POSSIBLE TO TRAVEL
AROUND THE WORLD WITH EASE.

A flying carpet was what was needed to travel across certain lands effortlessly, as in *The Thousand and One Nights*; failing that, a means of transport that was equally light and magical. A vehicle that enabled confortable movement and could be repaired in no time; one that could be driven by a woman as well as by a man, and that could be accommodated anywhere, even, if necessary, in a travel trunk. In short, a vehicle that was never a problem, no matter what the circumstances, and that was simple to use so as not to spoil the magic of journeying to the ends of the earth in the early twentieth century. Travelers at that time were passionate about archaeology, great monuments, architecture, and empires buried beneath the sand. Those taking off to discover them aspired to do so unhindered, with practical but comfortable means. They dreamed of exceptional vehicles, like the one made by Morel-Grümmer, a Parisian firm renowned as a luxury coachbuilder, that had nonetheless conceived a wonderfully light vehicle that seemed to positively fly through the air.

FIG. 79

Countess Blanche de Clermont-Tonnerre's tilbury designed
by the coachbuilder Morel-Grümmer, 1910.

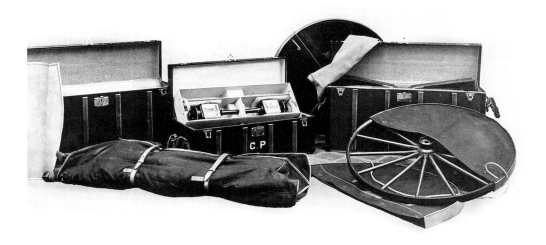

The vehicle was a tilbury that could be completely dismantled, specially designed for the eccentric French explorer Blanche de Clermont-Tonnerre who, in 1910, intended to travel across Persia, a land of elegant palaces, lively caravanserais, and mosques with famous turquoise domes. In order to do so, the coachbuilder had dreamed up a truly outstanding vehicle, almost entirely open, made of varnished walnut with highlights of yellow and black lacquered wood, with metal hinges and two removable black metal lanterns signed "V. Morel." The seating of the bench was covered with green leather, the axle was foldable, the shafts slightly curved. The whole thing could be dismantled and placed in three large purpose-built storage trunks covered in thick, red-coated canvas. These trunks, made by the Louis Vuitton house, had rope handles and could be transported with the help of long poles.

This wondrous vehicle not only enabled its intrepid owner to traverse the globe with the greatest ease, but also

FIG. 80

Dismantled tilbury stored in its red Vuittonite trunks, ordered
by Blanche de Clermont-Tonnerre, c. 1910.

provided a hitherto unthought of advantage—that of being
able to be packed away in the large travel trunks it was trans-
porting. No explorer had ever seen anything like it—a carriage
that could be folded away in a trunk like a garment! With it,

FIG. 81
The Countess Blanche de Clermont-Tonnerre, c. 1890.

the planet's most inaccessible regions resembled pleasure gardens. This tilbury was designed to make moving around as easy as for a bird, no matter where, allowing the traveler to see the surrounding landscapes properly rather than merely glimpsing them through a small window as in normal carriages. Blanche de Clermont-Tonnerre was therefore able to discover distant lands—Persia, Iraq, India, China—without a filter, without flapping curtains getting in the way as in most horse-drawn carriages of the period.

When one looks closely, everything about this tilbury was nimble and it was so maneuverable and well-adapted to all terrains that nothing seemed to prevent its progress. With it, its passenger could handle any situation. The Morel-Grümmer firm, with its first-class reputation, had chosen to combine great simplicity with exceptional technique. The coachbuilder was used to designing projects adapted to the specific needs of its clients, providing all the necessary fine-tuning. It was

FIG. 82

Frédéric Gadmer, *Pont à Zakho, Irak* [Bridge at Zakho, Iraq], 1927.
Boulogne-Billancourt, Archives of the Planet, Albert Khan collection.

not unusual for clients to come and see their carriages before they had been completed, to discuss any changes that needed to be made in keeping with their particular use. Just picture the scene in front of the entrance to the Paris workshops when these carriages emerged, one leaving rue Cambacérès, near the Champs-Élysées, to go to the Bois de Boulogne, while the other, the extraordinary collapsible tilbury, would be heading for the Middle East, dashing toward what explorers such as the Countess imagined were distant lands full of tales, of plains battered by desert winds, of secret oases in the land of Scheherazade, of *The Thousand and One Nights*—truly like a flying carpet.

FIG. 83

Frédéric Gadmer, *Mosquée du cheik Marouf* [Mosque of Sheikh Marouf], *Baghdad*, 1927.
Boulogne-Billancourt, Archives of the Planet, Albert Khan collection.

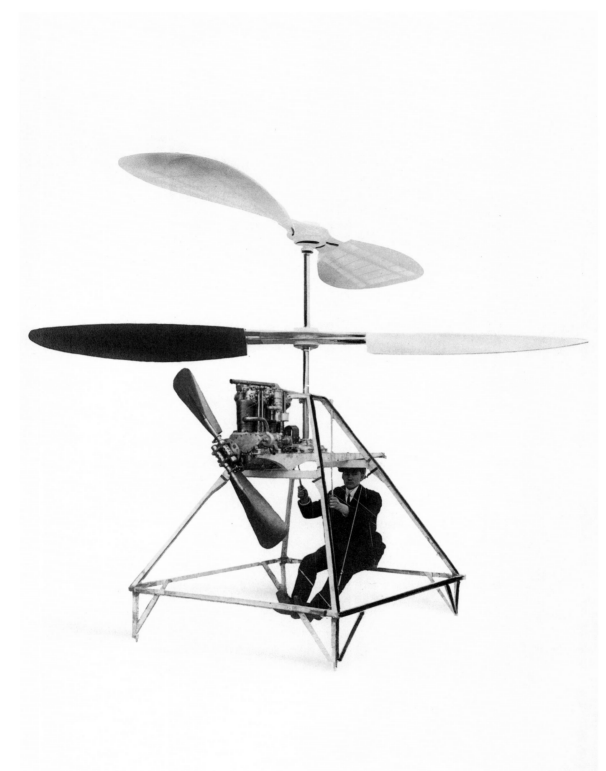

18

VERTICAL TAKEOFF

———

THE ANCESTORS OF THE HELICOPTER APPEARED
AT THE VERY BEGINNING OF THE NINETEENTH
CENTURY. BUT INGENUITY RHYMED
WITH DANGER.

Leonardo da Vinci had already come up with the idea during the Renaissance, if the drawings found in his sketchbooks are anything to go by. As for the eighteenth-century Russian chemist, physician, and astronomist Mikhail Lomonosov, he proved the existence of the force of levitation. Gustave de Ponton d'Amécourt is known for inventing the word "helicopter," in 1861, based on the Greek words *helix*, meaning "spiral," and *pteron*, meaning "wing." Between them, these three men more or less invented the machine, but it was ultimately a simple bicycle-maker with a small business in Normandy who really marked its creation with a saddle and four bicycle wheels. He added two levitation propellers, just under twenty feet in diameter, serving as rotors, and a twenty-four-horsepower engine. The two propellers were operated by a vast belt. As for the chassis, it was made of a steel tube equipped with piano strings. The machine and its pilot weighed a total of 728 pounds, and for the first trials, it was just placed on a plank in the middle of a field. Its inventor, the Frenchman Paul Cornu, was a handyman

FIG. 84
The *Vuitton II*, a flying device with two propellers,
designed by Jean and Pierre Vuitton, c. 1910.

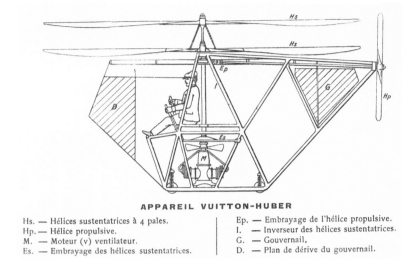

APPAREIL VUITTON-HUBER

Hs. — Hélices sustentatrices à 4 pales.
Hp. — Hélice propulsive.
M. — Moteur (v) ventilateur.
Es. — Embrayage des hélices sustentatrices.

Ep. — Embrayage de l'hélice propulsive.
I. — Inverseur des hélices sustentatrices.
G. — Gouvernail.
D. — Plan de dérive du gouvernail.

second to none, the eldest of a family of fifteen children.
He took after his father, who also had a number of inventions
to his name, including a project for an airship, and who ran a
bicycle repair workshop together with another one of his sons.
Paul spent his time watching them work and dreaming up new
machines. He was only fourteen when he invented an incubator
temperature regulator. This was followed by a motorized bicy-
cle, a steam-powered tricycle, a thermal pendulum, an ultra-
light car, and a gasoline engine which would even be exhibited
at the Salon de l'Automobile in 1901.

However, since 1905, he had been fascinated by aviation,
and more specifically by vertical takeoff. The era was one of
mechanical progress, experimentation, precursors, and pio-
neers. Every day saw the birth of a new attempt and, follow-
ing on from the gliders and aircrafts of Clément Ader and the
Wright brothers, people were now dreaming of flying "upward,"
remaining still, and then coming back down again as lightly as

FIG. 85

Sketch of the Vuitton-Huber helicopter created
by Jean and Pierre Vuitton, 1908.

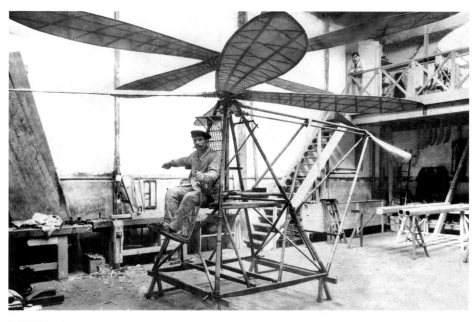

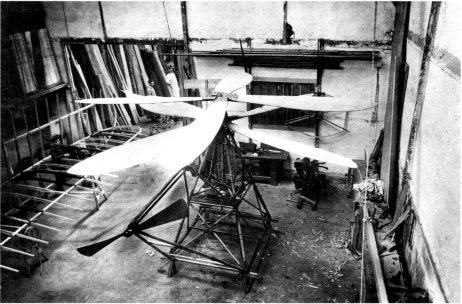

TOP AND BOTTOM: FIGS. 86, 87

Finalization of the Vuitton-Huber helicopter in the Asnières-sur-Seine workshop,
in preparation for the Exposition internationale de locomotion aérienne
at the Grand-Palais in Paris, 1909.

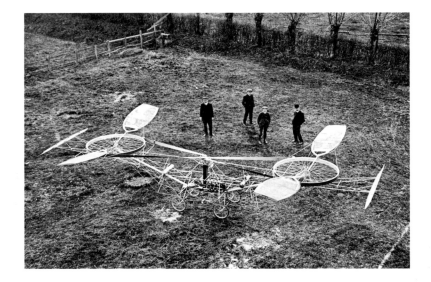

a feather. In France, the engineer Maurice Léger had attempted
this unsuccessfully, sinking his own personal fortune into his
project in the process. As for the young Louis Breguet, the
son of a well-known family of industrialists, he had designed
a "turning wing"—inspired by the technique described by Jules
Verne in one of his novels—which briefly got off the ground,
but never got beyond that.

There was no shortage of ideas, prototypes, and trials,
but it seemed impossible to get them to take to the air (last-
ingly). On November 13, 1907, Paul Cornu tried his luck near
the Touques River, not far from Lisieux, with an aircraft that
resembled a large insect, to which he had added a 121-pound
sack. It was his brother who started the engine and nearly got
carried off, as did Paul, who had great difficulty in holding
on to the machine. Another few seconds and it would have
got away from them completely. Luckily Paul succeeded in
jumping on one of the handles and hanging on to the chassis,

FIG. 88

Engineer Paul Cornu and his team present their prototype
helicopter at Lisieux, 1907.

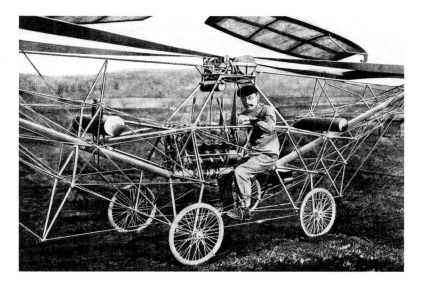

managing to reduce the speed. It took off, rose up with its weighted sack, and touched the ground again. It was not exactly an odyssey to the firmament and the flight, if it could really be called that, only lasted a few seconds, but it was enough to go down in history as having risen nearly five feet off the ground, and even more miraculously, without serious damage. It was the first vertical flight of a helicopter with a pilot, without anyone on the ground holding it with ropes to maintain balance. Never before had anyone developed a model capable of rising off the ground without external assistance and coming back down again like a feather, as all his rivals dreamed of doing. This was the precursor to the aircrafts that would one day take off and land on the narrowest strips of land, take the most inaccessible routes, and take off again within a few minutes—even managing on two occasions to land on the summit of Everest, in the Himalayas, the roof of the world.

FIG. 89

Paul Cornu at the helm of his helicopter, 1907.

FOLLOWING DOUBLE PAGE: FIG. 90

Louis Vuitton stand at the first Exposition internationale de locomotion aérienne, held in Paris from September 25 to October 17, 1909.

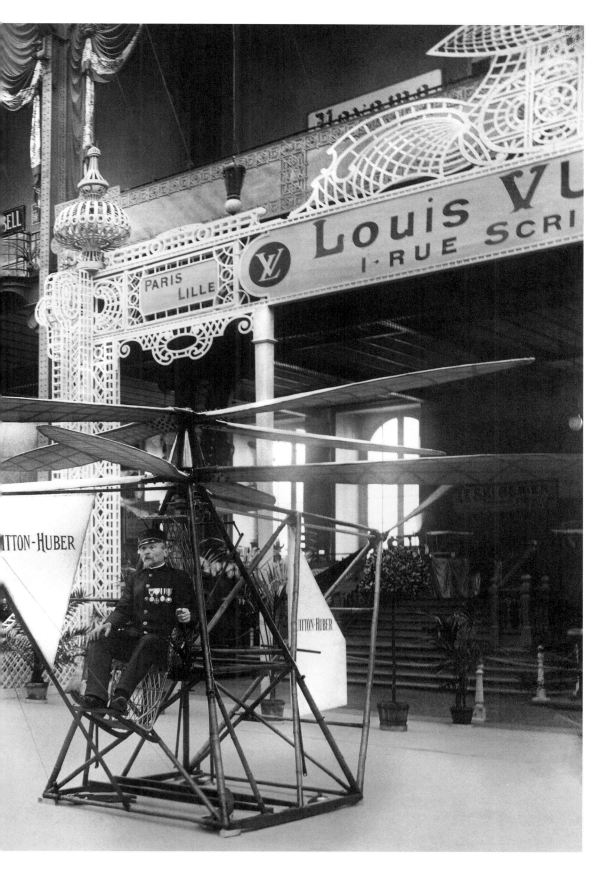

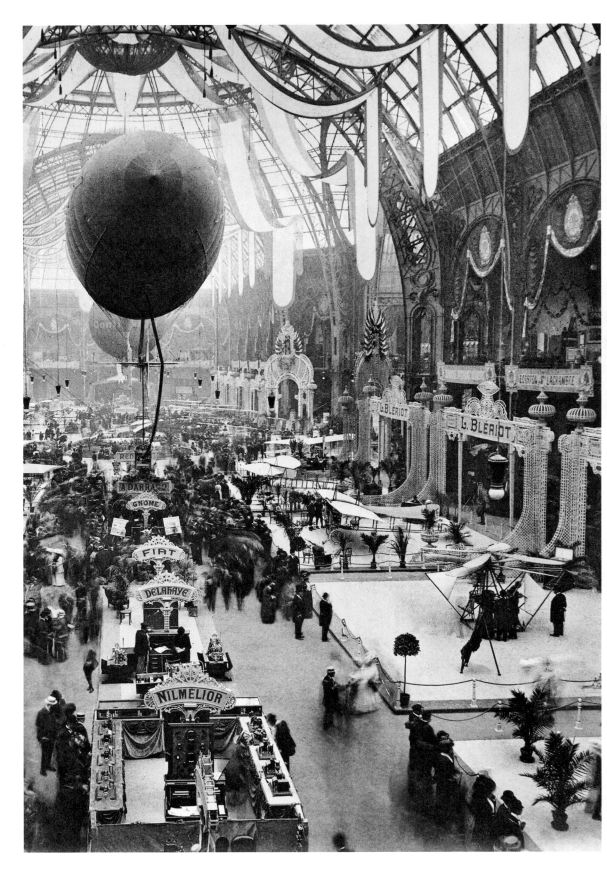

THE ZEPPELIN, A FANTASTIC UTOPIA

Unusual and ephemeral, the zeppelin is in itself extraordinary. Since its first flight in 1900, although its shadow was too seldom cast around the world, this aircraft's unusual design has continued to hover in the collective imagination. In 1937, at the end of a final transatlantic flight, the fall of the Hindenburg made the airship a legend. A luxurious flying vessel that became an instrument of war and then propaganda during the two world wars, within half a century, the zeppelin had contributed to aerial conquest and inspired the desire to break through the atmosphere. Having become a symbol of a lost utopia, the aerial monument now exists only through the period images, and representations continue to appear in popular culture. Even today, its fantastical qualities still hold a deep fascination.

FACING PAGE: FIG. 91

View of the Grand Palais nave at the first Exposition internationale de locomotion aérienne, held in Paris from September 25 to October 17, 1909.

LA CONQUÊTE DE L'AIR

Les Ballons Dirigeables

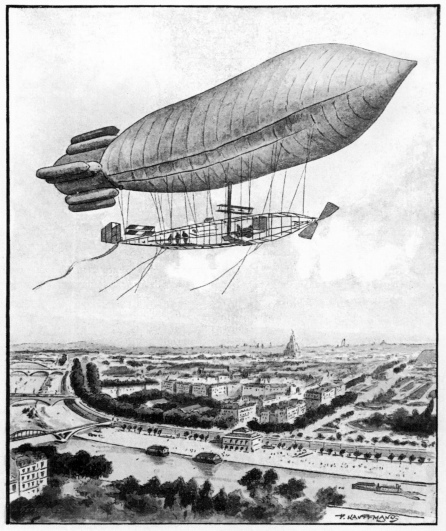

5. — Le *Ville de Paris*, planant au-dessus de Paris.

ÉCONOMATS DU CENTRE — 0,05

FIG. I

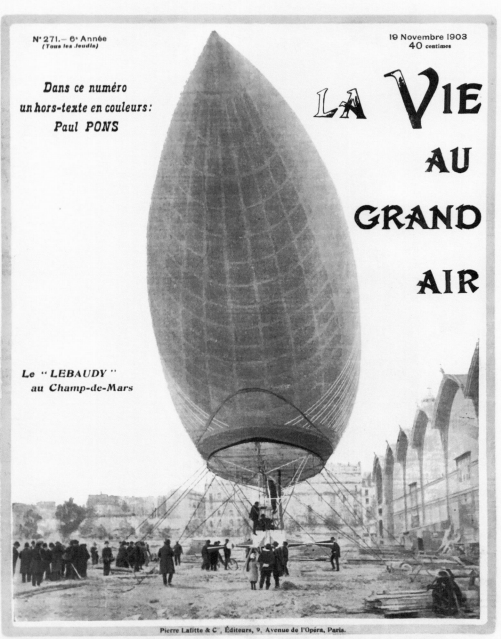

Le Grand Prix de Nice. – La Marche des Scolaires

FIG. II

FIG. III

Eroberer der Lüfte.
ZEPPELIN ihr Beherrscher.

FIG. IV

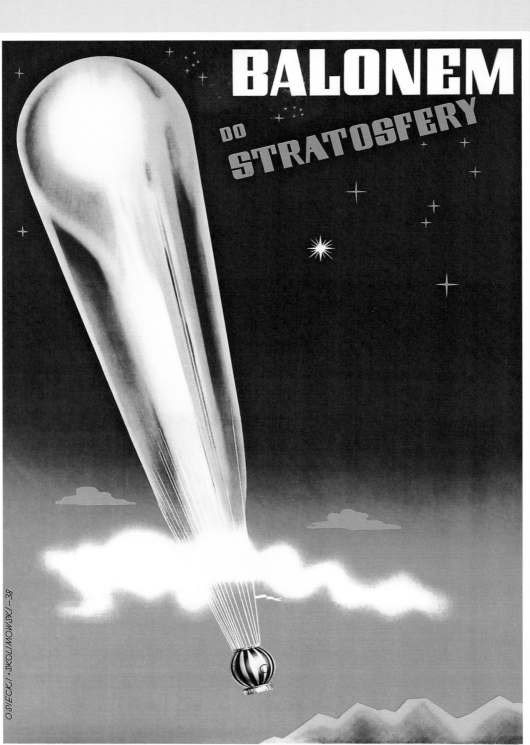

FIG. V

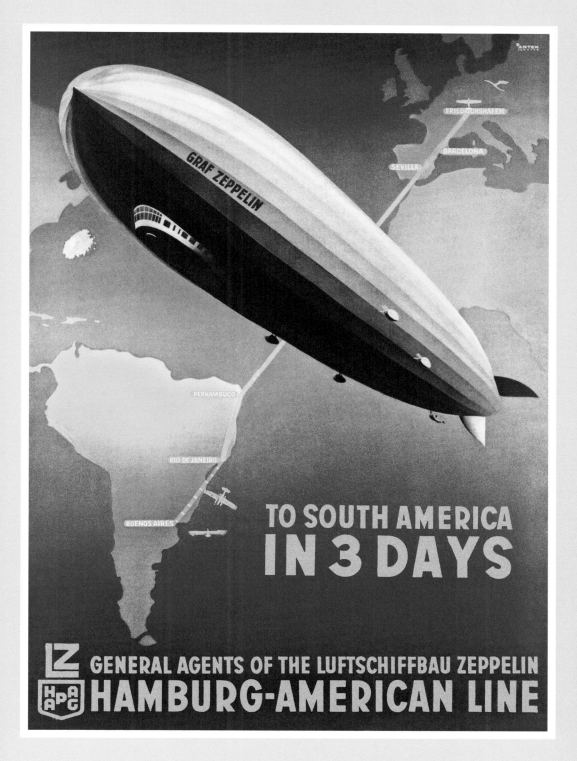

FIG. VI

CAPTIONS

FIG. I

Paul Adolphe Kauffmann,
*La Conquête de l'air. Les ballons
dirigeables. Le Ville de Paris,
planant au-dessus de Paris*
[The conquest of the air.
Airships. The *Ville de Paris*
hovering over Paris], c. 1930.
Paris, Bibliothèque Forney.

FIG. II

Cover of the magazine *La Vie
au grand air*, November 19, 1903.
Paris, Bibliothèque Forney.

FIG. III

Ernest Montaut, first Exposition
internationale de locomotion
aérienne, September 25–
October 17, 1909. Private
collection.

FIG. IV

Anonymous, *Eroberer der
Lüfte Zeppelin ihr Beherrscher*
[Conquerors of the heavens
steering their zeppelin], 1916.
Private collection.

FIG. V

Stefan Osiecki & Jerzy
Skolimowski, *Balonem do
stratosfery. Zwiedzajcie obóz
wzlotowy w Dolinie Chochołowskiej*
[Flight to the stratosphere.
Visit the takeoff area in
the Chochołowska Valley], 1938.
Warsaw, Muzeum Plakatu
w Wilanowie.

FIG. VI

Ottomar Anton, *To South
America in 3 days, Hamburg-
America Line*, 1932. Private
collection.

FACING PAGE: FIG. 92

The American airship ZR 3 over New York, near the Empire State Building
then under construction. It is accompanied by other zeppelins,
including the *LZ 126*, October 29, 1930.

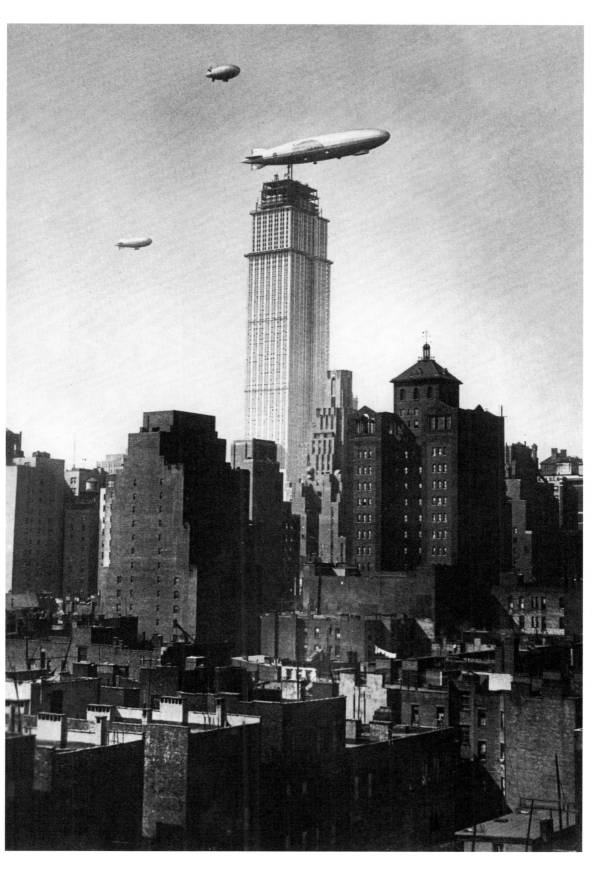

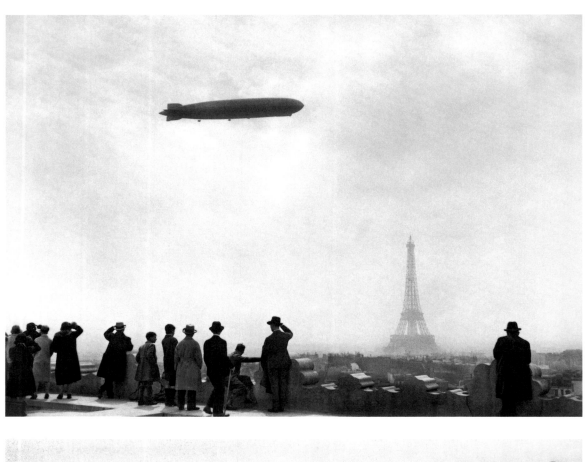

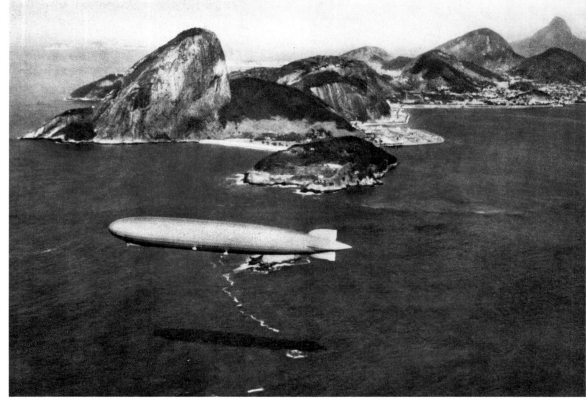

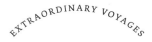
19

MONSTER OF THE SKY

COUNT FERDINAND VON ZEPPELIN
MADE THE RIGID AIRSHIP A REFERENCE
IN THE HISTORY OF AIRCRAFT.

The journey lasted barely eighteen minutes. Eighteen minutes over the green waters of Lake Constance, at the foot of the Alps. For Count Ferdinand von Zeppelin, it was the outcome of nearly a quarter of a century's work. Hot-air balloons had been the stars of the skies since the late eighteenth century, and by 1900 all the talk was of Santos-Dumont, Otto Lilienthal, and Clément Ader, successful pioneers from around the globe capable of defying gravity and enthusing the crowds. Count von Zeppelin, a career soldier passionate about airships, had already carried out several trials with a machine of his own making, which, while failing to convince the experts to whom he had shown it, had met with sufficient enthusiasm from the public to encourage him to continue experimenting. By then he was retired and had thrown himself into the construction of a new prototype, financed by his admirers, various donations, and the income from a lottery. It involved creating a rigid airship rather than the flexible ones of the period, with a metallic structure and a fabric envelope.

TOP: FIG. 93

The Graf Zeppelin *LZ 127* flies over Paris, April 1930.

BOTTOM: FIG. 94

Graf Zeppelin in the bay of Rio de Janeiro, with the Sugarloaf Mountain
in the background, May 25, 1930.

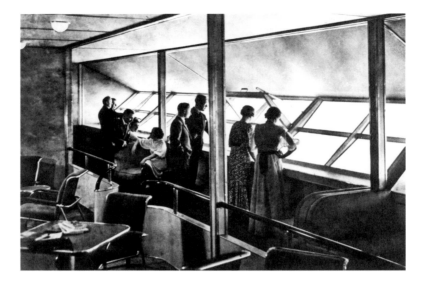

Where did Count Zeppelin get the idea for this from? From admiring hot-air balloons used during the American Civil War, in which he participated as an observer for the Army of the Potomac in 1863. The Union Army was the first to use hot-air balloons for military reconnaissance, which allowed it to observe enemy activity in a unique manner. The Count was impressed by this very modern approach to war and by these machines that could play a strategic role in the art of warfare. After his time in America, he began constructing his proto-type in a floating assembly hangar on Lake Constance. The choice of site was a stroke of genius, for it enabled the hangar to be turned easily to face the wind, thereby avoiding the usual difficulties encountered when taking off. The Count had reg-istered his patent a few years earlier, including all the charac-teristics of his future machine: rigid duralumin framework, space for the gas, external envelope made of a light fabric that enhanced the tension and diminished friction in the air.

FIG. 95

Interior of the passenger cabin of a Graf Zeppelin, whose windows
can be opened, 1930s.

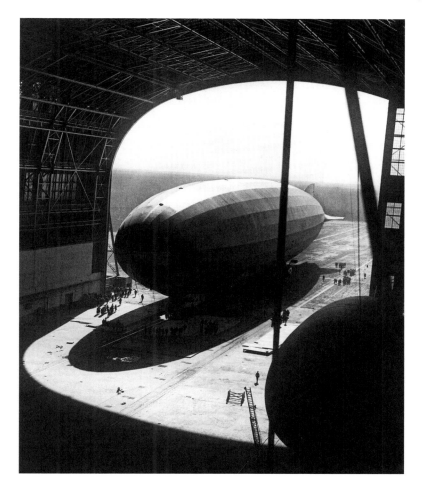

He founded a joint stock company to ensure its finance, invested his own money, and appealed to his admirers.

On July 2, 1900, the enormous bird was at last ready to take off. Any resemblance with a bird was, in fact, very distant; it actually looked more like an airborne monster—a monster 420 feet long propelled by two Daimler engines. It took off and circled the lake majestically, but as the mechanism that

FIG. 96

The American airship *ZR 3 USS Los Angeles* in the service of the US Navy operated for eight years, between 1924 and 1932.

balanced its weight broke, it had to land on the water rather than on hard ground, to avoid damage. The Count and four others took part in this short voyage, which marked the first zeppelin flight and, by the same occasion, presented a fantastic machine to the world—one that would make men around the globe dream. However, the Count did not get to see the crowds applauding his invention. He died in 1917, before partaking in the launch of the famous Graf Zeppelin, the largest airship at that time, which was to transport over thirteen thousand passengers during its lifetime in the most sumptuous conditions and with legendary punctuality.

At the time of the first Graf Zeppelin Atlantic crossing in 1928, fifty passengers were able to enjoy the unbelievable luxury on board, coming and going between the dining room and the magnificent reception room, meeting around tables with white table linen, silverware, and fine porcelain, strolling on the walkway, admiring the succession of landscapes from the windows which could even be opened. Never had anything so glamorous, modern, and stylish been seen in the sky before. Its arrival in New York unleashed an unprecedented wave of enthusiasm. As the crew advanced up Broadway, they were applauded by a delirious crowd, showered with confetti from the windows of surrounding buildings. These first passengers had just inaugurated a new golden age of air travel, and the welcome they received that day celebrated the genius of its inventor, albeit a generation after his actual invention.

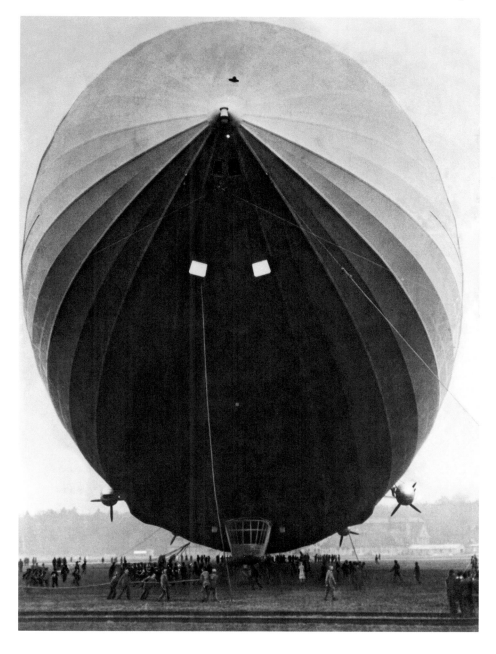

FIG. 97

The *LZ 129 Hindenburg* lands after a first test flight in Friedrichshafen,
Germany, in May 1936.

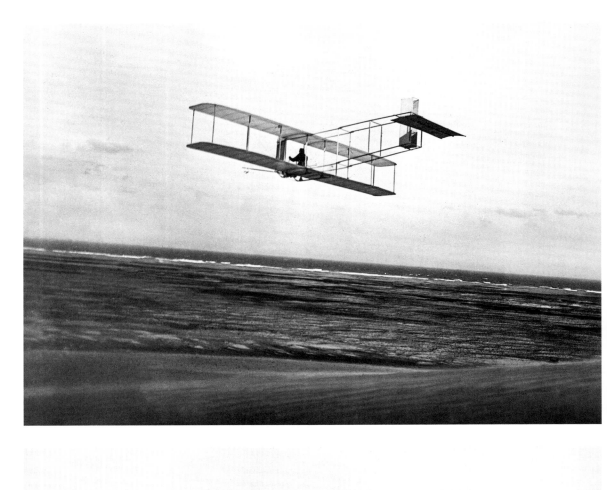

20

FLYING HIGH

———

On a beach in North Carolina,
the Wright brothers launched the first
flying machine in 1903.

One of the most beautiful and best-known photographs of the early days of aviation is undoubtedly that from a group of glass plate negatives acquired by the American Library of Congress in 1949 that shows Orville Wright and his brother Wilbur undertaking the first motorized flight in history, in 1903. This extraordinary feat was the result of relentless research carried out by the two brothers, their eternal faith in their project, and their many and repeated trials made with gliders. Both brothers believed that it was these machines that would enable the gradual discovery of a device capable of flying properly. They had been working on their idea for a long time, studying aerodynamism, tirelessly testing different crafts, creating particularly complex machines. They wanted to build a glider that someone could just climb into and take to the sky. This required thinking about the exact curve of the wing profile and of its surface which would enable the pilot to be lifted up, as well as the type of materials required. They studied all these details in the mechanics workshop next to their bicycle shop in Dayton, Ohio.

TOP: FIG. 98

The Wright brothers' glider in Kitty Hawk, North Carolina, 1903.

BOTTOM: FIG. 99

Wilbur and Orville Wright with their second glider on the Huffman Prairie,
Dayton, Ohio, 1904.

Airships had recently been invented, most notably by the German Ferdinand von Zeppelin and the Brazilian Alberto Santos-Dumont, but airplanes were still a thing of the future. When attending a congress of engineers, Orville Wright stated that, in his view, the main reason for the failure of previous airplanes was the lack of effective controls and the impossibility of balancing the plane after takeoff—which is what the two brothers chose to address diligently. They studied the notion at length, running over a thousand trials, seeking inspiration in the findings of other inventors who had demonstrated that a man could direct an airplane with the movement of his body once aboard, but at the end of the day, all their attempts ended in failures. They started by trying with a small biplane kite held by cables, then with a real glider, followed by a larger glider, without ever obtaining any reliable results. Finally, rather than risking their lives with a plane they couldn't control, they decided to build another glider that they would test in North Carolina, an ideal location with a large beach and sand dunes, perfect for lessening the impact of bumps and landings, and plains well-exposed to the wind.

For this trial, they enrolled the help of a French engineer, Octave Chanute, who had already assisted with their previous gliders. Their device was ready, the propulsion too—they had made their own engines and propellers in their workshops. The plane, a sort of piloted kite that looked like a large insect, was in fact a glider that had been transformed into an airplane. They saw it as the first real flying machine that would allow them to carry out something other than the aerial glides that they had managed thus far. At 10:35 a.m. on December 17, 1903, this ensemble of wood, fabric, and metal was on the beach, ready to depart. It took off into a strong wind. Orville had

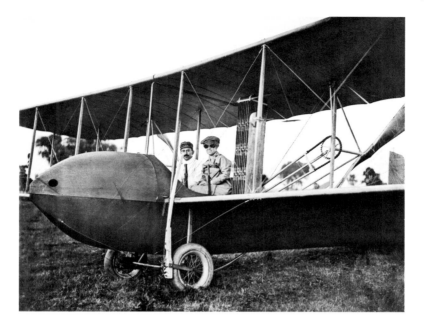

prepared for this moment perfectly and even asked a friend to take a photograph, but the latter had never held a camera before and was so entranced by watching the plane take off that he almost forgot to take the shot. For twelve short seconds, Orville Wright managed to fly, lying stretched out on his stomach on the lower wing, before landing on the sand 115 feet further on. A legendary leap, made in front of only five others, but one that would mark the birth of the first airplane in history, designed after years of experimentation with numerous gliders, all made in a modest bicycle hangar in Ohio.

FIG. 100

Katharine and Orville Wright aboard the *Wright Model HS*, whose fuselage was designed by the Wright Company, 1915.

FOLLOWING DOUBLE PAGE: FIG. 101

Orville Wright's first flight at Kill Devil Hills, North Carolina, December 17, 1903. On the right, his brother Wilbur.

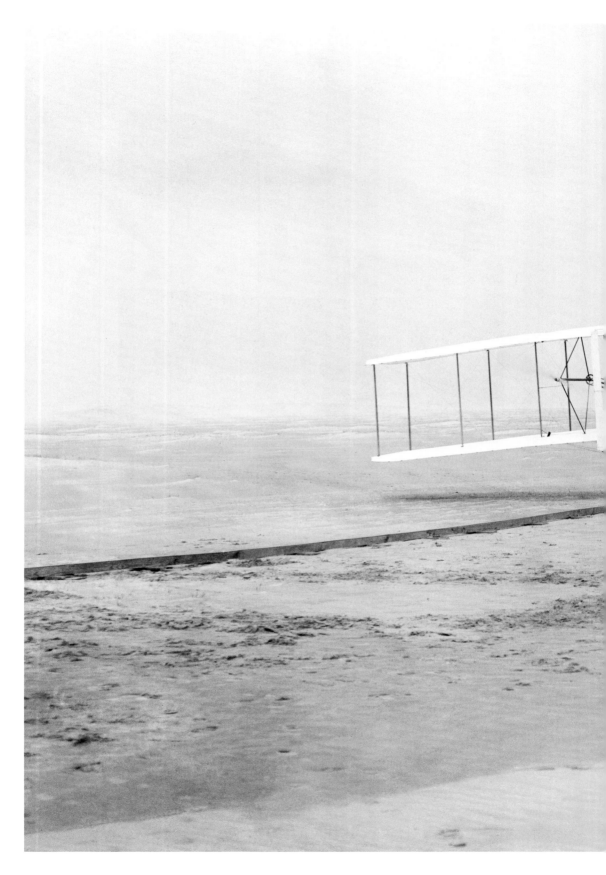

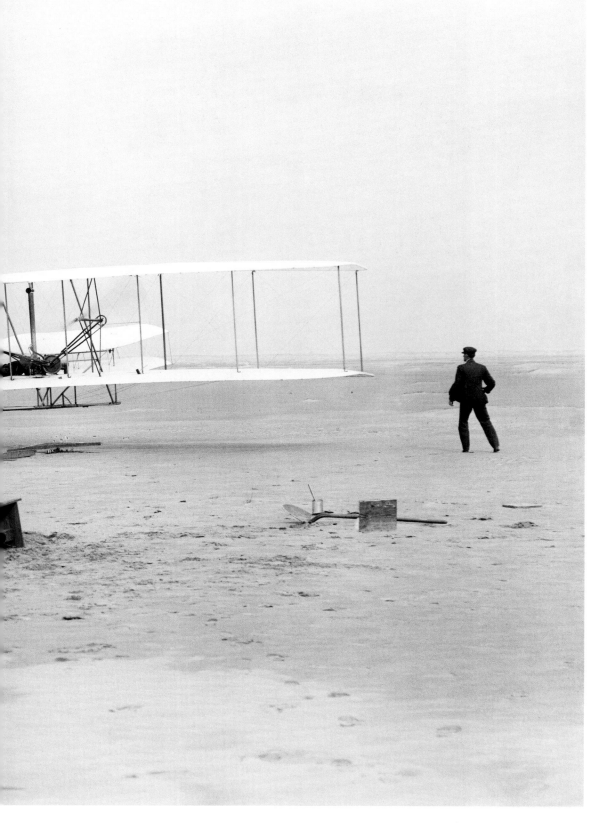

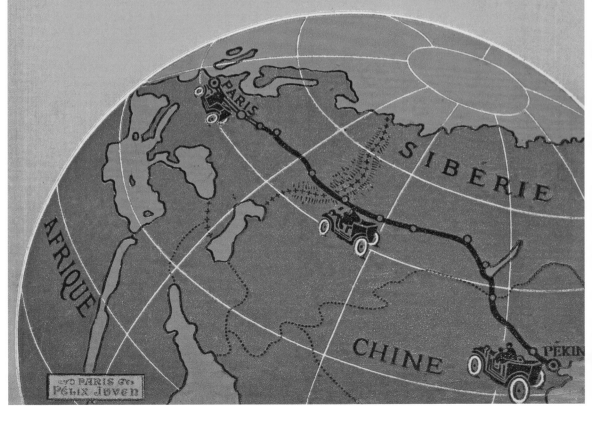

jean du TAILLIS

PÉKIN-PARIS

AUTOMOBILE

en

Quatre-vingts jours

PARIS
Félix Juven

21

SPEED DEMONS

———

INITIATED IN 1907 BY THE FRENCH DAILY
LE MATIN, THE PEKING-PARIS RACE
WAS A HUGE CHALLENGE FOR ITS
FIVE COMPETITORS.

It was the greatest motoring adventure ever undertaken. Ten thousand miles linking Paris to Peking (now Beijing), the first real race for those "car maniacs," opening the way for all the big automobile rallies to follow. The challenge was launched in 1907 by the French daily newspaper *Le Matin*, which presented this race that it supported as unprecedented. Forty or so cars enrolled straightaway, but when their owners evaluated the risks properly, many of them began dropping out, leaving only five competitors on the starting line in Peking—participants who were almost certainly unaware of what awaited them. The journalist Jean du Taillis was one of them, aboard a Dutch-made Spyker driven by Charles Godard, talented behind the wheel but a strange, eccentric character, utterly penniless, who was the only competitor not to be accompanied by a mechanic. Apparently this was a minor detail for the two boundlessly confident men who calmly pitched up in Peking on June 10, 1907, along with the other competitors.

The Belle Epoque, frequently mocked for its frivolity, was also an era of technological daring. The public had been

FIG. 102

Pékin-Paris—Automobile en quatre-vingts jours, cover of the book
by Jean du Taillis, published in 1907.

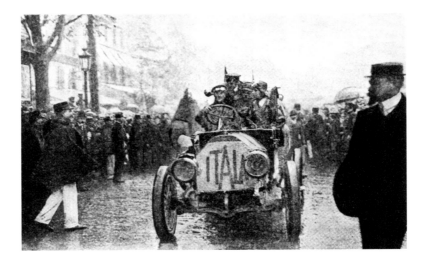

won over by cars, and newspapers, seeking to attract new read-
ers and thirsty for exploits, increasingly lent their support to
competitions for these astounding means of locomotion. They
were enthralled by races from one capital city to another and
avidly followed the progress of these machines as they madly
tore along roads that were even madder. They were captivated
by these feats as much as by the drivers, who were often half-
blinded by dust and only spotted their route at the last minute,
pushing their engines flat out in the hope of victory. The race
cars drove through crowds with little regard for safety, clearing
a path through the tightly packed spectators, at crazy speeds
that sometimes proved tragic both for the drivers and the spec-
tators, carried off on a hairpin bend or a dizzyingly high road.

When *Le Matin* announced its rally, most of the regions
through which it passed were still extremely remote and
uncharted, with no roads or roadmaps, but the interested
parties knew that the publicity surrounding the event would
be global, and the French motor industry was tremendously

FIG. 103
Arrival in Paris of Prince Scipione Borghese's automobile,
final stage of the Peking to Paris race, August 10, 1907.

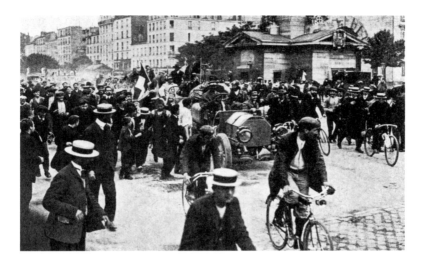

excited at the very idea of it. The newspaper was bound to get a scoop with such a thrilling challenge. Given the season, the organizers decided to swap the direction of the race from Paris–Peking to Peking–Paris, judging it unwise to end the rally in the rainy season. These organizers were highly optimistic and were put off by nothing, least of all the idea of launching an enterprise that would cost everyone a fortune and risk leaving certain vehicles behind in China—one where the drivers themselves would be abandoned to their own devices. None of this seemed to worry Charles Godard and Jean du Taillis, whose Spyker had been meticulously prepared by the constructor and who were all set to go on that memorable summer's day. Nobody had ever witnessed such feverish excitement before. It was not so much the start of a motor car race as a high society cocktail party celebrating the drivers, the constructors, and their race cars about to undertake the unthinkable. Emotions were running high by the time the cars finally started their engines, accompanied by military music. Prince Borghese,

FIG. 104

Prince Scipione Borghese crosses the Place de la Nation in Paris on August 10, 1907.

accompanied by his mechanic, drove an Itala; Georges Cormier was at the wheel of his De Dion-Bouton, one of two in the race.

Leaving Peking, the cars covered two hundred miles during the first week. That left 8,700 miles to go, including crossing Mongolia, the riskiest part of the journey, with no relays or outside help. At vast expense, caravans of camels had been hired to carry cans of gas to various remote telegraph stations along the route in the middle of the desert and deposit them there for the drivers. Charles Godard had kindly, and somewhat naively, accepted to carry some of the other competitors' baggage, abandoning one of his gas cans to make room for it, convinced that his fellow adventurers would come to his help if needed. This largesse nearly cost him his life. Meanwhile, to avoid getting bogged down, he had to charge through streams at full speed, while Du Taillis, holding the map on his knees, tried to find the various crossroads and telegraph poles, and to avoid marshes and the very worst tracks, when there were tracks at all, desperately seeking water holes to cool the car's engine. The two companions were exposed to terrible heat during the day and freezing cold at night, were obliged to stop in the middle of the Gobi Desert, and suffered from dysentery and malaria. But the idea that the journey might prove fatal never even seemed to have crossed their minds. Even today, we wonder what pushed the driver of the Spyker and his co-pilot to dice with death in this way, without any money or a mechanic to hand, on board a vehicle that had never been tested on terrain such as this. Production of this type of Spyker ceased during the First World War, but on that day, it completed the race in second place, bringing fame to the Spyker brothers and their vehicle.

FACING PAGE, TOP: FIG. 105
Bivouac in northern Mongolia, during the Peking to Paris race, 1907.

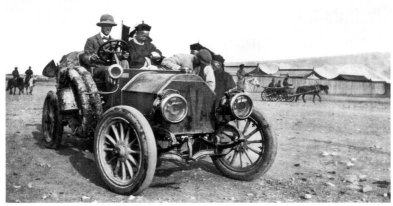

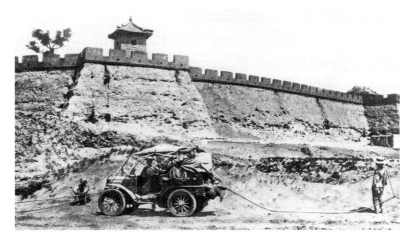

After covering about a hundred miles in five days from Peking, Prince Borghese and his co-pilot
Luigi Barzini, reached Kalgan, in the province of Hebei, on June 15, 1907.

BOTTOM: FIG. 107
Passing near the Great Wall of China, at the edge of the Gobi Desert, June 1907.

22

TOP MODEL

———

BY PRODUCING ITS FAMOUS FORD T
ON A PRODUCTION LINE FROM 1908,
THE AMERICAN MANUFACTURER DEMOCRATIZED
THE AUTOMOBILE.

It's difficult not to be overcome with emotion at the thought of "Tin Lizzie"—the nickname given to the people's car, one that many people could afford—and of the numerous myths it gave rise to on America's roads. For this pioneer was not limited to a simple car. Its invention in 1908 introduced a new era, one of innovation and resounding American prosperity, of skyscrapers launched toward the firmament like rockets, of jazz and blues, of triumphant optimism. And of assembly line production as well, with this, the very first car to be sold at an affordable price, made by workers each with a single task, which enabled production rates to be increased, to be more cost effective, and wages to be increased too, which in turn enabled workers to purchase the car they were making, thereby favoring mass consumption. An era of freedom, for men and for women who were equally captivated by everything this formidable machine promised.

Success came quickly. People rushed to buy this wonder, and to work for the Ford Motor Company, founded in Detroit

FIG. 108

Arthur Rothstein, *The Vernon family makes a stopover in Montana; they are traveling in their Ford T on their way to Oregon, where they wish to settle, July 1936.* Washington, D.C., Library of Congress, Farm Security Collection.

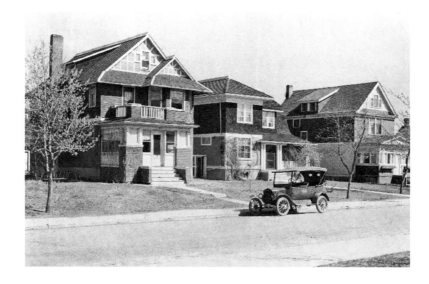

in 1903 by Henry Ford, the self-made man from Michigan. The Ford Model T was elected "the most important car of the twentieth century." And that's not all. While traveling the impracticable roads had been a real expedition until then, it was now possible to use them without fear, thanks to the car's high and widely spaced wheels, which meant it could even run on railroad tracks! Everybody could drive this vehicle thanks to its easily maneuverable automatic transmission and its pedals for moving forward and backward, and for braking. As for repairs, it was claimed that a piece of chewing gum would patch a leak in the fuel tank. The Model T was not so much a car that people bought for themselves as a new way of life in a country that was witnessing agricultural labor being transformed into a qualified factory workforce, countryside being transformed into towns, and the emergence of highways, and with them, a host of new services every day—garages, gas stations, car washes, to cite but a few—aimed at these new car owners and consumers.

FIG. 109

Frédéric Gadmer, *Ford T sur Lorne Street, à Regina, province de Saskatchewan, Canada*
[Ford T on Lorne Street, Regina, Saskatchewan province, Canada], 1926.
Boulogne-Billancourt, Archives of the Planet, Albert Khan collection.

It was a revolution, a profound one brought about by a new society that was in the process of completely changing its habits and way of life. Men and women who until then had only ever known long days of work, were now allowing themselves the leisure of going on trips along freshly asphalted roads, solely for the pleasure of getting away. Farmers, cowboys, and simple enthusiasts, at the wheel of their recently purchased vehicles, were suddenly taking the time to admire the magnificent landscapes of a country they barely knew, which they had only heard about or seen photos of. They visited their families on the other side of the country, took a ride in the sun, celebrated birthdays and weddings, went to see friends. They no longer had to rely on a bus arriving or on train schedules. They could move about as and when they pleased, at their own pace, stopping off along the way if they felt like it, setting off again when they chose to, totally free thanks to this small machine on wheels.

FIG. 110

Tin Lizzie storage area at the Ford Motor Company plant in Detroit, 1925.

From then on, this feeling of "hitting the road" was synonymous with escape, made possible by this wonderfully simple, modest car. At its wheel, every driver was a free and independent agent. Those who learned to drive with it, went on a trip in it or just an outing, would remember that first day's drive for the rest of their lives, as well as the happiness of visiting lands that seemed so distant, of traversing canyons, forests, deserted areas, of skirting huge lakes and endless beaches they had never previously seen. Many people would recall with emotion their love of cars as dating back to the day they first sat in their Tin Lizzie, the car that changed the world, one toward which all real car lovers feel fondness and gratitude.

FIG. 111

Frédéric Gadmer, *Ford T garées en épi sur Main Street, à Winnipeg, province du Manitoba, Canada*
[Ford Ts parked at an angle on Main Street, Winnipeg, Manitoba province, Canada], 1926.
Boulogne-Billancourt, Archives of the Planet, Albert Khan collection.

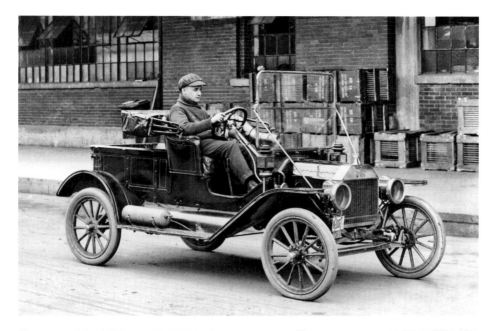

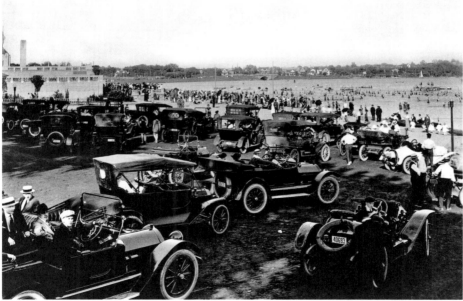

TOP: FIG. 112

American driver at the wheel of his Ford T, 1908.

BOTTOM: FIG. 113

Model T traffic jam during the summer season at Calhoun Beach,
Minneapolis, Minnesota, 1920.

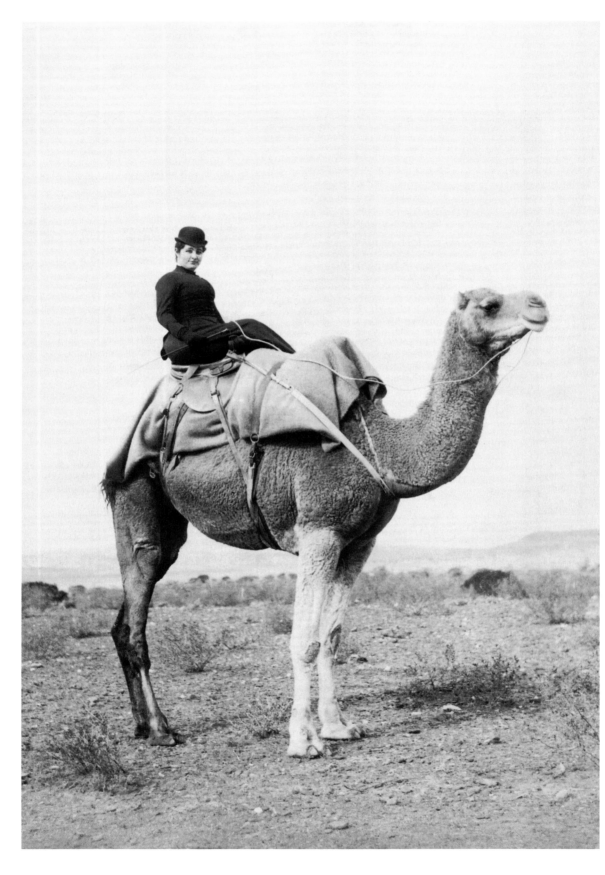

23

OVER THE HUMP

———

WHETHER FOR NOMADS OR ADVENTURERS,
THE CAMEL IS THE IDEAL MOUNT
TO FACE THE DESERT AND ITS DUNES.

Its feet are designed to prevent it from sinking into the desert sand and give it a remarkably supple gait. It can survive without eating or drinking for a week or more without suffering. It can carry huge loads, a heavy saddle fitted to its hump, large baskets filled to the brim, luxurious palanquins covered with weighty fabrics concealing women, children, supplies, riches. We call it a camel but we should really find a word to encompass its multiple functions: pantry, treasure chest, nursery. It provides everything useful for life in the desert and is its own guide, following its instinct and impulse. Its name conjures up images of long swaying caravans strung out under a burning sky and journeys in the Sahara and Gobi deserts.

In the 1920s, the first British travelers to visit Cairo and its pyramids were not shy of experiencing this spectacle from these unusual heights. Photos of the period show them in small groups, perched on top of their mounts in front of the pyramids of Giza, not another soul in sight. A magical scene, well before the arrival of the teeming crowds of tourists.

FIG. 114

Samuel Sweet, *Mrs. Philipson Bellamy in Egypt*, c. 1886.
Canberra, National Gallery of Australia.

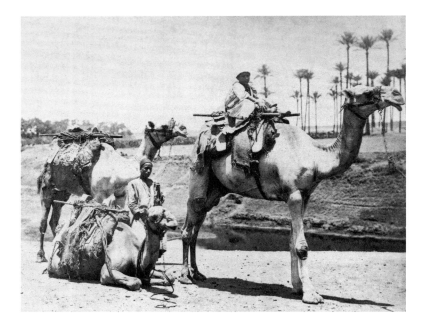

During the same period, the British archeologist Gertrude
Bell achieved her dream of living a different life, roaming
the Syrian desert on the back of a camel. From her saddle,
she would spend hours sketching the contours of the future
state of Iraq. She was capable of spending up to twelve hours
a day on the move, without a halt, nor even taking the time
to drink, capturing everything she could in her notebooks,
much to the surprise of her fellow travelers. In the process,
she became an explorer, diplomat, and spy, all at once, ever ele-
gantly dressed, with a shotgun wrapped in the folds of her skirt.

The camel is the nomad's companion, the preferred
mount of those explorers who traversed the Middle East at the
dawn of the nineteenth century. According to legend, Lawrence
of Arabia covered up to sixty miles a day in the Jordanian sands,
writing to his parents: "Over the past twelve months, I've slept

FIG. 115
"Bedouins in an Egyptian oasis," *Zangaki brothers album*, c. 1880.
Private collection.

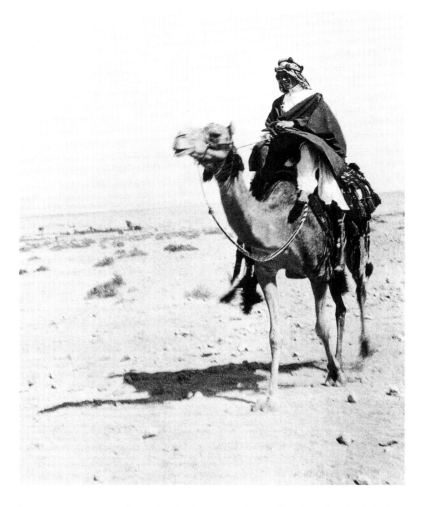

in as many as two hundred places perhaps." When he decided to become an "Arab guerilla," he adopted typical Bedouin clothing and local customs, and rode a camel like the tribal sheiks he encountered, who traveled for miles without needing to give their animals anything to drink, in the very hottest of temperatures. What other means of transport can offer such freedom

FIG. 116

British officer Thomas Edward Lawrence, a.k.a. Lawrence of Arabia, arrives by camel in Aqaba, present-day Jordan, during the Arab Revolt against the Ottoman Empire, 1917.

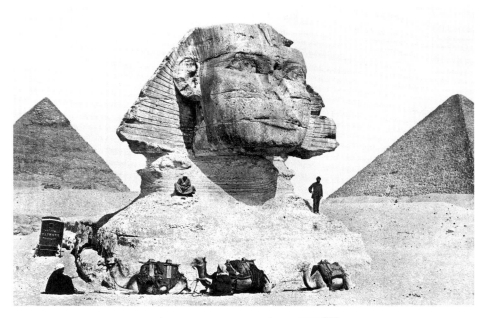

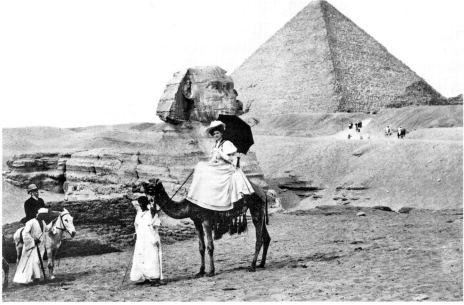

TOP: FIG. 117

"Self-portrait with the Sphinx of Giza," *Zangaki brothers album*, late 1870s.
Private collection.

BOTTOM: FIG. 118

British tourists in front of the Sphinx and the Great Pyramid of Giza, c. 1904.

of movement? For Lawrence, these magnificent creatures were the vessels of the desert, like ships traversing the oceans. He calculated that they could cover 250 miles between two watering points at a speed of nearly 4 mph, which fascinated him.

While it is probable that his crossing of the Nefud Desert on camelback was a myth of his own invention, there is no doubt however that for the photos, in which he too features, he wished to have the finest, most robust and impressive creatures—creatures that show that they were more than mere means of transport. Like those chosen for the great Arab Revolt of 1916–18 which, at their master's cry, got to their feet in a spectacular bellowing group and set off in a long, winding, silent column in the freshness of the early morning.

In other latitudes, in remote parts of Mongolia, different species of camels live in stony deserts. In summer, they gather on the banks of temporary springs and in winter quench their thirst in the snow. For thousands of years, they have transported goods in the most extreme conditions, on the ancient routes through the Pamir Mountains, on terrain that is inaccessible by any other means of transport, honoring travel, tradition, legends, and the magic of these places all at once, before disappearing into the distance like a vanishing spell.

FOLLOWING DOUBLE PAGE: FIG. 119
Bedouin caravan in the dunes of the Libyan desert, west of Egypt, 1921.

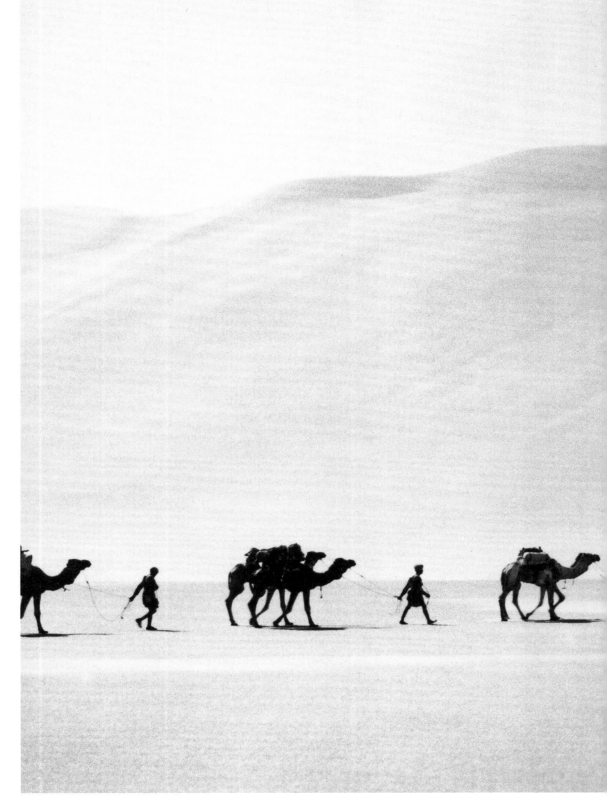

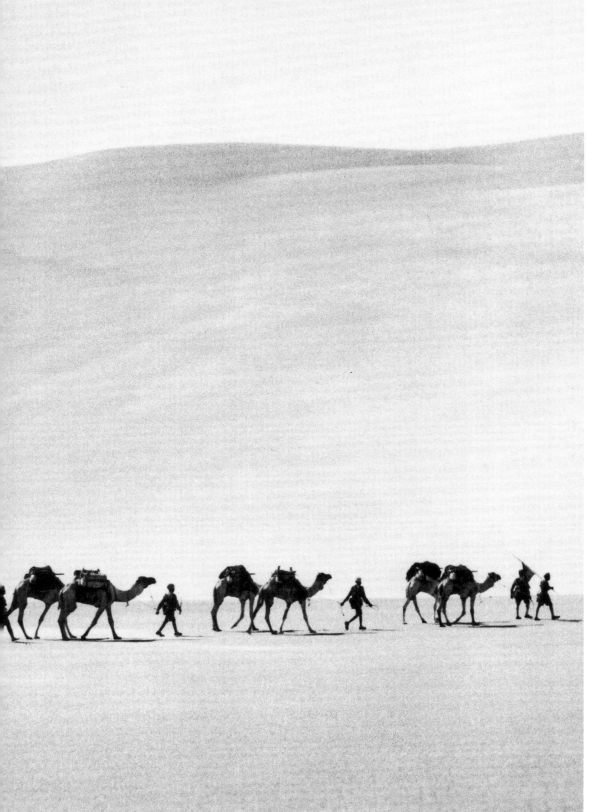

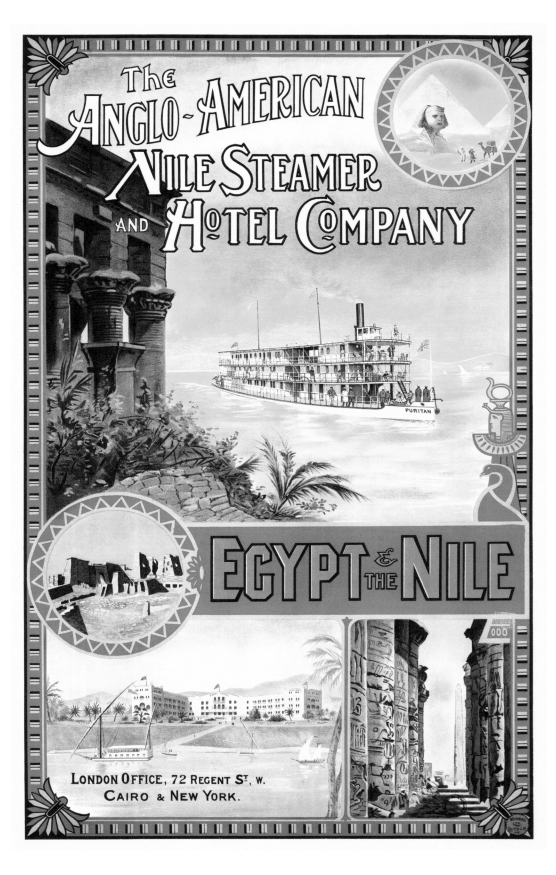

The ANGLO-AMERICAN NILE STEAMER AND HOTEL COMPANY

PURITAN

EGYPT & THE NILE

LONDON OFFICE, 72 REGENT ST, W.
CAIRO & NEW YORK.

24

ALONG THE NILE

———

THE LONGEST RIVER IN THE WORLD
PROVIDES AN INCREDIBLE SPECTACLE
FOR THE FIRST TOURISTS LANDING
IN EGYPT.

The voyage that the British company Thomas Cook was about to offer to its customers in 1869 was quite simply unprecedented. A few months earlier, its founder, the British travel pioneer and businessman Thomas Cook, had received a personal invitation to the opening of the Suez Canal from its developer, Ferdinand de Lesseps. Cook immediately spied an opportunity not to be missed, not only for himself but also for his best clients, and without losing any time, he chartered a special steamer for the occasion to give them the chance to participate in the river parade celebrating the event. Cook had already organized tours for tourists in Europe and worked in America and the Holy Land, and he foresaw that the inauguration of the famous canal would attract numerous representatives of colonial powers and Europe's aristocracy. He fully intended to take advantage of this amazing opportunity, as no tourist infrastructure yet existed in the land of the pharaohs and there was very little information for those who wished to go there. At that time, Great Britain was at the height of its industrial

FIG. 120

Poster for a cruise on the Nile from the Anglo-American Nile Steamer and Hotel Company travel agency, c. 1890. Paris, Musée des Arts décoratifs.

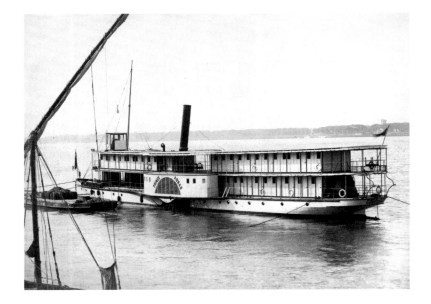

revolution and major international events like the world's fairs celebrated the Middle East. People became passionately interested in archeological digs, Luxor was becoming a cosmopolitan town, and British colonialism in Egypt was growing. Furthermore, Muhammad Ali of Egypt had decided to modernize his country, calling upon European experts to build canals and overhaul its ports.

The world's longest river, which carries the alluvium that fertilizes the land, was ready to receive its first tourists and, at the same time, the boats belonging to Thomas Cook and his son, for the latter was soon to join his father's company. On the back of the success of their first cruise, the two men decided to open an office in Cairo. They soon had their own fleet—superb steamships that they had made in Scotland and transported in pieces to Cairo where British engineers were in charge of assembling them. It was not long before Thomas Cook & Son

FIG. 121
The British steamer *King Abbas* along the Nile, 1894.

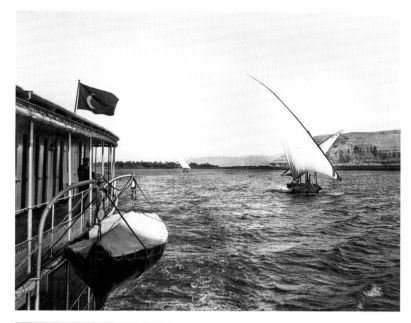

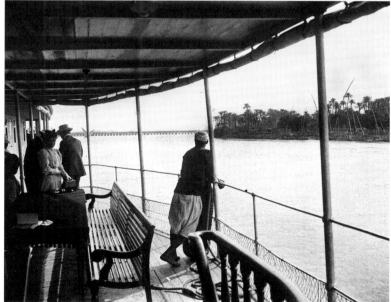

TOP: FIG. 122

Cook cruise on the Nile, c. 1900.

BOTTOM: FIG. 123

Tourists on a Cook cruise preparing to disembark in Aswan, c. 1900.

were able to offer their clients a choice of twenty-two different steamers that combined technology with luxury, much to the pleasure of their passengers. These floating marvels had names like *Rosetta*, *Damietta*, *Egypt*, *Arabia*, *Serapis*, *Seti*, and *Fostat*. They carried their passengers slowly and peacefully past vast ocher expanses where temperatures frequently rose above 104°F, in search of the kingdom of the pharaohs. Everything was brown, russet, and sandy-colored, and the hue of the water fused with that of the sky. A dazzling sight for those drawn to these places by their fascination with the Middle East.

From the upper deck and the large reception room giving onto the river, the "archaeologist travelers," Egyptologists, draftsmen, scientists, poets, and writers—basically, early "tourists"—could admire the most famous sacred buildings and majestic ensembles of Egyptian civilization, interrupting the navigation as they saw fit to visit where few foreigners had ventured. Watercolorists had part of the boat specially reserved for them, at the bow, while the ladies were provided with an area for their leisure, and the men could gather in the smoking room with a fine whisky or an old port and talk quietly. Not a sound, nor a breath of wind disturbed the peaceful atmosphere. The well-made vessel, assembled in Cairo, ran almost silently, with its passengers daydreaming peacefully on board, while the Nile continued to generously fertilize the earth.

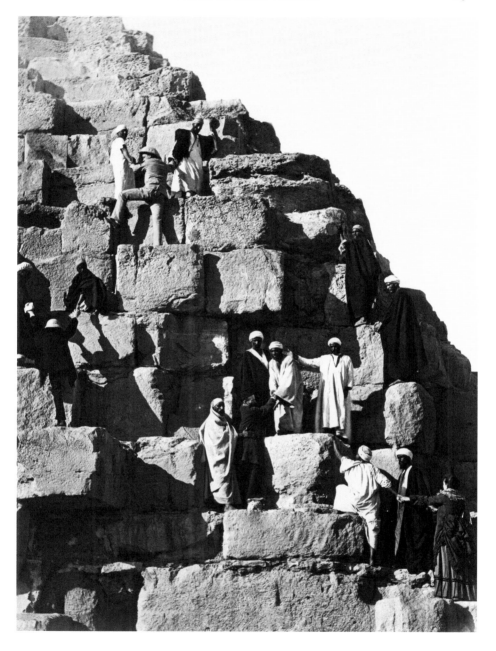

FIG. 124

British tourists and their guides discovering the pyramids, 1878.
London, Victoria and Albert Museum.

White Star Line

Europe to America

MONTAGUE B. BLACK.

THE LIVERPOOL PRINTING & STATIONERY CO. LTD

25

A MASTERPIECE OF LUXURY

———

EVERYTHING ON BOARD WAS EXQUISITE,
UNTIL THE MOMENT THE *TITANIC* HEADED
STRAIGHT FOR AN ICEBERG.
THE SHIPWRECK OF THE CENTURY.

While nature has erased all trace of the shipwreck's victims, the ship and its legend still lie at the bottom of the Atlantic Ocean, off the coast of Newfoundland. There, the most famous and elegant of shipwrecks disintegrated, ineluctably, and what was once the most luxurious ocean liner of its time ended up disappearing at a depth of ten thousand feet. Today, it's difficult to say whether the shipwreck belongs more to fact or fiction, such is the extent to which the two have merged over the decades, immersing the ship in an endless voyage through time.

In 1912, before the lookout Frederick Fleet called out "Iceberg straight ahead!" in the middle of the night, the *Titanic* was still referred to as "unsinkable" for its optimal level of security. For the ship had to do justice to the reputation of the famous White Star Line, impatient to show off its latest masterpiece to the world and to its competitors. This had entailed replacing the two standard funnels with four giant ones, painted beige and black, their vast dimensions being a sign of the ship's great speed. The fourth funnel was in fact fake, as it served for

FIG. 125

Poster of White Star Line's Europe to America line,
celebrating the speed of the *Titanic* with its four majestic funnels, 1910s.

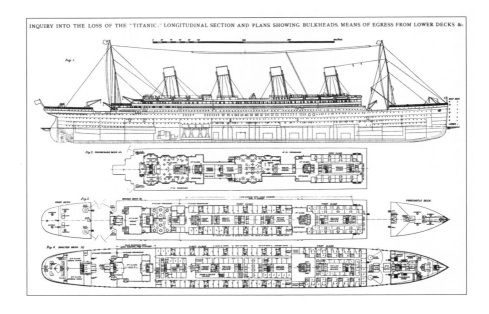

ventilation, but that did not matter as they made a fine impression overall—one that was reinforced by the upper deck, painted in white, by the gold border highlighting the main deck, and by the black hull which was red below the waterline. In addition to these attractive features, there were immensely sophisticated technical specifications that made it one of the most modern ships in the world. Its navigation system, for example, had equipment that protected against the risk of fire, a plotter, a compass, and even a device to detect submerged obstacles, which was extremely rare.

Most areas of the ship had natural light thanks to the two thousand or so windows and portholes throughout. For the interior lighting, there were some ten thousand electric bulbs that were turned on every evening, consuming more electricity than a small town in the early 1900s. The air-conditioning

FIG. 126

Cross sections of the *Titanic* showing the lower deck emergency exits, c. 1910.

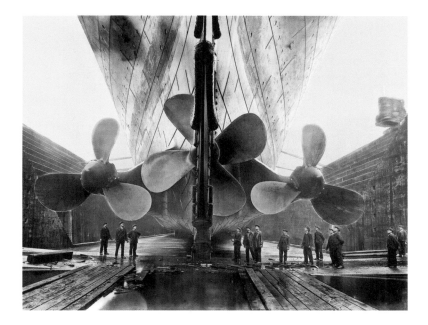

system had been studied closely, the engine room was impressive, and all of it was said to be far too large and solid to be carried away by a wave or to sink in the event of a collision. The hull was fitted with a double bottom, to withstand running aground, and fifteen watertight partitions had been installed throughout the length of the ship. They were equipped with sliding doors that could be controlled automatically. On top of this, there was the very latest telephone system with a "navigation exchange" linking the footbridge to every important part of the liner, and an interior telephone system with no less than fifty lines that enabled the luxury cabins to communicate with the ship's various offices which, themselves, were linked to the bakery, butcher, and kitchens, among others, to meet requests and pass along orders as quickly as possible. The telephone equipment was also intended for passengers' private use.

FIG. 127

Propellers of the *Titanic* at the Thompson Graving of Harland & Wolff shipyard
in Belfast, 1910–11.

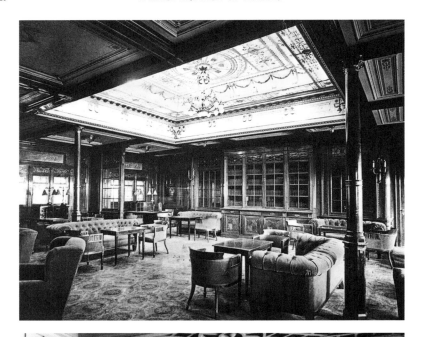

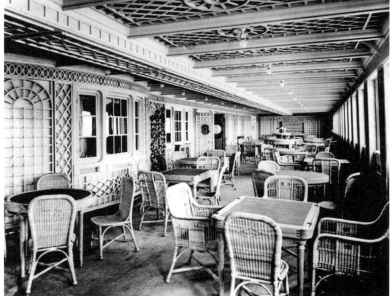

Lounge and smoking room reserved for first-class passengers,
aboard the *Titanic*, April 1912.

View of the Café Parisien, located on the B deck of the *Titanic*.
It was connected to the restaurant and was mainly frequented
by young first-class passengers, 1912.

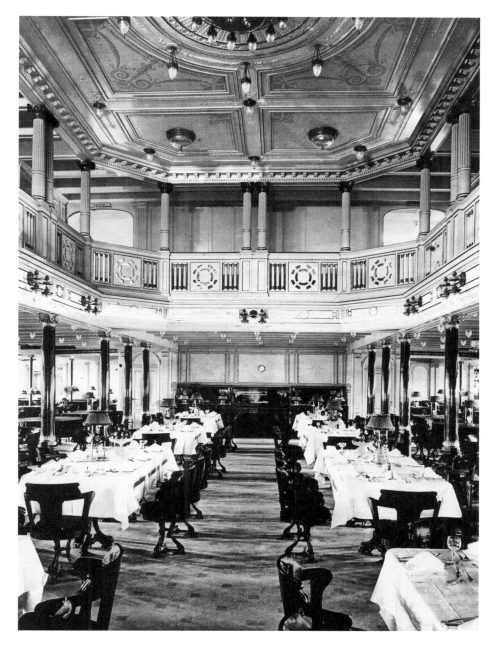

FIG. 130

First-class dining room, located on D Deck, where tea was also served, 1912.

Never had comfort, well-being, and attention to detail been assured with so much perfection. And never had there been such an abundance of luxury available to first-class passengers, in their apartments, bedrooms, bathrooms, and closets, in the conservatory, and the reading and correspondence room. Everything was of the utmost refinement, and the passengers were pampered by an army of stewards, chambermaids, chefs, and waiters.

Destiny seems to have played the greatest part in the disappearance of this sumptuous floating villa. On April 14, 1912, the night was starry and calm. The sky was apparently bright and clear over the Atlantic. The iceberg floating straight ahead of the ship should, therefore, have been perfectly visible. And yet it was not reported until the last moment by the lookout. At that moment, the ship was cruising at full speed and the impact was almost immediate. It's possible that the force of attraction between two masses may have provoked gigantic gashes in the ship that enabled the sea to cleave asunder the protective layers and flood the hull. The bow was thus full of water, adding weight at the worst places, creating an imbalance, a slope, before the inevitable collapse. It is likely that the colossal proportions and even the luxury of the ship contributed to its loss, that all the technology and modernity were fatal for it, at the end of the day, allowing water to pour in by the magnificent staircases, lifts, funnels, and elevators, and enter the smoking room, reception room, and dining room filled with people quietly talking and eating their dinner, never for a second imagining what was happening within a few feet of them.

The period was one of luxury ocean liners aimed at the very wealthiest passengers, and those shipping companies that could afford to competed with each other in designing ever

more sophisticated and impressive ships. Transatlantic liners
had never been so splendid and innovative, and the *RMS Titanic*
was the perfect embodiment of its time in that respect, parting
the waves at full speed, with over two thousand passengers
on board, only seven hundred or so of whom would survive
the shipwreck. On that fatal night, when the lighting went out
and the ship's stern rose up in the starry sky, the "unsinkable"
sank to the depths of a gaping gulf of silence and darkness.
Nobody could have imagined that all of this occurred within
the space of an hour and a half.

FIG. 131

Final arrangements before departure: installation of rescue boats
on the wharf of the port of Belfast, 1912.

FOLLOWING DOUBLE PAGE: FIG. 132

The *Olympic* and *Titanic* liners in the port of Belfast, 1911.
Almost identical in design, they offered exceptional luxury and the *Olympic*,
which was in use until 1935, was nicknamed *Old Reliable*.

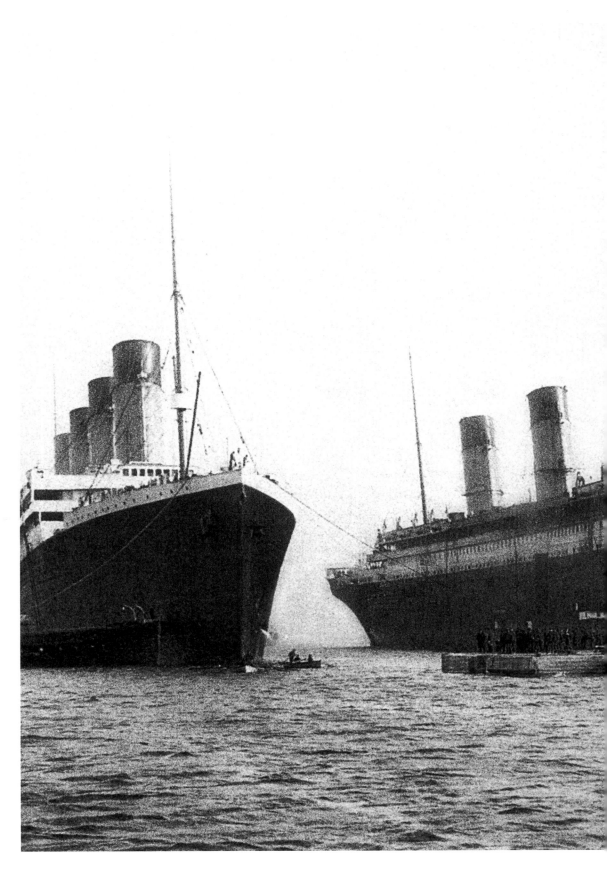

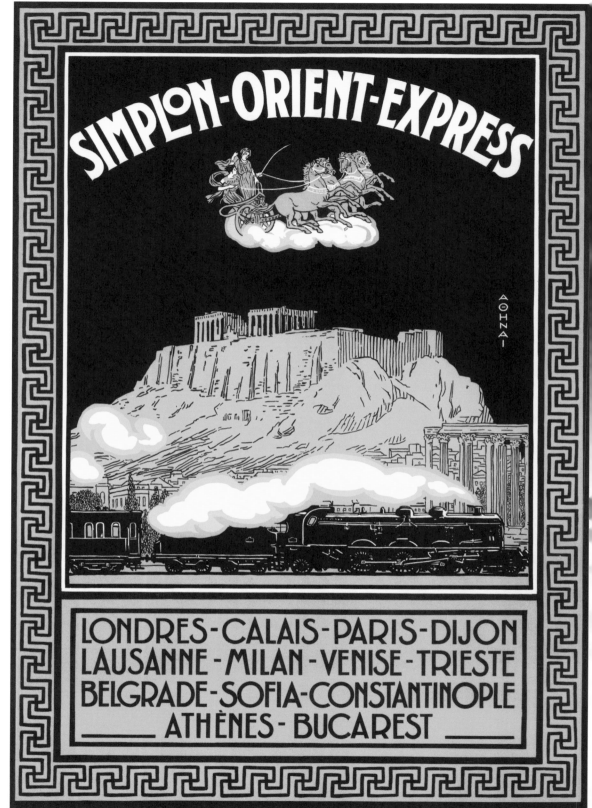

26
COMPARTMENTS
OF DREAMS

———

THE ORIENT EXPRESS
WAS EVERY TRAIN LOVER'S FANTASY.
A UNIQUE TRAVEL EXPERIENCE.

What's that noise, what's all the commotion about? Should we panic, call the police, arrest these people? And where are they all heading, crossing the Gare de l'Est so briskly? What could be causing so much excitement on this magnificent autumn day in 1883? Just look where they are headed to find out. The object of all this excitement presides over the tracks, placed there like a work of art, ready to carry them to the realm of the sultans. It is the Orient Express, the wonderful train that everyone has been talking about, and an unbelievable voyage awaits its passengers across a continent of many cultures—an excursion to other worlds that does not even require them to move from their compartments. The passengers' excitement is explained by the promise of a unique adventure. Indeed, they have all been asked to bring a weapon for it is not impossible, they have been told, that they may be confronted with attacks, plunderers, or other equally thrilling mishaps. These adventurers—artists, journalists, writers, politicians, distinguished guests, society gentlemen, wealthy merchants—are

FIG. 133
Poster by Joseph de la Nézière for the Simplon-Orient-Express luxury train,
connecting London to Constantinople or Athens, via Calais, Paris, Lausanne,
Milan, Venice, Trieste, Belgrade, and Sofia, 1920s.

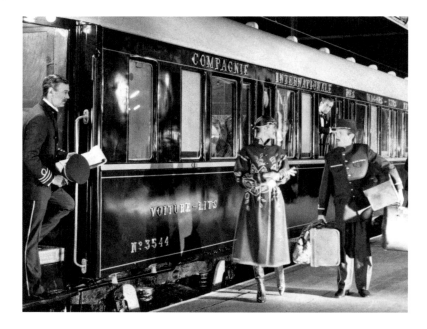

reasonably well-behaved, but when they enter these magnificent carriages on that special day, they are flabbergasted at the sight of so much luxury.

It must be said that the founder of the Compagnie internationale des wagons-lits et des grands express européens who dreamed up this wonder—a young Belgian engineer called Georges Nagelmackers—had wanted his train to be outstanding in every way, the "king of trains." Nagelmackers had spent a year traveling in the United States and had discovered Pullman sleeping cars which he considered excellent, if a little rudimentary. If the idea were to be brought to the old continent, however, he reckoned it would need to be considerably more sophisticated. More comfort, and above all, genuine luxury, with larger spaces, proper privacy for each passenger in place of a separating curtain, cabins like small private apartments,

FIG. 134
Departure of the Venice-Simplon at the Gare de Lyon, Paris, 1980s.

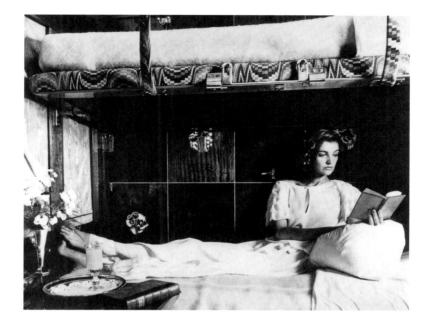

and decor that was as dreamy as the voyage itself and enabled the travelers to appreciate the beauty of the passing landscapes as well as the interiors of the carriages. He envisaged this train that he wished to create as uniting Europe's capitals in one fell swoop (Paris, London, Vienna, Budapest, Venice, Istanbul), providing a dream combining culture, geography, and life-style, all in a single journey. It was no longer just a train that was on offer, but an outright revolution on wheels, one with a thousand refinements.

Forget traditional carriages that had served their time. Here, the dining car was decorated by Lalique and the cabins were separated by solid partitions that replaced the thin curtains seen in the United States. There was a bar with a piano, to enable passengers to gather and relax over cocktails made to order. Stewards were in charge of preparing the cabins for

FIG. 135
Luxury sleeping compartment of the Venice-Simplon, 1980s.

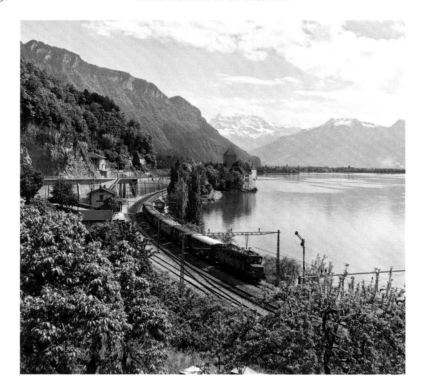

the night, changing the silk sheets every day, and, of course, everyone had their own bathroom, with all the hot and cold water they could wish for. In the dining car, the tables were laid with white linen and silverware made by the greatest craftsmen, and superb crystal glasses. Every detail, every effect, had been meticulously thought through and wherever one looked, it was but one continuous, divinely studied voyage giving those undertaking it the impression of entering a unique, secret universe. No need to cohabit with other passengers if you didn't want to. No tedious administrative formalities to carry out either. As the wonderfully evocative publicity posters led you to believe, life on board was

FIG. 136
The Simplon-Orient-Express running along Lake Geneva,
near Chillon Castle, Switzerland, 1950s.

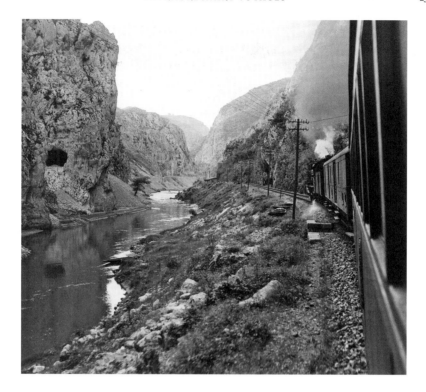

a far cry from everyday existence, in a world removed from all eventualities. Asia had never felt more accessible. The ever-changing horizon unfolded with the train's speed, grandiose panoramas of sea and mountains succeeded one another effortlessly, different climates, latitudes, and longitudes followed the train's progress. Over the years, new itineraries were offered to voyagers drawn to the south: in the 1930s, lines led to Damascus, Baghdad, and even Cairo. There was never any routine or time to get bored aboard this railroad poem rolling toward new worlds.

FIG. 137

The Simplon-Orient-Express, en route to Istanbul,
crossing the Austrian Alps, 1950.

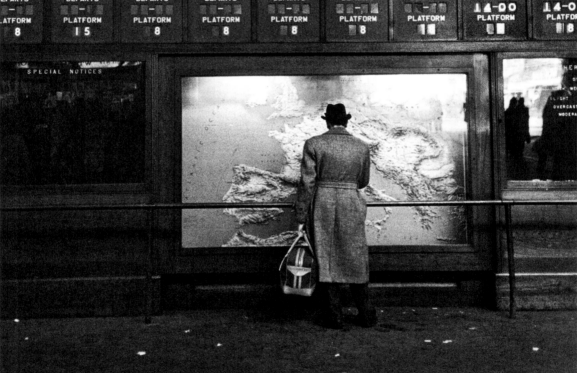

THE TRAIN, A WAY OF LIFE

The first passengers of the French railways could not have suspected that travel would never be the same. From 1840 onward, the railways developed and competition contributed as much to the popularization of this mode of transport as it did to a nascent practice, a market in the making: tourism. Distances became shorter, seaside resorts and spas boomed, and train companies communicated through colorful lithographs displayed in the stations and streets of Europe, the United States, and even Australia. A century later, inspired by the artistic avant-gardes taking over from powerful realism, posters show the machine dominating the space, the pleasure of travel over the destination. The railway era definitively transformed travel into a new way of life.

FIG. I

FIG. II

SUMMER ON THE FRENCH RIVIERA
BY THE BLUE TRAIN

FIG. III

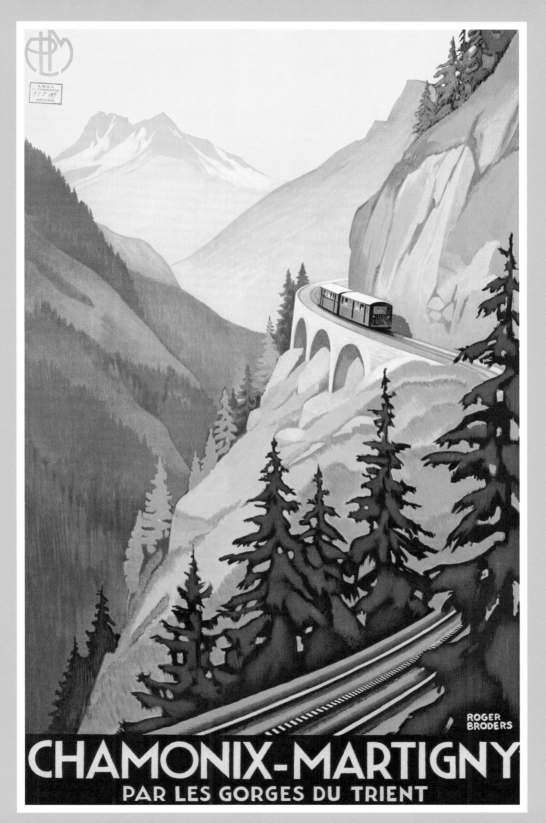

CHAMONIX-MARTIGNY

PAR LES GORGES DU TRIENT

ROGER
BRODERS

FIG. IV

FIG. V

FIG. VI

FIG. VII

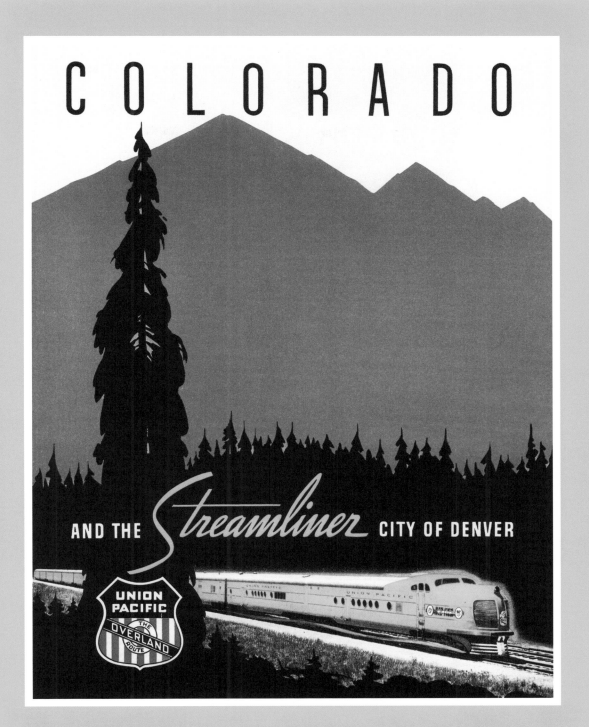

FIG. VIII

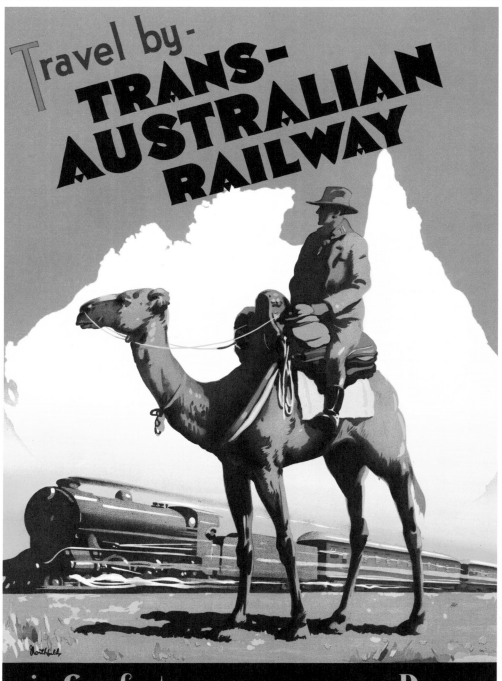

FIG. IX

FIG. X

CAPTIONS

FIG. I

Fix-Masseau, *Collection Venice Simplon, Orient-Express*, 1983. Le Mans, Centre national des archives historiques de la SNCF.

FIG. II

Fix-Masseau, *Venice Simplon, Orient-Express*, 1981. Le Mans, Centre national des archives historiques de la SNCF.

FIG. III

Charles-Jean Hallo, known as Alo, *Summer on the French Riviera by the Blue Train*, Compagnie international des wagons-lits, c. 1928. Le Mans, Centre national des archives historiques de la SNCF.

FIG. IV

Roger Broders, *PLM Chamonix-Martigny par les gorges du Trient*, 1930. Le Mans, Centre national des archives historiques de la SNCF.

FIG. V

Aage Rasmussen, *Vers le Nord, par le pont du Petit Belt au Danemark, chemin de fer de l'État danois*, 1951. Le Mans, Centre national des archives historiques de la SNCF.

FIG. VI

Janez Trpin, *Visitez la Yougoslavie*, c. 1935. Private collection.

FIG. VII

Ladislas Freiwirth, *Up to Scotland from King's Cross*, London & North Eastern Railway, 1935. Private collection.

FIG. VIII

Anonymous, *Colorado and the Streamliner, City of Denver*, Union Pacific, 1950s. Private collection.

FIG. IX

James Northfield, *Travel by Trans-Australian Railway in Comfort, save Days, across Australia*, 1933. Canberra, National Library of Australia.

FIG. X

Anonymous, *To the East in Air-conditioned Comfort, Trans-Australian Railway, Fast Diesel Electric Trains*, Commonwealth Railways, 1933. Canberra, National Railways Museum.

FACING PAGE: FIG. 139
Steve McCurry, *Old Delhi Station*, 1983.

FOLLOWING DOUBLE PAGE: FIG. 140
Steve McCurry, *Agra Station*, 1983.

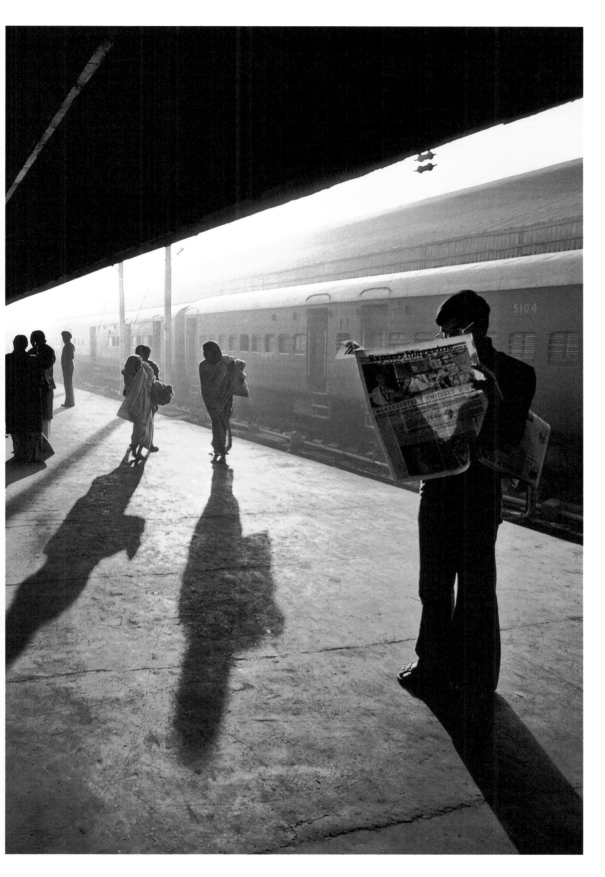

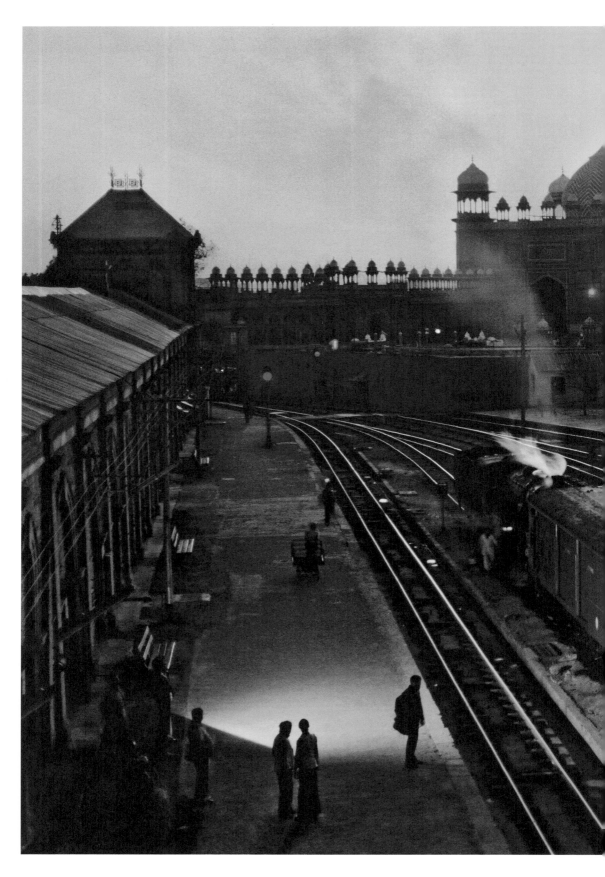

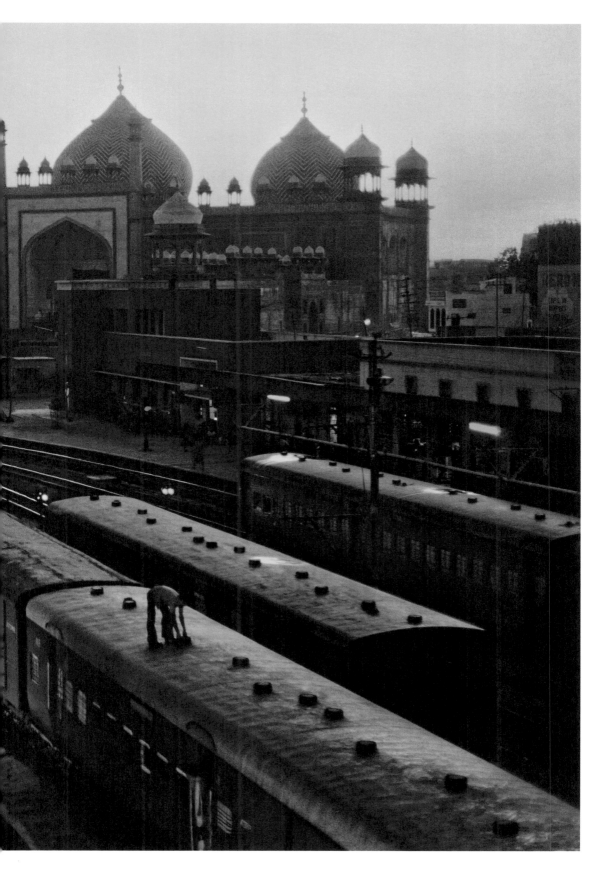

27

HIGH-ALTITUDE CARRIAGES

———

To reach Darjeeling from Siliguri,
the Himalayan train followed
loop after loop, more than 6,000 feet
above sea level.

The town of Darjeeling straddles a craggy ridge, surrounded by verdant tea plantations which, in the nineteenth century, supplied the extremely powerful British East India Company. The route up is frequently shrouded in cloud and too narrow for two vehicles to cross paths. The crops covering the surrounding hills are immaculately maintained, and in the year 1878, the summer capital of Bengal, colonized by the English, was buzzing with activity. Situated at the foot of the Himalayan state of Sikkim, at that time Darjeeling was a hill station reputed for its temperate climate, ideal for escaping the stifling temperatures of sub-continental India, and it had a definite air of prosperity about it. It was true that the site was superb, covered in dense forests, fragrant pines, bamboo, luxuriant ferns, and plentiful oaks that could not fail to dazzle those approaching it. All that was missing was a suitable means of transport to open "Dorje ling," the city of lightning, to the world and take advantage of the town's attractions properly. But the site posed a real topographical conundrum.

FIG. 141
The railway road, shortly before arriving at Ghoom, the highest station
on the line located at an altitude of 2,225 meters.

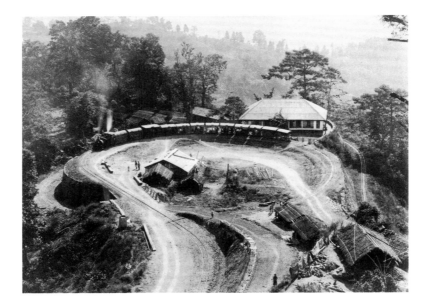

One evening that same year, Franklin Prestage, an official of the Eastern Bengal Railway Company, was preoccupied with this very matter. He had been invited to the elegant Planter's Club in Tindharia. The atmosphere was perfect except for Prestage, who could not stop thinking about his longtime project for a train, and, more importantly, the difficulty of accomplishing it in a region with such a vertiginous landscape. It was his wife Augusta who came up with the solution, whispering to him gently: "If you can't go forward, why not go backward?" This utterly novel idea gave birth to a train that was equally novel and provided the official with an answer to his problem.

The railroad track was therefore made up of loops, over a distance of fifty-one miles, from Siliguri to Darjeeling, with sections that zigzagged, where necessary, up to an altitude of just over 6,500 feet. This hugely daring technical solution for

FIG. 142
Crossing a hill on a double loop route of the Darjeeling Himalayan Railway, 1880.

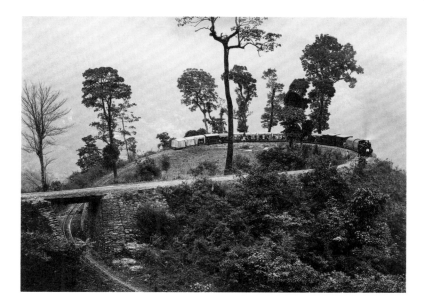

overcoming the geographical difficulties was a combination
of practicality and poetry, for on all sides there were nothing
but uninterrupted views, magical atmospheres, and grandi-
ose panoramas of verdant forests and mosaic-like patterns of
plantations with the Himalayas as a backdrop. The voyage was
unlike any other, and slow. Very slow. Sluggish even. But the
era was used to that. In putting forward his idea to the gov-
ernment, Franklin Prestage and his train were giving tangible
form to the British Raj's spirit of enterprise, and, at the same
time, becoming part of railroad history, instilling travel in this
region with a new magic. Imagine the long days of torpor that
awaited the passengers when the line was first opened in 1881:
the initial chaos, to put it mildly, the crowd pushing their way
into the carriages—at that time equipped with canvas roofs
and wooden benches—that followed the route dreamed up by
the officer, the very first steam engine imported by Atlas Works

FIG. 143

Agony Point, north of Tindharia, third loop of the line linking Siliguri to Darjeeling,
Album of views of India and Burma by Colonel Rawdon J. Macnabb, c. 1880.
London, British Library.

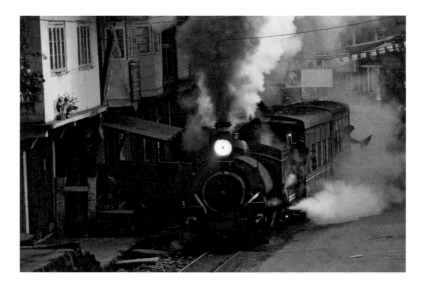

of Manchester belching out its white smoke while the whistle sounded suddenly, announcing the departure.

Nowadays, it is a trip for those who love drawn-out voyages, for those wishing to escape reality without minding frequent stops, for those happy to watch the engineers stoking the coal burner, the small stations heaving with people, the train setting off again, slowly, sputtering. The sight is superb, the train climbs, weaving its way along a route that defies logic, performing loops, half turns, even passing high above the rails on bridges, and moving backward to work its way up the hill. The edge of the precipice is never far away and, at each blow of the whistle, the passengers discover a new and exhilarating landscape. The route disappears, giving way to dense forest, vegetation, and tea plantations that stay with you long after passing, and, in the distance, the same bluish-white fog as when Prestage first built this railway.

FIG. 144

Passage of the Darjeeling Himalayan Railway to Sonada, West Bengal, 1990s.

FIG. 145

Advertising label for Air India, 1950s. Paris, Gaston-Louis Vuitton collection.

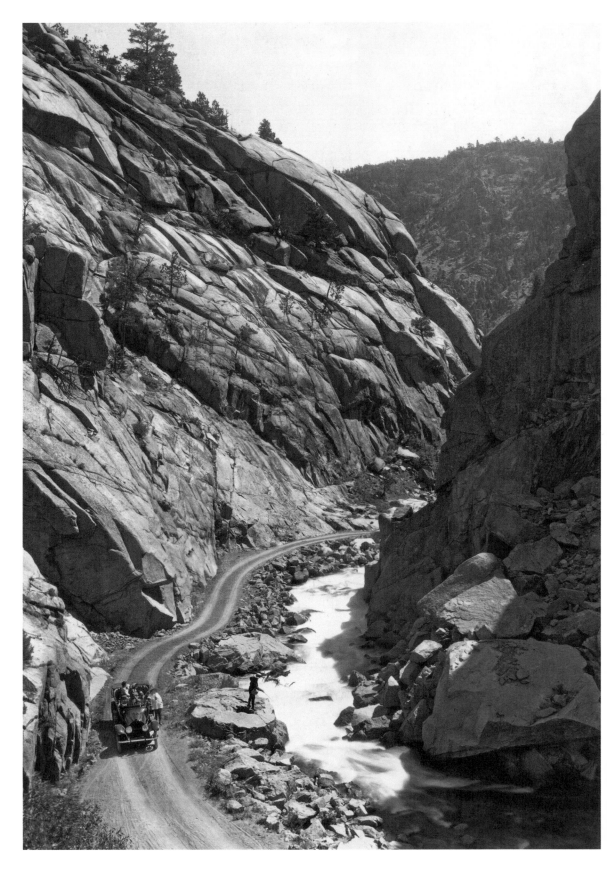

28

OFF-ROAD

IN THE REALM OF EXPLORERS,
THE ALL-TERRAIN VEHICLE OFFERED
A GLIMPSE OF NEW HORIZONS,
THRILLS GUARANTEED.

In the early twentieth century, new adventurers traversed the most hostile and remote lands, where no roads existed, at the wheel of a new type of vehicle that made that kind of trip possible. Faded photographs from the period immortalize these expeditions, showing off-road cars halted amid hazy landscapes, forests so dense that only the merest ray of light filters through, and the savannahs of Kenya and Tanzania. These images illustrate what these vehicles are capable of. These vast lands known only, until then, to their inhabitants, were from this point forward traversed, in blazing sunshine, by men and women dressed in khaki jackets, who had come to discover Africa and its wild animals. These safari lovers were accompanied by trackers who helped them find the paths of wild beasts, and carry the corpses of lions and tigers—their recently shot trophies.

These off-road vehicles are put on display in these photographs. They embody adventure and are as much the protagonists of these dangerous trips as the hunters themselves. Their

FIG. 146

Royal Geographical Society expedition crossing the Vrain Canyon
in the Rocky Mountains, Colorado, 1931.

greenish bronze color, their build, and their bodywork bearing traces of the difficult terrain they have traversed, or of a buffalo attack, give them their wild appearance. Photos dating from the 1920s show hunters picnicking during a break, peacefully installed in the savannah on large blankets, their enormous vehicle parked beside them, a buffalo head casually placed on a suitcase. In other images, the hunters stand leaning against their vehicle, seated on the roof. Yet other images show men sporting the inevitable pith helmets, proudly staring at the camera lens, seated in their "hunting car," halted in the middle of a dusty plain. It is easy to picture them traversing hundreds of miles in the heat, reaching the foot of Mount Kilimanjaro, settling in for the night in their tents, then rising at 5 a.m. the following day to pursue their trip until the evening, hunting gazelles, antelopes, zebras, and the "Big Five" of trophy hunting, a practice that was much more widely accepted at the time.

In some photographs, the Ngong Hills can be seen in the distance, behind the cars, or the Serengeti plain glimpsed through an open door. These overland vehicles often look enormous and basic. This was because they were required to be unusually resilient to be able to carry lions, buffalo, and elephants, as well as protecting the hunters while setting up their encampments, and transporting whole teams of men and supplies for several days if not months. Machines that were tough enough for any situation were needed in order to traverse impossible terrain, to escape charging rhinoceroses, to dash across the gigantic African plains, and to enable the hunters to cling on while waiting for the right moment to shoot.

If, as some people claim, the thrill of the hunt does not derive from encountering the beast but from the expectation of it, then a means of transport such as this, together with the

Arrival at the Gilgit pass, in Kashmir, of an automobile in the race from Beirut to Peking,
organized by André Citroën, between 1931 and 1932.

A team of explorers scouting for a safari in the former Belgian Congo, 1934.

approach it affords, the spectacle it enables even from afar, and the sense of risk it allows us to imagine, confirm this. And if an invention exists largely as a result of the desire that it incites, then the proof is seen here, and magnificently. If not, why would so many men and women want to own such an impractical vehicle for getting about towns with their networks of narrow streets, small squares, and restricted lanes? From 1905, the first off-road vehicles were seen on America's roads, and the Amsterdam Motor Show of 1948 featured the first Land Rover, with its square contours and steel framework familiar to lions and zebras throughout the world. From then on, off-road cars were to become increasingly common in cities as well as in the countryside. Numerous photographs illustrate this craze, with travelers proudly posing alongside their off-road cars dressed like explorers. These photographs also document their exploits: the rivers they crossed, the country roads where they got bogged down. Images that evoke a certain sense of adventure, for sure, but that are no real match for the superb sepia-toned photographs that pay tribute to African adventure and the first safaris carried out in these early off-road vehicles that appealed so strongly to Hemingway.

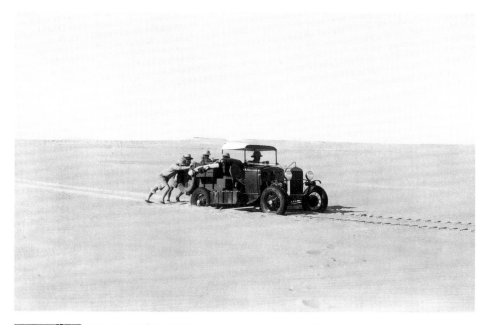

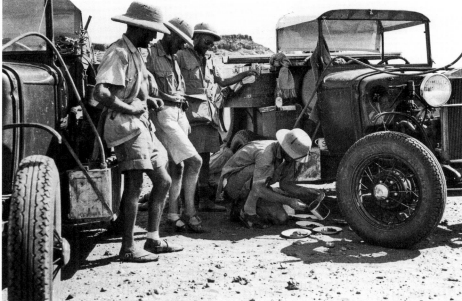

TOP: FIG. 149

A car stuck in the sand during a crossing of the Libyan desert by a Royal Geographical Society
expedition in western Egypt, c. 1932. London, Royal Geographical Society.

BOTTOM: FIG. 150

Lunch break for members of the Royal Geographical Society during an expedition
to the Libyan desert, May 1933. London, Royal Geographical Society.

29

CRUISE CONTROL

———

WITH THE FIRST TRANSOCEANIC JOURNEYS,
THE WORLD SUDDENLY BECAME
MORE ACCESSIBLE. A NEW *ART DE VIVRE*
WAS BORN.

What is immediately striking is the contrast between the vast ocean, devoid of any sign of human life, and the sea of faces on deck scanning the horizon, the never-ending space, and watching out for mainland. From my first trip, as a child, aboard the *MS Pasteur*, an ocean liner owned by the Compagnie des messageries maritimes sailing between South America and Europe, I recall images of Buenos Aires retreating at a surprisingly fast pace, silhouettes diminished by distance, passengers of all nationalities and origins gathered on deck, far removed from the world, en route to France. Passengers united by the same adventure, befriending one another effortlessly, quickly organizing their new life on board as if accustomed to long-distance voyages, wasting no time establishing a sort of timeless space out at sea.

It was the young Dutch legal expert Hugo Grotius, in the seventeenth century, who first mentioned the notion of international waters, open to all. But it was the Canadian businessman Samuel Cunard who brought about this perfect vision on July 4, 1840, sailing from Liverpool aboard the

FIG. 151

Cruise in the Norwegian fjords, 1930s.

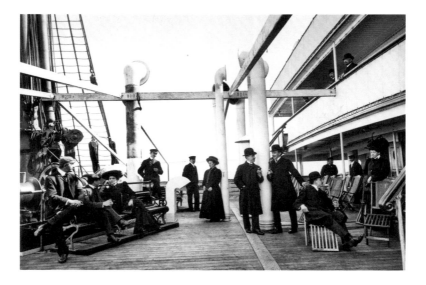

Britannia, his company's first mail steamer. His ship, backed in part by the British government, was 207 feet long and 34 feet wide—sizeable for the period—and could carry up to a hundred passengers. For this first crossing, Cunard was accompanied by his daughter Ann and sixty or so persons of note from all professions, together with their families. They sailed toward Nova Scotia with great excitement, unaware that they were inaugurating much more than a ship or even a voyage. The notion of "international waters" had just been created. Regular crossings did not yet exist. The *Britannia*, with its very first passenger cabins, its rules that would soon become rituals—impeccable dress required, the captain joining the passengers for meals—and its top speed of 8.5 knots would quite simply revolutionize the world of travel, sailing from the old continent to the new world in twelve days, seemingly without the slightest difficulty. Upon arrival in Halifax, Cunard and his guests were applauded and treated like heroes, showered with invitations,

FIG. 152

German travelers headed for the United States on the bridge of the *Cleveland*, moored in Hamburg, 1909. Berlin, Deutsches Historisches Museum.

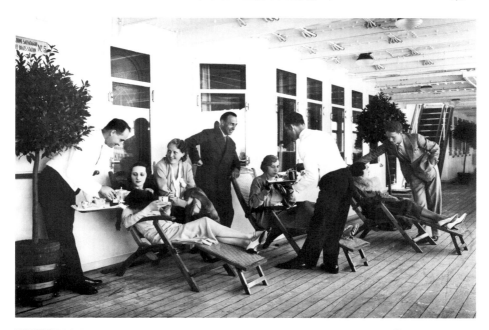

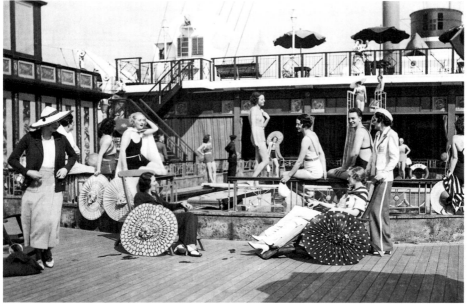

TOP: FIG. 153

Passengers on the first-class deck of the transatlantic liner *Victoria*, 1930s.

BOTTOM: FIG. 154

Sunbathing by the pool on the *Rex* transatlantic liner bound for New York, 1934.

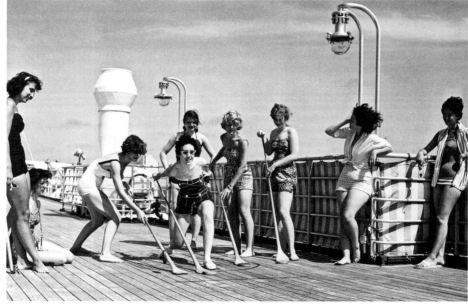

TOP: FIG. 155

Tennis match on the foredeck of the *Conte Rosso*, linking Genoa and New York
and renowned for its luxurious facilities, 1930s.

BOTTOM: FIG. 156

Croquet game on the deck of the *Giulio Cesare*, connecting Genoa
and South America, via Naples, 1959.

over one thousand of which were dinner invitations! They quickly unloaded the mail they were transporting, which, until then, had taken up to six months to arrive, and continued on their way to Boston, where they disembarked the following day, once again to great acclaim. The crossing had been fast, safe, extremely pleasant, and on schedule. Samuel Cunard could be proud. Not only had he clearly met the challenge he had set himself, establishing the first transatlantic service, but, at the same time, he had invented a unique and wonderful type of boat that offered no less than an entirely new way of living.

For cosmopolitan travelers, sophisticated explorers, and those who loved going on trips which they viewed as a way of life, it provided the opportunity of seeing and talking to others, flirting, attending social events, and enhancing one's contacts and encounters at a time when flying was no more than a dream. It was during a crossing in 1934 aboard the liner *Île de France*— the ultimate embodiment of luxury art deco style—that Ernest Hemingway, traveling second class and sporting a borrowed dinner jacket, encountered Marlene Dietrich, who, at the height

FIG. 157

Advertising label for the German luxury liner *Cap Arcona*, sailing between Hamburg, Northern Europe, and South America, 1927. Paris, Gaston-Louis Vuitton collection.

FIG. 158
Advertising label for the American-British shipping company Cunard Line, created in 1838.
Paris, Gaston-Louis Vuitton collection.

of her fame, was naturally traveling first class. And it was aboard the *Queen Mary* that Winston Churchill finalized his plans for D-Day, having gathered the most senior members of the allied forces in the office in his cabin, surrounded by fine crystal and wooden paneling. It was also during a crossing in the 1940s from Lisbon to New York on the *SS Siboney*, packed with intellectuals, that Antoine de Saint-Exupéry shared a cabin with the movie director Jean Renoir, who became his friend, and the Russian photographer Roman Vishniac, who was traveling with his family and his famous images of a world that was soon to disappear.

What a life! What an experience! What an incredible amalgam of people! While these liners may have been magnificent floating mansions competing to offer their passengers the safest and fastest crossings possible, they were also, more significantly, sublime showcases for disparate collections of cosmopolitan characters. Multimillionaires, Hollywood stars, famous artists, aristocrats, maharajas, women of easy virtue, penniless dandies, and sophisticated well-versed travelers crossed paths, sampling the pleasures of the liner as much as those of the voyage itself. Not forgetting, at different times and as nations succumbed to economic and political crises, the immigrants, expatriates, and refugees who occupied the next-door cabins, all watching the ocean shimmering in front of their very eyes, all passengers on a crossing that was necessarily extraordinary, whether leaving from Liverpool, Lisbon, or Buenos Aires.

FIG. 159

Advertising label for the Japanese shipping company Tokyo Kisen Kaisha, which served the ports of North and South America, 1920s.
Paris, Gaston-Louis Vuitton collection.

30

WHEN IN RIO

———

Don't forget to head to the top.
It's so much easier by cable car
since its inauguration
in 1912.

The *cidade maravilhosa*, or "Marvelous City" as Rio de Janeiro is known, is made to be discovered from the sky. Its magnificent bay and the surrounding hills covered in tropical forest overlooking the city are most impressive when seen from on high, thanks to the cable car. The trip way above the legendary beaches of Ipanema, Copacabana, Leme, and Leblon toward Sugarloaf Mountain should be made slowly, perched high in the blue of the sky, suspended beneath the celestial vault. That is how Rio should be discovered, or at least, that is how the Brazilian engineer Augusto Ferreira Ramos, imagined it happening when, in 1907, he decided to link the beach to the famous granite peak of Corcovado, inaccessible until then. The project, which covered a distance just under a mile in length suspended at an altitude of 1,300 feet, was intended to give a new image of the city which, at that time, was the Brazilian capital and in the midst of a transformation.

Ferreira Ramos was considered a madman; people made fun of his idea, even suggesting that the line should stop

FIG. 160

Cable car from Sugarloaf Mountain with Guanabara Bay in the background,
Rio de Janeiro, 1950s.

off at the asylum, located next to Sugarloaf Mountain. But from up on high, everyone was won over by the majesty of the landscape—who would not to want to fly over those vast beaches, admiring the hilltops whose slopes were at times gray and menacing, and at others, deep jungle green, and the sea with its ever-changing hues, all as if in a dream? Construction began in 1910, roughly ten years before the first stone of the statue of Christ the Redeemer was laid and the famous Copacabana Palace was opened, on the most beautiful beach imaginable. Four hundred laborers got to work, tirelessly climbing the mountain laden with long sections of cable. The pieces of machinery had to be taken up there one by one. Access to the mountain was particularly difficult, the ground stretching out endlessly under the blazing sun that shone throughout most of the year. A year or so later, the public were able to discover the first cabins that resembled small train carriages for twenty or so people.

By the time of its inauguration in 1912, other smaller cable cars already existed in Canada, in Tennessee, and in Brighton, England. While the first machine of this kind had been presented at the General Art and Industrial Exposition in Stockholm back in 1897, the oldest functioning one was that in Bolzano, in the Tyrol, built in 1908, but it had been forced to close in 1910 due to stricter safety measures, for it didn't have a brake system. The only two real "competitors" to the Sugarloaf cable car at that time, therefore, were the one in San Sebastián in Spain, and one in the Swiss Alps. This meant Rio was the only city on the American continent to have this type of machine. Before then, Brazil had been viewed as an underdeveloped country by most Europeans. This new technology was to change that, enabling it to demonstrate that it could

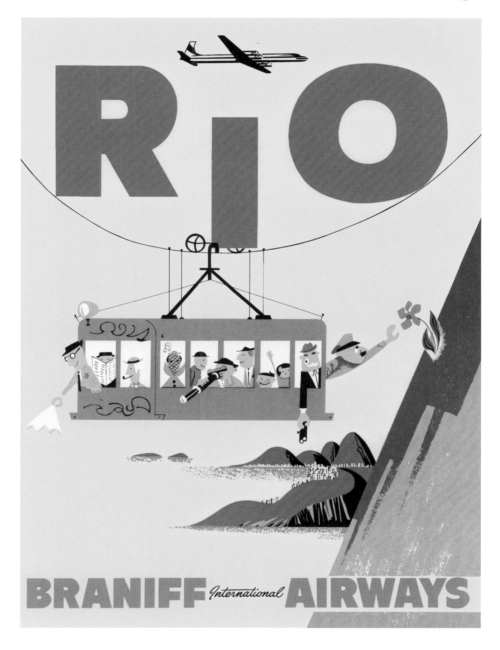

FIG. 161

Poster for the American airline, Braniff International Airways,
for the destination of Rio de Janeiro, 1959.

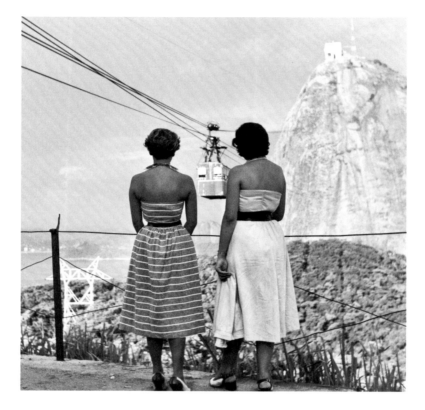

rival other nations in terms of modernity and success. As there
was no cable car constructor in situ, a German company was
contacted—one based in Cologne that had designed cable cars
for transporting merchandise. Most of the equipment was
imported directly from Germany and special security measures
were devised to help reassure passengers who were understand-
ably frightened by the proximity of the mountain that gave the
impression that the machine would crash into it at the slightest
gust of wind.

Despite a series of problems, the project was somehow
completed without mishap. More than five hundred people

FIG. 162
Passengers waiting for the cable car at the top of Sugarloaf Mountain, 1950s.

purchased tickets for the first trips of this *camarote carril* (cabin on rails, as it was called at the time), running from the *Praia Vermelha* (Red Beach) to Sugarloaf Mountain. They must have had the shock of their lives when they caught a glimpse of the grandiose panorama unfurling beneath them—a distillation of tropical nature and urbanism: the virgin forest encircling the city, the sea in its many different moods and colors, the undulating ridges of the hills as they came into view. After a short signal announcing their departure, these first passengers found themselves suspended over Guanabara Bay, amid a landscape composed of a thousand shades of green and impenetrable undergrowth. They could make out small dwellings as well as grandiose avenues, the entire rapidly changing city bathed in sunshine. From the cabin they could see creeks, islands, beaches, and sharp rocks emerging from the depths of the forest, imbued with an extraordinary light—a vision unlike any other. At the end of this gently swaying voyage, they reached in no time the dizzying heights of Sugarloaf Mountain's legendary summit.

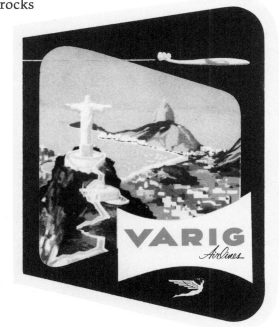

FIG. 163

Advertising label for the Brazilian airline, Varig, 1950s.
Paris, Gaston-Louis Vuitton collection.

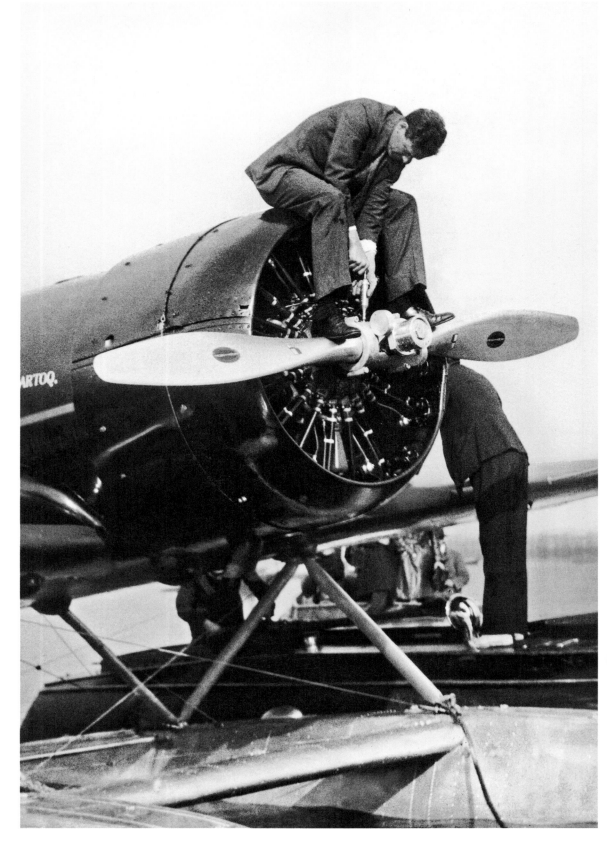

31

THE PIONEERING SPIRIT

———

ON MAY 20, 1927, CHARLES LINDBERGH
SUCCEEDED IN CROSSING THE ATLANTIC
ABOARD THE *SPIRIT OF ST. LOUIS*.

The scale of the expedition was unprecedented: a non-stop solo flight over the Atlantic Ocean from New York to Paris. The First World War had just ended, and pilots were keen to show that their planes could also be bearers of peace by creating records that were no longer linked to misfortune, fear, and conflict. As the specter of war and its horrors receded, people were thirsty for hope, freedom, adventure, and heroism. The American Albert Cushing Read and his flying boat had linked Long Island, near New York, to Plymouth in Britain in 1919, after a journey of twenty-three days and stopovers including Cape Cod, Newfoundland, the Azores, and Lisbon. Another crew had made the first non-stop coast-to-coast flight across the United States in 1923, followed by two French pilots who made a non-stop flight from Étampes, near Paris, to Villa Cisneros, in the Spanish Sahara, in 1925. There was no shortage of exploits nor indeed of pilots ready to attempt beating the records for speed, altitude, and range.

FIG. 164

Charles Lindbergh prepares his aircraft before leaving on a mission
to explore unknown lands in Greenland, 1933.

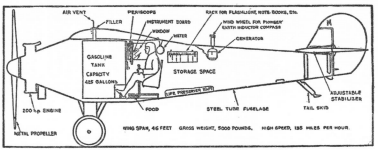

DIAGRAM OF THE "SPIRIT OF ST. LOUIS"

This longitudinal cross-section of Lindbergh's plane shows clearly the mechanism of the "little bus" that carried him in one hop from New York to Paris. The ship is a monoplane with a wing spread of 46 feet and a length of 28 feet. The operator sits in a wicker chair in a completely enclosed cockpit. On either side is a door with a window which could be readily opened. There is another window overhead, but the forward view is entirely cut off by the big gasoline tank holding 448 gallons, which is mounted just behind the motor. An optical instrument with reflecting prisms, known as a periscope, permitted Lindbergh to look ahead if necessary, but as the window and instruments gave all needed information, the periscope was little used. The instruments included temperature gauge, oil pressure gauge, tachometer, altimeter, turn and bank indicator, air speed and drift indicator, speed timer, and clock.

Yet the Atlantic seemed to remain insurmountable. The Franco-American businessman Raymond Orteig, a member of the Aero Club of America, wanted to be the one to realize this dream. He launched a challenge to pilots across the globe, offering $25,000—a fortune at that time—to the first to successfully fly from New York to Paris non-stop. The offer was valid for five years, and Orteig did little to hide his longing for a French pilot to win the prize. Plenty of famous pilots were interested, but no one accomplished the feat. Orteig renewed his offer for a further five years. Eight years passed before a twenty-five-year-old man showed up on the starting line— someone who was not an ace pilot, nor even a professional, but nonetheless a talented flyer with many flying hours under his belt working for the Chicago–Saint-Louis air postal service. He was an American, of Swedish descent, called Charles Lindbergh, and on May 20, 1927, he decided to have a go at this extraordinary race.

FIG. 165

Cross section of the *Spirit of St. Louis* showing the interior layout, including the large kerosene tank, 1927.

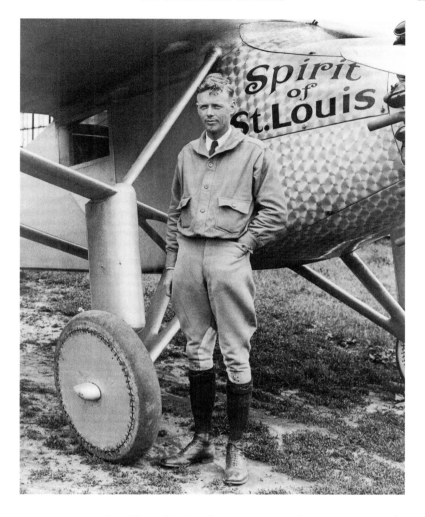

He took off early in the morning from Roosevelt Aerodrome on Long Island aboard his monoplane, the *Spirit of St. Louis*, named after the generous donators from St. Louis who had made its construction possible—businessmen who, after months of deliberation, had agreed to back the young man's dreams. It was clear that he would need a

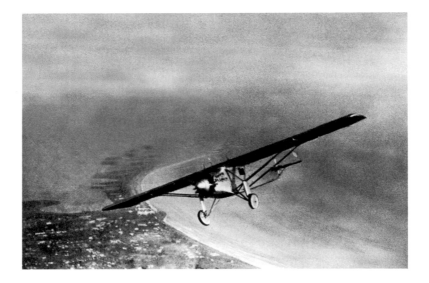

special plane and his most definitely was. He was partially
responsible for designing it, using the best possible instru-
ments for the time and a cockpit that was made-to-measure,
like the most perfect clothes. Lindbergh only took the bare
essentials with him, doing away with both parachute and
radio, normally considered vital. To increase his flight
range, he was laden down with gas tanks, one of which was
placed right in his line of sight at the front. On the day of
his departure, Lindbergh was seated on the wicker seat,
wearing a thick fleece-lined flying suit, with an inflatable
raft, some maps of air and shipping lines, a fishing line,
a knife, some sandwiches, and water by way of survival
equipment. He took off at 7:52 a.m. local time in Long Island
and began by following the coast north toward Newfound-
land. The following day he flew over Ireland and then south-
ern England. By the evening, he was reported flying over
Cherbourg in northern France.

FIG. 167
The *Spirit of St. Louis* flies over the Atlantic on June 30, 1927.

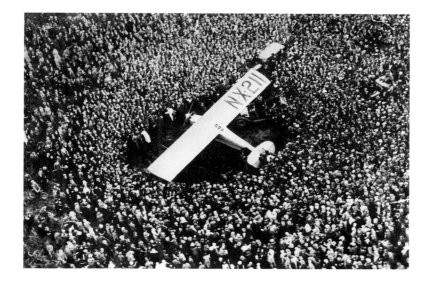

Not long before he landed, the spectators, who had been scanning the sky for a long time, cried out, "It's him!" Indeed, he landed at Paris's Le Bourget airport at 10:22 p.m. on May 21, successfully achieving an extraordinary feat. Twenty thousand overexcited spectators were there to greet him, crashing through the security barriers and rushing toward the plane. The police were unable to contain this extraordinary human onslaught that looked as though it would sweep the pilot away. Hysteria reigned on the tarmac, floodlit by huge projectors like on a film set. Nobody had yet achieved such an incredible flight. One that took just over thirty-three hours, with no sleep for the pilot, and almost no visibility, navigating by instinct. A flight undertaken alone, without any stopovers, guided solely by the sun, the stars, and a basic compass.

FIG. 168

The crowd welcoming the arrival of the *Spirit of St. Louis* at Le Bourget airport in Paris on May 21, 1927.

32

HER MAJESTY THE QUEEN

———

IT WAS NOT ONLY A HAVEN OF LUXURY BUT,
IN 1936, THE *QUEEN MARY* WAS
THE FASTEST LINER IN THE WORLD.

Those who lived through the golden age of large ocean liners will forever recall the marvelous moments of solitude experienced out at sea, when the voyage stretched endlessly into the future, and the blue expanse of waters on the horizon knew no bounds, as they passed from one continent to another in pursuit of conquering the waves. In the heyday of these large transatlantic liners, passengers were the conquerors as much as the ships themselves. At that time, they embarked for days of crossing and were welcomed as guests of honor. Upon arrival at their destination, they recounted their journey to those who had remained on land, keeping the dream alive, detailing every aspect of their adventure, describing the sumptuousness of the reception rooms, cabins, dining rooms, cocktail bars, and ballrooms, and the elegance of each moment. Departures, therefore, were always a moving experience, with passengers gathered on deck waving their last goodbyes to those on the quay.

As on May 27, 1936, in Southampton, when the *Queen Mary*, Samuel Cunard's latest jewel, left on its maiden voyage.

FIG. 169

Advertising poster for a cruise on the *Queen Mary*, c. 1934.

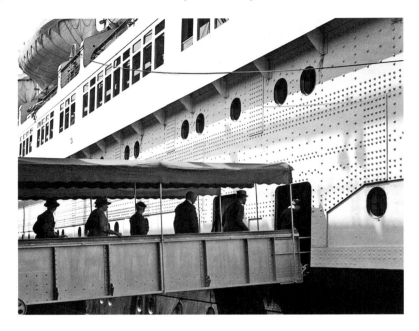

It was all set to plough the waves and, in keeping with tradition, a large crowd had come to admire this distillation of technology and luxury, this symbol of Britain's renewed strength. After the tragic sinking of the *Titanic*, this moment was akin to turning a new page on the ocean. The crowd present that day and the 1,841 passengers who had just boarded for the voyage from Southampton to New York were for the most part aware of the difficulties that had preceded this festive moment. As it happened, this fantastic ship that they were all admiring very nearly never came into being and owed its existence to good fortune. To start with, the Wall Street Crash of 1929 had not spared the company created in 1838 by the Canadian Cunard, who had been forced to put a stop to the ship's construction due to lack of funds, and was only saved by merging with his biggest competitor, White Star Line. When construction began

FIG. 170

Passengers boarding the *Queen Mary*, 1936.

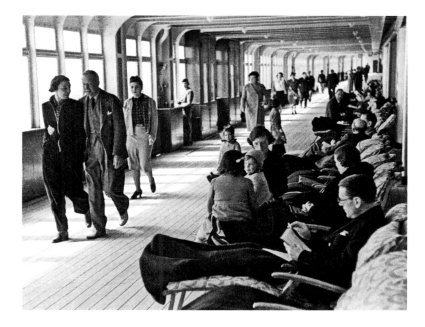

again, after a two-year hiatus, it was not without difficulty, including the removal of 143 tons of rust. Lastly, the name that had been chosen for the ship had also given rise to a misunderstanding that nearly proved to be extremely embarrassing: the company's president sent word to King George V asking his permission to name the ship after Britain's "greatest queen"—thinking of Queen Victoria—to which the king replied that his wife, Queen Mary, "would be delighted." Thus, for the first time in history, the name of a reigning sovereign was given to a commercial ship.

The liner had other distinctive features. Until then, ships sailing the various maritime routes mainly served to transport merchandise and immigrants. But on that day in 1936, not only was a new type of ship inaugurated—the first launched by a company composed of two rivals—but it was also about

FIG. 171

Stroll on the deck of the *Queen Mary*, equipped with deckchairs for resting, 1939.

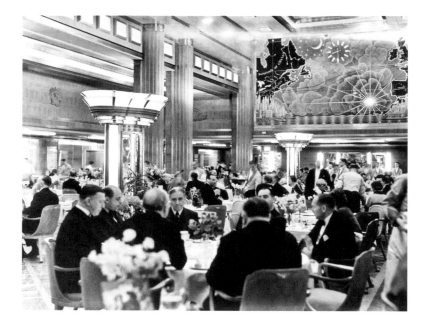

to initiate a new type of voyage. Shipowners had understood that a new kind of clientele was emerging. Their visionary spirit and business sense were almost certainly responsible for the appearance of these rulers of the oceans, and with them, the golden age of transatlantic liners. Ships that inspired dreams, and celebrated luxury and elegance, as well as maritime grandeur and pride. The most important architects, designers, publicists, and decorators were called upon to conceive something out of the ordinary.

When the *Queen Mary* arrived in New York on June 1, 1936, with almost as many crew members as passengers, a new era was proclaimed, banishing, for a while, the tragic memory of the *Titanic* from twenty-four years earlier. The captain was unaware that just a few months later, he would win the famous Blue Riband for the fastest Atlantic crossing by

FIG. 172

Dining in the luxurious restaurant of the *Queen Mary* on its maiden voyage
from Southampton to New York in May 1936.

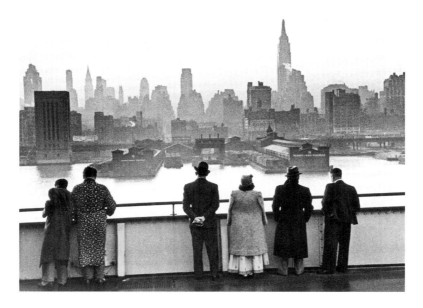

a regular passenger liner—an honor the *Queen Mary* was to retain, almost uninterruptedly, for fourteen years. Nor that he was entering a new era: that of the incredible transatlantic competition and the understated joy of being at sea; that of the battalions of stewards circulating with composure throughout the dining rooms with their cathedral-like ceilings, or making their way through the gilded reception rooms that looked out onto the endless landscape; that of fabulous crossings carried out regularly between Europe and New York; and finally, that of luxurious liners suddenly appearing on the horizon amid a silver wake.

FIG. 173

Passengers discover the Manhattan skyline at dawn, 1939.

FOLLOWING DOUBLE PAGE: FIG. 174

Arrival of the *Queen Mary* in New York, May 1936.

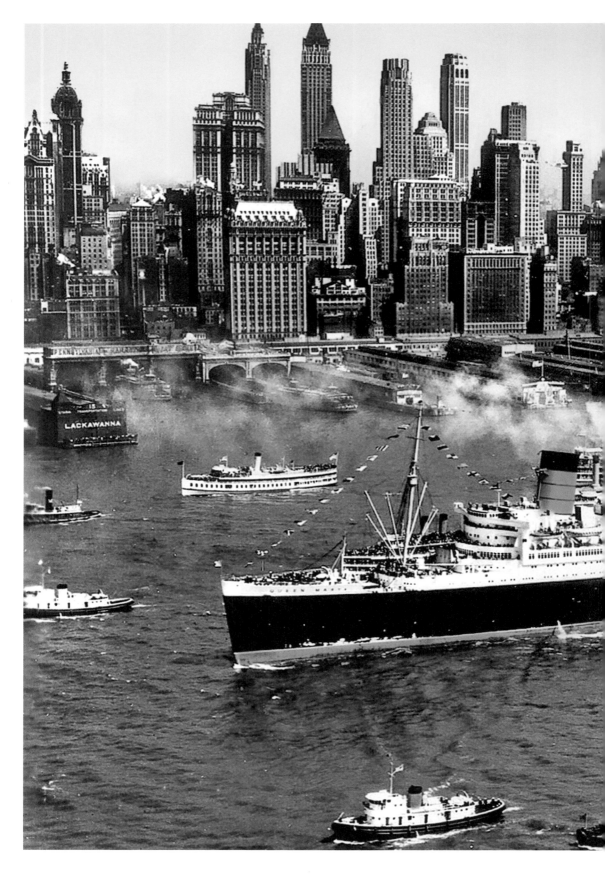

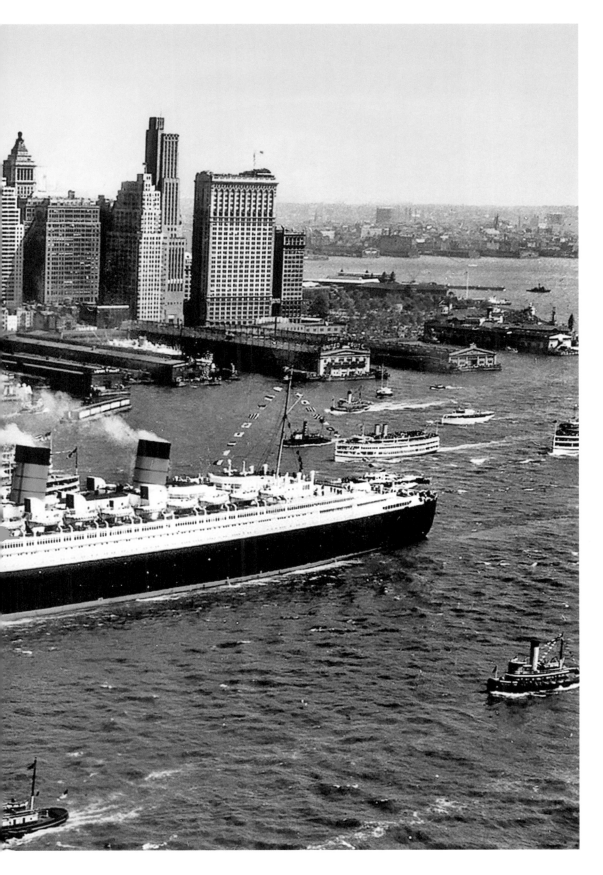

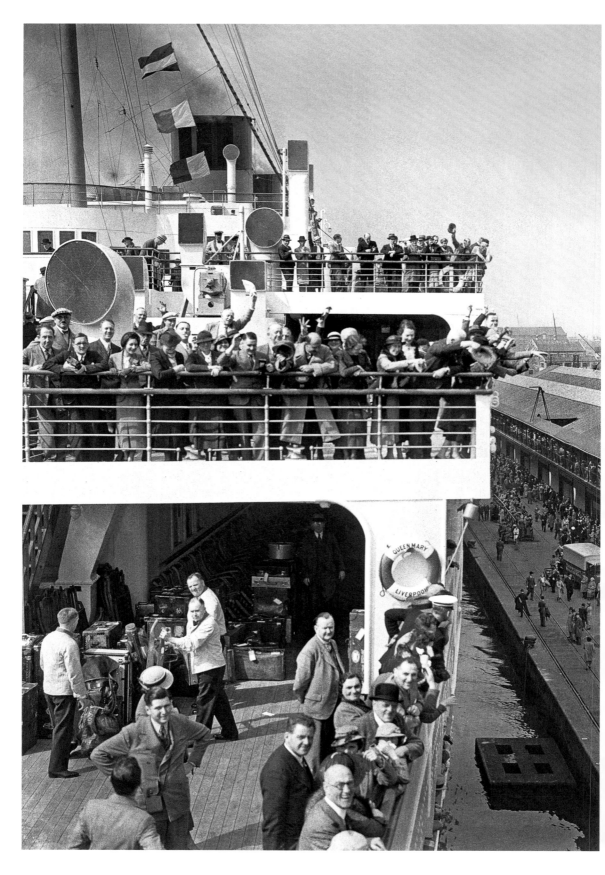

THE BOAT,
TIME SUSPENDED

At the turn of the nineteenth and twentieth centuries, emigration across the Atlantic and trade between the European colonial powers and their territories were expanding. These dynamics increased the volume of passengers and the frequency of connections to the Americas, Asia, and Australasia. From 1840 onward, the mastery of steam and powerful engines enabled liners to cross international waters in a race for comfort, safety, and speed. A century later, in competition with the airplane, the mythical transatlantic epic seemed obsolete and the routes were transformed into cruises, but these seafaring palaces remained. Looking back at the posters of yesteryear, in the life on board, in these crossings, there still seems to be a singular suspension of time.

FACING PAGE: FIG. 175

The *Queen Mary* leaving the British coast from Southampton, 1936.

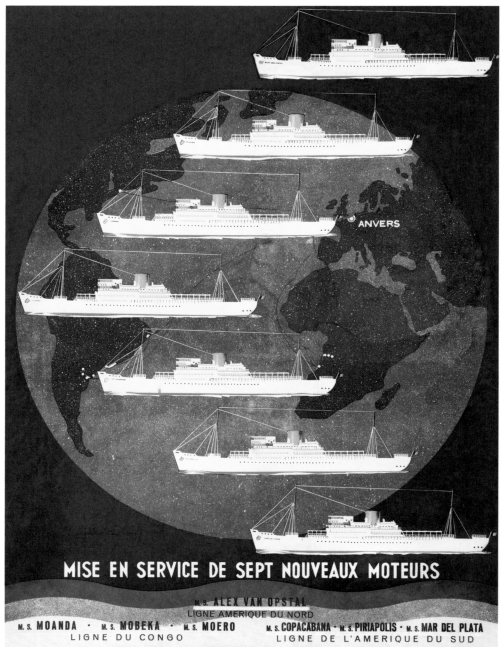

MISE EN SERVICE DE SEPT NOUVEAUX MOTEURS

M.S. ALEX VAN OPSTAL
LIGNE AMERIQUE DU NORD

M.S. MOANDA · M.S. MOBEKA · M.S. MOERO M.S. COPACABANA · M.S. PIRIAPOLIS · M.S. MAR DEL PLATA
LIGNE DU CONGO LIGNE DE L'AMERIQUE DU SUD

COMPAGNIE
MARITIME
BELGE
PASSAGES ET FRETS POUR TOUTES DESTINATIONS

G. FREDERIC.

FIG. I

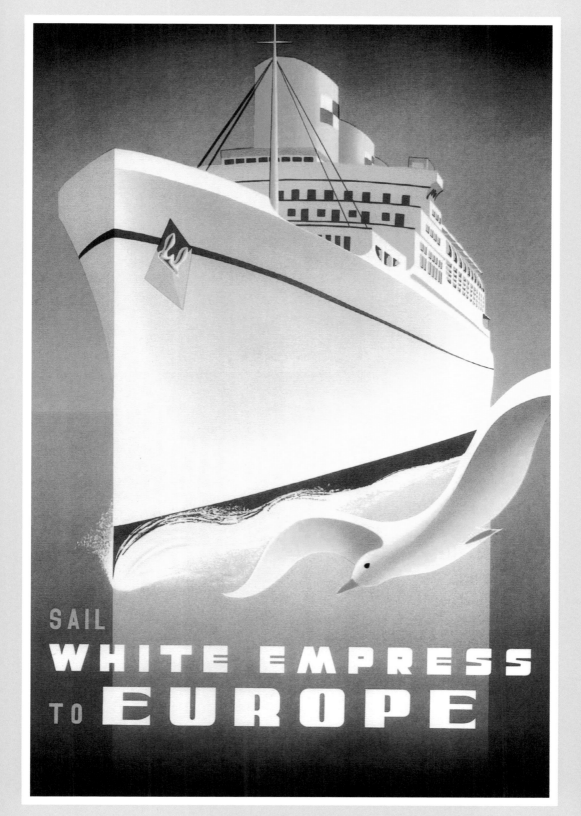

FIG. II

FIG. III

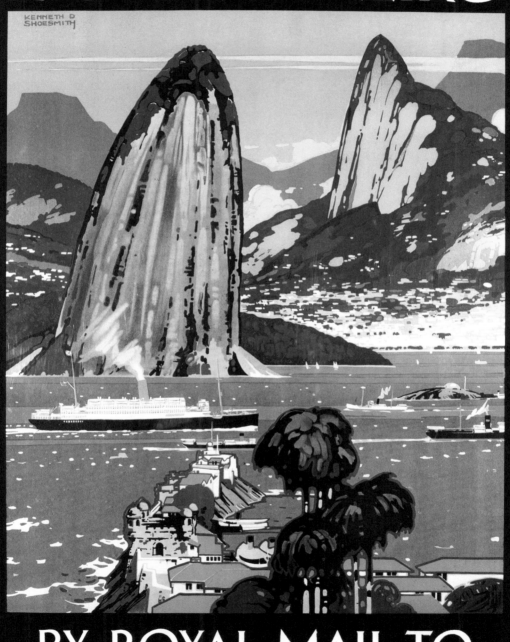

RIO DE JANEIRO

BY ROYAL MAIL TO SOUTH AMERICA

FIG. IV

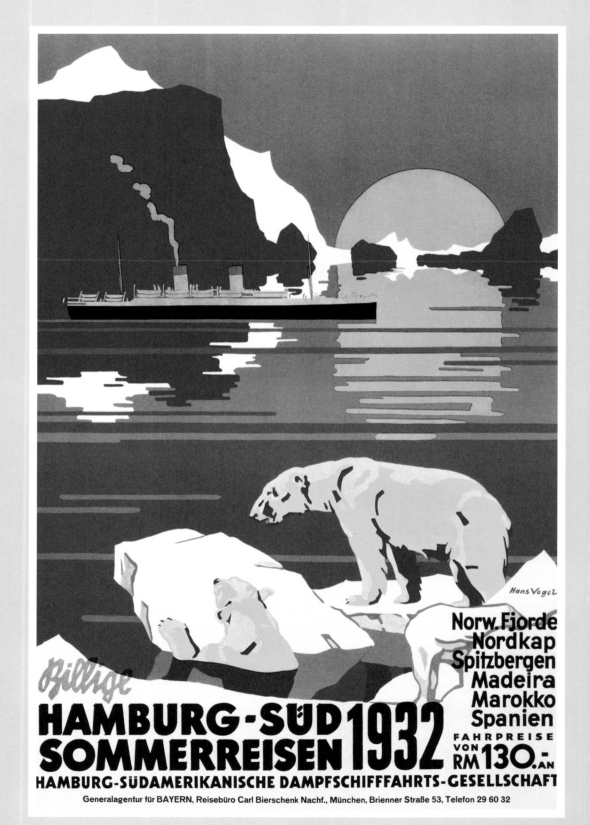

FIG. V

FIG. VI

FIG. VII

FIG. VIII

FIG. IX

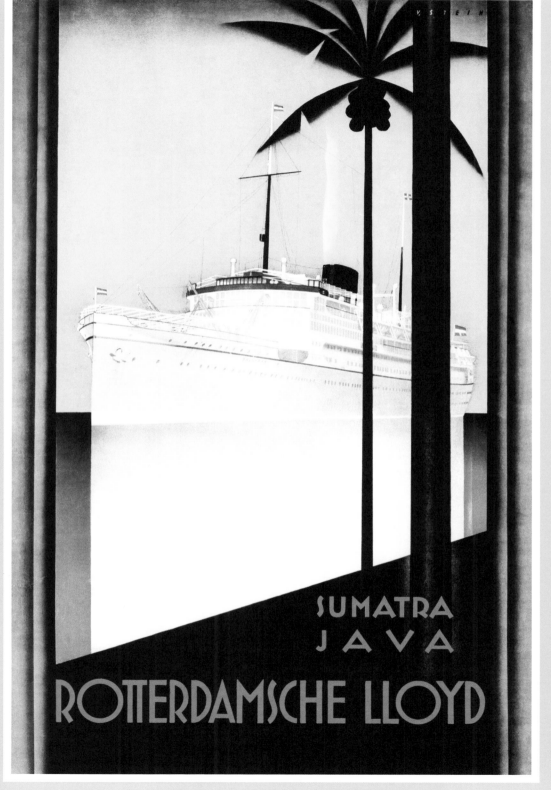

SUMATRA
JAVA
ROTTERDAMSCHE LLOYD

FIG. X

CAPTIONS

FIG. I

G. Frédéric, *Mise en service de sept nouveaux moteurs. Compagnie maritime belge, passages et frets pour toutes destinations*, 1937. Barcelona, Maritime Museum.

FIG. II

Roger Couillard, *Sail White Empress to Europe*, Canadian Pacific Company, 1960. Private collection.

FIG. III

Kenneth Shoesmith, *Cunard Line, Europe—America*, 1930s. Treviso, Museo Civico Luigi Bailo.

FIG. IV

Kenneth Shoesmith, *Rio de Janeiro by Royal Mail to South America*, c. 1930–35. Private collection.

FIG. V

Hans Vogel, *Hamburg-Süd Sommerreisen*, 1932. Private collection.

FIG. VI

Anonymous, *Canadian Pacific's fleet of steamers bound for China*, c. 1925. Private collection.

FIG. VII

Anonymous, *Around & About Central & South America*, Los Angeles Steamship Company, 1930s. Private collection.

FIG. VIII

Albert Fuss, *Viaje alrededor del mundo 1936, desde el 11 de enero hasta el 24 de Mayo con el vapor de lujo de tres helices "Reliance", Hamburg-Amerika Linie* [Travel the world 1936, from January 11 to May 24, with the luxury three-propeller steamer "Reliance"], 1936. Barcelona, Museu Marítim.

FIG. IX

Mario Puppo, *Home Lines. Argentina—Homeland, 2 salidas mensuales para Canada y New York* [2 monthly departures for Canada and New York], 1947. Barcelona, Museu Marítim.

FIG. X

Johann von Stein, *Sumatra Java, Rotterdamsche Lloyd*, 1931. Private collection.

FACING PAGE: FIG. 176

A couple of passengers enjoying the view from the front of a freighter, 1930s.

33

HOME PORTS

———

The Industrial Revolution transformed
maritime trade. The steel giants also
took adventurers on board.

Merchant crafts have been integral to trade between nations for
centuries. Thanks to them, goods and cultures were exchanged
and sometimes even an entire civilization came into being on
distant shores. But the Industrial Revolution was to transform
simple ships into gigantic island-vessels, sea monsters capable
of transporting the widest range of products, goods of all sorts.
Gone were the round-bellied boats adorned with swan's neck
figureheads. Now was the time of specialized vessels, behemoth
cargo ships made for seasoned sailors, globetrotters, loners,
and dreamers of another time, influenced by travel writers and
their extraordinary journeys.

Joseph Conrad shared with others a taste for long-haul
journeys, boarding a Scottish cargo ship in Marseille in 1878,
and, on the same occasion, distancing himself from some
murky business to do with arms trafficking and obscure peri-
ods of his past. Years later, Jack Kerouac set sail on a cargo-
carrying troopship crossing the Atlantic, performing scullion
duties in the galley. Both he and Conrad spent their seafaring

FIG. 177
Ara Güler, *A Sailor Repainting a Ship's Anchor, Karaköy Port District, Istanbul, 1954.*

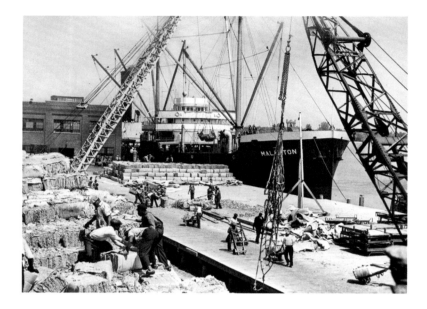

journeys in a waking dream, coming to grips with the mysteries of the world that they discovered at each port of call, each departure and arrival, enthralled by the everyday life of sailors, yielding to the very special rules of these unique vessels. For those who embark on them have to be prepared to share life on board, to let the merchandise take precedence, to live with the rumblings of the engine and the smell of fuel, to follow a straight route, the quickest, which faces up to all weather and never shirks violent seas. Passengers must respect the crew's habits, accept the obligatory ports of call, disembarking far from town centers, captains who focus solely on loading and unloading, who do not wait for latecomers, and who are in sole charge of their passengers' freedom.

The notion of travel changed completely with these steel giants, be they petrol tankers, cable layers, banana boats, icebreakers, supply ships, or oceanographic ships. Their presence

FIG. 178
Margaret Bourke-White, *Dockers unloading wood shipments for a paper mill*, 1939.

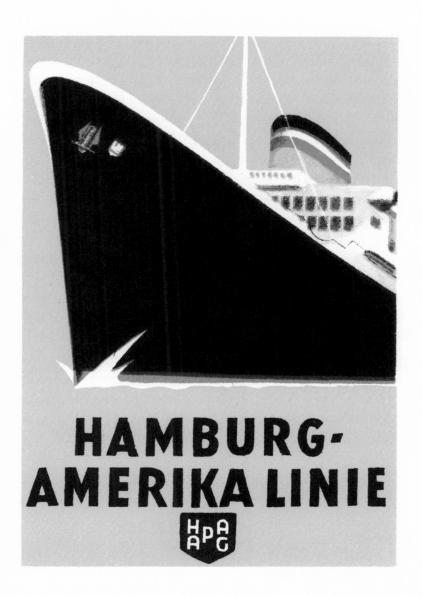

FIG. 179

Advertising label for the German shipping company Hamburg-Amerika Linie,
which had agencies in Cherbourg and New Orleans, among others, 1930s.
Paris, Gaston-Louis Vuitton collection.

conjures up infinite space, rich in sensations and new encoun-
ters. These cargo ships are a means of transport and locomo-
tion, for sure, but they are also extraordinary symbols of power,
the quintessence of maritime engineering. They are highly
technical and immensely complex, and mark a turning point
in shipbuilding. Stopovers are a race against the clock, ports
of call transforming vessels into vast hives of activity, full of
images, colors, smells, and music from distant ports, busy with
crews, young for the most part.

For the writer Joseph Conrad, every instant was a mix of
amazement and nostalgia aboard these extraordinary vessels
that carry their cargo on all seas, bringing prosperity to the
world and marrying the charm of a slow, steady pace with diz-
zying strength. The adventures he recounts have a salty flavor,
as dizzying as a drug. They celebrate the communion of the
wind, the waves, and the power of these cargo ships laden to
the hilt, taming the immensity of the oceans. These vessels
take us on real and imaginary voyages that pass by Gibraltar,
follow the coast of Portugal and Spain, and cross the Gulf
of Gascony, or follow the legendary trade routes opened up
by Marco Polo and Vasco de Gama. They reinvent escapism and
poetry, advancing beneath the heavenly vault at their own pace,
and tracing legendary shipping routes.

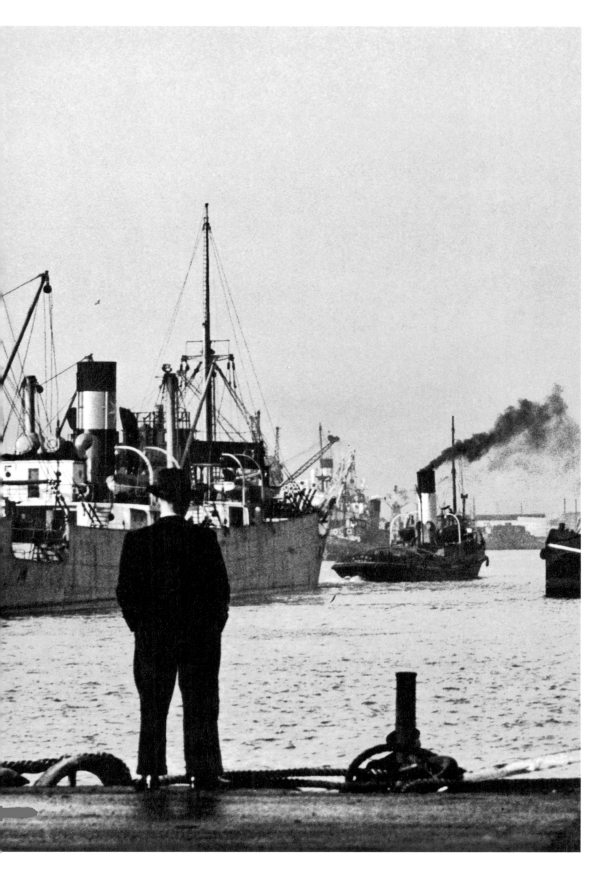

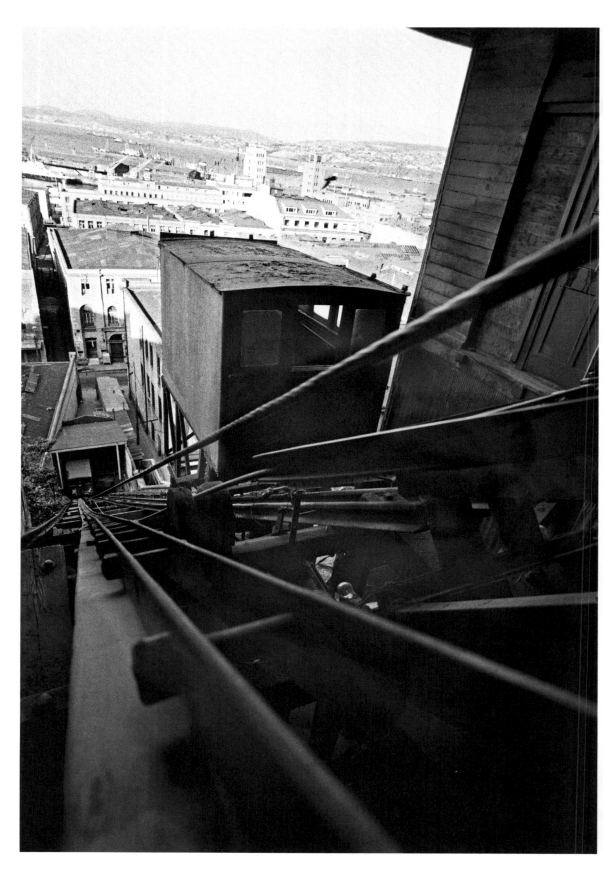

34

ELEVATOR FOR VALPARAISO

———

THE GREAT CHILEAN PORT TEEMS
WITH FUNICULARS THAT PROVIDE ACCESS
TO THE SURROUNDING HILLS.

Just one glance at Valparaiso and the numerous hills around its bay is enough to realize that the only way to approach such exceptional geography is with a similarly exceptional means of transport. This Chilean city is rife with ludicrous labyrinths and topographical oddities. Seawater is channeled through hidden recesses of the town's streets and squares. Stairways cling on, twist and turn, defying the rules of architecture. Those venturing among them soon lose their way. Cars have an advantage, but they are not really suited to climbing these hills, which are often tremendously steep. Horses and other animals able to climb also suffer on these crazy slopes crisscrossed by tortuous lanes. Walking is far from restful. Climbing to the top of a hill and back down again is like an expedition in itself. Funiculars, known locally as *ascensores* (elevators), specially adapted to the hills, are the answer. They allow you to rise above the urban chaos, cross the hills painlessly, sheltered from the wind and rain, find your way without worrying

FIG. 182
Sergio Larrain, *From the Cordillera Ascensor, Valparaiso, Chile,* 1963.

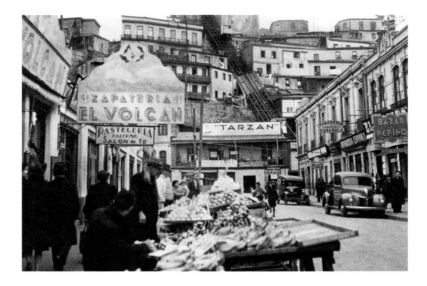

across the jumble of streets, passages, stairways, and hidden galleries that make the slightest journey difficult.

The funicular is a sort of moving chamber, climbing and descending the hills rapidly, as if propelled by a magical force. The construction of the first *ascensor*, that of Concepción, began in 1883 and linked Mount Concepción, the most emblematic of the hills around Valparaiso, with the lower part of the city, the port where sailors, pirates, and privateers used to stop in the days before the advent of traders from Europe and whale hunters barely recovered from rounding Cape Horn. This first *ascensor* marked the city's golden age, the halcyon days of industrial growth. European expatriates, lured by this new El Dorado, were advocates for installing these fabulous machines, providing their know-how, financial means, and new technologies. For these newcomers wished their new lives to be comfortable and practical. They wanted to be able to access their favorite districts easily, far from the rest of

FIG. 183

The Ascensor Concepción, commissioned in 1883, is the oldest funicular in the city. It leads to Paseo Gervasoni and its wonderful lookout point.

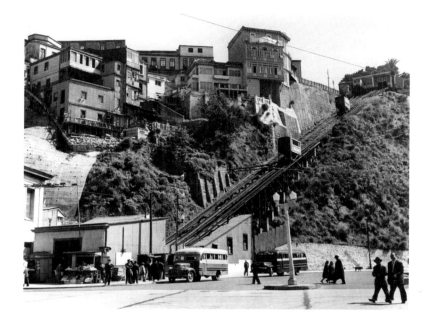

the population, but also to project a good image of the South Pacific's most important port and to develop urbanization.

To achieve this, they threw themselves into the campaign to "sell" these amazing cable cars with such vigor that the newly founded Compañia de Ascensores Mecánicos soon installed them in order to transform the city. Engineers, architects, and town planners were requisitioned and on December 1, 1883, the first funicular was inaugurated in great pomp with champagne and ice cream, and even a brass band playing "The Blue Danube." On that day, the inventor of this first *ascensor*, Liborio Brieba, who also happened to be the city's mayor and a writer, climbed into the first cabin, while other well-known figures held back, less assured, preferring to wait for the next one. The wooden cabins were set in motion thanks to a hydraulic system operated with the help of water reservoirs situated

FIG. 184
The Ascensor Florida connects the Plan (the lower coastal part of the city) to the Florida hill, 138 meters higher up, 1940s.

at either end of the line. It is said that the cabins stopped mid-journey to let the VIPs drink a toast to each other through the open windows. They then continued on to much applause and a shower of streamers.

As for the inhabitants, they took slightly longer to get used to this invention, which many judged to be diabolical. For a short while, they merely watched these "boxes" coming and going, not daring to get into them. But their reticence did not last, and, after several days, there had already been a thousand passengers. The machines even had to be halted for a while, for lack of coal. After ten days or so, ten thousand people had used the new means of transport, which prompted Liborio Brieba to write an article proclaiming: "The public has forgotten its fear." Upper middle-class women adopted the habit of taking the funicular to go for a walk up on the Paseo Gervasoni after shopping in the lower town. The men were pleased to peacefully admire the magnificent ships coming into port. Soon, there was even a photographic exhibition celebrating this magical machine with rails that shot straight up into the hills like arrows. While for some today, the coming and going of the Valparaiso funiculars and the sparks appearing out of nowhere in the night still have something diabolical about them, they remain a different way of seeing and experiencing this legendary city.

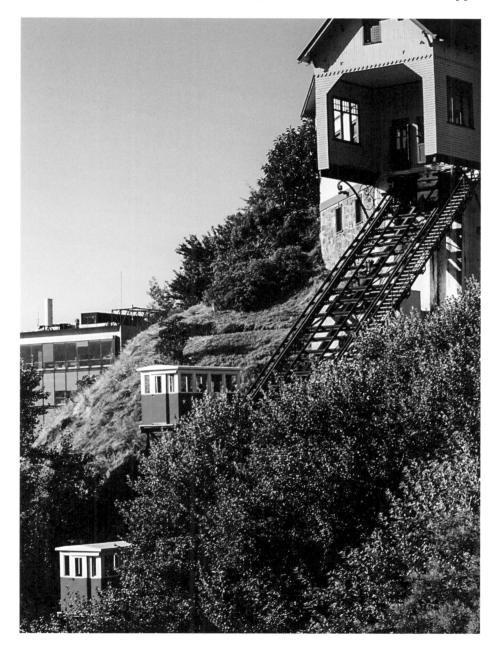

FIG. 185

Thomas Hoepker, *Valparaiso funiculars*, 2017. The city has some fifteen of them,
built during the port's golden age.

35

EXPRESS DELIVERY

———

L'Aéropostale marked a turning point
in aviation with the first commercial link
to the South Atlantic.

The sea plane Blériot 5190, christened *Santos-Dumont* in
homage to the Franco-Brazilian aviation pioneer, was made
by the aeronautical company of the Frenchman Louis Blériot,
who had made his fortune inventing car headlights. Having
produced numerous prototypes that were not always as suc-
cessful as he had hoped, Blériot ended up prevailing over
his competitors admirably by successfully making the first
Channel crossing, in 1909, aboard his first marketable air-
plane—an exploit that would make him known throughout the
world and enable him to develop his company. Aided by ever-
growing investments, Blériot decided to hire famous techni-
cians like the Italian engineer Filippo Zappata, who designed
this seaplane, the main originality of which was to house
the control cabin in a sort of central chimney. This gave it a
strange, rather thick appearance, as if it were carrying a house.
The plane could carry up to sixty passengers and had been
specially designed for transatlantic flights, which enthralled
the major aircraft manufacturers.

FIG. 186
Advertising poster for Aéropostale: "Faster, more economical," 1930s.
Paris, Musée Air France.

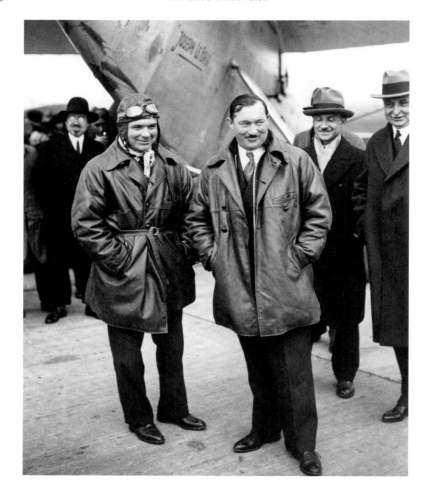

The 1930s were a decade of achievement, "the golden age of aviation," and, despite a succession of fatal accidents, pilots were still willing to cross incredible distances in order to open up new commercial and postal air routes. The most sought after were those across South America, the ideal continent for seaplanes thanks to its many rivers and high mountain lakes. In the space of a decade, technological developments made

FIG. 187

Pilots Lucien Bossoutrot (left) and Maurice Rossi, at the military airport
of Istres-Marseille, February 10, 1933.

huge bounds. After the First World War, mass production and the industrial sector became increasingly globalized and the major aircraft manufacturers competed to build airplanes that were ever cheaper, ever more reliable, and even capable of landing on water. Louis Blériot—an aeronautic pioneer—had his reputation going for him. He knew how to surround himself with the right people, and had the qualities both of an entrepreneur and of a manufacturer, which virtually made him a hero in the aviation world. He was aware that he had to maintain this fame in order to sell his creations, and threw himself into producing ever more innovative machines, which he had the talent to commercialize, for he was also extremely gifted in getting people to talk about him and his work.

With the *Santos-Dumont*—a large seaplane with a metal shell—he looked to distant parts of the globe, becoming interested in regions beyond the horizon, and taking on the transatlantic dream. But not without setbacks. Firstly, the assembly was not as simple as envisaged, and he found himself delayed by major financial problems. Then the test flights seemed to go on forever, and were interrupted by other unforeseen and worrying events, including a fire. Finally, on August 3, 1933, the pilot Lucien Bossoutrot was able to take up the helm of this seaplane and establish the first commercial route across the South Atlantic.

This flight demonstrated the plane's qualities and opened the way to long awaited transatlantic flight routes, also proving that

FIG. 188
Flota Aerea Mercante Argentina airline tag, 1949.
Paris, Gaston-Louis Vuitton collection.

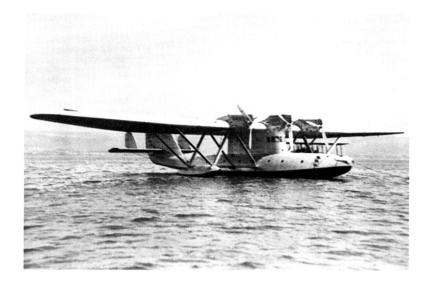

a line like this could operate regularly. This Latin American route was to have many memorable moments, such as when a plane encountered Count Zeppelin's airship over the Atlantic, on its way back to Europe.

In 1935, the *Santos-Dumont* was assigned to the regular postal service between France and South America. At the time, it was the only airplane available for this type of task, and remained so for some while, operating two crossings a week. The regularity with which this service was maintained was admirable, given the flight conditions, the strain put on the engines, and the potential disasters that could occur during a crossing. A magnificent performance from both the aircraft and the crew who, by ensuring this legendary route, ensured a place for the *Santos-Dumont* in the pantheon of legendary machines.

FIG. 189

The Blériot 5190 seaplane named *Santos-Dumont*, c. 1934.

FIG. 190

Advertising poster for the Compagnie générale aéropostale,
connecting Europe, Africa, and South America, 1929.

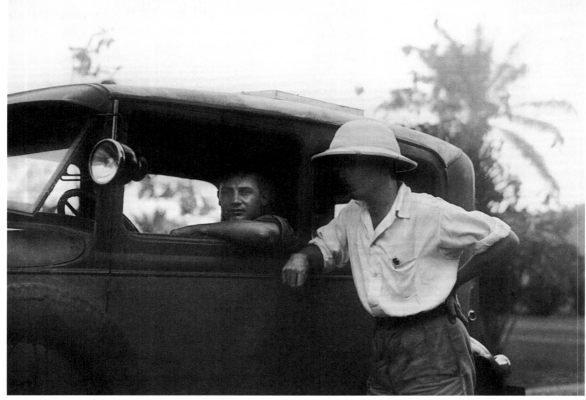

36

KANAGA AND WALU

In 1931, the Dakar-Djibouti mission
ushered in the era of French ethnographic
explorations, Thanks to Marcel Griaule.

The era was one of scientific epics undertaken on horseback, by car and boat, and of Trans-African automobile treks. People dreamed of striding across the same ground as lions, of sailing up Africa's rivers, of beating records using equipment as sophisticated as that described in the books and accounts of explorers. Every day, a new expedition was embarked upon in territories of the utmost beauty, and readers were left hanging on the adventures of these traveler-ethnographers perspiring in the sun, traversing mountains and plains.

People were fascinated by the lives of these young ethnologists who abandoned their comfortable existence to roam these distant lands—men and women who were not content to be bookworms with four-inch-thick reading glasses! The expeditions of the 1930s brought together amateurs and enthusiastic specialists, ethnologists, doctors, linguists, painters, naturalists, writers, botanists, archeologists, anthropologists, and photographers, hurtling onward at the wheels of their powerful cars, capable of mastering every kind of terrain.

TOP: FIG. 191

One of the trucks of the Dakar-Djibouti mission crosses the Pendjari River
on its way from Upper Volta to Dahomey on December 3, 1931.
Paris, Musée du Quai Branly-Jacques Chirac.

BOTTOM: FIG. 192

The ethnologist Marcel Griaule (right) with one of his fellow travelers, c. 1931.
Paris, Musée du Quai Branly-Jacques Chirac.

The Dakar-Djibouti expedition, organized by the ethnologist Marcel Griaule, was one of the most famous missions of the period. It ushered in an era of explorations when unfortunately it was possible to traverse a continent, select a particularly fine object, load it onto one's truck, and leave. But it was also one of the first missions to document the collection of objects in a scientific fashion, postulating that each piece was of interest because it reflected its culture, and that each served a specific purpose.

The ethnological prospection and immersion in these distant lands obviously required shrewd explorers, but also robust vehicles to carry the spoils destined to fill the display cases of European museums and collectors. Objects, plants, and animals were piled into trucks that served both as means of locomotion and treasure trunks and larders, as the writer Michel Leiris said of the Dakar-Djibouti adventure in which he took part as secretary-archivist, comparing the vehicles to a farmyard. And rightly so. They were laden with pigs and chickens intended as meals for the team, a strange jumble of beasts to be stuffed and beasts to be eaten.

For his next mission, this time in the land of the Dogons, Marcel Griaule opted for a lighter set-up with two Renault trucks named Kanaga and Walu, in reference to the Dogon masks painted on the vehicles' fenders. In fact, each truck displayed a reproduction of a rock drawing discovered by Griaule on his first visit to the region. These "coats of arms," which were symbolic for the team, underline the importance the masks had for them as well. For this trip, the members of the expedition were divided between the two trucks, Kanaga and Walu. Everything had been carefully organized and calculated, sharing out the tasks between the vehicles. The route gave

them no trouble for miles, until the region of Tamanrasset, then the vehicles got stuck in the sand several times, slowing progress to a camel's pace. After a lengthy journey across the Sahara, the expedition finally reached the long-awaited land of the Dogons, thus combining a scientific exploration with an automobile exploit. They established their headquarters at Sangha, a village isolated at the top of a sandstone escarpment in the middle of a vast plain, surrounded by brown and ocher lands, where cars and foreigners were a rare sight.

FOLLOWING DOUBLE PAGE: FIG. 193

Members of the Dakar-Djibouti mission built wooden bridges
to cross the rapids of the Pendjari River, December 3, 1931.
Paris, Musée du Quai Branly-Jacques Chirac.

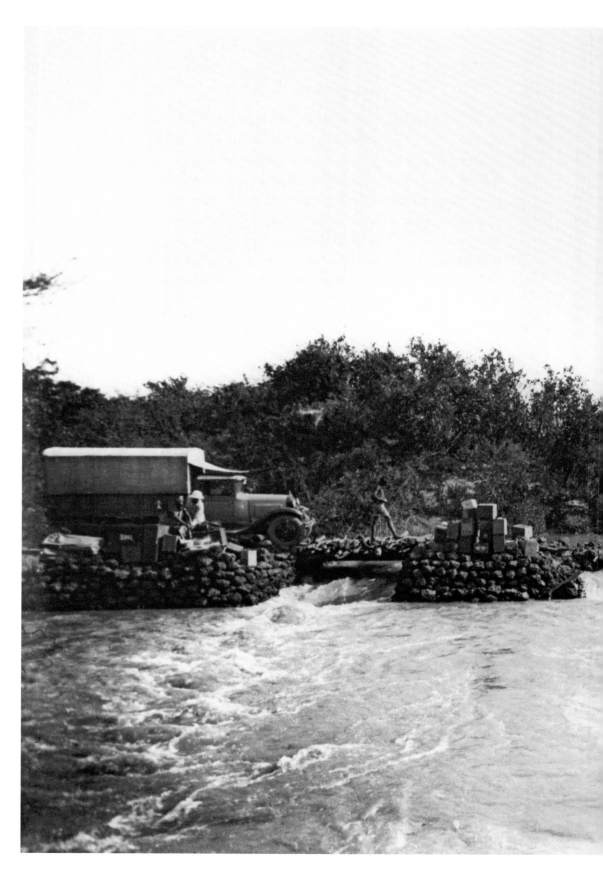

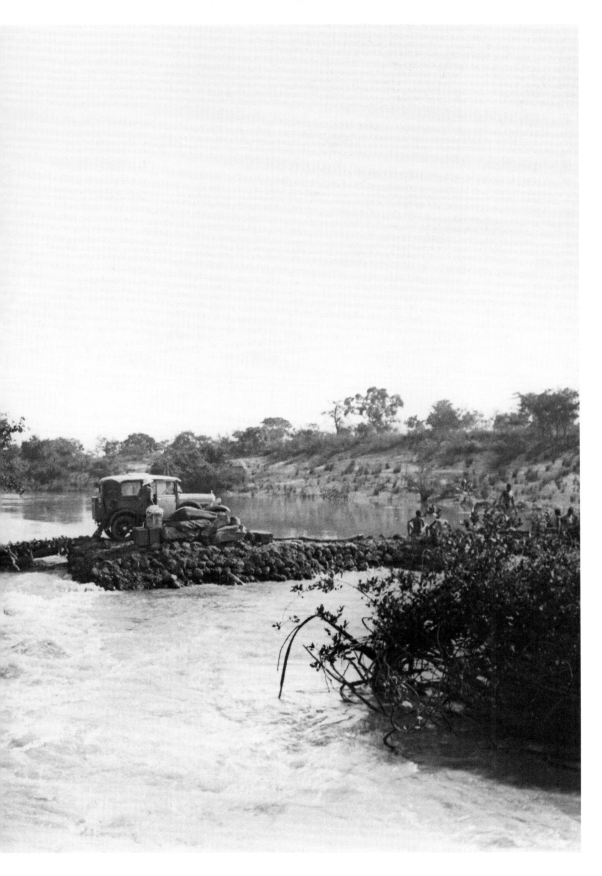

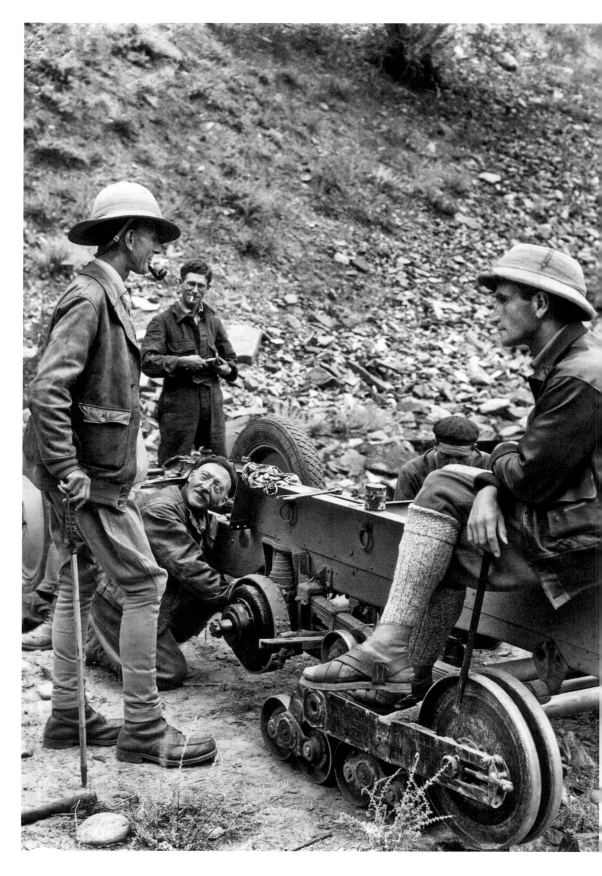

37
EASTERN PROMISE

———

BY LINKING BEIRUT TO BEIJING IN 315 DAYS,
ANDRÉ CITROËN'S JOURNEY ON HALF-TRACK
VEHICLES MADE HISTORY.

"You won't get through!" the British officers controlling the entrance point to Kashmir kept repeating. It was out of the question for the Citroën caterpillar cars to go beyond the village of Astor, in northern Srinagar, one of the most mountainous regions in the world. The crossing was far too difficult and so, on July 22, 1931, after all the effort that had gone into this unbelievable project, it looked like it really might be the end of the road for the French explorers. In April, they were still confident about undertaking the incredible, much talked about journey from Beirut to Peking without too many problems, thanks to their amazing vehicles equipped with caterpillar half-tracks.

Prior to their departure, the vehicles had already been seriously tested, with success, firstly in southern Tunisia and then in the Cévennes, in conditions similar to those they were likely to encounter in Central Asia. Georges-Marie Haardt, general manager of Automobiles Citroën, was equally confident about this project initiated with André Citroën, which set out to follow the silk route. The team had received the support of its tireless

FIG. 194
Repair of a half-track vehicle during the crossing of Kashmir, 1931.

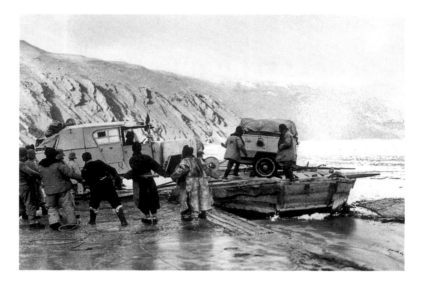

boss throughout every stage of the preparations. At that time, all of France was excited by great expeditions and explorers, and everybody was impatient to see these cars reach places where no other vehicle had ever ventured—something the manufacturer André Citroën understood perfectly and had decided to exploit.

But the expedition that aimed at proving the superiority of these vehicles and, as André Citroën had said, doing away with geographical, cultural, and political borders around the globe, looked as though it would not be able to be completed given the difficulties it faced in Kashmir. Were they going to have to admit defeat because of a high mountain pass? Should they turn back when the goal was almost within their grasp? All those taking part awaited Haardt's decision to know whether, after the vast expanses of arid plateaus, snow-capped passes, steppes, and boulders, they would at last be able to cross the Himalayas. "You won't get through with your vehicles!" is what they had been told.

FIG. 195
Crossing of the Yellow River, which originates on the Tibetan plateau, 1931.

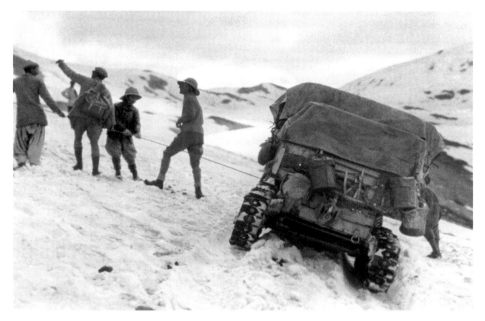

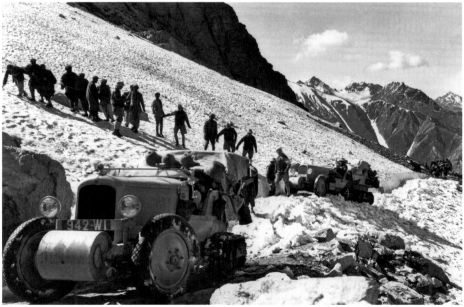

TOP AND BOTTOM: FIGS. 196, 197
Crossing a snowy pass beyond the village of Astor, Kashmir, 1931.

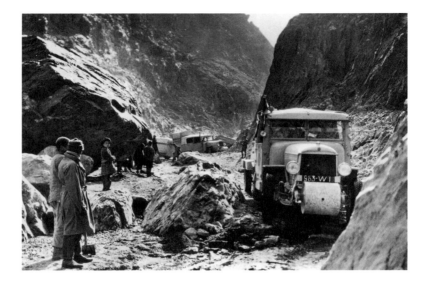

But the cars had been designed to be taken apart and
transported by mules, in order to adapt to the most rugged
terrain, and André Citroën had sung their praises widely, which
had had a huge impact at an international level. So, there was
no question of giving up. They needed to have their load light-
ened, that's all! Haardt was convinced that they could make
it. And they did indeed, albeit with tremendous difficulty, on
corners that had all but collapsed, avoiding crevasses, land-
slides, taking passages cut off from the rest of the world where
other explorers before them had paid with their lives. They
then still had to face snowbound regions and rivers trans-
formed into torrents. At one point, one of the caterpillar cars
was suspended over a void, brought to a halt by falling rocks,
its enormous body balanced between path and precipice.
The team had to wait five hours before finding a way to bring
the two-ton vehicle back to firm ground. At the end of the
day, the men overcame all the obstacles in an unconventional

FIG. 198
During the race from Beirut to Peking,
half-track vehicles cross Toksum Pass on March 26, 1931.

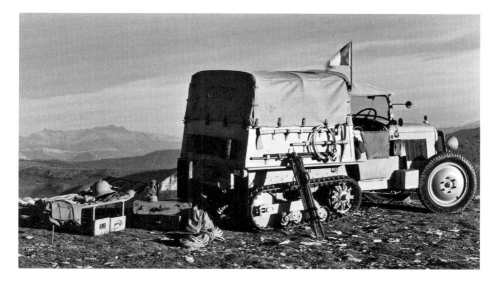

manner, by completely dismantling and rebuilding the vehi-
cles, and carrying the parts on their backs, thus outmaneuver-
ing the unfavorable predictions of the locals and the British
officers, a feat that would make the Citroën name legendary.

On February 12, 1932, at 11 a.m., the heroic caravan of cat-
erpillar cars finally entered Peking after a journey of 315 days,
proving to the world that these vehicles really could meet every
challenge and travel the ancient silk route once taken by Marco
Polo. The spectacle of their arrival would long mark those who
saw it and were able to follow the passage of this unbelievable
procession as it slowly drove its way through streets lined with
pagodas and temples before making a courtesy halt in the dip-
lomatic district, having traversed Turkestan, Xinjiang, the Gobi
Desert—Asia, one of the continents least known to Europeans,
with 7,528 miles on the clock.

FIG. 199

Setting up camp during a stage of the race from Beirut to Peking,
the Vuitton trunk bed has been unfolded on the left, c. 1932.

FOLLOWING DOUBLE PAGE: FIG. 200

Henri Pecqueur, secretary general of the race, and the explorer Georges-Marie Harrdt
at the Hindi camp in Kashmir, c. 1932.

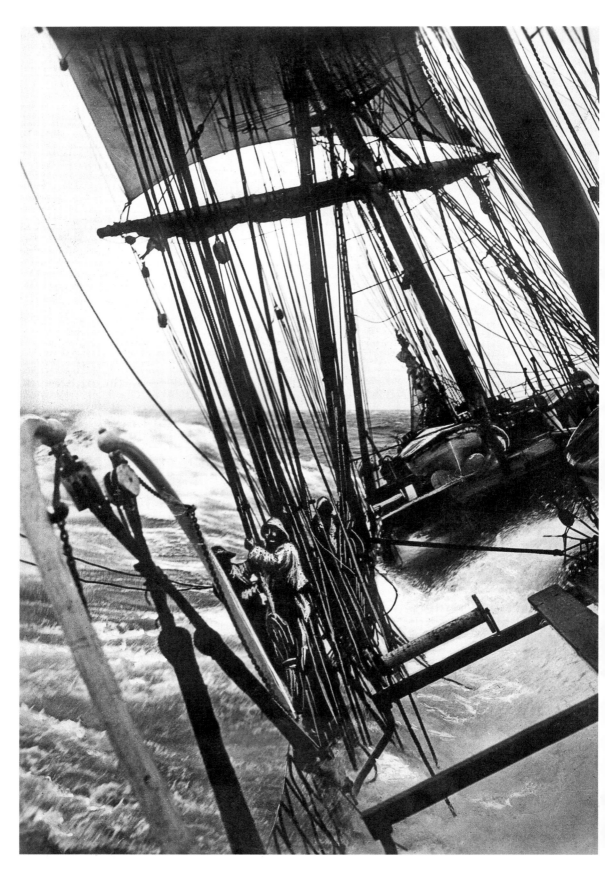

38

AGAINST THE GRAIN

CAPE HORN WAS AN OBLIGATORY—BUT RISKY—
PASSAGE FOR SAILING SHIPS LIKE THE *MOSHULU*,
WHICH CARRIED WHEAT.

The *Moshulu*: a ship with a black steel hull and four masts. In 1939, the tall ship was preparing to take on the most legendary of routes for navigators, that of Cape Horn, which was also the most difficult and most remote on the map. It was not only a question of rounding it, but of doing so before the other competitors. The *Moshulu* was one of the last of its kind that transported coal, wool, wood, and even grain on this route, renowned as one of the most dangerous in the world. These were the last days for commercial sailing ships, a form of navigation that had seen fabulous vessels brave all manner of winds thanks to their heroic crews capable of maneuvering in extreme conditions. The *Moshulu* belonged to the most important commercial fleet, the so-called "floating granary sailing ships," whose sailors were able to put up with the most spartan living conditions, leading a life unlike any other. These magnificent tall ships would soon struggle to rival ships with engines, but on the eve of the Second World War, they were still, for a short while longer, masters of the seas, celebrating

FIG. 201

A four-master passing Cape Horn, 1934.

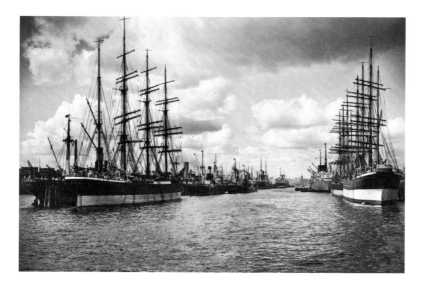

the final hours of a rapidly changing maritime world with their extraordinary adventures.

The *Moshulu* set sail from Belfast in October 1938, heading for Port Lincoln in Australia, with a crew of twenty-eight, a captain, and his second-in-command. At 220 feet from the keel to its highest point, it was the largest tall ship in service at that time. It could take up to 5,511 tons of grain, had a waterline length of 351 feet, and could unfurl 45,000 square feet of sail. Those left standing on the wharf looked like ants when seen from the deck. The crew had to have an ironclad disposition in order to tolerate the long days on such a boat and throw themselves into this incredible race. Once they were underway, the outside world no longer existed, the sea was but one with the sky and the same shade of blue, and there was no other choice but to put up with the cold, wet winds, the menacing swell, the crazy waves, the heavy sail overhead that soon became a gigantic, drenched, ghost-like mass. The ocean offered no

FIG. 202
Commercial sailing ships moored in the port of Hamburg, 1930s.

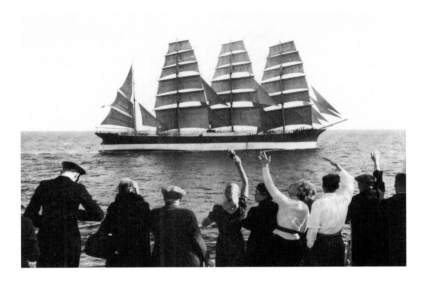

respite and the rolling confused everything, in an infernal din, making the voyage an extraordinary experience, as the English writer Eric Newby recounts, having been a young sailor on this last conveyance.

The journey was always the same: to go and fetch the first wheat harvest in Australia and bring it back to London as quickly as possible. In December, the crew celebrated Christmas in relatively calm waters, with strong alcohol, meat, pâté, canned beef, browned potatoes, apricots, and ginger pudding. A real feast, to which the captain added presents for each member of his crew. They reached Port Lincoln, Australia, in early January, where the sea was calm for a while, and set sail again in March, with close to sixty thousand sacks of grain in the holds. By the time the floating granary began its return journey, the weather was quite different—so grueling, in fact, that the captain was obliged to give his troops some rum to lift their spirits. The swell lifted the ship out of the water, bringing it crashing back down

FIG. 203
Departure of the *Moshulu* from the port of Belfast, 1938.

in terrifying troughs, the waves breaking violently over the deck, furthering the damage. When level with Patagonia, the ship was caught up in a terrible storm and the crew imagined the worst. At the ends of the earth, vessels really were on their own. It was pointless shouting or trying to give orders as sounds were lost in the general commotion, men were just muscles working cease-lessly, to the limits of their strength, never stopping.

On April 4, Cape Horn, the southernmost point of South America, and the most southerly of all the world's large capes, came into view. Here they were before this legendary passage that marked the end of the Pacific Ocean and the beginning of the Atlantic. A milestone which, according to tradition, gave sailors the right to wear a gold earring by way of a trophy. Conditions throughout the rest of the journey were equally grueling, alternating between huge waves crashing over the deck and relative peace, all the way to the final destination. It took the *Moshulu* ninety-one days to reach Fastnet, the "lost rock" to the southwest of Ireland, winning the very last grain race between these incredible floating granaries. It was June 10, 1939, the year that saw the start of the Second World War, and not long before a page of history was turned with the retirement of these ocean warriors.

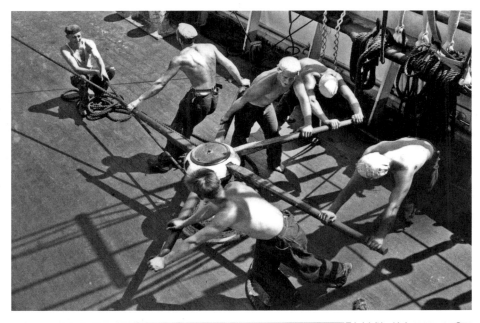

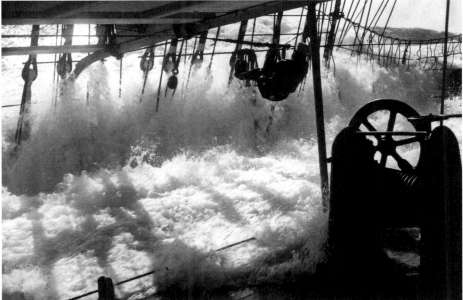

TOP: FIG. 204
Sailors in action shortly before the passage of Cape Horn in the late 1930s.
London, Royal Geographical Society.

BOTTOM: FIG. 205
Storm on the *Moshulu*'s return journey to Queenstown, Ireland, on its final trip in 1938.
London, Royal Geographical Society.

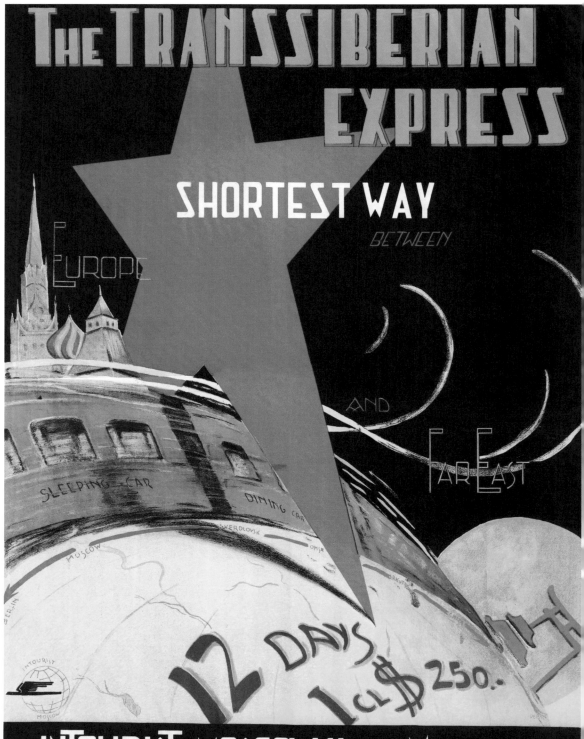

39

RUSSIAN EXPEDITION

———

THE TRANS-SIBERIAN RAILWAY
WHICH CONNECTED MOSCOW TO VLADIVOSTOK
ACROSS MORE THAN 5,600 MILES,
WAS A UNIQUE EXPERIENCE.

It's not a train but a magnificent distillation of the Russian soul. And it's not a railroad track either, but a wonderful route which, in order to exist, had to divert huge rivers, flatten forests, circumvent lakes, take an axe to the most outstanding land-scapes. It was as if this trip, which offered the world's longest, uninterrupted train journey, these carriages, wheels, and axles, this machinery capable of taking on the land of Genghis Khan, had been waiting for the right moment to put an end to centuries of the deepest isolation. How else would travelers have managed to access these vast regions so far from the rest of the world? And who would have thought of doing it, to begin with, other than explorers clad in reindeer skins, a few scientists sent on missions, merchants keen to sell their furs, and men with the appropriate dose of madness?

The idea of a train crossing Siberia was first floated in the 1860s. The project was revolutionary, for when the track was finally open to travelers, the train, or rather trains, that used it not only gave the first passengers a new understanding

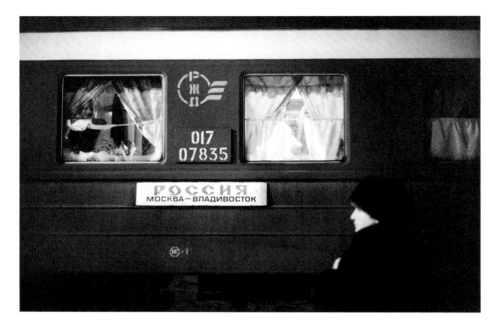

of their country but also another perception of this part of the world. After centuries of being totally cut off from the rest of the world, Russia's far eastern territories were on view to travelers. The first Trans-Siberian passengers discovered a universe which, until then, they had only heard about or seen in newspapers, images by painters, illustrators, and caricaturists.

During the nineteenth century, railway networks developed all over the planet, except in Russia where the main means of transport was still horses and conveyance by river. While these new lines were opening up at a frantic pace in the West—the train had even conquered the American Far West—this technological revolution was slow to come to Russia. The Russians, however, could not exclude themselves from this adventure forever, even if the project seemed mad, even if the climatic conditions were extreme, even if the financial investment

FIG. 207

Patrick Bard, *Le Rossiya, train n° 1 du Transsibérien, en gare de Malinsk*
[The Rossiya, train no. 1 of the Trans-Siberian Railway, at Malinsk station], 2002.

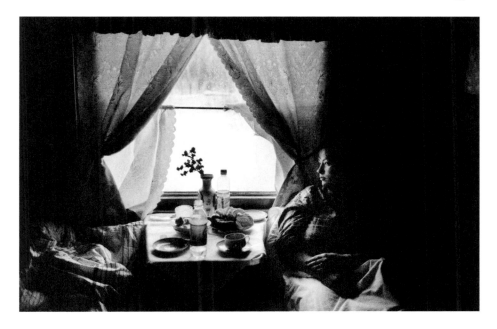

seemed crazy. The isolation could not last any longer. A tele-
graph sent from Siberia at that time, took fifteen days to reach
Saint Petersburg—that was worry enough to convince the Tsar,
who did not want to lose control of his territories and was well
aware of the tardiness of his country in this respect.

The Trans-Siberian Express was to introduce Russians
to unknown provinces of their own country, as well as setting
globetrotters from around the world dreaming. Some of the
train's first passengers were to recount their magical trip in
conferences, books, and accounts, sparking the imagination
of those back home. But the very first to discover this legend-
ary train were visitors to the Paris Exposition Universelle in
1900, where everything possible had been done to "sell" this
unique train and the adventure it offered to the world. After
the colossal, terrifying construction work, it was now time to

Patrick Bard, *Arrêt du Transsibérien en gare de Krasnoïarsk, en Sibérie orientale*
[The Trans-Siberian Railway stops at Krasnoyarsk station in Eastern Siberia], 2002.

dream. Nothing had been forgotten for this initial presentation
to the public, in order to make the magic of the trip as real as
possible: optical effects, panoramas, and slideshows—very
popular at that time—and magical settings. Visitors to the
Exposition could choose to take a seat in the carriages that imi-
tated the train's movement, and many of them did, while panels
with Russian landscapes (animated by a special machine) gave
the illusion that they were skirting the lakes and crossing the
forests of Siberia. The voyage lasted about forty-five min-
utes, passing through Moscow, Irkutsk, and Lake Baikal, with
the Great Wall of China in the background. Visitors felt as if
they really were in the carriage and could therefore appreciate
the incredible comfort! Comfort intended for all, or almost.
There were three classes of carriage: first class, the *spalny vagon*,
second class, the *koupé*, and third class, the *platzkart*. There was

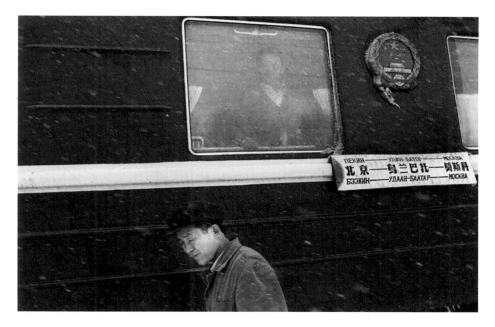

a samovar in each carriage, which enabled people to gather and talk during the voyage, and also a restaurant-car.

In the Bois de Vincennes, another site at which the Exposition Universelle was being held, a Trans-Siberian train was on show with plenty of information for those wealthy enough to envisage such a voyage. How magical! What better way of stirring people's aspirations. And for those adventurers for whom the luxury of the carriages on show might have given the impression of a rather too peaceful trip, history would make them change their minds a few years later, when the train was to play a crucial role during the Russian Revolution in 1917, embodying the spirt and the paradoxes of the Russian people.

FIG. 210

Guy Le Querrec, *Transmongolien à la gare de Kansk Enisieiskulle*
[Trans-Mongolian at Kansk Enisieiskulle station], 1984.

FOLLOWING DOUBLE PAGE: FIG. 211

Véronique Durruty, *Traversée en désert de Gobi en Transsibérien, Mongolie*
[Crossing the Gobi Desert on the Trans-Siberian Railway, Mongolia], 2013.

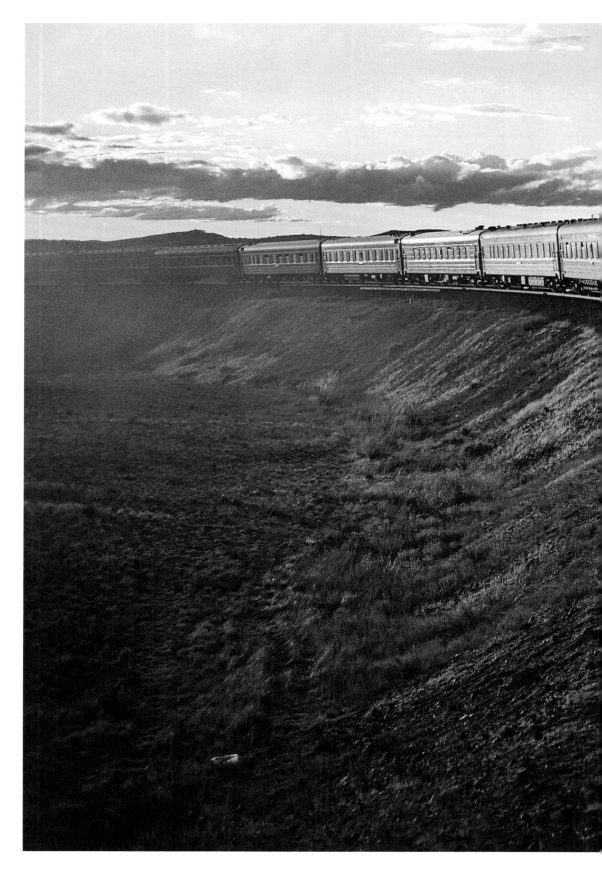

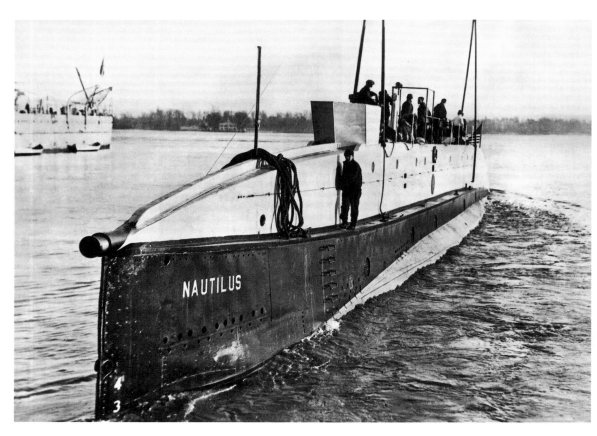

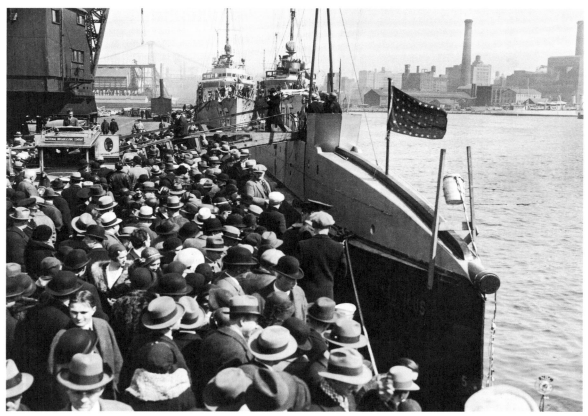

40

POLAR DIVE

———

NAVIGATING UNDER THE ICE
WAS THE CHALLENGE OF THE *NAUTILUS*,
WHICH ATTEMPTED A WORLD FIRST
AT THE NORTH POLE IN 1931.

The route was not overland but underwater, and the landscape was neither charming nor bucolic, but harsh and cold, both in terms of surroundings and atmosphere. By the 1930s, the passionate, relentless race for the poles was underway in what was undoubtedly mankind's last great adventure prior to the conquest of space. The North and South Poles constituted frozen continents and whichever nation owned them would have access to the resources they offered, while considerably enlarging its territory. The world had more or less been mapped by then. These frozen continents were known to have variable contours that changed with the seasons, to be made up of floating ice, and, contrary to what certain people thought, were not inhabited by dragons. Nevertheless, their exact dimensions and the depth of their waters remained a mystery that the most audacious, or reckless, wanted to be the first to elucidate. What was the precise extent of the Arctic Ocean? Was it true that the Arctic Basin was a large hole in the Earth? And what kind of life might one expect to find in these waters?

TOP: FIG. 212

Immersion of the *Nautilus* en route to its North Pole expedition, 1931.

BOTTOM: FIG. 213

Launch of the *Nautilus* on a dock in Brooklyn, New York, in the presence of Sir Hubert Wilkins, head of the expedition, and Jean Jules-Verne, grandson of the writer, who came for the occasion, 1931.

Those who had endeavored to answer these questions had frequently undertaken suicidal missions, and it was no different for the Australian explorer Sir George Hubert Wilkins who aimed to pierce these frozen waters with his submarine, despite his total lack of qualification for this type of adventure. Wilkins came from a family of sheep farmers in southern Australia and moved to England in 1908 where he became a pioneer of aerial images, working for Gaumont. After Charles Lindbergh's exploits, he became passionate about aviation and flew over the Arctic, which brought him fame and even a knighthood from the King of England. This recognition helped him realize his own project, which he managed to get financed by Lincoln Ellsworth, a wealthy patron and polar explorer, and by the American press magnate William Randolph Hearst. The latter, however, was determined to get a scoop for his newspapers and to be able to publish a daily account of the expedition, sent by wireless from the submarine. He also wanted Wilkins to write a book about the voyage, which he would publish. This financial backing, therefore, added a fair amount of pressure to the adventure, particularly as transforming an old First World War submarine into a floating laboratory took far longer than anticipated.

In June 1931, after years of trials, and because the press was beginning to grow tired of waiting, it was finally decided to launch the vessel. Wilkins had been strongly influenced by the work of Jules Verne and his *Nautilus*—hence the name of his ship—and fully intended to be the first to navigate beneath the ice floe. But reality soon caught up with him as the journey had barely started when the *Nautilus* had to face a terrible storm in the North Atlantic. Ten days after its departure, it was forced to send an SOS and to be towed to Ireland by a

US navy battleship. It took to the sea again a while later and headed for Norway, proceeding on the surface, but as the inside of the submarine was not heated or insulated, the *Nautilus* was soon covered in ice, both inside and out. It finally reached the ice floe around the 82nd parallel north—the most northerly latitude ever reached by a self-propelled ship at that time—and prepared to submerge. But there again, an unpleasant surprise awaited Wilkins when the underwater diver, who had been sent down to examine the hull, came back up announcing that it would be impossible for the submarine to submerge because there were no longer any diving planes on the rudder. Had they been sabotaged, and if so, by whom? It was impossible to tell. Hearst only wanted to lend his support to the expedition if the *Nautilus* dove under the ice in the North Pole. So, the vessel dived, as decrepit and ill-prepared as it was, sliding under a frozen fragment about three feet thick and resurfacing some five hundred miles from the North Pole, becoming, for a few moments, the first submarine to have navigated beneath the ice floe. Moments that were not to be repeated, for some parts of the boat had been damaged when submerging and the crew's life was now in danger. It was a failure from Hearst's perspective. Having failed to get the fantastic scoop he had dreamed of, he withdrew his support for Wilkins, who had nonetheless made history on board a vessel that was ill-prepared, dangerous, and equipped with outdated, deteriorated equipment, but that somehow managed to return from these vast frozen depths.

Cᴵᴱ AIR UNION LIGNES

D'ORIENT

41

BUSINESS CLASS

———

WITH THE *DEWOITINE 338*, THE JEWEL
OF ITS FLEET, THE AIR FRANCE AIRLINE,
NEWLY CREATED IN THE EARLY 1930S,
TOOK OFF.

It was one of Air France's jewels at the end of the 1930s. However, the furnishings were fairly austere! Early on, passengers were seated in simple wicker armchairs, air conditioning consisted of individual fans, and baggage racks were made of metal and netting. Luckily, there was a bar and it was made of mahogany. The airplane, the Dewoitine D.338, was said to be elegant, perform well, and vary its capacity according to use—qualities that not all its competitors possessed. It had a cruising speed of up to 155 mph and offered passengers the latest technological developments. It could take some twenty passengers for European flights, fifteen for the Toulouse–Dakar route, and eight to twelve for the East Asian one, where passengers were provided with seats that transformed into sleeping berths.

When Air France was founded in 1933, it was up against tough competition and was constantly having to acquire better airplanes and increase its list of destinations. Having been impressed by the prototype of the Dewoitine D.338, which was considered incredibly modern, the company decided to

FIG. 214

Poster for the French airline Air Orient, which operated flights between
Marseille and the Middle East and Asia, 1929.

purchase it. At a time when long-distance air transport was still something of an adventure and many people were scared by it, technical excellence and security were not to be ignored. In fact, everything to do with flight technology, at that stage, was a huge mystery for most travelers who had never even considered the idea of flying. While trains and boats were used by everyone, providing unbeatable value for money, airplanes remained relatively inaccessible as a means of transport for the general public, who tended to focus instead on the problems associated with it: turbulence, danger, accidents. Furthermore, passengers had to put up with all manner of climatic vagaries and not mind even having a change of route in mid-flight. Some pilots were said to have no qualms about deviating from their flight plan in order to admire a landscape or carry out technical repairs. Not to mention the change of seasons that sometimes made aerodromes unusable on the more exotic lines.

One point, however, made even the most recalcitrant members of the public think twice, and that was speed. Air France and all the other airlines were well aware of this and were continually offering the most tempting services and the fastest possible flight times. With its new acquisition, Air France would not only develop its most famous regular route at that time, between Europe and Asia, but also offer flights with stopovers every 1,250 miles or so, which considerably helped in reducing the duration of the overall journey time. As a result, it took passengers "only" six days to reach

FIG. 215
Air France airline tag, 1957. Paris, Gaston-Louis Vuitton collection.

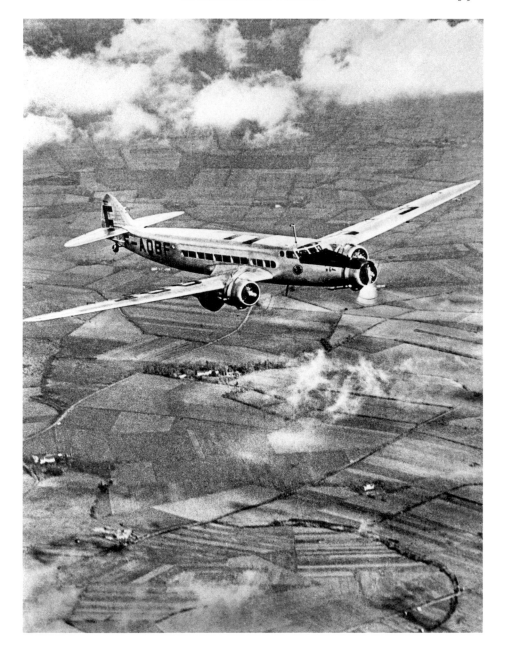

FIG. 216

A Dewoitine D.338 flies over Europe to Hong Kong, 1930s.

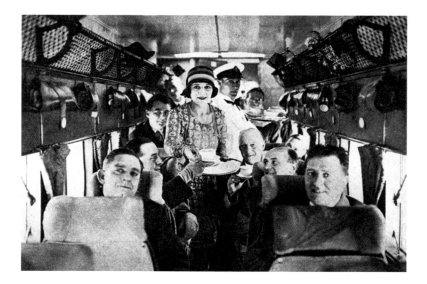

Hong Kong from London, or seven if leaving from Marseille. Over time, these journeys became increasingly comfortable, installed in a cabin that was well insulated, well ventilated, and reasonably silent. However, the flight was not exactly restful and only happened during the day, the nights being spent in hotels in the various stopovers. But what a voyage! With the Dewoitine D.338, Air France really took off. It was one of the jewels of the company's prewar fleet, featured in its advertisements, on postcards, and on stamps in sky-blue tones hinting at never-ending panoramas, discovered, as if by magic, with each stopover. This airplane soon came to be associated with East Asian destinations—Hong Kong, "the fragrant harbor," Saigon, not yet known as Ho Chi Minh City—and with flights that figured on all the early Air France world maps designed by the illustrator Lucien Boucher, showing vessels, sea monsters, wind roses, and two Dewoitine D.338s flying toward new worlds with an enchanted stroke of the pen.

FIG. 217
Cabin service at tea time on a flight from London, 1934.

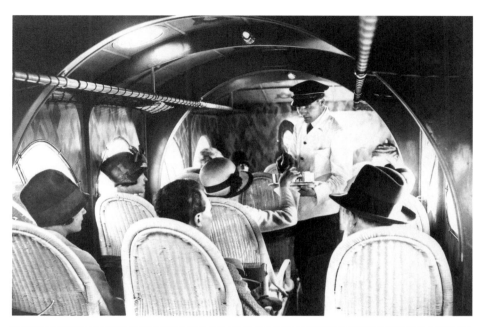

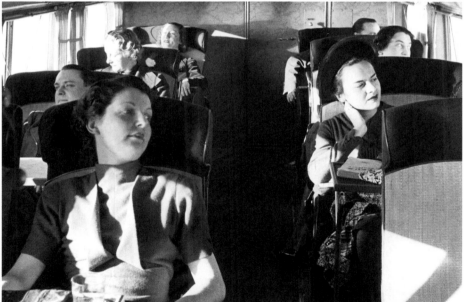

TOP: FIG. 218

Cabin of the D.338 equipped with wicker seats and net luggage racks, 1930s.

BOTTOM: FIG. 219

Passengers on a Berlin-Cologne-Paris flight, aboard a D.338, 1939.

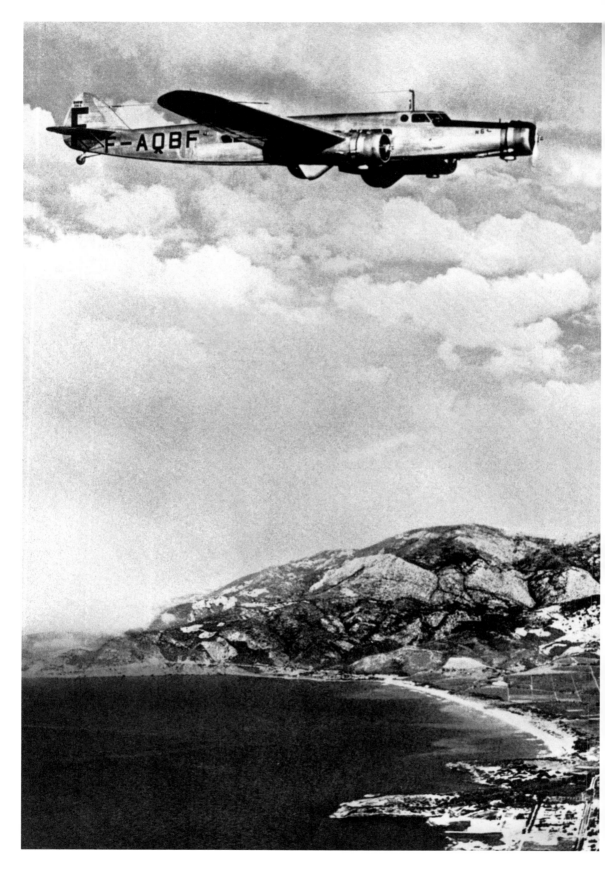

THE AIRCRAFT,
AN IMAGINATION AWAKENED

During the twentieth century, military research led to revolutionary advances in commercial civil aviation, mail, and passenger transport. Alongside the manufacturers, the pioneering pilots opened the legendary lines: over the North and South Atlantic, to West and Equatorial Africa, to the Middle East and Asia. The birth of the major airlines was marked by confidential communications inviting a certain elite to the aerial dream. These posters, realized when leading names were often commissioned to create illustrations for advertisements, elevate a savoir faire through art and allegory. While the era glorifies the machine, the airplane gives way to the immensity of the sky and the splendor of the earth. The gaze then turns to new horizons, and the imagination they awaken.

FIG. I

FIG. II

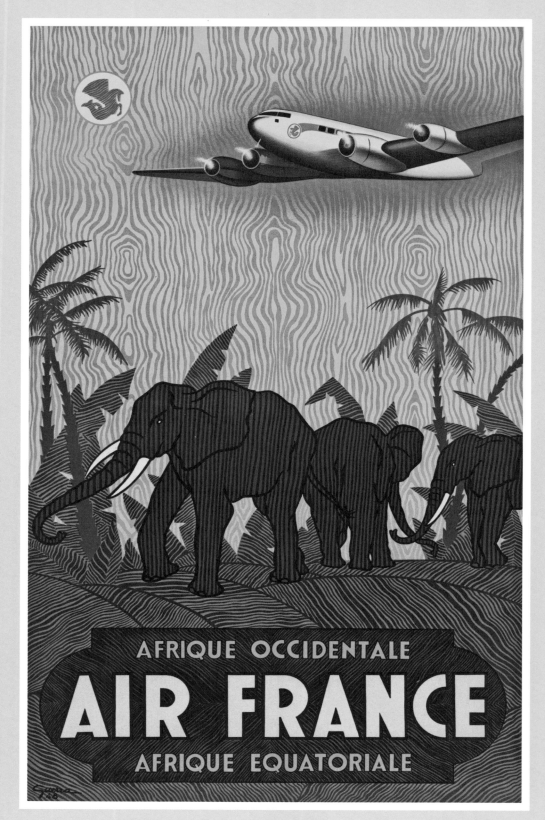

AFRIQUE OCCIDENTALE
AIR FRANCE
AFRIQUE EQUATORIALE

FIG. III

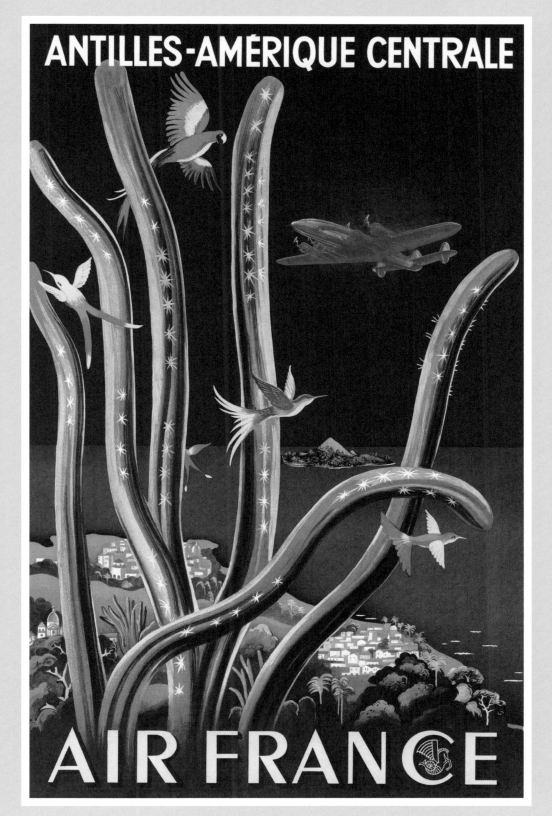

FIG. IV

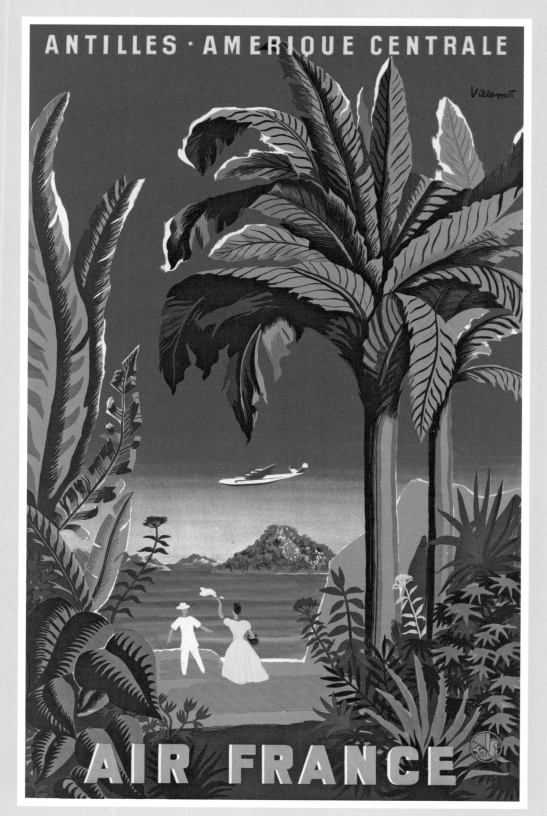

FIG. V

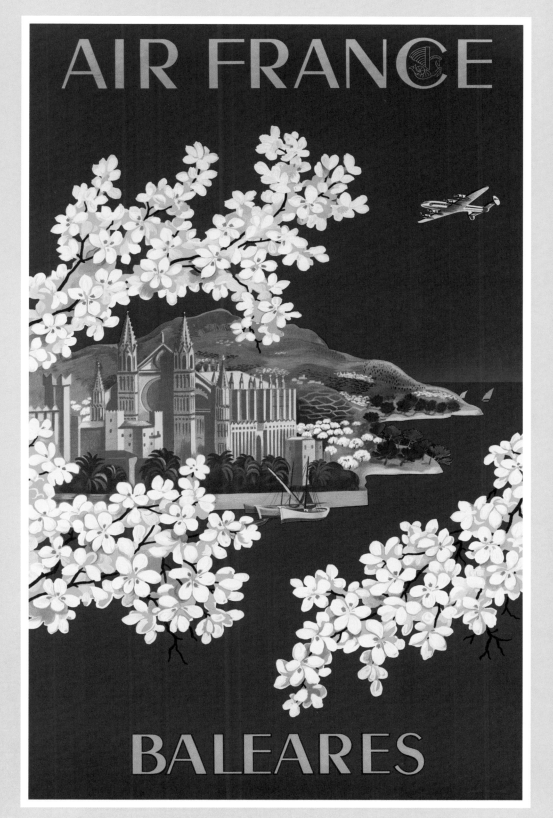

FIG. VI

FIG. VII

FIG. VIII

FIG. IX

...a very small world indeed!

PAN AMERICAN

FIG. X

CAPTIONS

FIG. I

Badia Vilato, *Air France,
dans tous les ciels*, 1951. Paris,
Musée Air France.

FIG. II

Lucien Boucher, *Air France,
Orient—Extrême-Orient*, 1946.
Paris, Musée Air France.

FIG. III

Vincent Guerra, *Air France,
Afrique occidentale—Afrique
équatoriale*, 1948. Paris,
Musée Air France.

FIG. IV

Lucien Boucher, *Air France,
Antilles—Amérique centrale*, 1948.
Paris, Musée Air France.

FIG. V

Bernard Villemot, *Air France,
Antilles—Amérique centrale*, 1948.
Paris, musée Air France.

FIG. VI

Lucien Boucher, *Air France,
Baléares*, 1951. Paris,
musée Air France.

FIG. VII

Anonymous, *Brazil, Braniff
International Airways*, 1950s.
Private collection.

FIG. VIII

David Klein, *India Fly TWA Jets*,
c. 1955–65. Private collection.

FIG. IX

David Klein, *New York Fly TWA*,
1956. Private collection.

FIG. X

Paolo Garretto, *A Very Small
World Indeed!*, Pan American,
1960s. University of Miami
Libraries.

FACING PAGE: FIG. 221
Air France passengers disembark at Roissy airport, 1957.

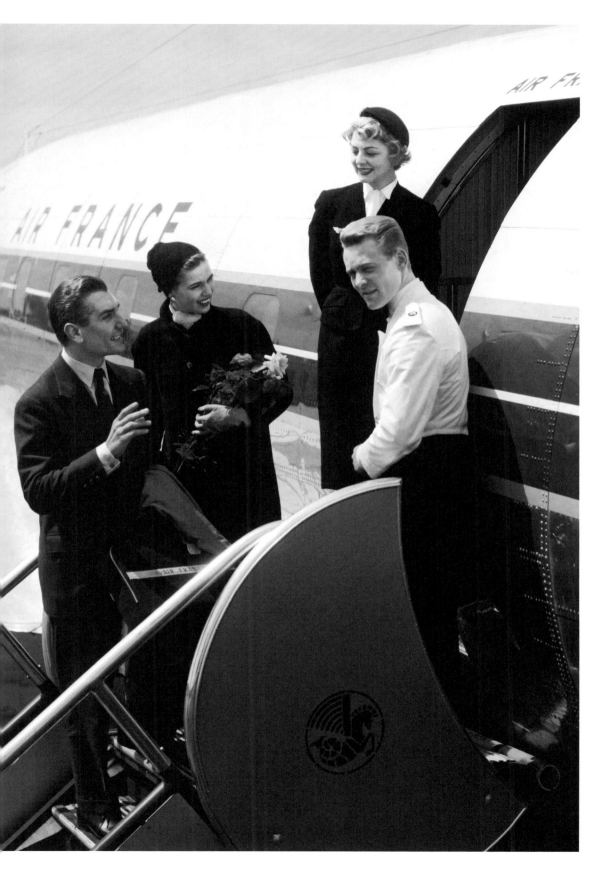

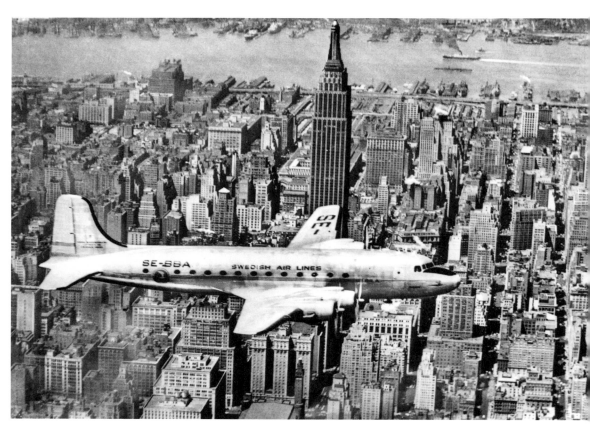

42

TWENTY-FOUR TRANSATLANTIC HOURS

———

In 1946, the Paris-New York route,
the line of the lords, was completed
in a single day thanks
to the DC4.

It was exactly midday in New York when the Douglas DC-4 from Orly touched down at La Guardia after a historic flight of 23 hours and 45 minutes. The airplane left Paris at 7 p.m. on a beautiful summer's eve in 1946. On board, the passengers were inaugurating both the airplane and its emblematic airline, the former already much talked about, unique in the history of commercial aviation, born of an agreement between a manufacturer and five major American airlines. For that matter, the manufacturer was unique too. His name was Donald Douglas, from Brooklyn, and in the 1920s, he had built an airplane for another American, David Davis, who intended to make the first non-stop flight across the United States. The construction of this plane took over a year and its attempts at making the crossing proved a failure, with some of the pilots nearly dying during one of them.

In the end, the United States crossing was accomplished by other crews, but the project gave rise to a new aeronautical constructor, the Davis-Douglas Company, in which the US Navy

TOP: FIG. 222

A DC4 flies over the East River, with the Empire State Building in the background, shortly before landing at La Guardia, 1946.

BOTTOM: FIG. 223

Cockpit of a United Airlines DC4, 1947.

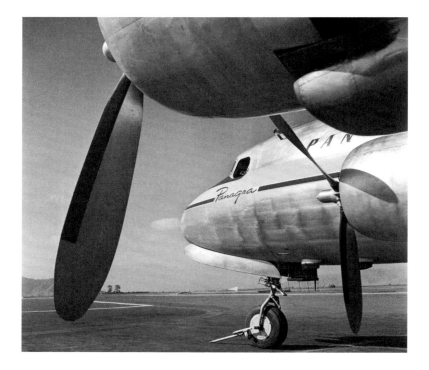

took a serious interest. So much so, in fact, that it purchased several of its airplanes, opening the door to a highly successful collaboration. Thus, the creation of the future DCs was just a matter of time. In the 1930s, a project for an airplane with four engines emerged in the offices of Douglas and Davis, who began to give it serious thought. They imagined an aircraft that was technically outstanding and far larger than its predecessors, that would revolutionize global air transport. It would be the famous DC-4, capable of flying non-stop from Chicago to San Francisco. Not only was it extremely complex technologically, but it also focused on the comfort of its passengers, with air conditioning, razors and electric curling tongs made available to all, closets for storing clothes, access to bathrooms and even shower rooms.

FIG. 224

A Pan American Grace Airways DC4 on the tarmac
of La Paz airport, Bolivia, 1947.

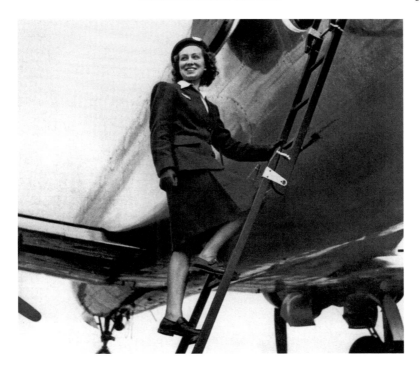

The cabin itself could welcome up to forty passengers during the day, and thirty at night on bunks. But if there was one innovation that particularly enchanted passengers, especially men, it was the introduction of air hostesses in 1931. For onboard this unique aircraft and on this emblematic airline, known as the "airline for lords," everything had to be perfect. This Paris–New York flight proved to be the perfect opportunity to welcome on board the first French air hostesses, born, as it were, at the same time as the airplane that they were to look after. The recruitement criteria demonstrates they were expected to possess just about every idealized quality. Thus, they had to be between twenty-one and thirty years old, measure between 5' and 5'4", weigh no more than 143 pounds,

FIG. 225

Stewardess Madeleine Thilphouse, dressed in one of the first uniforms created by a fashion designer for Air France, poses on the emergency ladder of a DC4, 1947.

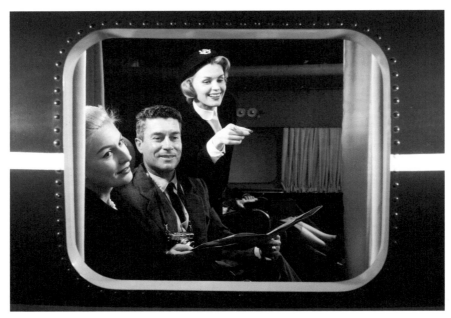

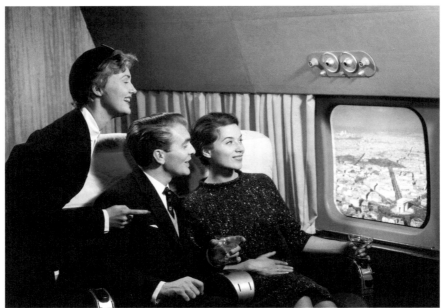

TOP AND BOTTOM: FIGS. 226, 227

First class service on board the new Air France aircraft, 1957.

and have a waistline no larger than 27.5 inches. It goes without saying that they had to be morally irreproachable, preferably pretty, or at least pleasant to look at, elegant, educated, resourceful, speak at least two languages and, on top of all that, capable of acting as nurses if required.

In short, they were expected to be perfect hostesses capable of dealing with extremely tedious administrative formalities on the one hand, while serving stiff whiskies with the other, smiling all the while. Think of the very first air hostess on board that DC-4 bound for New York in the summer of 1946; imagine her beaming smile when coming aboard for the first time after being selected from among so many other candidates, not to mention her surprise on reaching the two stopovers, in Ireland and Newfoundland. Think of her amazement at the sight of the final destination and when she disembarked onto the tarmac in La Guardia, sporting her brand new uniform on American territory that she was likely seeing for the very first time. She never could have suspected that one day it would take barely 8 hours to do this memorable crossing that she had just done in 23 hours and 45 minutes.

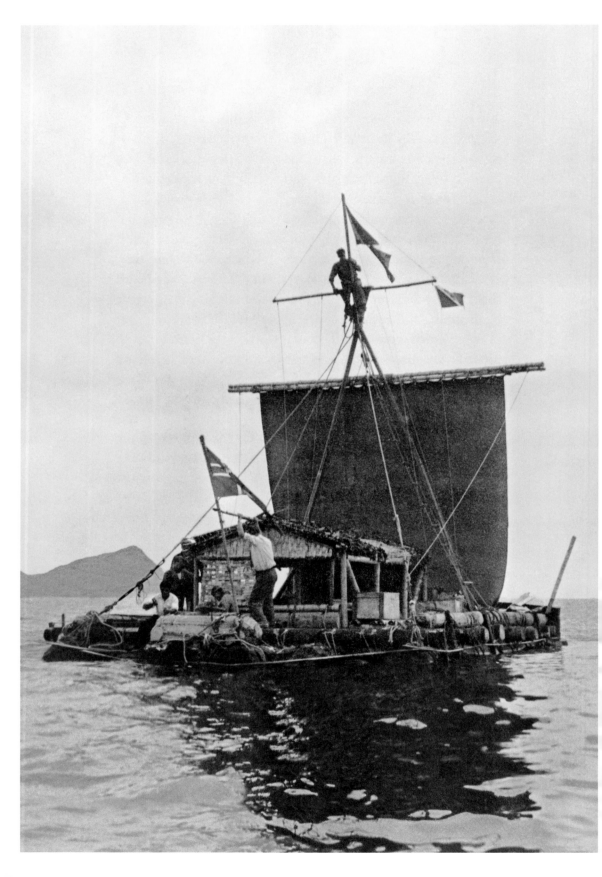

43

THE RAFT OF THE MEDUSA

———

THE *KON-TIKI* EXPEDITION,
WHICH LEFT PERU TO REACH TAHITI IN 1947,
WAS A RETURN TO THE ROOTS
OF NAVIGATION.

The most rudimentary forms of locomotion always fascinate people, perhaps because the voyages they conjure up seem more unpredictable, unusual, and thrilling than those offered by machines that always arrive at the right place at the right time. With the former, we tell ourselves that anything can happen, that we are at the mercy of the waves or gusts of wind, and that the main interest of such a voyage is knowing how to use and master them. That is probably what the crew of the *Kon-Tiki* reckoned when they made their famous raft. But more than anything, the expedition leader, the Norwegian adventurer Thor Heyerdahl, aimed to prove to the scientific world that the South Americans, in ancient times, were perfectly capable of crossing the Pacific Ocean on simple rafts to conquer and people the archipelagos located at the ends of the earth. The theory had frequently been discussed but never proved. The scientific community did not believe it could be done and did not hesitate to ridicule the navigator's idea. He decided to show them that it was possible to travel

FIG. 228

Last adjustments to the *Kon-Tiki* in Callao, Peru,
before its Pacific crossing in 1947.

the 4,950 miles that separated Peru from Polynesia on a craft as basic as a raft.

His team was made up of friends with the right qualities for this type of adventure. Heyerdahl apparently sold them the idea with the following words: "Free trip from Peru to Polynesia (return included). Reply wanted as quickly as possible." A way of presenting things that was bound to excite any adventurer. They all accepted the invitation, and it was therefore five Norwegians, one Swede, and a parrot named Lorita who, in 1947, undertook this old-style voyage, using nothing but the winds and currents, on the most primitive of crafts which they named *Kon-Tiki* in tribute to the Inca sun god. The raft was built based on sketches of Peruvian crafts brought back by the Spanish conquistadors and used hemp, balsa wood, bamboo, and banana leaves, without any nails, nuts and bolts, or wire. The raft resembled a cabin placed on top of large logs, with a large square sail hoisted on the most basic looking mast. The cabin was big enough to shelter all the crew and their mascot.

FIG. 229

Crew of the *Kon-Tiki* with explorer and anthropologist Thor Heyerdahl at the center, 1947.

They took with them 275 liquid gallons of water in 56 water cans and a number of sealed bamboo rods, food rations donated by the American army, a radio in case of problems, a sextant, and a hand-cranked generator; not forgetting fishing equipment—which proved extremely useful—fruit, vegetables, and coconuts. The equipment and provisions were supposed to be similar to those the Peruvians would have taken with them on their alleged voyage. The expedition's organization was not without its problems, particularly as the means of transport was far from perfect. Firstly, the raft was difficult to steer, which resulted in their overshooting the Puka-Puka

FIG. 230

Torstein Raaby and Herman Watzinger protect bundles of food and equipment from the waves shortly after reaching Raroia Atoll in the Tuamotu Archipelago, French Polynesia, summer 1947.

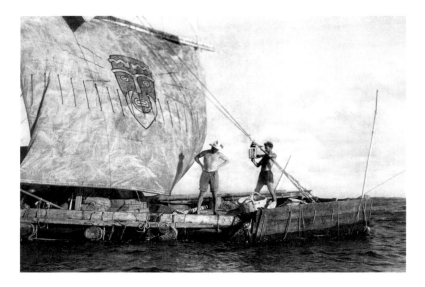

atoll, thereby making it impossible to land there. Secondly, the
person on watch had to attach himself to the raft with ropes
because there was no guard rail. The craft also had to face up
to storms, huge waves that crashed over the logs, and vari-
ous damage, inevitable on this kind of voyage, but it held out,
against all expectation.

Many people claimed that such a primitive craft would
break apart after a few weeks, and that the expedition would
be a suicide mission. They undoubtedly pictured the craft to
be like the very first rafts in history that floated on goatskin
gourds or amphorae, or like the fragile Egyptian skiffs, none
of which were made to last. Indeed, most people were certain
that such a basic vessel would not even be able to undertake
the first part of such a voyage. They could not have been more
mistaken. The raft reached the emerald waters of the Raroia
atoll in the Tuamotu Archipelago after 101 days at sea, success-
fully negotiating the large sheltered lagoons without having

FIG. 231

The *Kon-Tiki* sets sail for the first time with its sail unfurled shortly after its departure.
Navigator Erik Hesselberg and the engineer in charge of instruments,
Herman Watzinger, check the data.

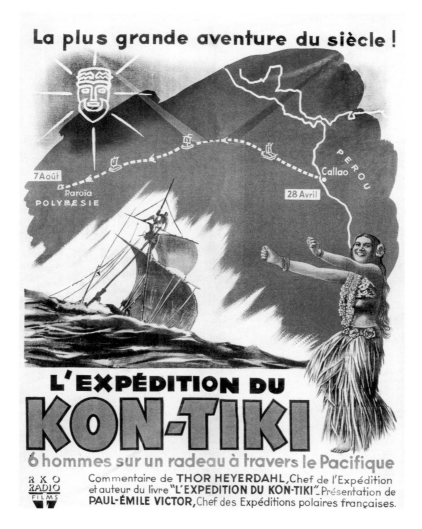

FIG. 232

Poster for Sol Lesser's film *Kon-Tiki*, made in 1951 with presentation
by Paul-Émile Victor.

suffered anything too drastic, proving if not that Heyerdahl's
theory was correct, then at least that a raft was able to make
such a voyage from South America to the Pacific Islands with-
out disintegrating or sinking.

44

BELOVED FREEDOM

―――――

THE JEEP, USED BY THE US ARMY,
SYMBOLIZED THE ALLIED ADVANCE AT THE END
OF THE SECOND WORLD WAR.

The idea could not have been simpler: a vehicle with a rectangular body, four-wheel drive, a fold-down windshield, and long-range headlights, small enough to slip into one of the vast gliders to be used for D-Day, as it was inevitable by then that the United States would be entering the War. It also had to be able to carry a machine gun and a team of three men, and be highly adaptable, driving along railroad tracks, for example, once its tires had been removed. In short, what was envisaged was a small jungle animal that could face up to everything and get itself out of any situation. The year was 1941, and the US government had decided to invent a light, practical reconnaissance vehicle. It was vital to modernize the equipment and forget horses, which until then had been used by armies the world over. Hence the idea of a brand new vehicle, destined to replace the poorly adapted civilian vehicles.

Manufacturers quickly turned their minds to the challenge, for time was of the essence. Two companies finished their prototypes on schedule. Bantam, a small firm with

FIG. 233
GIs and young Parisian women at the foot of the Eiffel Tower
during the Liberation, 1944.

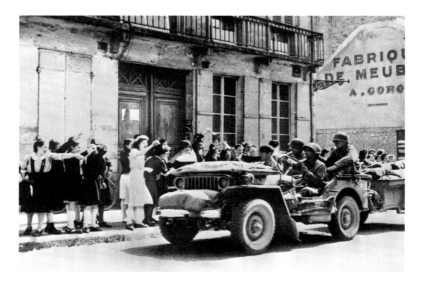

only fifteen employees, somehow managed to come up with
the required plans in time. It was Willys, however, that hit
the jackpot, providing the most effective vehicle at the best
price. The legendary jeep was ready to play its part in history,
its name, apparently, taken from GP for General Purpose, that
then became Jeep. Nonetheless, it was Ford that ended up get-
ting the contract to manufacture it, after the US government
realized that they needed not one hundred models but several
hundred thousand!

The US Army's little wonder would perform every role
in every world it was about to encounter: ambulance for the
Red Cross, platform for the machine gun or bazooka, snow-
plow, poker table on its hood, operating table for surgeons,
table for spreading out road maps, makeshift altar for the mil-
itary chaplain. An icon, above all, was born after the world
saw photographs of General Eisenhower seated at the wheel of
his jeep or the faces of the American GIs, heroes of the D-Day

FIG. 234

American troops of the 15th Army Corps under General Haislip's command
during the liberation of Alençon, August 1944.

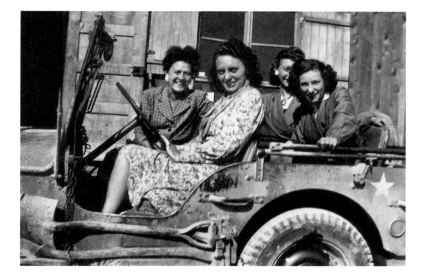

landings, moving down the Champs-Élysées in theirs, besieged by jubilant women. The photograph of Winston Churchill in his jeep halted in front of the Reichstag, sporting a half smile while touring Berlin in ruins, was like yet another blow for the vanquished. And when Churchill was photographed again calmly lighting a cigar on the Normandy beaches, comfortably seated in the jeep belonging to "Monty"—Field Marshal Montgomery—it was another iconic image that imposed itself on the postwar world, that of a modern man, seated not in a traditional car but aboard the victors' vehicle, that of freedom. The voyages of explorers and enthusiasts, expeditions to the ends of the world, mad undertakings at the wheel of the machine that the entire planet was dreaming of—these would be for later, once peace had been found and the desire for new sensations had returned.

The journey that the Frenchman Guy Galand undertook in 1955 in a jeep that he himself had fitted out, belongs to this

FIG. 235

Parisian women at the wheel of a US Army Jeep, August 1944.

category of mad expeditions. A 15,500-mile trek across Africa,
spurred on by his exceptional enthusiasm and a longing for
discovery and adventure. For three hundred days, he experi-
enced what few of us would even be able to imagine, turning
his hand to being a mechanic in desert temperatures of nearly
120°F in the shade, sleeping in his vehicle, rising at dawn to
reassemble the dismantled parts of the jeep, putting up with
heat, thirst, never-ending days on the move, interrupted nights
in his makeshift bed, and all manner of "mechanical mishaps"
before finally arriving safe and sound, against all expectations,
with more notes and anecdotes in his journal than he could
ever have hoped for. Unquestionably an exceptional voyage
and an excellent way of paying tribute to the continual daring,
dynamism, and defiance of these formidable legends on wheels
with their olive-green armor.

FIG. 236

Jeep expedition in the Gobi Desert, Mongolia, 1982.

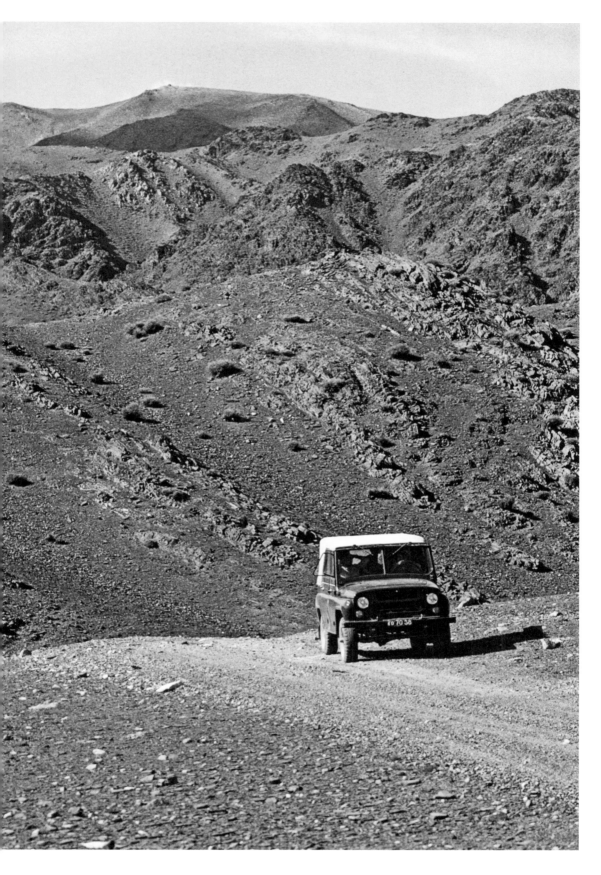

45

EASY RIDERS

———

A WIND OF FREEDOM BLEW OVER
THE UNITED STATES IN THE 1960S.
IT WAS THE AGE OF BIKERS.

The United States, 1969. The Woodstock music festival, anti-Vietnam demonstrations, the first man on the Moon, counterculture, the advent of Richard Nixon to the presidency, *Easy Rider* hippies riding their fiendish machines through the Mojave Desert with the utmost insolence. That year, the manufacturer of Harley-Davidson motorcycles, located in Milwaukee, a small town in Wisconsin, saw its trailblazing machines become a social phenomenon, symbolizing the free man, "born to be wild." Never had so much anger, so much anarchic revolt been associated with a machine. The modest company which, until then, had only distinguished itself during endurance races and by selling its motorcycles to the police services, was suddenly championed by rebels and outlaws.

The reliability of the machine's mechanics, its design, and style had earned it a favorable reputation that went beyond America's borders. But now this motorcycle was a myth. Two bikers speeding along the legendary Route 66, with no limits or particular purpose, wind in their hair, frequently

FIG. 237
Danny Lyons, *McHenry, Illinois*, 1965.

stoned, were to give birth to a new image: that of a machine riding through an American setting, driven by men with simple, free lifestyles. Cinema gave it its reputation and created its legend. The vast arid expanses, music by The Byrds, the two friends and their insane machines that stole the show, embodied a new America that rejected capitalism and the good old dreams of their parents to make others all of their own. Their dreams were made of peace, sex, and psychedelic trips on fiendish machines that allowed them to take off like the horses of cowboys in Westerns of old. These bikers mounted custom choppers, transformed to match their tastes, and when they hid their drugs, it wasn't in the saddle but in the gas tank, stamped with the stars and stripes. Asphalt replaced dusty tracks; the distinctive low throbbing announced their arrival in place of galloping and whinnying. The bikers were knights of the apocalypse.

When the first motorcycle came into being, who would have imagined it would transform into this extraordinary, flamboyant, highly individual machine that terrified people? This first one was invented by the Werner Brothers in 1897 and was just a motorized bicycle, "a high-speed velocipede" equipped with an engine that drove the front wheel via a belt rim. It was pretty unreliable, incredibly uncomfortable, and required constant mechanical intervention. Many modifications had to be made to create a motorized two-wheeler worthy of a long trip, and even more to come up with original models suitable for riding on asphalt roads. The mechanics of Indian Motorcycle, another legendary company, were among the first to produce solid, reliable models, quickly establishing their firm's reputation. Daimler, an equally legendary company, produced the first machine with an internal combustion engine. But it

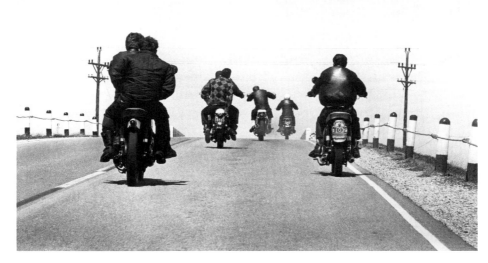

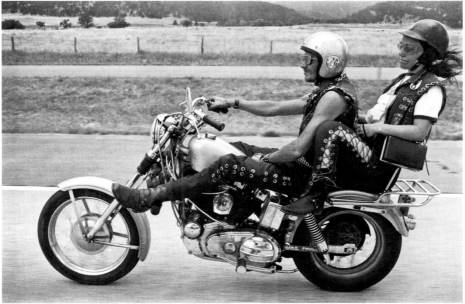

TOP: FIG. 238

Danny Lyons, *Route 12, Wisconsin*, 1963.

BOTTOM: FIG. 239

Dennis Stock, *Bikers*, 1971.

was two teenagers, William Harley and Arthur Davidson, who came up with the idea of creating powerful engines capable of winning competitions, which they also cleverly sought to organize. These motorcycles were a means of transport, for sure, but they were also unique and daring, and allowed people to cover spectacular distances. They accompanied the new heroes of the day and were at one with the landscapes they traversed, allowing their riders to speed effortlessly along the roads.

While early motorcycle models were used in the fight against Pancho Villa, and then by the armed forces in World War II, it was those from the 1950s and 1960s that became collectible objects of fantasy; accessories forever associated with rebels. And while the bikers of the sixties who were busy traversing the vast expanses of the Mojave aspired above all to live from day to day and startle the middle-class inhabitants of the towns and villages they passed through, in reality, they created a new way of traveling, of escaping, of living freely with and in nature, in a far more poetic fashion than they imagined.

FIG. 240

Danny Lyons, *Memorial Day run, Milwaukee, Wisconsin*, 1965.

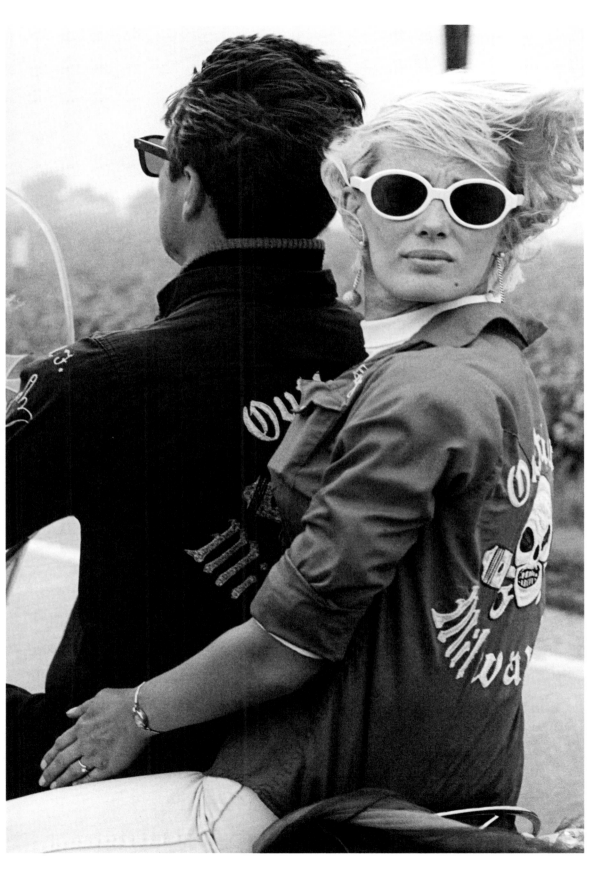

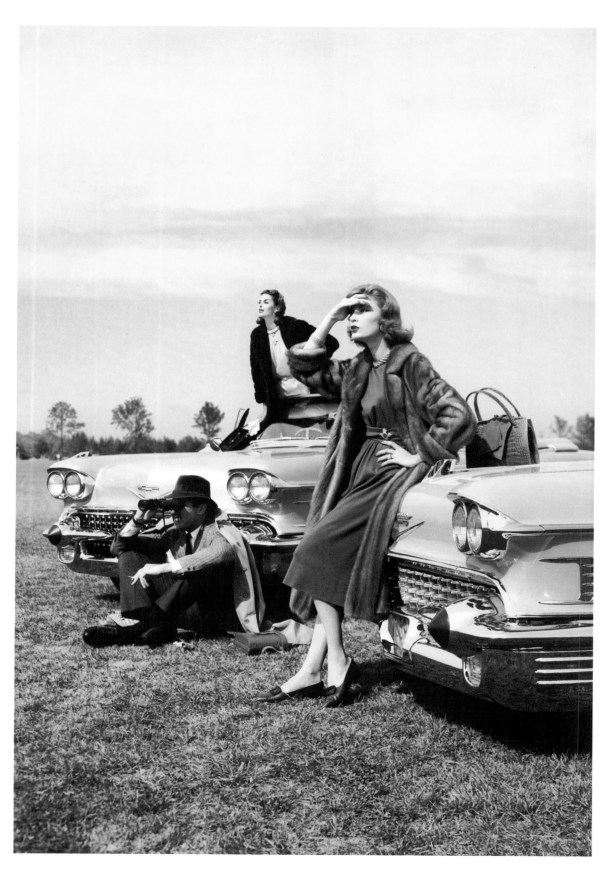

46
THE WINGS OF DESIRE

———

CADILLAC DEVILLE, CHEVROLET BEL AIR—
AMERICAN DESIGNERS RIVALLED
EACH OTHER FOR STYLISTIC AUDACITY
IN THE 1950S.

All of a sudden, these gleaming, flashy vehicles were every-where, with their chrome grilles, their distinctive silhouettes and their ultra-sexy curves, leaving parents' old jalopies by the side of the road. To be cool, you had to have one and be seen at its wheel, preferably with the convertible top lowered, casually cruising the streets for everyone to admire you at the helm of this machine with its white tires and shark-fin protuberances. Were they shameless, excessive, spectacular? You bet! These fantastic cars from the fifties were real fireworks on wheels!

After the hardships of war, this was the era of America as powerful and self-assured, with consumer society in full swing. The world of laborers had given way to employees and middle management. Households, won over by advertising, acquired radios, televisions, refrigerators. In a country devoid of hereditary nobility or any form of strict class system, social affiliation operated primarily through material possession, a sign of personal advancement, a means of asserting oneself, of winning respect and appealing to others. After all the

FIG. 241

A model poses against the hood of a pink Cadillac for *Vogue* magazine,
with a 1958 Cadillac Eldorado Biarritz convertible in the background.

rationing and deprivation, people longed to be able to treat themselves to the fabulous novelties of the period and, in so doing, be part of the much-vaunted Hollywood dream. They wanted to buy themselves Coca-Cola, hamburgers, popcorn, cigarettes, a house with an immaculate front lawn, and a ritzy automobile just like the movie stars.

What a pleasure it was to run your hand over the sleekly bulging fenders, to see your own dazzling smile reflected in the chrome work, to admire the fiendish bumpers, to take to the road with one of these asphalt angels. For the modern American, freedom was lived at the wheel of a brand new car that had to be swankier and longer than the neighbor's. It was American capitalism versus Soviet socialism; the Cold War brought right into people's own homes. Suddenly, it was no longer engineers who were called upon to make cars, but industrial designers—a new profession invented to create products that would please a generation hungry for comfort, leisure, and mobility. Just a few years' earlier, industrialists had been the ones to decide everything when a new model was about to be released. From now on, it was stylists, creative teams, and designers who were at the helm, racking their brains to come up with the most original colors, shapes, and details as style frequently triggers an initial purchase. Cars were no longer just a means of locomotion, but objects reflecting social status. They had to make their owners proud, convey a message, have style.

Harley J. Earl—the vice president of General Motors, who was always ahead of his competitors—understood this perfectly. It was simple; he set no limits. Not only did he launch the first automotive design department, but he also created several legendary models, equipped with streamline

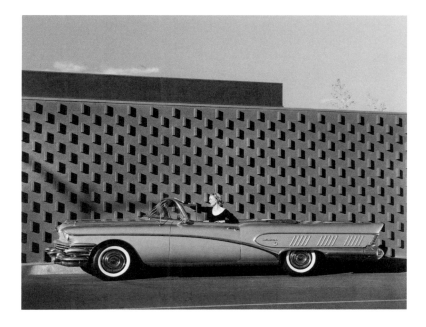

windshields, two-tone finishing, retractable headlights, and magical convertible tops that miraculously disappeared into the body of the vehicle. Earl was fascinated by military aviation and the conquest of space, and dreamed up fenders and chrome work inspired by rockets. The Cadillac Deville, Chevrolet Bel Air, and Oldsmobile Golden Rocket produced by his workshops were unbelievable, with enormous fenders, red leather interiors as soft as cashmere, and crazy colors including gold. Never before had cars like this been seen in combinations of lemon yellow and pink, turquoise and mauve, hues that matched the sun and the palm trees, dreamed up by the chemical engineers Dupont de Nemours. The uncontested architect of this extravagance, the designer Virgil Exner, understood that buyers aspired, first and foremost, to impress their neighbors. And he gave them exactly what they needed

FIG. 242
Luciano Rigolini, *Tribute to Giorgio de Chirico*, 2017.

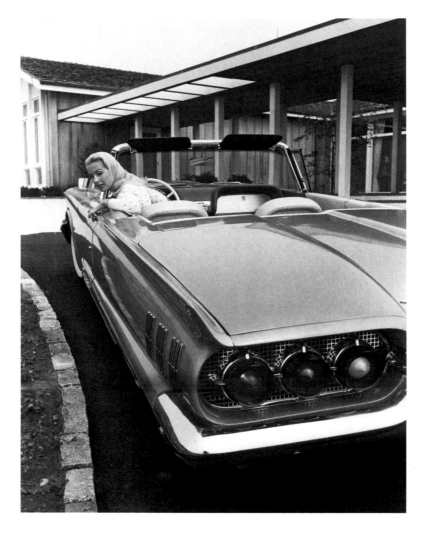

for that: cars with huge trunks and fins inspired by the fighter-plane Lockheed P-38, crazy stylistic innovations, glamor, sequins, and colors like those in candy stores, dream machines for a youth that was discovering rock 'n' roll, McDonald's, and Technicolor movies.

FIG. 243
Bob Henriques, *Actress Lee Remick at the wheel of her Ford Thunderbird*, 1959.

A new design was launched every year to make the previous one obsolete and oblige clients to change their car more often. There were Cadillacs over sixteen feet long, Impalas with six rear lights, Buick Super Rivieras as spacious as apartments, pistachio-colored Pontiacs pictured in advertisements alongside a beautiful woman in an evening dress or mink cape. The message was simple, written on all the posters in long, intertwined letters: "Look like a millionaire!" Looking at these wonders today, we too start dreaming of the good life, without a worry in the world, our imagination catching fire—as if running your hand over the chrome grille was all it took to reach for the sky and set out on a road trip, stopping off in the motels that used to light up the roads with their multicolored signs.

FIG. 244
Advertisement for the Chevrolet Corvette and the Bel Air Sport Coupe, c. 1950.

FOLLOWING DOUBLE PAGE: FIG. 245
The Golden Nugget Casino on the Las Vegas Strip at the intersection
of Fremont Street and South 2nd, 1953.

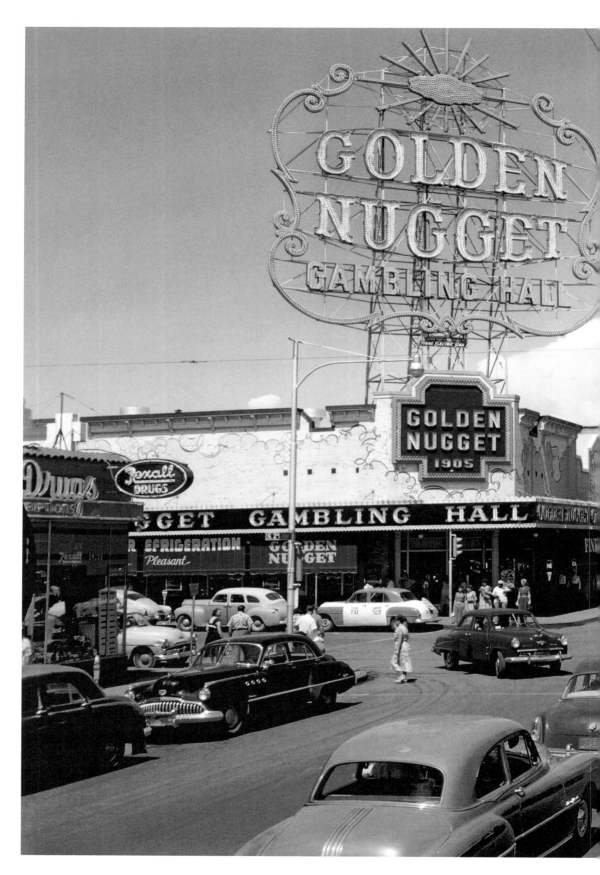

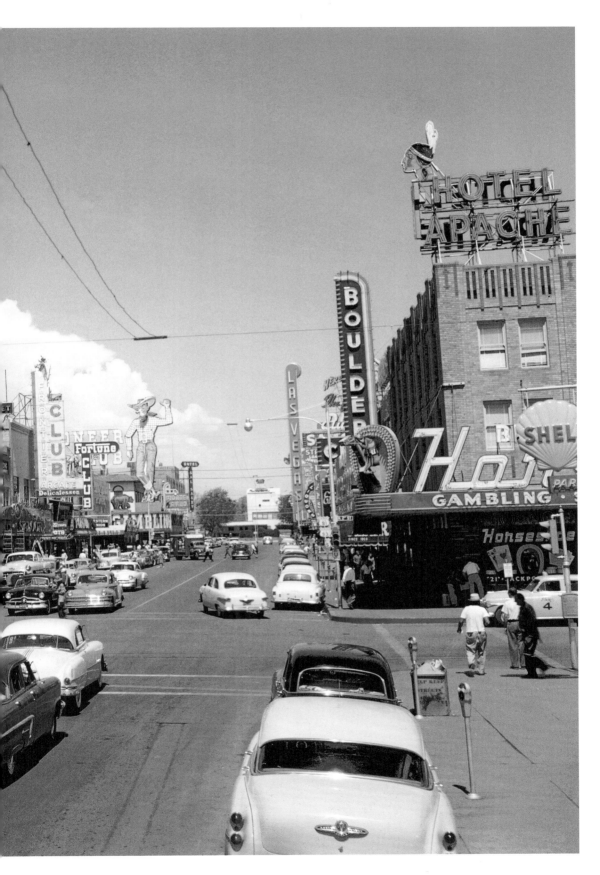

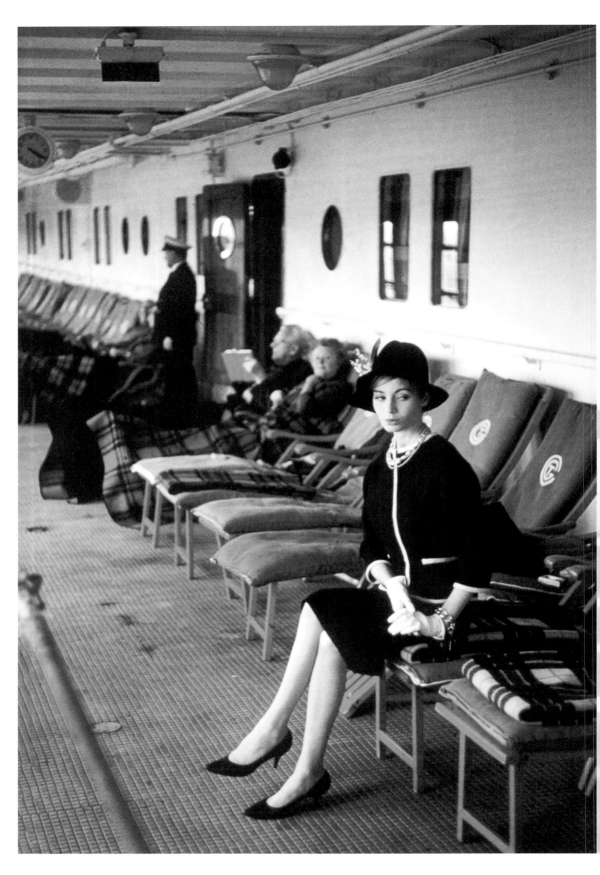

47

MADE IN FRANCE

IN THE EARLY 1960S, THE *SS FRANCE*,
THE FLAGSHIP OF THE FRENCH LINE SHIPPING
COMPANY, WAS THE LARGEST OCEAN
LINER IN THE WORLD.

May 11, 1960: the whole of Saint-Nazaire was holding its breath. The print, radio, and television journalists from around the world had flocked there for the occasion. As was customary, the tricolor ribbon had just been cut and the traditional bottle of champagne shattered against the vast black hull. The spectators were dazzled, some having arrived by specially chartered trains and planes, and those who had stayed at home were following the event on their televisions, dreaming in front of images that showed the two principal protagonists of the day, General de Gaulle and the *SS France*, French Line's latest jewel. The *Marseillaise* rang out as the hull slowly disappeared into the water. There, at last, was the *SS France* afloat, as the first siren blast sounded.

The longest liner of its time, as well as the world's largest, had just been launched to conquer the waves! The Compagnie Générale Transatlantique, or French Line as it was referred to in English, could be proud. In those few moments, it had made all those attending this memorable event feel the

FIG. 246

Passengers of the *France* on the deckchairs of the first-class
covered promenade, 1962.

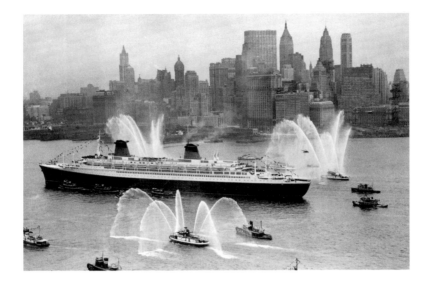

same admiration, the same pride, with no distinction between social class or religion, be they politicians, well-known figures, onlookers, civil servants, employees, architects, metalworkers, engineers, and laborers. They all had the same feeling of belonging to the nation that had created this unique ship, already seen as the "Versailles of the seas." It was far more than a culmination; it was a powerful symbol that was being displayed to the public that day. For this extraordinary launch was celebrating well-executed work, the perfect marriage of effort and excellence, but also, the recovery of France after World War II, thanks to the rebirth of its shipyards, which had been badly bombed. The liner was a larger-than-life ambassador, a showcase that was admired by all in silence. During its construction, journalists had been invited to visit both the site and the ship in the making. They were able to walk on the decks and explore right down to the boiler rooms. Wonderful brochures and color postcards were printed to show

FIG. 247

The *France*'s first arrival in New York, welcomed by fireboats
in front of Manhattan, 1962.

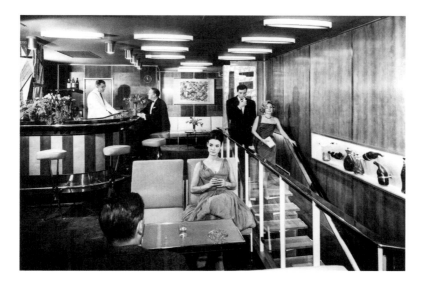

the progress of the work, to display the ship on blocks and on the slipway, and to give an idea of the challenge undertaken.

All these details amazed visitors, but they were astounded by the attention given to the details of the interiors and the luxury deployed on board. There were reception rooms adorned with works by famous artists, games rooms with pinball machines and table soccer, art deco–style restaurants, several swimming pools, a six-hundred-seat theater, and over three thousand plans made for the engine room alone. No matter how moving that moment of discovery was, it was but the small-est glimpse compared to the experience of those who would really embark on this ocean giant in 1962, for its maiden Trans-atlantic voyage. It's easy to imagine the amazement of those 1,806 passengers, some of whom had booked their tickets years in advance, when they discovered all the splendor they had heard so much about and when they entered their cabins fitted out like apartments, or when they first explored the various

FIG. 248
The "tourist" class Atlantic Bar received 1,226 passengers
on its maiden voyage in 1962.

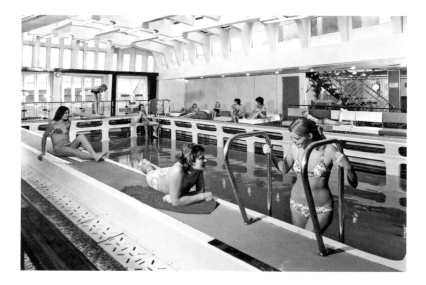

reception rooms reminiscent of those of the Carlton and the Ritz, wandering from the smoking rooms to the solarium, from the sun deck to the verandah, or from the sports halls to the bowling alley. There was even a game room for children, with a puppet theater, playpen, and nursery.

The reception rooms were adorned with Aubusson tapestries and the dishes, silverware and all the tableware had been made exclusively by the most prestigious French houses. In the first-class cabins, furnished like the most elegant Parisian home, passengers had use of telephones and individually controlled air conditioning, and could opt for peace and quiet or select what music to listen to. There were works by avant-garde painters such as Picasso, Braque, and Dufy. And to celebrate the modernity of the period, there was no third class aboard, for the luxury on offer was not solely intended for an elite as on previous ocean liners. "Tourist class" therefore had every comfort, including a library with some three

FIG. 249
The "tourist" class swimming pool located at the rear, on the upper U deck, had removable bay windows for sunbathing.

thousand books, a writing room, a swimming pool, a vast reception room with a dance floor, and a hair salon, to name but a few. Throughout the ship were honored celebrations and the elegance of dinners attended in evening gowns and dark suits. And for a full five days. Five days before the Hudson River loomed into view, together with the impressive escort of helicopters, tugs, small private boats, and the thousands of people come to welcome the first passengers who, gathered on deck on that chilly February morning in 1962, collectively discovered the Statue of Liberty as their boat slowly docked at Pier 88 where an enormous banner saying "Welcome SS France" awaited them. Looking back, we envy them.

FIG. 250
French Line shipping company luggage tag, 1960s.
Paris, Gaston-Louis Vuitton collection.

FOLLOWING DOUBLE PAGE: FIG. 251
Arrival of the *France* in New York, after a five-day Atlantic crossing, c. 1965.

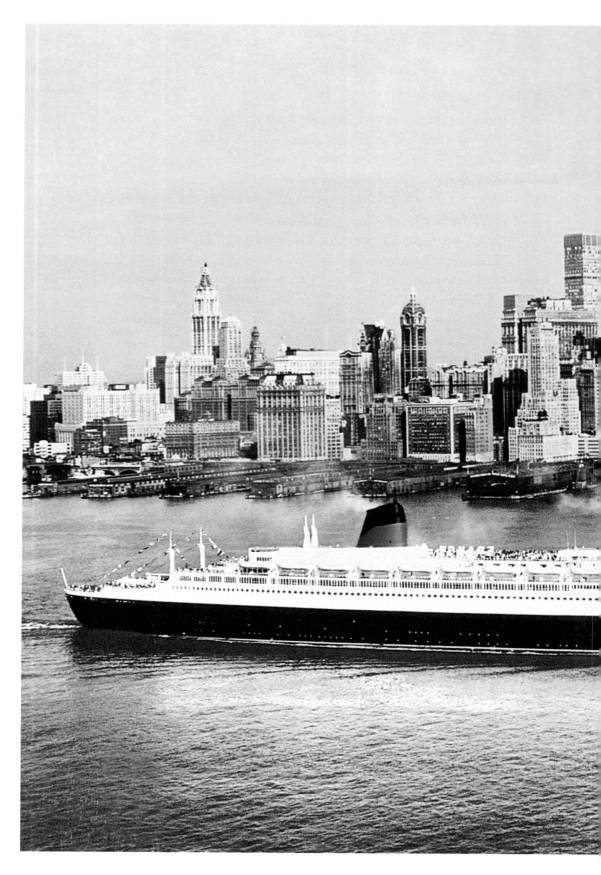

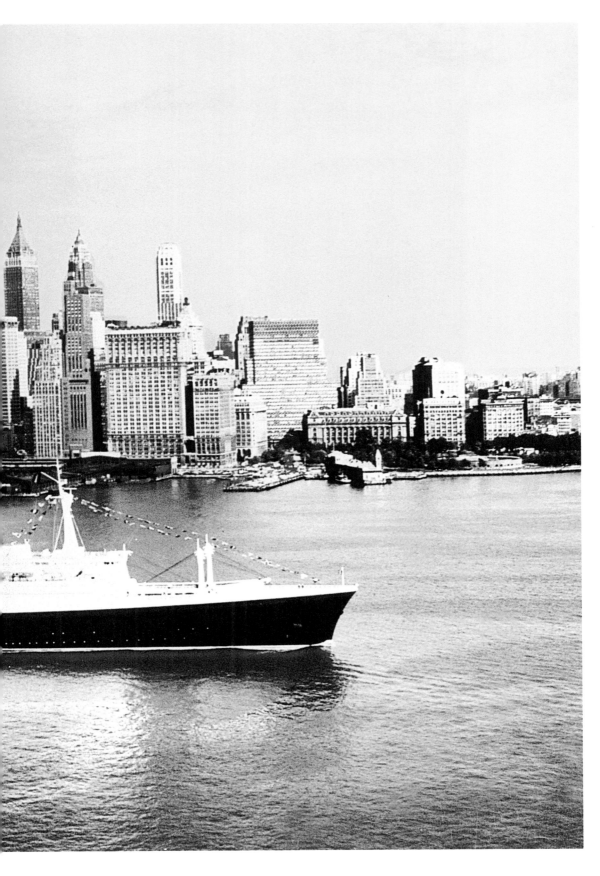

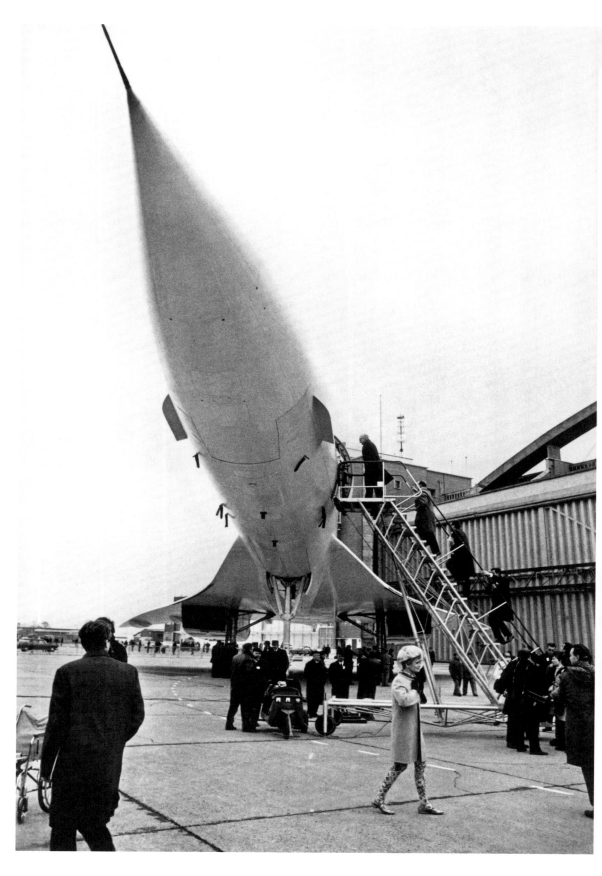

48

SUPERSONIC SOPHISTICATION

———

REACHING MACH 2 WITH A GLASS
OF CHAMPAGNE IN HAND WAS POSSIBLE
AS EARLY AS 1976 ON BOARD THE
FRENCH SUPERSONIC JET.

Every test pilot dreamed of it. Pushing the limits, breaking
the mythical barrier, flying at a speed greater than Mach 1
(760 mph) and causing the huge boom heard by all. That was
the ultimate challenge. In 1947, when the American test pilot
Chuck Yeager achieved this incredible feat aboard his rocket-
powered aircraft, despite having broken two ribs in a riding
accident in the Californian desert the previous day, they all
started dreaming of the next step. Of course, this record would
have to be broken, but it was also imperative to construct a
supersonic airplane capable of transporting passengers and of
achieving the same feat on long-haul lines. American, French,
British, and Russian engineers were under ever-growing pres-
sure from their governments. The countdown had begun. Who
would be first? Which country and what machine would win
the jackpot? In the middle of the Cold War, the project became
the number one national priority, providing the public with
a seemingly boundless race for innovation. The battle was
human, scientific, and above all, incredibly urgent for those

FIG. 252

Raymond Depardon, *Première présentation du Concorde à la presse,
aéroport de Blagnac, Toulouse* [First presentation of the Concorde to the press,
Blagnac airport, Toulouse], 1967.

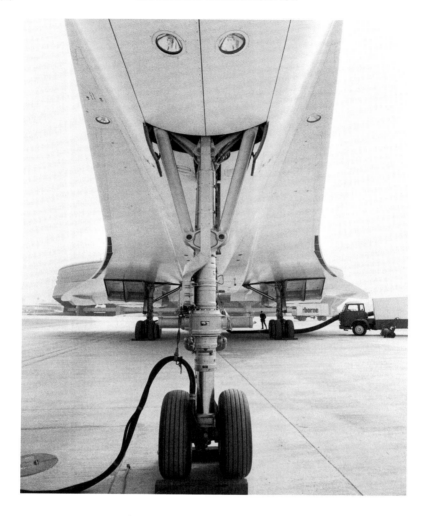

European countries set on countering American domination. What better and more extraordinary way of making a lasting impact than to transport passengers beyond the sound barrier in the most beautiful airplane in the world. Assuming its cost was not exorbitant. In 1962, an agreement was drawn up between the French and the British to share the construction

FIG. 253

Jean Gaumy, *Corps avant du Concorde, tarmac de Roissy*
[Front section of the Concorde, Roissy tarmac], 1974.

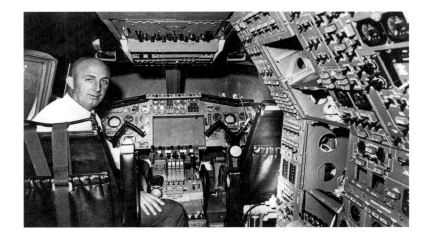

costs and risks. The Russians and the Americans monitored this closely, throwing themselves into the race every bit as fiercely. But the Anglo-French tandem had a head start, calling upon a large number of talented people, and it is said that no less than six hundred companies were involved in the program. The machine was to fly at Mach 2.2, enabling the flight from Paris to New York to be achieved in three hours and five minutes. It would be equipped with delta wings, rendered famous thereafter, and a long tipping nose that became equally famous, and would welcome ninety-six to one hundred passengers, depending on the fittings. It would be the subject of all manner of technical innovations and would be outstanding from every point of view.

What a shock it must have been for the first passengers to discover this incredible white bird and its magnificent cabin tapered like a cigar. When settled in their seats and sipping their first glass of champagne in the privacy of this immensely elegant cabin, they would have been able to admire the highly sophisticated harmony of its beiges and browns, the design

FIG. 254
French pilot André Turcat in the Concorde 001 flight simulator,
February 26, 1969.

of every smallest detail including the cutlery, and the very latest technology combined with a contemporary look. Even the uniforms of the cabin crew were designed by famous French couturiers. There was no doubt: it really was the most beautiful airplane in the world. Architecture and transport were brought together, and with such a sense of style. As for breaking the sound barrier, which worried people as much as it fascinated them, a Machmeter had been installed in front of the passengers so that they could experience the moment live. They wouldn't miss any of this incredible instant which would propel them, so to speak, above other mortals.

All that was missing was a name for this marvel. It was decided that it would be "Concorde" with an "e," for excellence, Europe, England, entente. Four words that stated its cosmopolitan nature loud and clearly. In British and French boardrooms, around large conference tables, at the heart of governments and general headquarters, nobody imagined that this project would be the subject of one of the Cold War's most far-reaching industrial espionage affairs. In 1964, the public learned that the British were pulling out of the project for economic reasons. It took the threat of legal proceedings to bring them back into the program. In 1965, the first pieces of the prototype were manufactured and assembled and, a year later, the final assembly was carried out in Toulouse. In 1967, the model of the interior layout and fittings was presented to a handful of airline companies and, in December, the prototype finally left the aerospace hangars in Toulouse-Blagnac. Meanwhile, however, the cosmonaut Yuri Gagarin and a Soviet delegation visited the French factories and the hangar where the future airplanes were being designed—a visit that allowed plenty of time for KGB agents to photograph the plans which were then sent back to the USSR as microfilms concealed

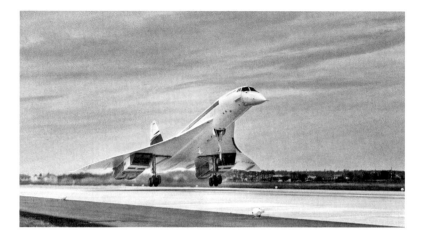

inside harmless looking tubes of toothpaste. A vast Soviet spy ring was dismantled, but too late. The plans were on their way.

In 1968, Concorde was still in its initial trial phase when the Tupolev Tu-144, its Soviet copy, suddenly emerged from a secret hangar, validating those who had suspected from the outset that there was an incredible novel being written in the shadows. The Tu-144 was therefore the first airplane to make a commercial flight that broke the sound barrier, beating Concorde by just two months. This was a terrible blow for the Europeans and one that did not bring good luck to the Soviet manufacturer. Recurrent accidents and a lack of Russian clients for this type of airplane clearly showed that it was unreliable. It did not compete with Concorde for long, and most definitely not in terms of dreams. The "white bird" (as the Concorde was known to the French) still holds all the records and fantasies, with its unique elegance and a silhouette that takes your breath away. An aeronautic icon that made a lasting impact, as its designers had hoped, becoming the most beautiful airplane in the world, carrying terrestrial poetry up to the stars.

FIG. 255

Piloted by André Turcat and Jacques Guignard on its first flight, the F-WTSS prototype
gave the green light to supersonic air travel with its four turbojet engines.

FOLLOWING DOUBLE PAGE: FIG. 256

The *Concorde* departing from Heathrow, London, 1975.

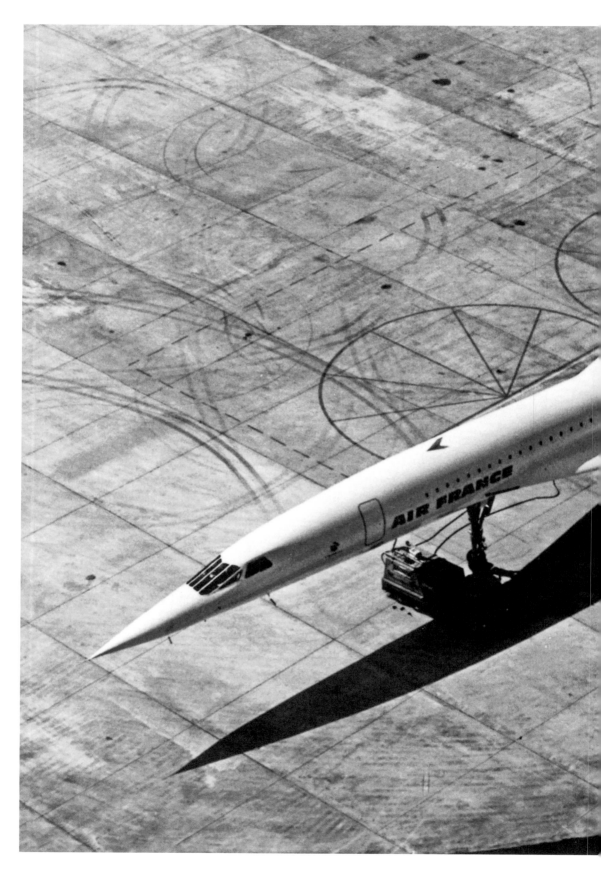

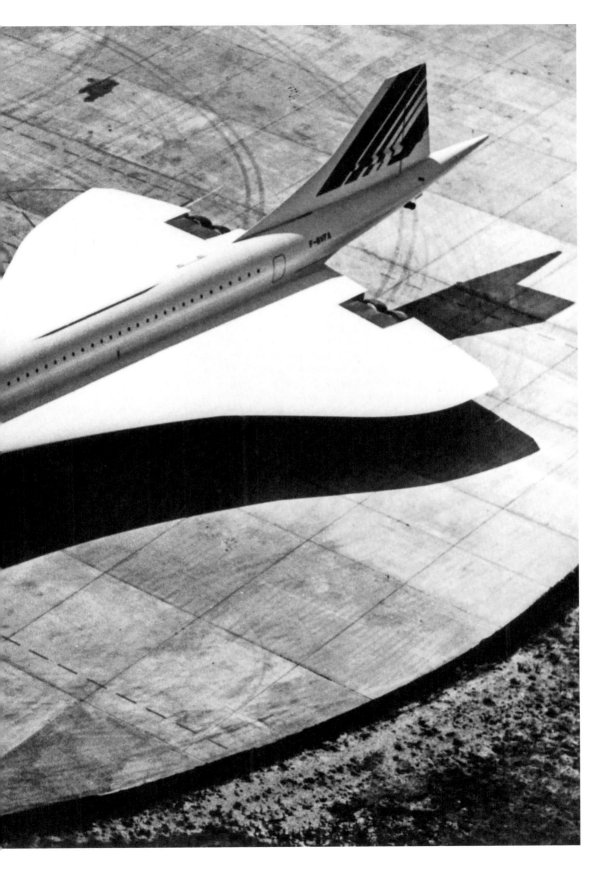

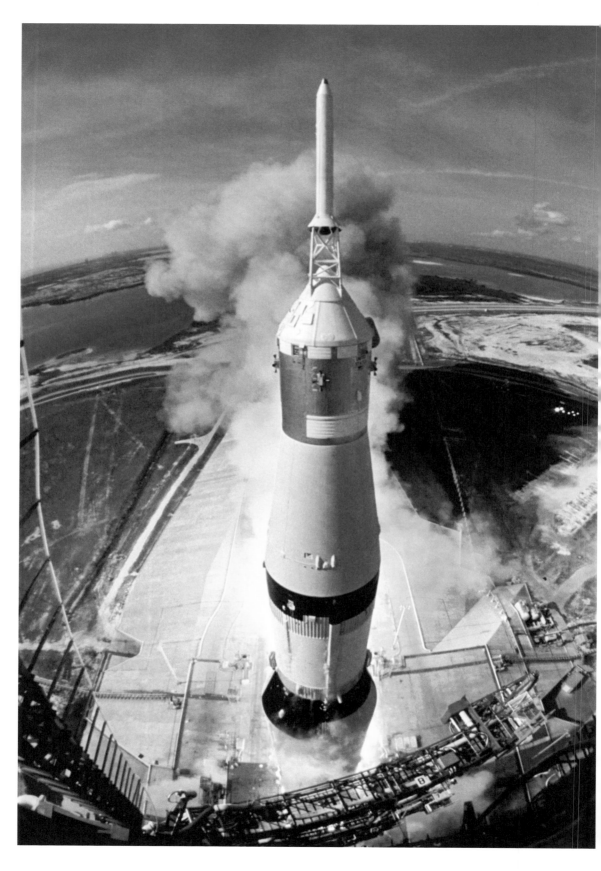

49

DESTINATION MOON

———

THE DREAM CAME TRUE ON JULY 20, 1969.
NEIL ARMSTRONG WAS THE FIRST MAN
TO SET FOOT ON THIS
FARAWAY LAND.

The expedition had an air of magic and extraordinary antic-ipation about it. This was the era of sending capsules into orbit, of men who had the makings of heroes, of voyages that would shake up our future. Of journeys so fantastic that they would thrill the entire planet, left hanging on the displays of these outstanding machines and their extraordinary pilots. The launch of the first man into space by the Soviets had con-vinced the Americans that they had to go all out to beat them on the battlefield of the stars. The whole world was on the lookout and in the Oval Office brains were being racked around the clock to send a man to the Moon using real pilots, men who could fly a rocket like an airplane, vital for this phenomenal challenge to succeed. It was imperative, in the middle of the Cold War, to be the first to carry off this feat and, what's more, in splendid fashion.

The idea, however, was not new. As long ago as the thirteenth century, Chinese scholars had dreamt up a rocket (tubes of card or paper containing gunpowder of uncertain

FIG. 257
Liftoff of the Apollo 11 mission with astronauts Neil A. Armstrong,
Michael Collins, and Edwin E. Aldrin on board, July 16, 1969.

projection). In the seventeenth century, the English writer Francis Godwin described a fanciful voyage to the Moon, followed two centuries later by Jules Verne who sent his heroes aboard a shell fired by a giant canon. In 1901, H. G. Wells published a novel with an entire fleet of space vessels and in the early twentieth century, the Russian Konstantin Tsiolkovsky dreamed up a jet plane that could be put into orbit and reach space. But from then on, it was a question of winning the race for the firmament decisively, rather than simply creating a rocket suited to circumnavigating the Moon. This new vessel had to land on the Moon before returning safely to Earth, a feat accomplished thanks to its heroic pilots who would be watched by half the planet, glued to their television screens.

To this end, NASA's highly trained teams devised the Apollo program which enabled several preparatory missions to be carried out with increasingly high-performance rockets. In 1961, this work led to the creation of the vessel for the Apollo 11 mission. While these men were the best scientists of their time, they knew nothing about the Moon's surface and could only attempt to envisage the risks for the vessel and its crew as realistically as possible in order to achieve maximum reliability. What perseverance, what a singular battle, what courage, and what confidence on behalf of them all! They were all readying themselves for a historic first. On July 16, 1969, this new rocket took off from Cape Canaveral in front of a thousand people who had come to share the moment, packed onto the nearby beaches. At the same time, some 600 million listeners and spectators were seated in front of their radios and television sets across the globe—men, women, and children who had stopped whatever they were doing and were breathlessly awaiting news of the vessel's progress.

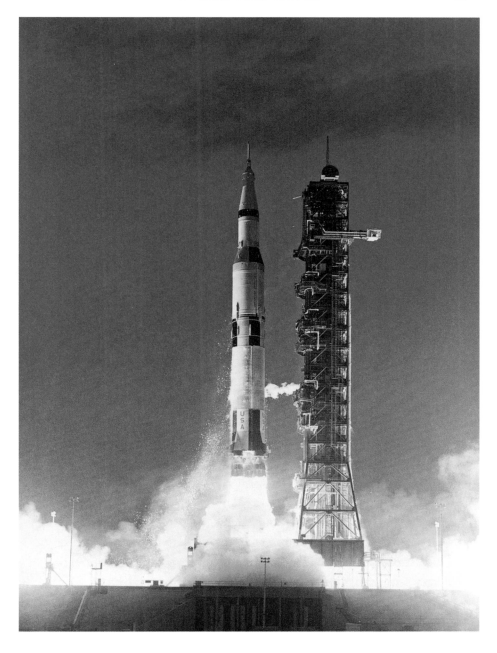

FIG. 258

Liftoff of the Saturn V rocket for the Apollo 11 mission,
at Cape Canaveral, Florida, July 16, 1969.

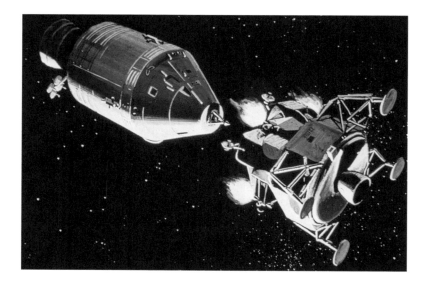

Twelve minutes after takeoff, the success of the first stage of the voyage was announced. A few hours later, the three astronauts on board were propelled toward the night star. After two days, they were more than 186,400 miles from Earth, and some 37,280 miles from the Moon. Their speed increased, bringing them ever closer to their destination, seemingly as easily as a car driving along a highway. All eyes were fixed on the screens transmitting the black-and-white images, while all ears strained toward the radios, listening out for the slightest piece of information or new detail. Were they really going to experience Man's greatest ever exploit live? Were they really going to see the vessel move through space in real time and partake in the craziest dream Man had ever attempted? Speechless, Earth's inhabitants followed every stage, in their homes, apartments, offices, with their friends, in their living rooms, kitchens, garages, and restaurants, fascinated yet incredulous. Five days after takeoff, the pilots

FIG. 259

The Apollo 11 lunar module separates from the control module
on its way to the Moon, 1969.

were about to reach their destination when Mission Control announced that their "module" was on the point of running out of fuel, just one hundred feet short of the Moon's surface! The suspense was palpable. They finally touched down four miles or so from the planned touchdown point and once NASA had given the go ahead, the astronaut Neil Armstrong moved toward the airlock, which he slowly opened. He really was on the Moon. He descended the steps, jumping onto the Moon's surface from the last rung, which was too high off the ground. A memorable jump, on that July 20, that brought smiles to everyone's faces, and tears too, as they all finally let go of their anxiety! The astronauts and their spacecraft had just accomplished a spectacular, almost unimaginable adventure aboard the most staggering means of locomotion ever invented, pushing back the limits of Man, and, at the same time, of his imagination and destiny.

FIG. 260

Commander Neil A. Armstrong training in a lunar module simulator at the Kennedy Space Center, Florida, June 19, 1969.

FOLLOWING DOUBLE PAGE: FIG. 261

The Apollo 11 spacecraft on its way back to Earth, July 24, 1969.

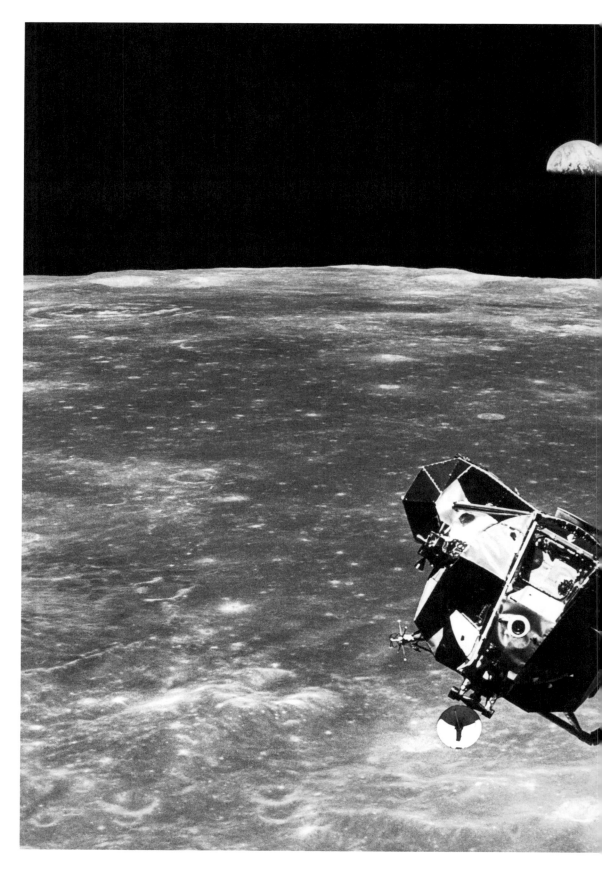

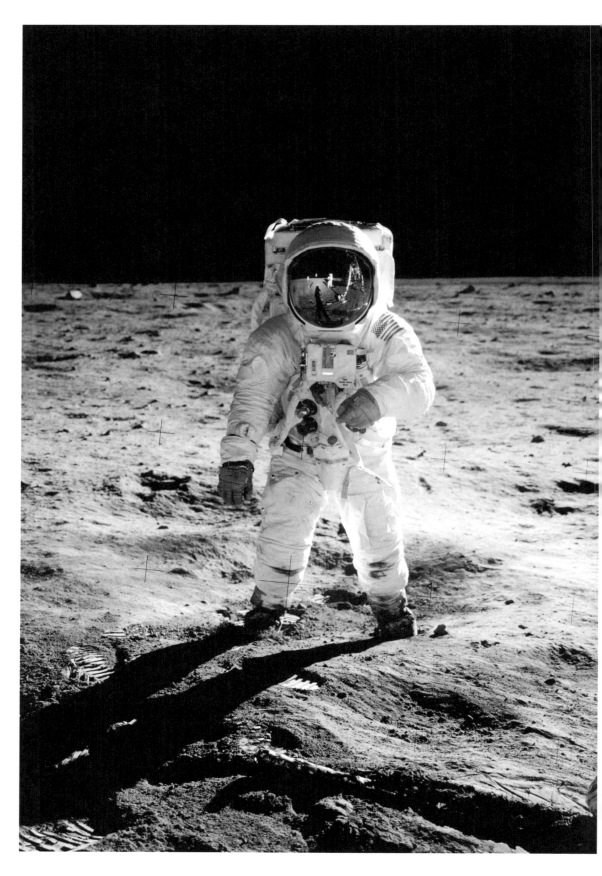

APPENDICES

FACING PAGE: FIG. 262
Neil A. Armstrong takes his first steps on the Moon, July 20, 1969.

CHRONOLOGY

———

1769 The Montgolfier brothers successfully achieve
 the first hot-air balloon voyage.

1807 Robert Fulton built the first commercially successful
 steamboats.

1825 Launch of the first railroad in England on
 September 21, designed by George Stephenson,
 running from Stockton-on-Tees to Darlington.

1855 Émile Pereire founds the Compagnie Générale Maritime.

1861 The Michaux family invents the velocipede.

1872 The first transcontinental railroad in the United States
 opens to the public.

1876 Georges Nagelmackers founds the Compagnie
 internationale des wagons-lits (CIWL) in Brussels.

1883 Inaugural voyage on October 4 of the Orient Express
 linking Paris to Constantinople.

1891 Construction of the Trans-Siberian Railway begins.

1908 Henry Ford launches the first assembly line for the
 production of cars.

1909 Pierre and Jean Vuitton exhibit a helicopter
of their own making, the Louis Vuitton II,
at the Paris Air Show.

1909 Louis Blériot crosses the Channel in an airplane.

1927 Charles Lindbergh makes the first non-stop flight
between New York and Paris.

1930 Ellen Church, an American nurse, becomes the world's
first flight attendant.

1960 French Line launches *France*, the world's most
luxurious and modern ocean liner.

1964 The Shinkansen, the first high-speed train, links Tokyo
to Osaka on the eve of the Olympic Games in Japan.

1969 The Concorde makes its first successful flight.

1969 Neil Armstrong and Buzz Aldrin set foot on the Moon
on July 20.

1976 Concorde's first commercial flights occur on January 21.
One plane takes off from Paris to Rio de Janeiro,
another from London to Bahrain.

ACKNOWLEDGMENTS

The author would like to thank
everybody who has helped create this book:

Michael Burke and Stefano Cantino,
as well as Julien Guerrier, Valérie Viscardi,
and Nathalie Chapuis.

My thanks also to Bertrand Mattéoli, as always.

Not forgetting Philippa and Eduardo Yrarrázaval,
Alejandra di Andia, Joy Sulitzer,
and Don Eduardo Yrarrázaval-Concha,
an inexhaustible source of inspiration who never
imagined that his name would travel
from Chile to this page.

Thank you also to Julio Piatti
and everybody who was a part
of this adventure in so many ways,
both near and far.

IMAGE CREDITS

ADOC-Photos: 397 (collection Casagrande) • AKG Images: 54 top (Science Photo Library), 224, 232–233, 282 (Imagno, image colorization Sébastien de Oliveira), 326 (Imagno), 427 (photo Jean Dieuzaide) • Archives Gertrude Bell, Newcastle University: 161 • Archives de la Planète – musée départemental Albert Khan, Boulogne-Billancourt: 166, 167, 206, 208 • Archives Louis Vuitton Malletier, Paris: 5, 14, 16, 18–19, 21, 22, 25, 26, 27, 28–29 (photo Mark Segal), 31, 32 top and below, 33, 34 (photo Félix), 35 top and below, 36, 38 (image colorization Sébastien de Oliveira), 39 top and below, 40 top and below, 41 top and below (image colorization Sébastien de Oliveira), 42 below, 43 top, 44 top and below, 122–126, 162–165, 168, 170, 171, 261, 273, 274, 275, 281, 313, 327, 341, 342–343, 364, 419 • Bibliothèque Forney, Paris: 115, 178, 179 • Bibliothèque nationale de France, Paris: 51, 53 top and below, 62, 104 • Bridgeman Images: 42 top (archives Charmet), 43 below (archives Charmet), 47 (Tallandier), 48 (Jean Bernard), 54 below (MEPL), 56 (MEPL), 57 top (Granger), 57 below (MEPL), 60–61 (MEPL/image colorization Sébastien de Oliveira), 65 (Granger), 67 top and below (SZ Photo/Scherl), 68, 71 (Keystone/Zuma), 85, 92 (MEPL), 93 (Underwood Archives/UIG), 95, 96, 98 (Tallandier), 99 (Giancarlo Costa), 100 (Granger), 101 (SZ Photo/Scherl), 102, 105 (Look and Learn), 106 (Avant-Demain), 107 (MEPL), 108 (Buyenlarge Archive/UIG), 111 (Luisa Ricciarini), 112 & 113 (Mary Evans Pictures Library/Onslow Auctions Limited), 114 (Mary Evans Pictures Library/MEPL), 128 (Alinari Archives, Florence), 131 (Granger), 133 (MEPL), 134 & 137 (Granger), 143 (Granger), 144 (Granger, image colorization Sébastien de Oliveira), 146 & 147 (Peter Newark American Pictures), 149 (Granger), 150–151, 173, 174–175 & 176 (image colorization Sébastien de Oliveira), 180 (Dagli Orti/De Agostini Picture Library), 183 (MEPL), 185 (Spaarnestad Photo), 186 below (Leonard de Selva), 188 (Spaarnestad Photo), 189 (SZ Photo/Scherl), 191 (Everett Collection, image colorization Sébastien de Oliveira), 192 top (Universal History Archive/UIG), 192 below & 195 (Granger), 196–197 (PVDE), 198 (Leonard de Selva), 200 (Tallandier), 201 (Leonard de Selva), 203 top and middle (Touring Club Milano/Marka/UIG), 203 below (Leemage), 210, 212 (Avant-Demain), 214 top and below, 220 (Granger), 221 top and below (Lux-in-Fine), 223, 226 (The Stapleton Collection), 227 (Prismatic Pictures), 228 top (United Archives/Carl Simon), 228 below (Prismatic Pictures), 229 & 231 (United Archives/Carl Simon), 249, 259 (British Library Board), 260 (Dorling Kindersley/UIG), 268 (image colorization Sébastien de Oliveira), 270 (DHM), 271 top (Touring Club Italiano/Marka/UIG), 271 below (Alinari Archives, Florence), 272 top and below (Touring Club Italiano/Marka/UIG), 284 (MEPL), 286 (SZ Photo), 288, 301, 329 (Archives Charmet), 336 (Leonard de Selva), 338 (Tallandier), 339 top, 339 below (Leonard de Selva), 340, 344 (SZ Photo/Scherl), 346 (Arkivi UG), 347 (Look and Learn/Naylon Maritime collection), 350 (Christie's Images), 358 top (SZ Photo/Scherl), 362 (Buyenlarge Archive/UIG), 365 (Tallandier), 366 (MEPL), 367 below (SZ Photo/Scherl), 368 (Tallandier), 390 (Everett Collection), 393 (Leonard de Selva), 394 (René Saint-Paul, image colorization Sébastien de Oliveira), 396, 399 (Alain Le Garsmeur), 420–421, 425 (AGIP), 428–429 (AGIP), 433 (NASA/Novapix), 434 (Granger), 438 (NASA/Novapix) • California State Library, Sacramento: 156, 157 • Centre national des archives historiques du Groupe SNCF, Le Mans: 234, 242, 243, 244, 245, 246 • Centro Storico Fiat, Torino: 116 • Collection Air France - Musée Air France, Paris: 324, 367 top, 370, 371, 372, 373, 374, 375, 385 • Collection French Lines & Cies, Le Havre: 414, 416, 417, 418 • Gamma-Rapho-Keystone: 186 top, 356–357 (Véronique Durruty), 381 (Eugène Kammerman), 386 top and below • Getty Images: 45 (Corbis/Condé Nast Archive), 59 (Time Life Pictures/Mansell), 64 (Three Lions), 72 (Fox Photos), 73 (Transcendental Graphics), 79 (Didier Noirot/Gamma-Rapho), 84 (Buyenlarge), 88–89 (Popperfoto), 110 (Swim Ink 2, LLC/Corbis), 136 (Transcendental Graphics), 139 top (Michael Maslan/Corbis/

Originally published in French as *Voyages Extraordinaires*
by Atelier EXB, Paris in 2021

Library of Congress Control Number: 2021930590

ISBN: 978-1-4197-5786-0

Printed and bound in Italy
10 9 8 7 6 5 4 3 2

Abrams books are available at special discounts
when purchased in quantity for premiums and promotions
as well as fundraising or educational use.
Special editions can also be created to specification.
For details, contact specialsales@abramsbooks.com
or the address below.

Abrams® is a registered trademark
of Harry N. Abrams, Inc.

ABRAMS
The Art of Books

195 Broadway
New York, NY 10007
abramsbooks.com